SAVING
MICHELANGELO'S
DOME

SAVING MICHELANGELO'S DOME

How Three Mathematicians and a Pope

Sparked an Architectural Revolution

WAYNE KALAYJIAN

PEGASUS BOOKS

NEW YORK LONDON

SAVING MICHELANGELO'S DOME

Pegasus Books, Ltd.
148 West 37th Street, 13th Floor
New York, NY 10018

ISBN: 978-1-63936-586-9

10 9 8 7 6 5 4 3 2 1

Printed in the United States of America
Distributed by Simon & Schuster
www.pegasusbooks.com

Dedicated to Charlie Kalayjian

CONTENTS

TIMELINE OF EVENTS: CIRCUS OF CALIGULA TO THE HOOVER DAM

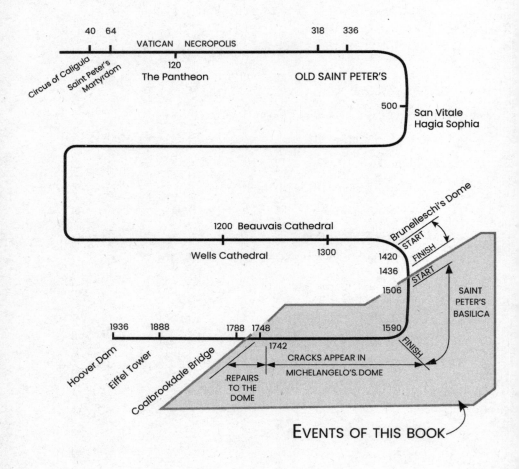

TIMELINE OF EVENTS: 1400 TO 1750

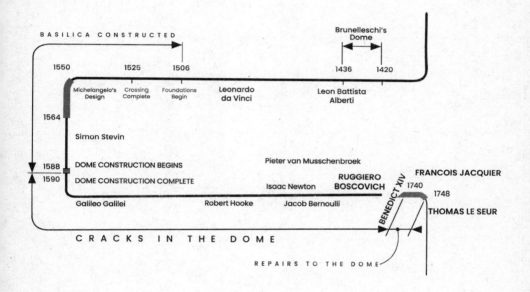

BASILICA CONSTRUCTED

Brunelleschi's Dome

1550 1525 1506 1436 1420

Michelangelo's Design Crossing Complete Foundations Begin Leonardo da Vinci Leon Battista Alberti

1564

Simon Stevin

Pieter van Musschenbroek

1588 DOME CONSTRUCTION BEGINS

FRANCOIS JACQUIER

Isaac Newton RUGGIERO BOSCOVICH

1590 DOME CONSTRUCTION COMPLETE 1740

1748

Galileo Galilei Robert Hooke Jacob Bernoulli

BENEDICT XIV

THOMAS LE SEUR

CRACKS IN THE DOME

REPAIRS TO THE DOME

1
THE POPE'S PROBLEM

The dome at St. Peter's Basilica had been an ambitious idea from the start. Four popes had joined with artistic legends such as Donato Bramante and Raphael Sanzio to prepare its early design on Vatican Hill. Then, around 1550, Michelangelo Buonarroti—in his seventies and as gifted yet temperamental as ever—had a different idea, and for inspiration turned to his native city, Florence, and its magnificent cupola at Santa Maria del Fiore. "I'm going to Rome to make your sister, bigger than you yes but not more beautiful."[1] Michelangelo meant for a majestic spectacle at St. Peter's, and his models made of timber and clay showed a titanic, double-shelled hemisphere that hovered some thirty stories off the basilica's floor. Only one or two others had ever been tried at such a monumental scale, and in this way Michelangelo's dome became at once the emblematic pride of Italy, the papacy, and Christendom.[2] But it was also expensive and complicated to build, and though Michelangelo lived a long and fruitful life, his grand design ultimately languished on the drawing boards.

The dome was raised a generation later in a fevered campaign directed by Giacomo della Porta and his able deputy, Domenico

Fontana. But to do it, they had to first gain the personal approval from Pope Sixtus V to change the shape of Michelangelo's outer shell. Together, these three became a formidable team that led a backbreaking effort to vault the dome in twenty-two short months. Though their collective achievement was considered a triumph of construction, there grew nagging questions and rumors about the dome, almost from the moment that Della Porta pulled away his last scaffold off the job. Ominous cracks began to appear and then propagate, and no architect or builder knew why they had formed, how to stop them, or if they could be fixed. Many just ignored them. But the cracks worsened and continued to grow deeper, longer, and wider so that, after 150 years, they were so numerous that the dome faced an imminent threat of collapse. It was a monumental problem in search of an inspired solution, and no one would have supposed that an answer might spring from a most unpromising place—the fractious, embittered, and exhausting papal conclave of 1740.

<p style="text-align:center">≈</p>

The Sacred College of Cardinals had been sequestered for half a year inside the Vatican's Sistine Chapel. It was an elite institution that featured many of Europe's most prominent personalities and fifty-six of them had gathered from Austria, France, Germany, Hungary, Portugal, and Spain, but most were from the Italian peninsula. Though splintered by disparate politics and geographies, the college was nonetheless bound in its common faith and allegiance to the Roman Catholic Church.[3]

The group had been meeting in its secret session of conclave, duty-bound since February to choose their next pope. From within this pool of cardinals had emerged a few favorites, known as the

papabili, to succeed the popular and now deceased Pope Clement XII, who had been elected ten years earlier. Conclave had been a tradition for nearly five hundred years, since the Council of Lyon, and once the doors to the Sistine Chapel were closed and sealed, no one was allowed to enter or leave until an agreement was reached by two-thirds vote. Until then, Vatican Hill would be placed on lockdown, while the rest of Rome joined in a steady stream of rumor and gossip about who their next pope might be. The speculation became a favorite pastime along the Italian peninsula, and an entire industry of wagering and placing bets on outcomes had swelled around these elections, though the papal threat of "perpetual banishment" had tried to tamp down the practice.[4]

Like other conclaves from the recent past, the Sistine Chapel in 1740 had been converted by carpenters into a makeshift hotel. Each cardinal was assigned a two-story flat that included a small bedroom, study, and valet quarters, and during the conclave their contact with the outside world—even food and drink—could only be accommodated through small, revolving turntables from beyond the chapel walls. Though graced by Michelangelo's wondrous frescos on the altar wall and ceiling, the place was otherwise chilly and cramped. Most of the cardinals in the college were past sixty years old and well beyond their physical prime, so it was not a large surprise when four fell seriously ill from the unhealthy conditions, and two caught fever and died.[5] But even these deprivations could not spur a consensus in the choice of a new pope.

This was because the college was facing a tall task. It had to find the one among them who was best suited to balance the spiritual well-being of Christendom as well as govern the serpentine-shaped territory controlled by the Vatican—known as the Papal States—while also navigating the cloak-and-dagger intrigue of international diplomacy. These pragmatic realities caused rifts

to form that had splintered the cardinals. Some supported those candidates favoring strong Italian-centric policies, while others were more disposed to those *papabili* with a more multinational point of view. A third bloc of voters had emerged, too, called the Zelanati, and it demanded that any nominee possess the moral and spiritual fiber necessary for the job (which had not always been the case). Under these fractious conditions, the conclave became a high-stakes game of political chess.

Those *papabili* with the best chances of winning were tendered to the Sacred College of Cardinals in February and March 1740 through a process known as "scrutiny." Some candidates came closer to election than others, and fell shy by only one or two votes, like Cardinals Aldrovrandi of Bologna, Lanfredini of Florence, Riviera of Urbino, and Ottobani of Ostia (who was also dean of the college). None received the needed majority, however, so other names were floated, which only added to the intrigue. Dozens of ballots were cast as winter turned to spring, yet the conclave remained in a stubborn deadlock. Then came the infamous Roman summer, and with it the fleas, the lice, the dust, and the stale smells of an airless, humid chapel that had never been designed to serve, quite literally, as a college dormitory. By the end of July, the conclave had cast more than two hundred ballots and yet remained no closer to electing a new pope than when it had started.

But fate intervened a few weeks later, while Prospero Lambertini was having his early morning tea in the flat of his friend, Cardinal Acquaviva of Aragon. Apparently, the topic had turned to Lambertini's interest in assuming the vacant papal seat, to which he had not previously given much serious thought. Until then, Cardinal Lambertini had enjoyed a long and productive ecclesiastical career inside the Vatican and was known for an affable temperament, well-rounded intellect, keen memory, and

a quick wit that had only sharpened with age. He also held the plum position as archbishop of Bologna and relished everything about his job—the post, the people, the place—and could not wait to return to his beloved native city once the conclave had finally finished its business.

Within hours, the temperature on his papal prospects began to rise. "More and more cardinals pressed in to see him," and this sudden swell of support was as remarkable as it was swift.[6] The conclave took up Lambertini's candidacy without hesitation, and he was vetted by midmorning; later that day, the college cast its 255th ballot—a record for the conclave—where he captured a resounding majority of the votes.[7] In twelve short and astonishing hours the archbishop of Bologna, who had never campaigned for the job and apparently never wanted it, had become the next pope. On that sultry evening, August 17, Lambertini addressed his colleagues to accept the election's outcome "for three reasons; so as not to resist God's will; so as not to be ungrateful for your kindness; and so as to finish our assembly, which has lasted so long that I think it is giving scandal to the world at large."[8]

Five days later, Lambertini ascended the throne as pontiff to the Roman Catholic Church. At that time, he assumed the ancient papal staff and crown, along with his new name, Benedict XIV, directly beneath Michelangelo's miraculous dome.

The same dome that was silently yet steadily cracking apart.

❧

Prospero Lorenzo Lambertini had been born sixty-five years earlier, in March 1675. Both parents—his father, Marcello, and mother, Lucrezia Bulgarini—were descendants from noble Bolognese families. Marcello's branch traced its ancestral roots in

northern Italy back some eight hundred years, having served God and country as soldiers, priests, and politicians. One, named Gerard, had led the Bolognese guard in 1096 during the First Crusade to Jerusalem, while another, Albert, was made archbishop of Milan in the fourteenth century. Marcello had followed in this tradition of public service, too, and was one of forty senators to govern Bologna, while Lambertini was a boy. Later, he was elected as *gonfaloniere* (the city's chief political magistrate), which was a prominent and prestigious position of public stature.

The Bologna of Lambertini's youth was a prosperous and broad-minded place. It had been a thriving commercial hub that connected key cities like Florence, Milan, and Venice for centuries, and this confluence of trade had welded many ancient cultures together inside its city gates: Byzantine, Etruscan, Gallic, Gothic, Lombard, and Roman. Bologna was also a sophisticated university town and home to a vibrant community of scholars and teachers that, since 1088, had been the first and most venerable center of higher learning in Europe. Its medical school, for example, had been established nearly five hundred years earlier and was among the world's most advanced in surgical techniques, and the university's notable graduates included author Dante Alighieri, architect Leon Battista Alberti, and scientist Nicolaus Copernicus.

Lambertini attended school at the local Convitto degli Ardenti. His first instructor there was a benevolent doctor of letters, Sante Stancari, who spotted the youngster's quick intelligence and nimble mind. Stancari noted that his star pupil had "outstripped all his contemporaries," and for eight formative years this teacher and student forged a pivotal bond that revolved around books and learning.[9] Lambertini fondly recalled the relationship years later when, during the fateful conclave that made him pope, he wrote to a friend of his "true gratitude to Signor Dottore Stancari."[10]

Maybe young Lambertini's most important lessons at the Convitto were while learning his Latin. Though maybe difficult to imagine today, Latin had been recently resurrected to become the common form of discourse within Europe. It had always been the language of the church, but by the early 1700s it had also become the way for scholars, diplomats, physicians, lawyers, scientists, and businesses to communicate with one another across international borders (just as English has become the global language in our twenty-first century). Though Lambertini could not know it yet, his mastery of Latin would open many doors and profoundly shape his life.

Lambertini left the Convitto and his family at thirteen. That was the year he moved to Rome to attend the Collegio Clementino, which was near the Tiber River and down the broad avenue—now known as Via della Conciliazione—from the Vatican.[11] He studied more Latin there, along with coursework in astronomy, mathematics, philosophy, and physics. Lambertini absorbed them all and by sixteen his academic achievement was so widely recognized that he became the clear choice to deliver that year's class speech, which was a notable annual event that was commonly attended by dignitaries. One of them was a certain Cardinal Beneddetto, who was favorably impressed by what he heard and reported it to Pope Innocent XII; this earned young Lambertini his first papal audience and a financial grant to pay his way through school and graduate a few years later with a dual doctorate in theology and law.

Not yet twenty years old, Lambertini decided to stay in Rome and pursue a legal career. His practice thrived from the start, with much of his case load streaming through his connections within the Rota—the Vatican's judicial court—where he investigated hundreds of disputes referred to the pope for dispensation. Lambertini could have effortlessly continued down this professional path but

had a change of heart three years later, when he opted to pursue his orders as a priest. For the next thirty years he assumed new and various roles from within the Vatican, first at the Rota and then the church's administrative arm, known as the Curia. For twenty of them, he held the office of Promotor Fidei (Promoter of the Faith, or Devil's Advocate), where he adjudicated and clarified delicate disputes of theology, law, and science then facing the church and papal policy. One of his landmark contributions was the objective yardstick he created for the Vatican to use when evaluating a candidate's status for sainthood, in a process known as "canonization," which remained in place for the next two hundred years. Lambertini's heightening status was predicated on his investigative integrity, a willingness to challenge conventional thought, an ability to keep an open mind, a knack for gaining consensus among others, and his focus on solutions that were pragmatic and workable. He thrived in these roles, and they propelled his reputation for professional competence, a sharp intellect, and an amiable demeanor.

After the Vatican hired him in 1703, Lambertini then joined a literary society known as the Pontificia Accademia degli Arcadi. Anyone notable and worth knowing in Rome seemed to have been a member at the Arcadi, and young Lambertini came to regularly meet and befriend there a broad range of the most cosmopolitan and learned people in Italy and Europe. They were diplomats, politicians, scientists, lawyers, historians, mathematicians, archivists, musicians, artists, philosophers, and archaeologists (then known as antiquarians), along with a new breed of traveler that today we would call "cultural tourists." One of them, Celestino Galiani, was the chair of history at the University of Rome, known as La Sapienza. He was Rome's earliest enthusiast of Isaac Newton's revolutionary and thunderous view of modern physics, which had recently taken the continent by storm.

Lambertini's cumulative career at the Rota, the Curia, and the Arcadi had by now put him on a first-name footing with dozens of influential cardinals and three popes.[12] Of them, Cardinal Vincenzo Maria Orsini seemed to have held the young priest in highest esteem.[13] Orsini had been born into a noble Roman family of great wealth, but then turned his back on it all at age eighteen to enter the Dominican Order of Friars. That did not stop his powerful family, though, which had found a way to influence Vincenzo's promotion to cardinal, apparently against the young man's personal inclination. Fifty years later, following the death of Pope Innocent XIII in 1724, Cardinal Orsini was elected as pope after a three-month conclave—though with reluctance since he felt unworthy for the job. He assumed the name Benedict XIII and earned high marks for his devout faith and genuine concern for the needy. But this came with a high and hidden price, since his lack of experience and savvy with Vatican politics made him pliable and easy to manipulate, as subsequent events would make plain.

Benedict XIII's promotion held meteoric implications for Lambertini, who was now fifty and well into middle age. As a gesture of gratitude for his support at the conclave and in recognition of Lambertini's many years of service to the Vatican, Benedict XIII named him bishop of Theodosia (in Constantinople) just eight days after the papal coronation. More than that, Lambertini during this time became the new pope's personal advisor, and whenever any thorny matter or "difficult point of Canon Law came up for discussion [Benedict] was observed always to ask 'What has our learned doctor [Lambertini] to say about it? What does he think?'"[14] It was no surprise, then, in 1726, when Benedict XIII named Lambertini as a cardinal-in-waiting (or *in petto*), which took effect two years later when the next available seat in the Sacred College of Cardinals became vacant.[15] Though a prestigious and

life-altering event, Lambertini wrote to a friend in 1728 with his
customary modesty that "in this transformation I am changing
nothing but the color of my clothes, and that I am still the same . . .
in my character, my light heartedness and my lasting friendship for
you."[16] By now, Lambertini had been named and appointed to yet
another post—this time as the bishop of Ancona, the strategically
vital papal port on the Adriatic coast.

In a remarkable four years, Lambertini had been transformed
from a well-regarded functionary within the Vatican ranks to an
elite and respected luminary across the Papal States.

Cardinal Lambertini's career entered an even higher orbit in 1730.
That was the winter when Pope Benedict XIII had died from fever,
and it had prompted a new conclave, which was Lambertini's first
as an elector. Once in session, the College of Sacred Cardinals
learned of a scandal perpetrated by two of their own—Niccolò
Coscia, the Vatican's treasurer, and Francesco Finy, its financial
auditor—who had duped the now-departed pope and had then
bribed and embezzled their way into draining the church coffers.
Their scheme was uncovered during Benedict XIII's last days,
prompting Coscia to flee Rome in immediate panic. But he was
discovered soon enough and quietly escorted back to the Vatican
under safe conduct where, incredibly, he was allowed to participate
and presumably vote at the conclave. It was under this dark cloud
that the college spent the next four months inside the Sistine
Chapel to deliberate and ultimately elect Cardinal Lorenzo Corsini
as its new pope.[17] At seventy-eight years old, Corsini was frail
and in poor health, yet was surprisingly energetic when he assumed
his papal name as Clement XII. Since he and Lambertini had

been friends for many years, it is an easy stretch to imagine how Lambertini's vote had likely helped to tip the conclave's nip-and-tuck outcome in Pope Clement XII's favor. The new pope visibly demonstrated his gratitude ten months later, when he resigned his prominent and plum position as the archbishop of Bologna and then named Cardinal Lambertini as his replacement to that post.

News of the prestigious promotion reached Bologna in May 1731, where "bells pealed in jubilation, suitable prisoners were let out of jail, and the night sky fizzed with fireworks" to celebrate their native son's imminent return.[18] Lambertini arrived three weeks later, and in a manner that had by now become typical of the man: without fanfare, in "a small suite, no procession, and not the slightest fuss."[19] The next day, he had his usual breakfast of hot chocolate and biscuits and set out to survey the city's streets "to see with his own eyes what was going on."[20] This is how Lambertini came to know his flock—rich and poor, great and small, man and woman, young and old—while they, in turn, fondly recalled their archbishop on his daily rounds as "not very tall, plumpish, with a round full face, a jolly way with him, and a genial expression."[21]

Lambertini remembered the next nine years as the most satisfying of his career. Though his calendar was filled with administrative duties and clerical functions that came with the archbishop's job, he always found time to leverage his elevated stature and improve the public good, advance cultural causes, and champion social reforms. The cardinal took weekly hospital rounds to look in on the sick, for example, which heightened the practice of nursing, patient care, and women's health within the city. In the meanwhile, his visits to comfort those imprisoned led to reforms in criminal justice that banned the use of torture and public floggings.[22] Lambertini also recognized the importance of Italian art and antiquities, and created museums so that the public could enjoy

them. He advocated for the instruction of modern, experimental science at Italian universities—like anatomy, obstetrics, physics, and surgery—and nurtured the University of Bologna and the city's nascent Accademia delle Scienze dell'Istituto di Bologna with gifts of equipment, books, and money.[23] But maybe Lambertini's most progressive cause was his vigorous support for women scholars, artists, and scientists, and he helped them to pursue academic excellence, public recognition, and professional positions, which, until then, had been exclusive to men.

Lambertini's daily routine commonly began before 5:00 A.M. and often ended around midnight. He did not lack for friends, and his favored circle included Francesco Peggi, who taught philosophy at the University, and was a guitarist; Eustachio Manfredi, scientist and founder of what by now had become known as the Accademia delle Scienze dell'Istituto di Bologna; Celestino Galiani, scholar at La Sapienza and archbishop of Thessalonica; Antonio Galli, obstetrician; Ercole Lelli, sculptor; Lelio della Volpe, publisher; Giampetro Zanotti, poet and playwright; Girolamo Baruffaldi, preacher and poet; and Horace Walpole, English statesman and tourist.[24] These were the people who knew Lambertini best, along with his sharp wit, self-deprecating manner, animated sense of humor, and innate sense of fair play. Lambertini possessed a widely known distaste for intrigue and double-dealing that would commonly lead to fits of bad temper and a liberal use of startling and salty language that was "not very Cardinalish" (and for which he felt immediate remorse).[25] In sum, those who knew him best uniformly recognized that Lambertini was a man to be trusted, and who had a gift for resolving controversies and difficult disputes.[26]

These attributes would prove invaluable in the coming storm to save Michelangelo's dome.

In the meanwhile, and back in Rome, Pope Clement XII was making progress of his own. He had descended from two of the most prosperous family dynasties in Florentine banking—the Corsini and the Strozzi—and took an immediate and necessary interest toward restoring the depleted papal coffers. For this, he revived the public lottery (which his immediate predecessor, Benedict XIII, had banned) and demanded restitution from Cardinal Coscia and his gang of thieves. Though these measures improved the Vatican's cash flow, any gains were illusionary and quickly offset by Clement XII's ambitious and expensive program of construction for which he is best remembered: as patron and founder to the Capitoline Museums and sponsor for the Trevi Fountain, while simultaneously funding the large-scale paving and widening of streets across Rome.[27]

But Clement XII could not outrun his age. He was bedridden and blind during the last of his eighty-seven years, and he died in February 1740, during the heart of that year's Carnevale season. It was a time of festivals, though, and the news of Clement XII's death was delayed for a few days since few wished to stop the revelry; in Bologna, for example, Archbishop Lambertini was out of town and likely in nearby Cento to visit his friend, Girolamo Baruffaldi, with whom he often stayed during the holidays and "especially at Carnival time, when Bologna was noisy."[28] Baruffaldi was a "delightful" and "laughing, good-humoured man, as well as a remarkable preacher," and Lambertini appeared to have enjoyed his host's hospitality for about a week, during which time the archbishop remained unaware of Clement XII's passing.[29] By then, the parameters of the conclave to elect the next pope were taking shape in Rome, where the Sacred College of Cardinals was soon expected

to assemble. It would be Lambertini's second as an elector and he did not relish the inevitable politicking and electioneering ahead, nor being away from home for an extended and indefinite period. As he entered his carriage that wintry morning for the long ride to Rome, he undoubtedly wished for a short conclave and a quick return to the city that he had helped to transform.

It did not work out that way. Lambertini never saw Bologna again.

⁂

Six months later, Cardinal Lambertini became the next pope and assumed Benedict XIV as his papal name, in tacit acknowledgement of his former friend and patron who had died ten years earlier. But once informed of the final tally inside the Sistine Chapel, Lambertini was "more resigned than pleased. 'Ah,' he said, 'I'm lost! Your composed air tells me I'm going to be deprived of my freedom.'"[30] This premonition was not based on idle musing, nor was it his lighthearted attempt at humor. Lambertini had personally known all the popes since his early days at the Rota and had witnessed firsthand the heavy burden of the papal office. He saw how "smothered in very serious business" these pontiffs were in their role and knew that he would soon assume that same heavy yoke.[31] Now, he was no longer Cardinal Lambertini, keeper of his smallish flock in Bologna; rather, he was Pope Benedict XIV, the spiritual shepherd for Roman Catholics everywhere and a sovereign head of state to those who were not. Gone were the quiet mornings in Bologna, his strolls around the city, and relaxed evenings with friends. They would be replaced by the full weight of the papal crown and staff—fiscal, administrative, diplomatic, and, of course, spiritual. To his annoyance, he also had to deal

with the ever-present sycophants who "suffocate me with praise, [making me] . . . forever rowing against the current lies they try to make me believe [and] against the pride with which they try to make me drunk."[32]

At the time of Pope Benedict XIV's papal coronation, the Roman Catholic Church was among the most ancient of institutions on Earth. It had been founded 1,700 years earlier and had tried to build a reputation that was based on good works and kindness shown toward people among all stations of life. At its core, the church was dedicated to one central tenet: the shepherding of souls toward a path of salvation through the redemptive power of Jesus of Nazareth. There were few organizations like it, and Benedict XIV had every intention of furthering and growing its noble traditions.

But the church was not perfect. As with any powerful institution, it had lost its way from time to time with ambitions, crusades, schisms, and policies that did not always align with its central mission. While other organizations may have buckled under these circumstances, the church did not—and thereby showed a resilient knack for making course-correcting reforms when it had to. But this changed in 1517 when Martin Luther, a devout and principled priest from Germany, could no longer ignore the misconduct and papal excess he saw around him. His Ninety-Five Theses sparked the Reformation, which challenged, undermined, and fractured the Vatican forever. Many of Luther's concerns about the Roman Catholic Church stemmed from its practice of raising money through the sale of indulgences, which were payments made to wipe away one's spiritual transgressions. Paradoxically, these were the very sources of funds being used in force to build

St. Peter's new basilica and its dome, then under way on Vatican Hill. [33] Luther, and others who thought like him, believed instead in a brand of Christianity where salvation was more simple and direct, and that these conniving practices, like the sale of indulgences, were symptomatic of a larger corruption within the clergy. This made him a threat to the church and it responded to these Protestants—Lutherans, Calvinists, Anglicans, and Huguenots, among others—with a curious combination of tolerance and self-reflection on the one hand (the Counter-Reformation), and of excommunication and brutal punishment on the other (infamously known as the Inquisition).

By 1740 Pope Benedict XIV had inherited a Roman Catholic Church that had largely ceased these punitive policies. But the price paid for its grudging acceptance had come at a high cost. While the church had remained a spiritual beacon for millions of believers around the world, it had also lost much of its moral authority, political clout, and international standing along the way. Protestants and their movement had continued to grow, especially in northern Europe and among their fledgling colonies of North America. They were a reckoning force and were here to stay.

⚬

Beyond his station as shepherd of the faithful, Benedict XIV was also the leader of a sovereign territory—known officially as the Republic of Saint Peter but more commonly called the Papal States. [34] In this role, he found himself awash in debt from previous Vatican administrations, while surrounded by a sea of wealthier secular states that were regularly engaged in political intrigue with the church and with each other. This potent combination had first emerged during Luther's day and had prompted a long and

steady decline in papal prestige within Italy and the international community. It hampered Benedict XIV's diplomatic and spiritual leverage, too, as each nation state tried to create its own identity, carve its own frontiers, codify its own rules of law, and further its own economic self-interests.

There had been occasions of cooperation, however, and one was triggered by the Treaty of Utrecht in 1713. It was launched when Benedict XIV—then Prospero Lambertini—was a young man and managed to establish some calming prosperity and a free flow of traffic among nations for the next twenty years. This, in turn, had helped to promote an exchange of powerful new paradigms then taking shape in Europe. One was called the Enlightenment, with its emphasis on logical thought and reason, which advocated for meaningful reforms in matters of politics, law, economics, and self-governance. Its chief proponents were John Locke in Great Britain, along with René Descartes and François-Marie Arouet (better known by his nom de plume, Voltaire) in France. In the meanwhile, a parallel phenomenon had sparked a similar explosion of intense curiosity about the heavens above, the world around, and the human body within. It had been termed the Scientific Revolution and its wonder-filled discoveries had recently launched the burgeoning fields of astronomy, anatomy, biology, chemistry, geology, and physics, among others. "Soon the popularity of science became impossible to ignore" among all walks of society, and dozens of pioneers had ignited this dynamic movement in the preceding two centuries, with Galileo Galilei and Isaac Newton among the most recognized and celebrated.[35]

These new ideas—and their rapid spread—were part of a dizzying and unsettling continuum of secular change that was transforming governments, nation-states, institutions, and every walk of society. They had shattered the conventions of the aristocracy

and traditions of the church, too, who their opponents saw and mocked as old-fashioned and being out of touch with modern life. These paradigms had led to rapidly changing views about the human condition and radically different attitudes toward God, religion, social norms, and ways of seeing the world. Now, faith was replaced by reason, feelings by facts, and Christianity no longer held singular sway over Europe's system of belief. While the church had had its authority questioned before, these new ideas were foundational challenges to its very existence and relevance, be it Catholic or Protestant.

This burst of discovery had extended into the world of mathematics as well. For thousands of years, the rhythm of numbers had served dual roles: as both a pragmatic tool to measure things with, like money, lengths of road, and spools of wool, as well as a theoretical framework to reveal the secrets of nature. Because of these cosmic implications, the church did not view mathematics with the same discomfort as other pockets of scientific discovery, anatomy and astronomy most of all. Over the centuries, many new concepts in mathematics had been proposed by scholars from within the church itself, where these ideas were often viewed as an extension of God's creation and a way to explain the mysteries and sacred nature of life. When Benedict XIV became pope, there were many scientists, academicians, and theologians alike who held mathematics in high and often mystical regard, and as a most noble and worthy discipline of study.

The Roman Catholic Church as an institution may have felt understandably threatened and under siege by the Enlightenment and the Scientific Revolution. But Benedict XIV, personally, did not.

Throughout his career he had championed many of these same progressive ideas in science, medicine, public education, penal reform, health care, and the advancement of women. More than that, his studies at the Collegio Clementino, professional training at the Rota, social standing at the Arcadi, and pragmatic experience as archbishop had put him in close orbit with those same authors, scholars, inventors, and intellectuals who had created such novel concepts in the first place. These principles were deeply engrained in Benedict XIV, and he had remarkable respect and intuitive appreciation for the intersection between modern science and mathematics on the one hand, and the traditions of Christian theology on the other. He was uniquely positioned to weave them into the Vatican's search for relevance in an increasingly secular society once he assumed the mantle of papal leadership in August 1740.

Two years into Pope Benedict XIV's tenure, the Vatican's architect, Luigi Vanvitelli, submitted a troubling report for the new pope's urgent review. It had been prepared because of the hundreds of cracks that had by now propagated in and around Michelangelo's dome, built just 150 years before. The news was bleak, and there were darkening rumors that this architectural jewel of the Roman Catholic Church might weaken and possibly collapse.

It is hard to know whether prior popes had been aware of these same cracks, which were now obvious, impossible to ignore, and became Benedict XIV's problem to solve. But what could be done? And by whom? The cracks posed a daunting challenge because in the long history of construction, these kinds of domed structures had been notoriously difficult to design and to build. There were

only a few that could compare, and Michelangelo's dome at the top of Vatican Hill was among the most majestic in size and silhouette. Others were the Pantheon in Rome (built in the second century), the Hagia Sophia in Constantinople (vaulted in the sixth century), the Basilica di San Marco in Venice (from the twelfth century), and the cupola at Santa Maria del Fiore in Florence (built three hundred years before). It was universally acknowledged that the behavior of domes was hard enough to predict under defined and controlled conditions, but the risk to Michelangelo's dome was more pronounced because the design records were meager and its construction had been rushed.[36] In short, fixing this kind of structure was like walking into the dark without a torchlight. It defied an easy solution, and to compound matters there were few tradesmen or architects with experience in domed construction that could be recruited for reliable guidance. Even then, their guidance would be suspect, since most of these earlier domes had had their share of cracks, too.

So, no one knew how to solve the problems described in Vanvitelli's report. Following his inspection, however, the chief architect had believed the dome could be fixed by wrapping several horizontal rods made of iron—known interchangeably either as "chains" or "hoops"—around its circumference to hold it in place. This was a customary construction practice of that day and had been recently used at the Hagia Sophia and other domed structures in Venice, Pistoia, and Montefiascone. Vanvitelli was aware of this tradition, too, and that it was tethered only to a hunch. He had no basis beyond his own intuition to prove how these iron chains would stop and then fix the cracks; which was an unsettling prospect for Benedict XIV to accept, since, beyond its technical complexity, the pope also recognized Michelangelo's dome as a political emblem of the Papal States and a spiritual beacon for the

global Roman Catholic Church. Its damage could catastrophically tarnish those images, and Benedict XIV as its shepherd could not have that happen.

What this pope saw under Michelangelo's dome in September 1742 was an enormous, high-stakes problem. He needed a solution that was at once definite, precise, and reliable, and he faced a choice: either accept the subjective and traditional hunch of his able architect or get a second opinion that might explain the cracks and how to permanently fix them. It is difficult to find the words to adequately describe what Benedict XIV then had in mind, or what might come of it. But he was aware of the latest trends in scientific thought. It was his creative spark to seek an opinion from three respected mathematicians that would launch an entirely new way of thinking in an already bold age of discovery.

2

BUILDING THE BASILICA

Michelangelo's dome was the capstone achievement on Vatican Hill. It marked a legacy of construction that had encompassed some two thousand sinuous years and was part of the larger story of emperors and popes, architects and builders, and the bickering and bargaining that went on between them. But to an observant eye, it also offered a few clues about the latent cracks that had now become Pope Benedict XIV's headache to solve.

The dome, of course, had crowned St. Peter's Basilica, its piazza, and the dozens of gardens and buildings that had grown around the papal complex. Though the scale and cost of such an imposing architectural program had rivaled the pyramids of Egypt, the effort at Vatican Hill had been far more fragmented and contentious in approach. Decisions in design at St. Peter's Basilica were endlessly modified, scrapped, and replaced over the two hundred years of its evolution, between 1450 and 1650, when at least seventeen popes, twenty architects, multiple master builders, and a committee of sixty experts, known as La Fabbrica di San Pietro in Vaticano (or the Fabbrica for short), had participated in this seemingly chaotic process. So many cooks in the kitchen had understandably led to

an architectural outcome that was both disjointed and unsatisfying. There were also the dozens of other obstacles to contend with once construction began—intermittent funding, artistic differences, professional rivalries, personal jealousies, and papal apathy—that made the project that much more difficult to build. In this context, and against these many headwinds, it is a miracle that St. Peter's Basilica was ever finished. But there were other, deeper problems, too, and their roots were burrowed into the very site where the church had been planted.

The hill itself (or Vaticanus Mons) would never have been confused with the Garden of Eden. It was a steeply sloped and desolate tract on the western side of the Tiber River that was well beyond the safety of Rome's early walls and later landmarks like the Pantheon, Spanish Steps, and Trevi Fountain. No one could say how the name had stuck. It may have been the site of an earlier Etruscan village known as Vatica or Vaticum, or it might have been the home to a mythical deity known as Deus Vaticanus who protected its slope. Perhaps the name was a remnant from the cult of Cybele, with its sacred shrine and where rites were held each spring *ex vaticinatione archigalli* (conforming to the high priest's prophecies).[1] Whatever its origins, the hill remained barren for many generations, and Pliny the Elder, in his encyclopedic manner, noted it as a lonely marsh that was plagued by mosquitos, the *infamis Vaticanis locis*. There were efforts to make the place arable, but even then it produced a caliber of wine that, according to the Roman poet Martial, was "poison."[2]

As the imperial city's population grew and densified during the first century, the land around its gates became more valuable. This was when Vatican Hill was developed in a more purposeful way. Caligula, as third emperor, built a sizeable racecourse—called a circus—at the base of its slope which then became a favored haunt for

Nero, the fifth emperor, who seemed to show more interest in racing his chariots there than in governing his empire.[3] "It was gravely reported, and firmly believed" that Nero had enjoyed watching the spectacle of Rome's grievous fire around the year 64 C.E., and "to divert a suspicion" of incompetence and indifference he had to find a scapegoat to blame for the tragedy.[4] Consequently, he found it politically expedient to hunt down, round up, and imprison those who belonged to a fledgling religious sect—called Christians—and then kill them for popular sport and entertainment. Simon Peter was their prominent leader, who in his earlier life had been among the first to follow the movement's founder, Jesus of Nazareth. For the next thirty years, Peter had spread across the Roman Empire an alternative message of hope and salvation, which made him a dangerous political threat to the Romans on the one hand, and a bedrock and the first pope for these early Christians on the other.

Nero's vindictive policy caught up with Peter soon after the fire and the first pope was imprisoned and then crucified inside Caligula's circus. Though his precise burial plot became a subsequent mystery, an unpresuming shrine, or aedicula, appeared on the nearby hillside soon after, in remembrance of Peter's execution.[5] Over time, the unassuming site was encircled by the tombs and graves of eleven successor popes, and for the next few centuries the place grew into a modest-sized cemetery for people of very modest means.

This all changed during the reign of Constantine the Great. He was the singular driving force that turned Vatican Hill into the sacred shrine of pilgrimage that we know today. Constantine was

a hard-edged and unsentimental character, even by the rough-and-tumble standards of imperial Roman politics. He had a gift for political statecraft, and his tactics were direct, effective, sometimes brutal, and often eliminated any obstacle in his way, even when presented by his own wife and son.[6] But Constantine had a softer side, too, that was commonly reserved for his mother, Helena, who was a devout Christian. After consolidating his sovereign power around the year 312 C.E., the new emperor grew more committed to the church, and his Edict of Milan legalized a tolerance for Christianity within the Roman Empire that placed it on an equal standing with Rome's many other practicing faiths of the time. Now, Christianity became at once mainstream and even fashionable within Roman society and Christians could come out from the shadows to congregate and worship en masse. Constantine sponsored this very practice over the next thirty years, when he commissioned the construction of an impressive number of new churches in Italy, the Holy Land, and beyond.[7] As their relationship with imperial Rome grew increasingly intertwined, it made sense that Christians began to pattern their new churches after an architectural staple that had served the empire for so long and so well, known as the basilica. Basilicas were well-suited to meet the needs of this fast-growing, religious movement: they were simple, enclosed, rectangular spaces made from stone and timber that were generously sized for worship and assembly of the faithful.[8]

Among the finest of these early churches was the one planned by Constantine to commemorate the martyred Saint Peter on Vatican Hill. It would have been far easier and less expensive to build it on the flat terrain once occupied by Caligula's nearby circus, but Constantine and his pope, Sylvester I, recognized the symbolic power of having Peter's sacred aedicula become the focal point and central heart of the new basilica. Instead, he stationed the new altar directly

above the venerable cemetery and its pockets of tombs. But this meant that the sloping and marshy hillside, along with its irregular terrain, would need to be leveled and groomed by bringing large amounts of soil, or fill material, onto the site. The new fill had different characteristics than the native marsh, and this combination of conditions—the sloped site, imported fill, pockets of tombs, and marshy soil—would complicate how the new basilica would behave once its weight bore down on the earth beneath. The problem would only compound years later, when these soils would be further compressed by the mountainous mass of Michelangelo's dome.

Work began on Constantine's new basilica around the year 318 C.E. and was finished eighteen years after the emperor had himself carted its first twelve bushels of fill onto the site. Its vast interior was designed to accommodate thousands of pilgrims, and as the message of Jesus continued to spread across Europe, so did the church on Vatican Hill. The place became a sacred magnet of Christendom, and visitors filled it with appreciative gifts of money, gemstones, candelabra, statuary, and mosaics that only added further luster to the place. But in time, the venerable church, like any other building, needed to be repaired and improved, and through the generations it also suffered from damage caused by pillage, an earthquake, and neglect—when the papacy temporarily moved from Rome to Avignon, France.[9]

When Nicholas V was elected pope in 1447, the Roman metropolis was in steep decline, its population in retreat, and its people thoroughly discouraged. He was startled, too, that by this time the basilica on Vatican Hill was "now deplorable" and in "serious disrepair"; it was in such a sorry and perilous state that its southern wall (which faced the former circus) "leaned six feet out of the perpendicular [with its] mosaics . . . covered with dust as hardly to be visible."[10] The damage was so severe that notable architect

Leon Battista Alberti warned after his personal inspection "that very soon some slight shock or movement will cause it [the south wall] to fall."[11] Under these circumstances, it was only prudent that Nicholas V consider wholesale replacement of Constantine's basilica, and for this he hired the Florentine architect and sculptor Bernardo Rossellino to prepare a new design (with likely guidance from Alberti).[12] But Nicholas V, "who had been turning the city upside down with all his building projects," died before much new work could advance at St. Peter's, and the next six papal administrations deferred any discussion about Rossellino's proposal by opting instead to repair rather than replace the celebrated shrine.[13]

❧

It was Pope Julius II who revisited the plan to tear down the worn-out basilica and have it rebuilt. But by now the place had become hallowed ground and was "revered as it was by the whole world."[14] Scores of popes had been enthroned there and dozens of saints laid there to rest, and Romans deplored any thought of its demolition. The outcry was palpable around the city, and the cardinals and Curia did not like the controversial idea, either. But Julius II was undeterred. Like Constantine, he was used to getting his own way, having taken his papal name not from Pope Julius I (who succeeded Constantine between the years 337 and 352 c.e.), but from Julius Caesar himself, as an indication of his imperial aspirations. Julius II was brash, impulsive, hot-tempered, sometimes reckless, and for sound reason, had earned a reputation as *il papa terribile* (the fearsome pope).[15]

Julius II faced three choices in that fateful summer of 1505. He could either restore the old basilica, enlarge it according to Rossellino's design, or build something altogether more magnificent

(which was his inclination). He did not need a nudge to pursue this third option once he saw the eloquent proposals prepared by Donato Bramante.[16] Julius II and Bramante were like-minded, cut from the same cloth, and got along well. They were both in their sixties and had the same impassioned, restless, determined, and at times unscrupulous temperaments, and for the next eight years their shared ambitions forged an effective partnership to get the new basilica financed, off the drawing boards, and under construction.

From its start, Bramante had envisioned that he would design the most glorious church in Christendom. It featured a symmetrical floor plate, known as a Greek cross, that assumed the shape of an intricate snowflake pattern and was capped by a stately, hemispheric dome hovering high above the basilica's core—some three hundred feet above Saint Peter's tomb—and in the area known as the crossing. A few large domes and tall towers of such complexity had been built over the centuries—namely, at the Pantheon in Rome, Ely Cathedral in England, the Basilica di San Marco in Venice, and Santa Maria del Fiore in Florence. They had each relied on an intricate network of interconnected walls and buttresses to support their enormous weights and to keep them stable and standing. But Bramante's idea at St. Peter's was more simple and more radical, having proposed a dome that would rest on only four separate and titanic columns that were roughly sixty feet square and known as piers. Today, his design might raise immediate eyebrows about excessive compression, flexure, buckling, and torsion within the piers, and how they might affect the soils below. But complications like these were not well defined or understood in those times, and Julius II and Bramante just went ahead and tried it. They were not young men, after all, and in their impatience to save time were also known to sacrifice prudence for the sake of expedience.[17]

Julius II had named Bramante as his *capomaestro*, or master of the work, and Bramante, in turn, created a vast enterprise to build the job. This included his hiring of "an army" of some three thousand artisans, craftsmen, and laborers to address the ocean of challenges at the site: from its details in design to the hauling of material stock, and from the daily planning of the work to payroll administration.[18] Bramante had enrolled the most talented batch of young artists in Rome as project assistants to help with this effort: Raffaello Sanzio da Urbino (better known as Raphael), the brothers Antonio and Baldassare Peruzzi, Giulio Romano, and Antonio da Sangallo the Younger, among others.[19] They were a formidable team who together prepared a prolific assortment of precisely scaled drawings to communicate on paper the details of construction that the masons and carpenters could then use in their day-to-day trade work. This was a novelty for the industry and a harbinger of modern architectural practice.

Consistent with current customs, Julius II intended to keep the old basilica in operation for as long as possible. He would then demolish it in small stages as the new church took shape around it. Work started at the crossing, where the foundation pits for Bramante's piers were carefully excavated around Saint Peter's shrine; these pits dug deep into the ancient remnants of Vatican Hill and were then filled with flagstones. Under Bramante's direction, and with the funds arranged by Julius II, it took just six years to dig the pits to some twenty-five-foot depths, install the new footings, raise the colossal piers to full height, and then stabilize them with a ring of masonry arches around their tops.[20] Now, everything was ready and in place to build Bramante's dome.

But time caught up with Julius II, who died in 1513, and then with Bramante the following year. The next pope, Leo X, was part of the Medici family from Florence; he had a predilection for

extravagance that personified the "infinite mischief and disorders" within the Church at the time, and which had prompted Martin Luther to launch the Reformation.[21] The mischief was evident at the new basilica, too, where Leo X promoted Raphael to the vacant role of *capomaestro*, although the gifted artist was known more for his skill with a paintbrush than a mortarboard. Just as Julius II had forged a strong, personal bond with his chief architect, so Leo X did the same with Raphael, but they preferred instead to live the good life, along with its "amorous pleasures," rather than engage in the more serious business of construction.[22] Raphael had hired Giuliano da Sangallo (then aged seventy-one) and Fra Giovanni Giocondo (who was eighty-one) as his seasoned lieutenants, and though they modified Bramante's architectural floorplate, not much new work was otherwise performed in the next few years.[23] Citizens of Rome were shocked and grieved by Raphael's sudden death in 1520 at the age of thirty-seven, and no one more than Leo X. But he managed to briefly wake from his misery to fill the void of chief architect with Antonio da Sangallo the Younger (with Baldassare Peruzzi as his deputy).

<p style="text-align:center">❧</p>

The next fifteen years were a bitter pill for the Roman Catholic Church to swallow. It had lost Germany to the Reformation, England to King Henry VIII, international prestige within Europe, and then suffered an ultimate disgrace—the sack of Rome by King Charles V of Spain. Pope Clement VII witnessed this humiliating "pyramid of catastrophes"; he was another Medici and his unpopular policies and poor political judgment had turned him "from a great and renowned Cardinal into a little and despised Pope."[24] During Clement VII's tenure, Rome was plundered and ravaged by the

marauding Spanish army for the better part of 1527, leaving thousands dead and the city in tatters. Understandably, these were lean years of progress at the new basilica, as best captured through the haunting sketches of a Flemish artist, Maarten van Heemskerck. His many views of Vatican Hill showed it as a lonely and abandoned place, framed by Bramante's skeletal piers under an open sky, which more closely resembled an ancient Roman ruin rather than a modern and active construction site.[25]

Though Clement VII's papacy was a disaster, he had managed to make one important contribution toward the construction of St. Peter's Basilica. It came early in his term and in direct response to Martin Luther's reproach regarding profligate spending at the project, and for which Clement established in 1523 La Fabbrica di San Pietro in Vaticano. The Fabbrica was a papal institution comprised of some sixty experts from across Europe whose mission was to oversee the financial and administrative aspects of the work. This now freed the *capomaestro* to focus solely on issues of design and construction, and was a prudent reform given the basilica's growing complexity and soaring costs.[26] But it also established a new source of friction between the builders and the bureaucrats, and it would sorely test them all.

Few tears were shed when Clement VII died in 1534. Yet it created the pivotal void that transformed the "able, diplomatic, crafty, and very popular" Cardinal Alessandro Farnese into Pope Paul III.[27] He was a curious paradox, as someone accustomed to luxury and loose living, but devout in his faith and aware that moral reform was necessary within the Roman Catholic Church. Paul III was also determined to recommence construction at St. Peter's, though his treasury was presently bare. In the meanwhile, Antonio da Sangallo the Younger as *capomaestro* had tossed aside the prior designs by Bramante and Raphael and was working

up a new and ponderous plan of his own, capped by a dome that resembled a fanciful, multitiered wedding cake. Paul III approved the idea and from 1539 to 1546 the basilica again became a thriving construction site.[28] During these years, Antonio da Sangallo the Younger spent some 162,000 ducats at the project, which was a staggering sum of money and twice the amount spent by Julius II thirty years earlier.[29] This raised the specter and suspicions of corruption within the Fabbrica and the rumors that Antonio da Sangallo the Younger, his family, and his friends—known as *la setta Sangallesca* (the Sangallo set)—were getting fat and rich off the project.[30]

Despite the graft and the greed, there were signs of progress, nonetheless. One of Antonio da Sangallo the Younger's more important tasks had been to fix the cracks that had recently shown up and propagated along Bramante's massive piers. They were telling symptoms of overstress that could have originated from many possible sources, like settlement in the soil, a failed foundation, or buckling in the piers. On a hunch, the *capomaestro* managed to solve the immediate problem when he raised the basilica's floor by some twelve feet, to shorten the height and better stabilize these massive columns.[31] But this had prompted a disturbing question that Antonio da Sangallo the Younger could not answer; namely, that if Bramante's piers had cracked without the dome yet in place, then how might they perform once the dome was wholly installed and its titanic loads were bearing down with full force?

⧖

Like many previous popes, Paul III had kept his *capomaestro* engaged on multiple projects beyond St. Peter's Basilica. In the summer of 1546, for instance, he had tasked Antonio da Sangallo the Younger to break ground for a new canal along the Velino

River, outside of Rome, and while on assignment there, the chief architect caught a sudden chill and died a few days later. Paul III was genuinely saddened by the loss, but the large amount of remaining work on Vatican Hill required him to move swiftly and find a suitable replacement. So, the pope solicited one of Bramante's earliest deputies at the job, Giulio Romano, who was now a successful painter and architect living in Mantua. Romano accepted Paul's lucrative and prestigious offer as the next *capomaestro* straightaway, but he, too, caught a fatal fever before starting down the road to Rome. The Fabbrica then approached yet another former assistant to Bramante, Jacopo Sansovino, but he was leading a contented life in Venice for the moment and was reluctant to leave it. Frustrated and anxious, Paul III at last sought out the man he had wanted all along and who, coincidentally, was local and working from his nearby workshop in Rome.

That man was Michelangelo. But, unfortunately for Paul III, the artist was by now jaded, fed up, and did not want anything to do with St. Peter's Basilica.

In the autumn of 1546, Michelangelo Buonarroti was seventy-one, worn out, and mistrustful of the Vatican and its popes. The renowned sculptor, painter, architect, and poet had, after all, known and worked for them all—Julius II, Leo X, Clement VII, and Paul III—since he was young. But Michelangelo did not like their politics or their meddling and, most of all, their broken promises on payments. In short, he felt exploited when hired and working on their projects. They, in turn, tolerated Michelangelo's prickly, obstinate, and exasperating manners because the man was a creative genius and the best artist they had ever seen.

His supreme talent was evident at sixteen, and with his earliest sculptures in stone. By thirty, Michelangelo had already carved two astonishing masterworks out of Carrara marble: the *Pietà* and *David*. He then began to paint the Sistine Chapel's ceiling at age thirty-three, where at perilous height, under poorly lit conditions, and on an oddly shaped surface he created in four years one of the world's most extraordinary and magnificent murals. Remarkably, Michelangelo had "hardly touched a paintbrush" before this and—incredibly—had had little experience with fresco technique, which is among the most difficult mediums to master.[32] Soon after, he was hired by the Medici family, his longtime patrons, at the Laurentian Library in Florence, where he designed an interior space that was at once stately, monumental, and pragmatic—features that would define his architectural legacy.

Against any standard, Michelangelo had achieved the stuff of dreams. He was a thundering talent who was in high demand, commanded high fees, and created spectacular work for the most plum commissions and prestigious of clients. He was also a celebrity and living legend across Europe and on personal terms with the most powerful people in Italy, though he commonly spurned their recognition. Michelangelo often viewed his rivals with distrust (like Bramante) and disdain (like Antonio da Sangallo the Younger), and they often reciprocated. Pope Leo X, for example, described the artist as "an alarming man, and there is no getting on with him," while another antagonist, Cardinal Cervini, was known to use "the most intemperate language" against Michelangelo.[33] (Cervini subsequently became Pope Marcellus II in 1555, and would have been a formidable enemy had he lived beyond his twenty-two days in office.) Rather, the artist preferred to limit his social circle to a small number of friends and family to whom he was intensely loyal. One was Giorgio Vasari, who wrote an

admiring biography of Michelangelo and reported on his restless mind, superb memory, devout faith, sturdy constitution, and an acerbic wit that commonly produced many priceless quips.[34]

It was no surprise, then, when Paul III turned to Michelangelo and tried to charm him out of retirement and into the role of *capomaestro* at St. Peter's Basilica. Paul III had long admired Michelangelo's magnificent body of work and the two were already on cordial terms from their collaboration a few years earlier on the *Last Judgment*, which now decorated the altar wall inside the Sistine Chapel. He had also been the driving force behind Michelangelo's prestigious and unprecedented designation as "Chief Architect, Sculptor, and Painter to the Vatican Palace."[35] While flattered by his elevated stature, Michelangelo was feeling his age after fifty dutiful years of service to his beloved church and still carried a grudge for his mistreatment, whether real or imagined, from previous popes. But in time, the reluctant artist agreed to assume the role as *capomaestro* "for the love of God and not for any other reward," albeit on two conditions: that he maintain total authority in all decisions related to design and construction, and that he earn no salary beyond his current monthly stipend from the Vatican Palace.[36]

Paul III agreed to those terms, and so began the final, fruitful chapter of Michelangelo's heroic career.

There was bound to be trouble, and it started on the first day Michelangelo showed up at the site. That was when he scrapped the fussy design by Antonio da Sangallo the Younger, and the "infinity of mischief" that came with it.[37] Instead, he reverted to Bramante's earliest proposal from forty years before and worked to simplify its parts so that the basilica was more unified as an

architectural whole. Michelangelo reduced its dimensions, too, and "brought direct [sun]light into all parts of the interior, and saved incalculable time and expense in construction."[38] By the summer of 1547, he was ready to design his colossal, new dome and wrote to his nephew in Florence, asking for the height and measurements there of the Duomo's cupola.[39] Though Pope Paul III had previously blessed Antonio da Sangallo the Younger's work, he quickly changed course and became an avid champion of Michelangelo's new proposal, requiring that it be rigorously followed, especially as it was now far less costly to build.

These events infuriated *la setta Sangallesca* along with certain factions within the Fabbrica. They viewed Michelangelo as a threat to Antonio da Sangallo the Younger's memory, and their personal authority, as well as a diminished opportunity to feather their own nests. They "hated Michelangelo so deeply, [with] a hatred that grew every day," and it established a feud that ran for the rest of his life.[40] One antagonist was Nanni di Baccio Bigio, who was openly hostile and determined to have Michelangelo thrown off the job. The depth of ill will and distrust ran so high that Paul III was often obligated to intercede between the parties and reaffirm Michelangelo's absolute authority on decisions. It was a daily struggle about which the *capomaestro* bitterly and constantly complained.[41]

Despite these unsettling distractions, much of the new design was ready for construction by 1549, and once finalized, Michelangelo made models in wood "so as to show the exact manner in which [these aspects were] to be finished."[42] But the artist was notorious for tinkering with his work and changing his mind, to the perpetual frustration of every mason and carpenter at the site. This extended to his hemispheric dome, too, which was under continual design evolution until the day he died, and while we know the dome's outer shape and height at that time, it remains an open question whether

he would have maintained this same silhouette into construction.[43] Its most prominent feature was the double-walled design, with its protective outer shield, its inner decorative shell, and the spiral stair that separated them. Both shells were comprised of sixteen radial segments that were evenly divided and infilled by layered webs of stone and brick. Three tiers of windows punctured the outer shield to allow sunlight into the inner stairwell, and this massive framework was then crowned by a sizeable lantern. This formed the essence of Michelangelo's design—lantern, inner shell, outer shell, and spiral stair. It sat on a circular platform, called an attic, that was supported, in turn, by a circular drum. The entire assembly, from the tip of the lantern to the base of its drum was about twenty-five stories and weighed a staggering thirty-three thousand tons.[44]

THE DOME OF SAINT PETER'S BASILICA IN ROME
AS DESIGNED BY MICHELANGELO AND DELLA PORTA

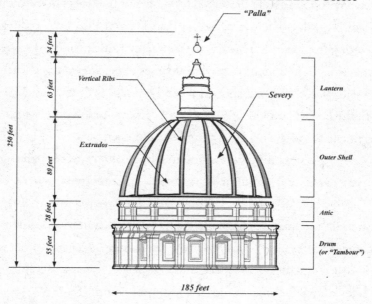

The primary components of the dome as designed by Michelangelo (circa 1550) and erected by Della Porta (1588–1590). © Wayne Kalayjian

Michelangelo assumed an enormous risk when he designed his dome at St. Peter's Basilica. Only one other, at Santa Maria del Fiore, could compare to its titanic scale, complexity, and sheer mass, and no one could say with certainty how to best build it or whether Michelangelo's dome would safely stand. Everything would rely on the judgment of the *capomaestro*, the intuition of its builders, the quality of workmanship in construction, and the integrity of Bramante's four piers, and there were no objective or scientific standards in place to gauge any of them.

Beyond the dome, Michelangelo had supervised other work at the basilica, too. Most of these other parts were installed between 1549 and 1558, and during this time he had notably "discovered that the four main pillars made by Bramante . . . were weak" and then set out to strengthen them.[45] But funding began to stall—again— around 1560, and an aging Michelangelo found himself slowing down with it. He had now served five popes in the role of *capomaestro* (Paul III, Julius III, Marcellus II, Paul IV, and Pius IV), and was faltering from painful physical ailments, embarrassing mental lapses, and errors in judgment that were at times expensive to fix. Clearly, Michelangelo had had enough when he wrote to "the Most Worshipful Lord Cardinal of Carpi" that "I have endeavored without payment to carry out during the last seventeen years. . . . If I am successful in obtaining permission to relinquish my task I shall consider it as the greatest kindness that could be conferred upon me."[46]

But when he died in February 1564—two weeks shy of his ninetieth birthday—Michelangelo had done as much as Bramante to shape the project and ensure the success of its legacy. By now, his drum was nearly in place and the perilous work of vaulting Michelangelo's dome would, it was hoped, soon begin.

It took five months for another Medici pope, Pius IV, to grieve, reflect, and fill the chasm created by Michelangelo's passing. The job went to Pirro Ligorio, who was then the acting chief architect at the adjacent Vatican Palace. Ligorio was explicitly instructed to not stray from Michelangelo's design, but he could not resist the temptation and was immediately sacked for it by the successor pope, Pius V. This prompted the sensible promotion of Giacomo Barozzi da Vignola to the role, since he had been an assistant to Michelangelo about ten years before. Vignola had not executed many designs on his own but was a celebrity of sorts after publishing a popular book that had offered practical architectural guidance to everyday builders titled *Regola delli Cinque Ordini d'Architettura* (The Five Orders of Architecture). Then, in a clever move to deter future departures from the master plan, Pius V hired Michelangelo's longtime confidante, Giorgio Vasari, as Vignola's deputy "to protect, defend, and preserve the labors of such a great man" and ensure "that the designs left behind by Michelangelo would be followed."[47] But this precaution was not necessary after all, since little of consequence was built in the ten years while Vignola was in charge.

Felice Peretti had known poverty as a boy in the mountains of the papal province of Marche. But he was determined to leave a legacy marked by merit, hard work, and tenacity, and when elected as Pope Sixtus V in 1585, he became as fiercely driven as Constantine and Julius II to heighten the Roman Catholic Church's stature and influence. Sixtus V reformed the Curia, restored the papal treasury, and stopped the political gamesmanship within the Sacred College of Cardinals by capping its membership at seventy, where it

remained for 375 years.[48] He had larger aspirations, too, and took
on Rome's darkest problems of crime, unemployment, bad roads,
and poor drinking water. Under his leadership, law and order
prevailed, jobs were created, streets were improved, monuments
were built, bridges were spanned, and the city's water supply was
restored. In a few short years he transformed the city and became
the father of modern Rome. Sixtus V faced as big a challenge on
Vatican Hill, too, where the drum of St. Peter's Basilica remained
headless and in a state of purgatory. Undeterred, he then turned
to his capable *capomaestro*, Giacomo della Porta, and his brilliant
deputy, Domenico Fontana, to raise Michelangelo's dome.

Della Porta was a familiar face on Vatican Hill, where he had
spent a long while as Michelangelo's field assistant. By the spring
of 1588, he was fifty-six years old and had been the basilica's *capo-
maestro* for about five years. On the other hand, Fontana was new to
Rome and had come to the pope's recent attention when, two years
earlier, he did what Michelangelo himself had said could never be
done, by lifting the 320-ton Vatican Obelisk near Caligula's former
circus and moving it a thousand feet to the basilica's eastern face,
where it was reerected. Fontana won the competition from a field
of some three hundred entrants, and his scheme relied on nine
hundred men, four months, and an ingenious number of land rafts,
scaffolds, towers, winches, and hoists to get the job done. It was a
Herculean feat, and once accomplished, Rome "sang and danced,
drank and feasted, rang bells and let off fireworks."[49] Sixtus V
was suitably impressed, too, and from that moment forward grew
convinced that Della Porta and Fontana were the men who could
find a way to vault Michelangelo's dome.

Before now, Della Porta understood that Michelangelo's design
at St. Peter's Basilica was sacrosanct and had never thought to alter
it. But the dome posed a different kind of technical challenge and,

over time, the *capomaestro* grew convinced that he had to change its outer shell from a hemispheric shape to an elliptical silhouette; this was the best way, Della Porta reasoned, to mitigate the powerful force, known as "thrust," that he expected to encounter during construction. Thrust was an unavoidable phenomenon that was well-known at the time, and builders were keenly aware of its punishing potential at *any* dome, let alone Michelangelo's dome, which was among the largest yet conceived. Then, as an additional measure of safety, Della Porta proposed that three, massive chains made of iron be wrapped around the dome's circumference to overcome the dome's expected hooping strain, like the metal staves around a barrel to keep it from bursting.[50] One of these chains would encase the base of the dome, where the thrust and its outward "kick" was most severe; another would encircle its mid-height; while the third was planned to wrap around the top of the dome and just below its lantern. This kind of construction strategy had been used before at other domes and tall towers, but no one could say with certainty whether it had really worked, or how well.

No other changes were made to Michelangelo's dome. The inner and outer shells would retain their titanic skeletal frames, made from sixteen vertical ribs that resembled the shape and curvature of a lemon wedge. Each rib was assigned to a separate team of masons, who would use an elaborate system of temporary scaffolds to vault the inner shell and outer shell in tandem on their continuous vertical climb more than three hundred perilous feet off the basilica's floor. The open space, or web, between each rib, known as a severy, would be artfully filled by bricks and stone blocks and then mortared together in an interlocking, herringbone pattern to stabilize the ribs as they scaled to the sky.

Though their plan for construction appeared logical and well thought out, the project was, after all, a daring and grand

experiment. Della Porta and Fontana did not know whether their elliptical shell or iron chains would work. They did not know how much the dome would weigh, the magnitude of its thrust, the strength of the dome's vertical ribs, or whether their temporary scaffolds would hold firm during construction. But none of this uncertainty affected Sixtus V or altered his determination. He was resolved to build Michelangelo's dome and was less interested in the mechanics of structures, the strength of materials, and the details of its construction than in the speed that it could be built. He wanted the job done, and when told by Della Porta that it could take ten years or more to install (by comparison, the cupola in Florence had taken sixteen), Sixtus V promised his *capomaestro* all the money and men he needed to shorten the schedule and finish in just thirty months.

Once the work began in July 1588, it could never go fast enough. Sixtus V was a man on a mission and a benign taskmaster who wanted to know every aspect about the job. He was good to his word and staked an enormous sum of money to fund the project and keep construction on the move. Della Porta did his part, too, and kept some eight hundred workers busy in the field day and night, through all sorts of weather: rain and shine, fair and foul, summer and winter, and the frightening, occasional strikes of lightning. The only respite came on Sundays, during an abbreviated morning mass. By Christmas 1588 and after just five months, the dome had already climbed forty feet and continued thereafter at a staggering average rate of four vertical feet each month.[51] The triumvirate of Sixtus V, Della Porta, and Fontana were focused, capable, and driven to get things done. No one could remember seeing anything like it, and much of Rome turned out to watch the dome's astonishing climb toward the sky.

Still, those with experience in construction had to wonder how the speed, the cold, the wet, and the work at night might

affect the quality of workmanship. Mortar, after all, had to be carefully mixed and applied under a narrow range of temperatures, and by custom needed a month (or more) to properly set and cure. This was one reason why the cupola at Santa Maria del Fiore had been such slow going and had advanced only one foot of vertical rise per month, compared with nearly five at St. Peter's.[52] Also, there were only so many courses of stonework that a mason could prepare before fatigue and exhaustion took over and mistakes were made. Through the lens of today's construction industry and its current standards for quality control and worker safety, Della Porta's plan seemed reckless, and it is not hard to foresee how this breakneck pace might have undermined and compromised the dome's structural integrity. But this was a problem for another day.

The dome's outer shell was "topped off" in May 1590, just twenty-two months after starting work (and eight months *ahead* of schedule). It had been a remarkable display of collective teamwork, as Michelangelo's dome hovered some 365 feet off the ground, making everything else across the city look small by comparison. Now, Sixtus V could savor his achievement as "the greatest builder of all the popes," having built in two short years what had taken sixty to plan.[53] He died three months later, and with the likely satisfaction that even Julius II, *il papa terribile*, could not have done more.

⬿

Though the dome may have been finished by 1590, there yet remained a lot of work to do around the rest of the site. The lantern, for example, took three more years to assemble atop the dome's crown. Then came the ruinous decision to change

Michelangelo's architectural intent and enlarge the eastern end (or nave) of the church. It played out in an open competition that was won by Carlo Maderno, Fontana's nephew.[54] Pope Paul V had appointed Maderno as *capomaestro* after Della Porta's death in 1603, and under Maderno's supervision the last remnants of Constantine's church were torn down five years later. By this time, all that was left of the old basilica was Saint Peter's modest tomb, tucked underneath and protected by Michelangelo's magnificent dome.

The new church on Vatican Hill was consecrated by Pope Urban VIII on November 18, 1626, 1,300 years to the day after Constantine the Great had blessed the site. It was a happy occasion that was celebrated across the city, but it had come with a heavy price: 120 years, millions of ducats, and a bitter divorce that had launched the Reformation and fractured the church forever.

At this stage, Michelangelo's dome had been perched in place for thirty-five years and, so far, no cracks had been reported. But then again, no one had given it a long, hard look.

3

MASTER BUILDERS
AND THEIR METHODS

I n the speed they went and the innovation they showed, Gia-
como della Porta and Domenico Fontana had joined an elite
circle of pioneers in construction. The two were now part of that
same, rich legacy that included the likes of Imhotep, designer
of Egypt's first pyramid more than four thousand years before,
and Robert of Luzarches, who had vaulted the soaring arches
of Amiens Cathedral in thirteenth-century France. All of them
had relied on inspiration and tenacity to break with tradition and
achieve what their peers believed could not be done.

Other visionaries had invented the dome as an entirely new
kind of architectural space. One of the earliest was the Treasury of
Atreus on the Peloponnesian peninsula more than three thousand
years ago. It was a structure that resembled a beehive in cross-
section with a diameter that was nearly fifty feet at its base. The
stonework was dry jointed, meaning that no mortar was used to
hold its thirty-four horizontal bands, or courses, of stone blocks
together. Instead, these stones were wedged into place and the

spaces in between, or interstices, were filled with small rocks and
then packed with clay for a snug fit. These rings gradually tapered
into smaller concentric circles as they climbed toward their apex,
about forty-five feet above the floor, and each provided a ledge, or
corbel, to underpin the succeeding course above. This subtle detail
in design eliminated the need for temporary scaffolds and kept the
structure in an ingenious state of equilibrium and balance during
construction. The Treasury of Atreus was a novel architectural
experiment and the first that might qualify as a dome.[1]

It took 1,300 years before the next dome of any consequence
was vaulted, and this time it was in imperial Rome. There is a
tendency to dismiss Roman architecture as a shallow derivative
of what the Greeks had previously invented, but to the contrary,
there was a revolution in architectural thought taking place
about two thousand years ago that undermines this mythology.
These Romans had developed fresh ideas about spatial planning,
ornamental technique, grandiosity in scale, and new kinds of
materials to use for construction (like concrete). Many were
discussed by Marcus Vitruvius Pollio, who, after retiring from
Julius Caesar's vanquishing army, changed careers and became
an architect. We know him as Vitruvius, and he wrote *Ten
Books on Architecture*, which became a comprehensive guide of
tips and techniques needed to solve all sorts of thorny problems
in construction. By the early 1400s, *Ten Books on Architecture*
had become compulsory reading for aspiring architects and
builders everywhere, including those at St. Peter's Basilica, like
Leon Battista Alberti, Donato Bramante, Raphael, Antonio da
Sangallo the Younger, Giacomo Barozzi da Vignola, Giorgio
Vasari, Della Porta, Fontana, Carlo Maderno, and even Michel-
angelo. Vitruvius used "definite rules" to elevate the art of
construction and to improve "the welfare of society in general,"

and his masterwork became one of history's most influential publications.[2]

※

Though Vitruvius cited them only twice, it is no coincidence that domes entered the lexicon of Roman architectural practice just a short time after *Ten Books on Architecture* was published.[3] For the next 1,600 years, domed structures would be vaulted in greater numbers and in a way that would conspicuously shape the architectural character of Europe. Over time, they came to crown the most prominent and fashionable buildings of their day, especially churches. Many were built in Rome and along the Italian peninsula, in western France, the Balkans, and in Asia Minor, while some of the most inventive were raised in far-off Armenia, between the Black and Caspian Seas. But they were expensive and complicated to build, so they tended to be smaller in scale and with dimensions that were often governed by the limitations of construction, like the lengths of a timber beam that could be pragmatically sawed and used for temporary support (known as falsework or centering).

When their spans were shorter and easy to manage, builders could rely on traditional techniques and small innovations to maintain the delicate balance of vertical and lateral pressures that were inherent to domed structures. The Basilica of San Vitale in Ravenna was a fine example and was raised around the year 530 C.E. Its distinctive design had incorporated hollow earthen pots made of clay—rather than much heavier brick or stone—to reduce the dome's weight and thereby lessen its lateral thrust.

Most domes sat on a podium, known as a drum (or tambour), many stories above the ground. The drum served a vital role since it bore the brunt of the dome's thrusting force. It was connected to a

network of other, underlying components—known as a squinch and a pendentive—that transferred the pressure from the dome above to the ground below. Pisa Cathedral was built around the year 1100 and was among the most visually dramatic of these assemblies. Its drum and elegant patterns of structural framing sat some ten stories above the Campo Santo (Holy Field) and supported an elliptically shaped dome that launched another forty feet toward the sky. The design was, and remains, an architectural jewel that is rightfully celebrated for its refined proportions and exotic ornament, though the cathedral is commonly upstaged by its adjoining, and more renowned, leaning tower.[4]

Gradually, builders began to tinker with larger domes, too. These experiments were more radical and spectacular in spatial effect, since their diameters were now three and four times wider than preceding designs, and with heights that soared at least twice as high. But this made their behavior that much harder to predict, and with their longer spans it became more difficult and costly to find suitable timber for scaffolds as temporary support. So builders found it impractical to vault these larger domes with traditional falsework and invented more flexible techniques in construction, like movable scaffolds to use for temporary support as the vaults climbed toward their peaks. For all these complicating reasons—constructability, cost, and reliability—few of these larger domes made it off their drawing boards.

Despite such long odds, three magnificent domes were raised before Michelangelo's day. Each was an astonishing experiment in size, scale, silhouette, creativity, and daring, and nothing like them had been built before. The Pantheon was first, designed by

Apollodorus of Damascus in the second century and sited in the heart of imperial Rome. Its dome was made of concrete—which the Romans had newly invented—and in the shape of a hemisphere that was about seventy feet high and twice as wide.[5] These Romans had had an intuitive grasp of the colossal thrust that their oversized dome might create, so they poured a massive belt of concrete around the drum's circumference as a buttress against these punishing downward and outward forces. It ran seven stories high and was more than twenty feet thick in some spots. Then, as another extraordinary precaution for its time, an enormous, circular foundation was trenched beneath the belt to ensure that the dome's thrust would safely dissipate into the ground. But these builders did not stop there. They continued to innovate, and pioneered the use of lightweight concrete along with a coffered (or, hollowed out) ceiling to reduce the building's titanic weight and corresponding thrust. The Pantheon, with its magnificent dome, is as stunning today as when it was completed some two thousand years ago and remains a brilliant triumph in the history of construction.

The Hagia Sophia (or Church of the Divine Wisdom) was another wonder for its time, built on the Bosporus Strait in Istanbul. The design was conceived by Anthemius of Tralles and Isidore of Miletus and was raised around the year 535 C.E. under the direction of Emperor Justinian I, who had also commissioned the Basilica of San Vitale. Its diameter did not match the Pantheon's, but it was formidable enough to span the width of Fifth Avenue in New York City. One of the Hagia Sophia's most distinguishing features was the steady stream of sunlight that bathed its vast interior. But with the sunlight came a price, because this kind of heavenlike effect could only have been achieved by puncturing the dome's drum and supporting walls—some twelve stories overhead—with sizeable openings that had thereby undermined

their structural integrity. More troubling was that its magnificent dome and drum sat on just four piers, like Bramante's design at St. Peter's Basilica, and relied on a delicate network of buttressing that was strategically positioned around the building's perimeter to keep the assembly in place. It was a revolutionary yet flawed concept in design, since the system was intrinsically fragile and had neither the strength nor stability to resist the massive loads imposed from above. Its novelty also required the use of certain, untested techniques in construction, and to compound matters the Hagia Sophia has always been vulnerable to the vagaries of seismic shocks. This potent combination of factors—earthquakes and a punctured drum, along with an unorthodox design and irregular techniques in assembly—all contributed to the severe damage and complicated repairs sustained by the Hagia Sophia through the centuries, and they remain an ongoing concern.

But of these larger domes, the vaulting of the cupola at Santa Maria del Fiore in Florence was maybe the most striking. It took sixteen years to build between 1420 and 1436 under the meticulous eye of Filippo Brunelleschi, and held a profound influence over Michelangelo when he designed his own dome at St. Peter's Basilica.

For half a century, the builders of Santa Maria del Fiore had been searching in vain for a way to raise the widest and tallest dome ever conceived. They did not know how to span its unfinished diameter (143 feet 6 inches) or its ambitious height (120 feet), which would need to launch from a drum some eighteen ominous stories above the city's streets. This prompted a famous, civic competition in August 1418 to gather proposals from the most accomplished builders in Tuscany, and Brunelleschi's entry was selected for the path going forward. To us, his idea was daring and deceptively simple, though at the time many thought it foolhardy and reckless.

But Brunelleschi was undeterred, and he invented a revolutionary way to vault the colossal, double-shelled dome with new kinds of means, methods, and technologies in construction. The key ingredient to his plan was its methodical placement—under carefully controlled conditions—of masonry blocks in concentric layers, so that each successive layer would serve as a platform for the course directly above as the dome scaled to its apex. This was the same technique used at the Treasury of Atreus some two thousand years earlier, though on a more monumental scale and with higher stakes. It, too, eliminated the need for expensive falsework and cumbersome scaffolds during construction.

Brunelleschi was cannily protective of his idea, and he kept it secret until given the recognition, authority, and remuneration he had been promised. But once his contract was in place, he drove the work forward and Florence became entranced by the steady climb of its miraculous new dome and the civic pride it had generated. More than a century later, Michelangelo—who was not often known for his deference to other artists—praised the cupola at Santa Maria del Fiore when he told some friends while mulling his own design at St. Peter's, "Certainly I can make it different, but not better."[6] Like Michelangelo, Brunelleschi had performed his work "in a climate of suspicion and accusations," and experienced similar headaches with artistic rivals, building committees, and payment for services.[7] This was no surprise, since his dome was among the most conspicuous and prestigious of its time, and attracted more than the customary scrutiny and sniping from jealous competitors. But it is also hard to overlook that Brunelleschi had an obstinate and sometimes petulant personality, and that many of his miseries were often of his own making.

These two majestic domes—one in Florence, the other in Rome—were among the most complicated structures ever

conceived. They shared many common features in design, like
their double shells, crowning lanterns, oval silhouettes, a spiral
stairway, skeletal ribs, severies of stone, and hooping chains around
their circumference. Yet these similarities were not a coincidence,
given Michelangelo's long-standing admiration of the cupola in
Florence, which he had personally inspected three times while
capomaestro at St. Peter's.[8] Both domes generated an enormous
amount of thrust and tonnage that were resisted solely by a sin-
gular drum, a few piers, and some underlying walls. The system
worked well so long as its combination of stone, bricks, mortar, and
chains acted in harmony to absorb the punishing force from the
dome above. But if there was a weak link within, then the dome
would be overwhelmed and fail, causing cracks to form as a way to
relieve the pressure at the structure's most vulnerable spots. Once
they appeared, these cracks would commonly propagate, deepen,
and permanently impair the entire structure from the top of its
dome to the base of its foundations. This had already happened
at the Hagia Sophia and at Santa Maria del Fiore, where cracks
had repeatedly shown up in troubling spots, both during and after
their construction, and had caused severe damage and even the
threat of collapse.[9]

None of this anxiety had surfaced at St. Peter's Basilica as the dome
neared its completion in May 1590. The effort had been heroic, and
was achieved by Della Porta with many of the same conventions
that were then taking shape at other projects in Europe. These
projects shared many of the same challenges in construction and
required skillful planning, sophisticated logistics, complicated
supply chains, innovative means and methods, backbreaking

work, and lots of money to reach their ends. All of them—bridges, cathedrals, fortifications, and the like—were full of risk, and were commonly threatened by bad weather, labor shortfalls, cost over-runs, sporadic funding, poor workmanship, unpredictable soil conditions, and schedule delays. Their challenges ebbed and flowed in a sea of logistical headaches, and because there were so many of them and there were so many ways things could go wrong, a pragmatic system started to emerge to help manage this messy and complicated enterprise of construction.

It began with a steering committee to oversee and finance the project. The group assumed many different names over the centuries, and at St. Peter's Basilica was known as La Fabbrica di San Pietro in Vaticano. [10] In turn, these committees often designated an agent, known as a *custos fabricae* (keeper of the fabric) to administer contracts, make payments, and manage other commercial aspects of the project. The committee's most important mission was to hire a competent master builder at the outset of the project, whose role was to prepare its final design, supervise the construction work, and shepherd the day-to-day progress at the site. In Italy, he was addressed as *capomaestro*, while in France he was a *maître*, and in Germany a *baumeister*. By custom, a master builder was usually an accomplished mason because of his expertise with the workings of stone, brick, and mortar, the primary materials of construction used on these larger kinds of projects. But every so often, a carpenter was selected for the job. He was responsible for the procurement of stone from quarries, lumber from forests, hiring (and firing) of the labor pool, scheduling the work, and keeping the project on budget. The master builder also oversaw a smaller circle of artisans from within the specialty trades, such as plasterers, glazers (for glass-work), and roofers (who were also known as tilers or plumbers since the tiles were often made from lead). [11] Though subordinate to the

master builder, these specialty masters were highly skilled techni-
cians who, as they do today, often directed and supervised their
own teams around the site.

Master builders were valuable assets and in high demand, and
consequently earned three or four times more than other seasoned
tradesmen. It was a coveted role, too, and at St. Peter's, from
Bramante to Maderno, the job commonly came with long-term
security and stipends for housing, meals, clothing, and transporta-
tion. Master builders, for example, often continued to draw their
salary if illness kept them away, at a time when most workers
were paid only when they showed up for work that day, and even
then by the number of pieces they installed (called piecework).[12]
Master builders had almost unlimited artistic license around
their construction sites and a commanding civic stature off of
them, and they frequently wore distinctive clothing like fur-lined
gloves and robes to signal their elevated social standing. Though
they commonly worked in anonymity, this had changed by 1200,
when their identities became increasingly preserved—for example,
Andrea Pisano, Arnolfo di Cambio, Bernard de Soissons, Hugues
Libergier, Jean de Chelles, Lorenzo Maitani, Matteo Gattapone,
Pierre de Montreuil, and Robert of Luzarches. Perhaps the best-
known was Villard de Honnecourt, an itinerant consultant whose
famous sketchpad showed the most up-to-date means and methods
in construction as he toured many active project sites around
thirteenth-century France, Hungary, and Switzerland.[13]

There began in the fifteenth century a gradual but definite shift
in the way that construction work was executed. It was marked by
an increasing emphasis on design as a discrete and distinctive pro-
cess unto itself, which would then be turned over to a constructor
to build. Under this new paradigm the master builder, as designer,
became more distant and removed from the process of installation,

which more closely resembles how architects work today. It was
evident at St. Peter's Basilica, too, in the proposals prepared by
Bernardo Rossellino for Pope Nicholas V around 1450, and into
the next century by Bramante, Raphael, Antonio da Sangallo the
Younger, and Michelangelo.

Then, as now, it was common for a steering committee or spon-
soring patron to have an active voice in the project's final design. It
was a process richly steeped in geometry, philosophy, theology, and
harmonic theory that were then blended with the pragmatic reali-
ties of construction. This was apparent at St. Peter's Basilica, with
its hundreds of drawings that were prepared from 1505 to 1549
that displayed an ongoing evolution in design taking place between
the *capamaestros*, the Fabbrica, the Curia, and the pope. Ironically,
a design feature on which they all agreed was its placement of the
high altar—the most sacred spot and directly above Saint Peter's
tomb—at the western end of the basilica. Yet their collective decision
undercut a central theological tenet of church design for the time,
which specified altars to the east, toward Jerusalem and the rising
sun. To this day, the west-facing altar at St. Peter's Basilica, the most
celebrated church in the world, remains a great paradox in the long
arc of church construction and architectural history. [14]

Once a consensus was reached in design, master builders were
then known to prepare a small-scale, three-dimensional model to
codify the final plans. It was put on prominent display and used as
a convenient and ongoing reference for the construction team and
steering committee. Some designs were produced on pen-and-ink
parchment, which was a practice extending back as far as Vitruvius,
if not earlier, when he advised that "an architect . . . must have
a knowledge of drawing so that he can readily make sketches to
show the appearance of the work which he proposes." [15] But paper
was expensive, so the ink was often erased and its parchment was

repurposed for future projects. This, in tandem with their degradable fibers, explains why so few design drawings have survived through the years. When parchment was not available, the master builder often worked up his architectural ideas on the floorboards of his tracing house, by etching the design onto thin, layered sheets of wet plaster.

For generations, there remained a collective spirit of camaraderie among the master builders of Europe. They were known for their fraternal hospitality, particularly within the masons, who over the centuries developed secret handshakes, symbols, signs, and passwords to preserve their prestige and status. They even formed exclusive lodges that often prohibited their members from teaching their craft to anyone outside of their vocation.[16] These master builders were among society's professional elite and their working knowledge, technical expertise, acumen for business, organizational skills, imagination, and leadership around a construction site cannot be overemphasized. Without them, Michelangelo's dome and the grand structures that preceded it would never have gone beyond the tracing house floor.

❧

Once the design was well advanced and the project funding was in place, the master builder could turn his attention to the details of construction. At this stage, he mobilized the labor, materials, and equipment necessary to get the job built, and relied on a diverse work force comprised of men and women on-site as well as the quarries, forests, smith shops, dockyards, and bakeries to support the overall effort. Teamsters would float and haul the vast quantities of stone blocks, which were set into position by the rough masons and then shaped into final form by the freemasons.[17] Some workers

made bricks. Those who mixed and carried the mortar were pivotal to the process and often formed the largest part of the project's labor pool. Smiths forged the hardware and tools that were made from iron, like nails, hammers, trowels, and axe heads. Foresters felled and trimmed the trees for lumber, while carpenters sawed and framed the timber as planks and scaffolds. From ladders to baskets, and pulleys to hoists, the many staples of construction were assembled by hand and needed in large supply. Though they resembled many of the same tools and equipment in use today, workers showed a propensity to continually innovate, seen by the evolution from handbarrow to wheelbarrow, as well as the invention of movable falsework, known as *cerce*, and while vaulting Michelangelo's dome their system of measurement relied on the braccio, which was roughly the length of a person's arm.[18] They lived hard lives and their toil followed the sun, which in the summer shone for fifteen hours or more. Commonly, their pay was modest, and their employment was seasonal and sporadic, running from March to November, after which most operations were suspended in the cold, dark, and more inclement winter months.[19]

Like present-day projects, the first task of construction at St. Peter's Basilica was to smoothen and then mark the site in a process called staking, which used exotic equipment like a theodolite and a levelers rod to lay out the building's future columns and walls. Once the stakes were in the ground, the foundations could then be trenched and filled with stone blocks and rubble. Sometimes these footings were shallow, but other pits might be fifteen feet deep or more, as at St. Peter's and the Pantheon. On occasion, these foundations required extraordinary thought and care, as at la Cathédrale de Notre-Dame de Paris, where long and deep retaining walls were necessary around the site's perimeter to keep water out from the adjacent Seine River.[20] Then again, the reverse was true in Salisbury,

England, where the ground held firm and minimal trenching was necessary to support the magnificent cathedral there.

These different kinds of foundations, and their methods of installation, reveal the limited state of knowledge about soil behavior in those times. The advice from Vitruvius, whose *Ten Books on Architecture* was commonly the sole written guidance then available, cryptically suggested that they be "carried down into solid ground as far as the magnitude of the work shall seem to require, and the whole substructure should be as solid as it can possibly be laid."[21] This was representative of a rich variety of technical issues that a master builder might face at the site, where he was heavily reliant on rudimentary geometric principles, general rules of thumb, oral tradition, collective judgment, and trial and error to solve the difficult challenges of construction. In other words, the process was entirely subjective. There were no defined procedures in place to calculate the depth for a foundation trench in silty soils, for example, or the thickness of a masonry wall to prevent it from buckling, or the distance that a roof beam might span before it splintered under a heavy blanket of snow, or the heft of a flying buttress to withstand a crushing winter's gale. This was ominously evident when the German *baumeister*, Lorenzo Lechler, advised his son in 1516 that "an honorable work glories its master, if it stands up;" and in Florence, too, when a hundred years earlier the wardens at Santa Maria del Fiore had admonished Brunelleschi to use an empirical, wait-and-see approach when raising their titanic dome "because in building only practical experience will teach that which is to be followed."[22]

In the absence of written rules, therefore, a master builder's response to these complicated problems became intensely personal and individualistic. This had sparked a remarkably creative record of artistic achievement that produced in Europe a diverse,

imaginative, and often charming assortment of bridges, fortresses, and cathedrals that were similar in aesthetic intent yet never built exactly alike. Though we admire their handiwork and intuitive grasp of structural behavior, these master builders did not know with certainty whether their structures would stand up, or why. Their empirical methods "provided no basis for choosing between the safe and the unsafe . . . [and] particularly when attempting any-thing new, the builders had to make choices for which [they had] no guidance."[23] In short, these master builders were often playing with fire, and they knew it. Their uncertain methods could lead to treacherous outcomes and were most apparent when vaulting a masonry arch—or a dome—whose behavior was notoriously difficult to predict, and was known to crack, sag, and collapse, sometimes with catastrophic consequences.

Master builders knew that their structures had to be strong, safe, stable, and stand the test of time. But this was a tall task, given the years of punishing sun, rain, ice, snow, and gales that were expected over their life cycle, in tandem with the grinding wear and tear of daily use. In today's parlance, these forces of nature could be classified into many, distinct categories. There were downward weights caused by gravity, known as dead and live loads, and lateral forces that were side to side. They could be applied in a gentle and gradual way, like a steady breeze or blanket of snow, or they could be jolting, like an earthquake. Some forces were more prevalent at a bridge, caused by a sudden impact, known as a point load; or were part of the steady hum from everyday traffic, called a rolling load. Then there were the imperceptible yet very large forces at work when a structure warmed

up by day and cooled down at night, in a process called thermal expansion and thermal contraction.

To illustrate how some of these forces work, first consider a column inside an ordinary building. Its job is to transfer vertical loads from the floors above to the ground below, while at the same time resisting possible sidesway imposed by wind or an earthquake. Now, imagine this column as a standing pencil with a downward pressure applied at its top. This pressure is known as a compressive force, and either our pencil will possess enough strength and stability to resist the downward push and lateral sway or it will buckle and snap from the stress. We can use our same pencil and then lay it flat to resemble a bridge girder. If enough downward pressure is applied along its horizontal shaft, our pencil will start to curve and bend. This is known as flexure, and it causes compression to form along the top of the shaft and tension along its bottom. So, our simple pencil illustrates how columns and girders resist the steady push and pull of everyday forces at a building like St. Peter's Basilica. Some construction materials—such as stone, brick, and mortar—possess lots of compressive strength but not much tensile capacity. Timber, by contrast, has lower compressive strength than stone, but higher resistance in tension.

There were other powerful forces at work in these structures, too. Imagine a sharp pair of scissors as it slices through a sheet of paper. This slicing action is known as shear and can rip a column or girder apart if not properly considered in their designs. Now think of a doorknob that is twisted with a force called torsion, which if overlooked can shred the connections that hold our columns and girders in place. Yet perhaps the most complicated of all is thrust—which is organic and unavoidable at every dome—where dead, live, and lateral loads collide to produce a relentless and punishing outward kick.

Thrust was a well-known phenomenon to the *capomaestro* of St. Peter's, Giacomo della Porta. He was likely aware of the heavy damage it had caused the Hagia Sophia and the Duomo in Florence, and clearly knew to expect it when he and Domenico Fontana set out to vault Michelangelo's dome in the summer of 1588. But what they did not know—and could not predict—was how large these thrusting forces might be or how they would migrate through the dome's complicated curvature. Neither did Della Porta know the precise combination of stone, brick, mortar, and iron that would provide optimal strength, since each of these materials possessed a differing set of chemical and physical properties. In short, he did not have the tools or knowledge to measure the thrust under Michelangelo's dome (known today as demand), or how to calculate the dome's resistance (which, in current parlance, we call capacity).

On top of these uncertainties in design, there were the typical flaws in workmanship that Della Porta and every other master builder encountered and tried to minimize at their projects. "Of the Defects in Buildings," Leon Battista Alberti wrote, "some [were] innate and owing to the Architect, and others proceed[ed] from foreign causes."[24] This applied to walls that were out of plumb, floors that were uneven, mortar that was badly cured, and most common of all: water leaks. The Cathedral of Saint Peter of Beauvais was built some sixty miles north of Paris and it collapsed at least twice, in part because its columns were unstable and overstressed.[25] Other catastrophic failures were recorded at Chichester Cathedral and the Campanile di San Marco in Venice. Wells Cathedral had its fair share of puzzling problems, too, that were only solved after a set of unique, elegant, and world-renowned scissor vaults were installed around its crossing to stabilize the central tower.

Cracks were among the most mysterious and unwelcome of these defects, and they had plagued every aqueduct, cathedral,

fortress, palace, and pyramid since the dawn of construction. Alberti believed that many kinds of cracks could be traced to "faults in the foundation," which was yet one more "foreign cause" for mishap.[26] This was glaringly apparent at the Bent Pyramid in Dahshur, which was built during the Old Kingdom of ancient Egypt, whose silhouette was abruptly altered midway in construction—from fifty-three to forty-five degrees—because the underlying bedrock gave out and could not support the structure's extraordinary weight. The same was true at Pisa, when its magnificent, eight-story campanile sank unevenly into the soil beneath (in a process known as differential settlement, and which was a notorious problem around the city). It caused the tower to lean perilously out of plumb and thereby became the world's most celebrated construction defect in history.[27]

These were just a few of the headaches that were commonly encountered around a typical construction site. They were evident on Vatican Hill and at the Old St. Peter's Basilica, too, where by 1450 Emperor Constantine's church had sunk and settled into the earth so that its walls had pulled away from its roof by as much as six feet. Pope Nicholas V had recognized this as a worrisome safety hazard and an expensive problem to fix, while Pope Julius II had used it to justify (at least in part) his tearing down the old to build anew.[28]

But these defects persisted, even once the new basilica had been raised. Disturbing cracks were discovered at Bramante's piers, for example, just twenty years after their installation (and, ominously, *before* the dome's construction). Though Antonio da Sangallo the Younger had managed to fix them in the 1540s, he did not know how these cracks had first started or whether his repairs would hold.

❧

This was the uncertain and precarious state of knowledge at every construction site across Europe when Benedict XIV became pope in the summer of 1740. Within two years, the disturbing chatter about Michelangelo's dome had become fact; the cracks were obvious and the damage seemed to be worsening. But was it a cosmetic issue and of no real consequence? Or was it symptomatic of a deeper and darker flaw? And how would anyone know with certainty, or be able to predict, one way or the other?

4

THE ABLE ASSISTANT

Everyone knew Luigi Vanvitelli as a capable architect. Born to Anna Lorenzani and Gaspar van Wittel, the family was "driven from Naples by an insurrection and an epidemic" in 1701 when Luigi was an infant.[1] They then lived in Rome for many years with Anna's father, Giovanni Lorenzani, who was a cultured artisan, dramatist, poet, and noted authority on church history, having written a defining, twenty-two volume compendium that had documented many papal conclaves and administrations, and is now part of the Vatican Library. Lorenzani was also a collector of fine books and must have owned a sizable house, because his private library of nearly three thousand volumes was among the largest in the city. Vanvitelli inherited a valuable portion of his grandfather's prized collection while a young man, and it triggered a love of reading, language, and poetry that stayed with him for the rest of his life.[2]

Vanvitelli's father had come from a very different sort of background. He had emigrated from the Netherlands years earlier, in 1675, and over time developed into an accomplished *vedutista* (painter of landscapes) for fashionable clients in Rome. In 1709

he earned his Roman citizenship and promptly Italianized his surname to "Vanvitelli."[3] By then, he had also acquired a skilled proficiency in hydraulics, the science of fluids as they flow through pipes, conduits, and other kinds of waterways.[4] It was a brand of expertise that was in high demand by municipalities and townships across Italy at the time, who were trying to harness water for drinking, sanitation, military advantage, and commercial gain. Van Wittel passed down this diverse set of valuable skills to his attentive son, who would in time become a talented painter himself and design several prominent waterworks, too—aqueducts, fountains, and ports—in the decades ahead.

Vanvitelli's interest in architecture began when he was a teenager, probably while poring over the collections in his grandfather's treasured library. There he had likely found a copy of Vitruvius's *Ten Books on Architecture*, which ignited his lifelong passion for the classical and contemporary monuments of Rome. Around this time, Vanvitelli may have been introduced through his father to Filippo Juvarra, a talented and well-connected architect then working in the city, whose Basilica of Superga in Turin stands among the masterworks of Italian baroque.[5] It was said that Juvarra, as "one of the most gifted draftsman of his age," had informally critiqued many of Vanvitelli's sketch works, drawings, and paintings, and became an early enthusiast of the young man's talent.[6] This heartening endorsement may have been the catalyst that furthered Vanvitelli's interest for a career in the arts, and it exposed him to the drama and flair of other baroque architects, such as Gian Lorenzo Bernini, Francesco Borromini, and Carlo Fontana in Italy, as well as André Le Nôtre and Louis Le Vau in France.

About ten years earlier, Juvarra had won the *concorso* (art competition) sponsored in 1705 by Pope Clement XI, and was subsequently asked to submit designs for several projects around Rome, including

a new sacristy for St. Peter's Basilica under Michelangelo's dome.[7] Through the *concorso*, Juvarra had likely developed many professional contacts inside the Vatican, and it was possibly through him and these contacts that Vanvitelli met its chief architect, Antonio Valeri.[8] Vanvitelli's talent must have been obvious and his training impressive, because in 1726 La Fabbrica di San Pietro in Vaticano hired him as an assistant to Valeri, who became an enduring mentor to the aspiring young architect in the decade ahead. Now in his mid-twenties, Vanvitelli was walking in the same legendary footprints as former deputies at St. Peter's like Domenico Fontana, who had vaulted Michelangelo's dome in the 1580s, along with Raphael, Antonio da Sangallo the Younger, Giorgio Vasari, and Giacomo Barozzi da Vignola. With his new and elevated stature inside the Vatican, Vanvitelli came to the immediate attention of many persons with money and influence, including Cardinal Alessandro Albani, who in his thirties was already a leading collector of antiquities in Rome. Albani had a reputation for being "worldly, amiable, and idle," and as Pope Benedict XIV later quipped, "must have been born on a Sunday, for he is strongly opposed to 'servile works.'"[9] He and his older brother, Annibale, were nephews to the recently deceased Clement XI and became early patrons of Vanvitelli. They helped to launch his career by sponsoring several architectural commissions in their cosmopolitan home city of Urbino, at Villa Albani as well as the Basilicas of San Francesco and of San Domenico.[10]

By 1728, Vanvitelli's well-rounded intellect, professional achievement, and social ambitions had earned him a membership at the Pontificia Accademia degli Arcadi, the most renowned literary club in eighteenth-century Italy. The Arcadi's mission was dedicated to the strengthening and propagation of Italian culture, tradition, literature, drama, and poetry while advancing

the most recent discoveries in scientific thought, which were then growing by leaps and bounds. [11] Its membership was open to men and women along the Italian peninsula and, unlike at other social clubs of the time, one did not need to be noble-born to join the Arcadi. Any woman could join, so long as she "was at least twenty-four years old, reputable, and 'practicing poetry or some other sort of literary endeavor.'" [12] This was a pragmatic extension of the Arcadi's founding principle that "women are capable of every virtue, both moral and intellectual," which was routinely on display at the many concerts, discussions, and scholarly debates where they were encouraged to participate and voice their points of view. [13]

At the Arcadi, Vanvitelli would have met and befriended the tallest intellects of his day, like Cardinal Prospero Lorenzo Lambertini, the future Pope Benedict XIV. Lambertini had joined the society as a young man, too, some twenty-five years earlier, and had been subsequently recognized as among the Arcadi's "most devoted and zealous members." [14] During these years, Vanvitelli may also have come to know Cardinal Silvio Valenti Gonzaga, a close friend to Lambertini and who would be named as his secretary of state, once pontiff. Beyond its impressive roster of members, Vanvitelli was further attracted to the Arcadi because of its overarching emphasis on proper decorum and good taste, which suited his staid personal temperament and professional approach toward architectural design.

In the 1730s, Vanvitelli began to collaborate with Nicola Salvi on a few architectural commissions. Salvi was two years older and they were by now fast friends, probably through the Arcadi, which Salvi had joined in 1717 while still in his teens. Their first joint design, in 1731, was for the waterworks sponsored by Pope Clement XII in the village of Vermicino, outside of Rome. [15]

Aqueducts and fountains in those times were not the faceless pipe-
lines and pumping stations that we build today; rather, fresh water
was far less abundant and therefore more highly valued then, so
these kinds of projects were symbols of immense civic pride. Such
commissions were plum assignments that combined architectural
fancy with hydraulic ingenuity, and often became a prominent
centerpiece within Italy's many public squares.

Around this same time, Vanvitelli and Salvi competed sepa-
rately at two, other prestigious contests sponsored by Clement XII,
known as the *concorsi clementini*. They were part of a long line of com-
petitions for which the Italians—and Popes Clement XI and XII,
in particular—were reputed, and "were the best means by which an
unknown foreign artist . . . could gain professional prominence."[16]
The first contest sought to redesign the front façade for the Basilica
of St. John Lateran, the oldest in Rome. Back in Constantine's
day, the emperor's second wife, Flavia Maxima Fausta, had owned
a large plot of land and a palace inside the city gates that had
descended from the ancient and once powerful Laterani family.
Though the circumstances are murky, Constantine executed
his wife and eldest son and heir, Crispus, in the year 326 C.E.
for unexplained crimes that remain shrouded in mystery. Constan-
tine had previously offered Fausta's palace, known as the Lateran,
to Pope Sylvester I to use as his residence, and then—perhaps to
ease his conscience for Fausta's death—Constantine donated the
land and money needed to build a new basilica on the adjacent
site. It was dedicated to Saint John (another early follower of
Jesus of Nazareth) and became the official place where the pope's
chair, known as the cathedra, was kept for safekeeping.[17] When
Pope Nicholas V reestablished Rome as the papacy's permanent
site, more than a thousand years later, he found the Lateran Palace
neglected, ravaged, and uninhabitable, so he moved his residence

to Vatican Hill, where it has since remained. But the cathedra stayed inside the Basilica of St. John Lateran and the decision in 1732 to award its new design to an outsider, Alessandro Galilei, who was a personal favorite of Pope Clement XII's Corsini family, was viewed as a betrayal that angered "the Roman architectural establishment at seeing the prize awarded to a Florentine."[18]

Another renowned *concorso* surrounded the design of Trevi Fountain. It was stationed in the heart of baroque Rome and marked the terminus for the aqueduct known as Acqua Vergine Antica. Though this competition was somewhat clouded by history, it appears that five artists were vetted "in a complicated decision-making process that took more than two years and involved several different stages."[19] A diarist from that time, Francesco Valesio, furthered to muddy the water when he mistakenly wrote in August 1732 that Vanvitelli had submitted the winning entry but then corrected his journal a few weeks later.[20] Valesio's conflicting entries have helped to create a lasting misimpression that Salvi and Vanvitelli had worked jointly when, in fact, Salvi was solely awarded the project. His dramatic composition and majestic mythological characters have made Trevi Fountain among the most cherished and well-known landmarks in Europe.

Though Vanvitelli did not win either of these contests, his entries were favorably received and gained him heightened standing within the Curia, the Fabricca, and by Pope Clement XII. They recognized Vanvitelli's inborn architectural talent and over the next two decades assigned him a steady stream of diverse projects to design across the Papal States, from the working ports of Ancona and Fiumicino to the Villa Tuscolana (also known as the Rufinella) in Frascati, and from the ceremonial Arco Clementino to the campanile for the Apostolic Palace near St. Peter's Square. Vanvitelli designed many churches, chapels, and basilicas during

this time, too, such as Santa Maria della Misericordia in Macerata, San Ciriaco in Ancona, the Convento degli Olivetani in Perugia, Santa Maria Maddalena in Pesaro, Sant'Andrea delle Fratte in Rome, San Feliciano in Foligno, along with separate commissions for the Augustinian order (Sant'Agostino) at Cesena and Siena.[21] His masterwork in these early decades was an austere, pragmatic, and distinctive five-sided military hospital known as La Lazeratta, built on an artificial island inside Ancona Harbor and which bears close resemblance to the Pentagon in Washington, DC.

Throughout his career, Vanvitelli's brand of architecture contained various philosophical threads that combined the stately proportions of the Renaissance, the dramatic flair of the baroque, and the staid sobriety of neoclassical restraint then overtaking Europe. Like every other practicing architect, Vanvitelli was well-schooled in Vitruvius's *Ten Books on Architecture*, yet he was much more of a modernist, too, meaning that he preferred his buildings to reflect their present-day purpose, and did not agree with those of his peers who found it fashionable to blindly borrow and mindlessly copy the architectural patterns from the past. "The theories of Vitruvius are great," he wrote, "but not applicable in all cases: and let's speak honestly . . . and without Vitruvian posturing, the cases are rare in which his theories can be adapted."[22] So, in the tradition of his grandfather, Vanvitelli assembled an impressive library of his own, which he used for reference and occasional inspiration. He had collected many guidebooks that had been published and widely disseminated since the 1450s, written by architectural luminaries like Leon Battista Alberti, Francesco Borromini, Guarino Guarini, Filippo Juvarra, Andrea Palladio, Sebastiano Serlio, and—Vanvitelli's personal favorite—Giacomo Barozzi da Vignola (the former *capomaestro* at St. Peter's Basilica and onetime assistant to Michelangelo). What had differentiated

Vignola's work, the *Canon of the Five Orders of Architecture*, was its "clear illustrations with brief captions and no elaborate corpus of theory."[23] Vanvitelli owned multiple copies of this book, and its no-nonsense and straightforward guidance appealed to his pragmatic inclinations.[24]

Despite these modernist leanings in his professional practice, Vanvitelli was nonetheless, deep down, a classicist by temperament and training. As hard as he tried to appreciate the avant-garde discoveries in science and mathematics that were then sweeping over Europe, these concepts did not always come easy to him and Vanvitelli "gained little from what he read" on the topics.[25] Rather, he gravitated to the legacy, literature, poetry, and music of Rome and Italian culture that had enveloped him as a boy at his grandfather's house, and that were reinforced at the Arcadi. Vanvitelli loved the structure and syntax of language, and his ease with it extended to Italian, Latin, French, Spanish, and some Dutch, though "English . . . was impossible."[26] These traditions shaped his overriding sense of good taste, moderation, and lyrical rhythm, which was evident throughout his architectural career.

Vanvitelli demonstrated the same sense of decorum with his immediate family that he maintained in professional practice. He seemed to be a dutiful eldest son and kept in close touch with his mother and father as they aged, and with both his siblings, too, especially his brother, Urbano, who was a few years younger. His parents had been married for some forty years when Gaspar died at the age of eighty-three; Anna followed just three months later, in December 1736, and in between came the death of Antonio Valeri at eighty-eight, his mentor at St. Peter's for the preceding ten years. The loss of these three formative figures in so short a time must have created a deep void in his life, which might explain why, a few months later, Vanvitelli chose to settle down

at age thirty-seven and start a family with his new bride, Olimpia Starich, the daughter of an accountant at the Fabbrica. Their long marriage would be filled with the routine joys and common tribulations that came with raising five boys and three girls, along with the sadness and grief when two of them did not live beyond their fifth birthdays.[27]

<p style="text-align:center">�</p>

During the 1730s and 1740s, four architects came to dominate the most important commissions of the day in Rome: Vanvitelli and Salvi were native sons, while Ferdinando Fuga and Alessandro Galilei were from Florence. Another young architect, Giovanni Battista Piranesi, had recently arrived from Venice with his superb talent for draftsmanship, which would propel his career in the decades ahead. Fuga and Galilei were part of a recent wave of immigration that began when Cardinal Lorenzo Corsini—from the princely and powerful dynasty of Florentine bankers by the same name—was elected as Pope Clement XII in the conclave of 1730. Clement XII's entourage had also included Giovanni Gaetano Bottari, the "confidential chaplain" and "cultural advisor" to the Corsini family, who was a noted scholar, theologian, and curator of art and books.[28] Within a year of his move, Bottari had been appointed to chair the departments of ecclesiastical history and polemics—the practiced art of debate—at Rome's leading university, La Sapienza. Eight years later, he was rewarded with the plum position as prefect (chief officer) of the prestigious Vatican Library.[29] Despite his elevated status and string of professional success, Bottari seemed to possess a malicious temperament and "a polemic mind" that sought controversy and enjoyed argument for their own sake; this corrosive aspect of his personality along with

his inborn talent for disparaging the reputations of others would play an enormous role in the decade ahead, after the cracks were detected at Michelangelo's dome.[30]

In the meanwhile, there had been a seething resentment that was building among the architects of Rome. They were protective of their city and its architectural heritage and did not want it overrun by designs from outsiders, most especially by the Florentines, who were known for their aesthetic arrogance and sense of artistic self-superiority that was steeped in the Tuscan traditions of Michelangelo. This irritation was often evident in Vanvitelli's many feuds with Fuga as a professional rival and his reprimands of Bottari, whom Vanvitelli viewed as a "malignant hypocrite [who] . . . wants to look like he is an expert in everything while he actually knows nothing."[31] Despite Vanvitelli's sense of social decorum, neither he nor Salvi could disguise their mutual "disdain" for the "intrusive presence" of Clement XII's *favoriti*: Bottari, Fuga, and Galilei.[32] Their feelings were reciprocated and the collective animosity between these two factions was palpable, personal, and ugly. Bottari published many unkind words about Vanvitelli's designs during these years, and conditions did not improve when, in 1743, Piranesi got into the fray and "declared himself free and emancipated from the 'decayed' state of Roman architecture."[33] Years later, a prominent British architect, William Chambers, "harshly condemned" the "deficiencies and bad taste" on display in Rome and Naples during this era. He wrote in an unflattering and backhanded way that "you will see some execrable performances there, of Vanvitelli, Fuga, and some blockheads of less note [and] avoid them all . . . excepting Salvi, who had indeed no general principles to guide him, yet sometimes fortunately hit upon the right, as appears by parts of his fountain of Trevi."[34] These bitter personal attacks, criticisms, and gratuitous insults that Vanvitelli

faced, and would continue to face, all came with the job and the prestigious post as architect to the Vatican. They would intensify as the disturbing rumors about the cracks at Michelangelo's dome began to escalate in the 1740s, and would extend toward, tarnish, and then undermine the work and reputations of three innovative mathematicians who were trying to save it.

By 1740, Vanvitelli had been gainfully at work on behalf of the Curia, its influential cardinals, and the pope. In his coveted role, he had for fourteen years designed and built many projects within the Papal States, though few had been on Vatican Hill or inside St. Peter's Basilica. But that changed early during the administration of Pope Benedict XIV, when there emerged a growing alarm about the structural integrity of Michelangelo's dome. Rumors like this had been swirling for at least sixty years, first when Gian Lorenzo Bernini—the recently deceased *capomaestro* at St. Peter's and preeminent sculptor of the Italian baroque—"was blamed because he had made small modifications to [Bramante's crossing] piers." This had prompted Pope Innocent XI to investigate the matter, which was led by his new *capomaestro*, Mattia de Rossi, in 1680. Bernini had been a mentor to De Rossi, so perhaps it was no surprise that De Rossi exonerated Bernini "after careful inquiry," stating that "the fears were judged to have been exaggerated."[35]

But the concerns about Michelangelo's dome did not quietly go away. More "sinister and various voices" surfaced ten years later in the 1690s, during the reigns of Popes Innocent XI and XII. This launched a second investigation, this time by a talented architect and master self-promoter, Carlo Fontana. Like De Rossi, Fontana's

report provided "broad and generic reassurances on the 'steadiness'" of Michelangelo's Dome."[36]

The cracks became more visible in the 1730s and had seemed to coincide with a sequence of powerful earthquakes that had ravaged the nearby provinces of Umbria, Abruzzo, and Calabria. Though the seismic record is far from complete, the available data nevertheless offers some valuable clues about what may have happened to Michelangelo's dome during this era. Of the twenty-five earthquakes that were registered between 1590 (when the dome was finished) and 1694 (when Fontana completed his report), seven were close enough to have been felt in Rome. They were significant events that featured "extreme" ground shaking, large amounts of building damage, and caused about six thousand combined deaths.[37] Their recurrence rate during this interval was, on average, about twelve and a half years.

By comparison, the seismic record for the next half century revealed thirteen events of similar intensity. Seven of them, too, were within Rome's reach. During this interval, their recurrence turned out to be twice as frequent as during the previous century and they were, arguably, more destructive as evidenced by the estimated fifty-one thousand people who perished in their wake.[38] Moreover, these statistics do not consider the dozens of other earthquakes that went unrecorded in those days, which may have further shaken and undermined the buildings in Rome. Within this framework, it is difficult to ignore that the shock waves generated during this period of high seismicity, 1695–1740, may have contributed to, and had combined with, the titanic thrusting forces inside Michelangelo's dome to steadily weaken the structure. This could have caused cracks to form and propagate quickly—and especially in the presence of possible, preexisting defects that had been "baked" into the dome during its construction between 1588

and 1590—in tandem with the gradual degradation in the mortar joints that was common to all structures made of masonry. When all these complicating factors are taken together, they lead to a logical hypothesis that corresponds with the suspicions and contemporaneous patterns of cracking that were recorded at Michelangelo's dome by 1742. These kinds of cracks were also consistent with the latticework of deadly and destructive damage that we commonly see today after an earthquake jolts, shakes, and rattles its way across a structure made of stone and brick.[39]

<p style="text-align:center">❦</p>

We may not know when the first cracks became plain and visible, but they seemed to quickly propagate after 1695. Within forty years, they had become so obvious and worrisome that the Vatican and the Fabbrica were forced to take notice and thereby commission Vanvitelli, as *capomaestro* at St. Peter's Basilica, to investigate them after the papal coronation of 1740. It must have challenged him, since Vanvitelli was accustomed to the more traditional aspects of construction and had never tackled an issue as novel and complex as this before. How would he do it? Where would he begin? What might he find?

As a sensible first step, Vanvitelli had to locate the cracks he had seen within Michelangelo's dome and then draw them onto an existing set of building plans. As it turned out, he had a few options to go by. Surveys of St. Peter's Basilica had been performed at least twice in the last century, to document the design, construction, and condition of the church. The first was prepared in 1620, while Carlo Maderno was *capomaestro* and working to complete the new nave. It was titled *Architettura della Basilica di San Pietro in Vaticano* and was coauthored by a father and son team: Giovanni

Battista Costaguti the Elder and Giovanni Battista Costaguti the Younger. Their survey included the dozens of extraordinarily crafted engravings by Martino Ferabosco, who had pioneered the invention of precisely measured and finely scaled architectural drawings that we would recognize and expect at a modern construction project. Ferabosco prepared his floorplates, elevations, cross-sections, details, and three-dimensional renderings with magnificent technique in draftsmanship that has since become a lost art. He further acknowledged that his complex arrangement of drawings would "be a challenge for the 'intelligent professor' who will then have to read them."[40] It is noteworthy that Ferabosco did not seem to mention or record any cracking in Michelangelo's dome at this snapshot in time, some thirty years after its construction.

There was a second set of drawings, too, that were available to Vanvitelli, which were based on the investigation by Carlo Fontana for Pope Innocent XI in the 1690s. Fontana was something of a showman—which was evident by his self-designation as an "Illustrious Architect of Our Century"—and who had also been a mentor to Juvarra, the same architect who may have advised Vanvitelli as a young man.[41] We do not know whether *this* Fontana was a family relation to Domenico Fontana, the brilliant and determined former deputy who had vaulted the dome in the previous century (though both were raised in the same region of northern Italy). But we do know that Carlo Fontana wished to create and reinforce this perception, and his survey of 1694 was a masterwork intended "to showcase his own talents and abilities in relation to other great masters."[42]

Fontana's folio was dedicated to the Sacred College of Cardinals and to the Fabbrica, and was written in both Latin and Italian in a split-page format, titled *Il Tempio Vaticano e sua Origine.* The

book was some 550 pages and structured into seven chapters, or
libros, that showed dozens of sumptuous site maps, renderings,
landscapes, elevations, cross-sections, and architectural details of
the papal complex on Vatican Hill. Each page was presented with
meticulous clarity and a penmanship that was florid yet easy to
read. Though commissioned for many reasons, the report's core
purpose had been to explore the rumors "questioning the structural
capabilities" of Michelangelo's dome—as addressed in *libro* v—and
for which Innocent XI "was anxious to know the truth."[43] By
now, the dome had been in place for a hundred years, and though
Fontana did find "a lesion along a rib," he offered no further issues
of concern. This was probably not the whole story, however, since
he curiously thought to also include a proposal to wrap three
more iron rods around the inner shell's circumference that would
"improve the resistance of the tambour and the dome."[44] This was
an odd and out of place suggestion, since Fontana had just assured
the pope and the Fabbrica that the structure was sound: it sent a
mixed message that did not go unnoticed and only furthered the
suspicion of a deeper problem.

≈

The cracks continued to grow in the 1730s, and Benedict XIV
tasked a commission to "make a detailed examination" of the dome
soon after his coronation. The group was chaired by the Fabbrica's
director, Francesco Olivieri, while Cardinal Carlo della Torre di
Rezzonico (who would succeed Benedict XIV as pope in 1758,
as Clement XIII) may have also participated. Their findings did
"not achieve any result" and, like Fontana's report from fifty years
earlier, had "reported that no danger threatened Michelangelo's
work."[45] But it is difficult to gauge the value of these findings since

few in the group seemed to have had much practical experience with construction or architectural design. More revealing was that, by 1741, the cracks were now "perceived as critical," and "worrying gossip" and "chatter" about them "must have been widespread" around the city.[46]

At this stage—in 1741 or 1742—the pope was compelled to establish a second committee and make another "fresh examination" of the dome, attic, and drum. The effort included Vanvitelli and the Fabbrica's master mason, Nicola Giobbe, along with other notable architects such as Nicola Salvi, Ferdinando Fuga, Giuseppe Sardi, and Domenico Gregorini. The Vatican's resident expert in construction, Niccola Zabaglia—whose role would soon expand in scope and import—probably took part in it too.[47] The committee "examined both the dome and all its supports" and delivered their findings to Benedict XIV in mid-September 1742.[48] Though we do not know its precise form—whether a multipage manuscript, a summary memorandum, or an oral representation—Vanvitelli reported that the damage was limited to the dome and drum and recommended "a number of remedial measures" to fix these problems.[49] This is an important detail because nine months later, in June 1743, and after more research and inspection, Vanvitelli prepared a lengthy written discussion and a number of drawings that had characterized these earliest observations.[50] For this reason, it is difficult for us today to separate what he knew and saw before September 1742 from what he learned thereafter, and from the many other voices who had by then joined the firestorm of opinion.

In any case, it was clear that Vanvitelli had formally acknowledged by September 1742 what was plainly visible and could no longer be avoided. The presence of these multiple and ominously shaped cracks in Michelangelo's dome now posed a discomforting

problem of unknown severity. But at the same time, he believed the damage was not grave and that the dome could be stabilized by wrapping additional rods made from cast iron around its circumference. This was consistent with conventional construction practice, as well as Della Porta's design in 1588 and Carlo Fontana's recommendation of 1694. These early findings by Vanvitelli were pivotal to everything that followed and "initiated a period of widespread consultation and intense debate about what, if anything, should be done" to Michelangelo's dome.[51]

Though we do not know Benedict XIV's precise reaction to Vanvitelli's report, his actions demonstrated a clear sense of urgency and immediate concern. He now knew there were many large cracks in the dome, but did not know their precise number, their size, their full extent, when they had first appeared, or what had caused them. Might they, for example, have originated when Sixtus V insisted the dome be vaulted in two rushed years? Had Constantine's decision to build over the marshy soils of Vatican Hill caused the dome to shift and settle? Was the design for Bramante's massive piers a flawed concept from the start? Or might the earthquakes be to blame? Yet even if Benedict had these answers, he did not know whether the cracks in Michelangelo's dome were a nuisance or if they might lead to catastrophic failure. Most important, he did not have assurance on how to have them fixed.

Benedict XIV did not commit to Vanvitelli's analysis and recommendations, which may have worked at other domes in the past, though no one really knew why. He was searching instead for a more definite way to understand the damage at Michelangelo's dome and to find a permanent solution, if possible, that was premised in certainty rather than belief. It was the kind of promise offered by the latest trends in science and mathematics that his friends across the river at La Sapienza and the Arcadi might

provide. So, in his customary and inquisitive way, Benedict XIV asked for their help, though he did not know where it might lead.

*

A few days later, three young and talented scholars—and mathematicians by reputation—were ushered into St. Peter's Basilica. Vanvitelli was there as a guide, along with his colleague Nicola Salvi and his professional rival, Ferdinando Fuga.[52] Studying the dome that day, the architects (who had more than sixty years of collective construction experience between them) must have skeptically asked the scholars (who had almost none) how their exotic expertise in mathematics might stop the cracks and keep the magnificent structure intact. It was a ridiculous and almost absurd question since this kind of problem, and with such high stakes, had never been solved in this way. Yet, and seemingly without hesitation, the mathematicians accepted the challenge.

5

MATTEMATICA AND *SCIENZA*

R oger Joseph Boscovich, François Jacquier, and Thomas Le Seur may have been mathematicians, but *mattematica* in those times meant far more than a nimble facility with numbers and arithmetic calculations. It was a field that was richly inter-twined with burgeoning areas of discovery like astronomy, hydrau-lics, mechanics, and physics, in which these three had excelled and were well-respected. Paradoxically, they were ordained priests, too, which cut against the superficial narrative that the Roman Catholic Church was opposed to scientific inquiry. Boscovich, Jacquier, and Le Seur were part of an innovative, broad-minded, and fast-changing tapestry that had come to define the scientific community for the last two hundred years and that had dramatically changed the world. They, like their colleagues before them, were shaping a host of new concepts that bewildered the common person, and were inventing a growing language of words and phrases to express their novel ideas, such as *statics, dynamics, elastic behavior, force vectors, virtual work,* and *strength of materials,* to name several.

It was no coincidence that this culture of science had coincided with the Italian Renaissance. Both movements were revolutions in thought and had introduced disruption, and sometimes chaos,

into a world that was far more comfortable with convention. Just as Michelangelo had shown a new way to express the cosmos and our place within it, the Scientific Revolution had demonstrated how that same cosmos really worked. In both instances, artist and scientist had broken with tradition to reveal the natural world around them by using a systematic process to see the stars above, the streets around, and the body within. Some of these pioneers in science had become celebrities in their own time, like Leonardo da Vinci, Galileo Galilei, and Isaac Newton, but dozens were less well known and often worked in relative obscurity. Theirs was a process that was dedicated to creative thinking, objective experimentation, and a genuine curiosity about cause and effect.

Though it did not have a precise starting point, a case could be made that the Scientific Revolution began in the fifteenth century. That was when, around 1450, Leon Battista Alberti published his book in sixteen folios, *Ex Ludis Rerum Matematicarum* (Games in Mathematics, or better known in Italian as *Ludi Matematici*). The book showed how numbers, arithmetic calculations, and mathematical principles could be used to pragmatic advantage to measure all kinds of things in everyday life: distance, speed, volume, weight, and even time. Though Alberti's work was steeped in theory, he "took pains to write in a very accessible way," so that "an apt modern translation would be 'cool things you can do with mathematics.'"[1] His book also revealed a useful gadget called an *equilibra*, and it foreshadowed the coming obsession with new branches of discovery that relied on mathematics to predict how objects move, accelerate, slow down, and remain in balance on Earth and in outer space.

This fascination with equilibrium and balance became a recurring theme of the Scientific Revolution. The idea began to crystallize in the 1500s through the creative insights of Leonardo da Vinci. He was a restless and brilliant inventor who, having read

Alberti's books on mathematics, had developed a deep curiosity about geometry, among dozens of other topics. It led to his famous experiments with ropes and weights that defined for the first time "the essence of force," which he described in his customary, lyrical way as a "spiritual virtue of invisible power."[2] But da Vinci was a supremely talented artist, too, who often worked by creative impulse rather than the disciplined and methodical regimen followed by most scientists. Nevertheless, he observed and then correctly concluded that a force consisted of two primary ingredients: it had a certain size (or magnitude), and it had a direction, and that when taken together, these ingredients combined to form a force vector.

Around the same time, Simon Stevin was investigating this same notion in the Netherlands. He was a merchant-turned-mathematician whose tinkering with weights and strings—like da Vinci—had led to a new theory about the composition of forces. Stevin then took it one step further and revolutionized the concept by representing da Vinci's force vector in brilliant pictorial form: as a straight line that moved with a directional arrow and whose length was proportionate to its magnitude. His methodical and exhaustive research was published in five volumes titled *Tomus Quartus Mathematicorum Hypomne-matum de Statica*, which for the first time identified this fledgling science, known as statics. Though it became the foundational basis that would inspire so many new ideas in the decades ahead, Stevin's early contributions remained less well-known since "his ideas were originally written in Dutch and thus read by few."[3]

No one personified this intense surge in scientific discovery more than Galileo Galilei. He was a towering personality of

physics and astronomy who, like da Vinci, defined his era and impressed Europe with his pure intellect, probing curiosity, new discoveries, and conviction to personal principles. Born in Pisa in February 1564 (three days before Michelangelo's death), Galileo was as titanic a figure to the culture of science as that artist had been to the art of the Renaissance. Neither were modest about their capabilities "and always sought recognition for [their] work," though Galileo seemed more empathetic and tolerant toward his students than Michelangelo was with his clients.[4] Galileo's first post was at the University of Pisa, which at the time was "something of an intellectual backwater."[5] Three years later, at age twenty-eight, Galileo got a better paying job at the University of Padua, the leading European institute of science, where he taught astronomy, mathematics, and physics. While there, he "became gradually convinced of the truth of the new 'world system'" first proposed by the Polish polymath Nicolaus Copernicus, who had studied at the University of Padua about ninety years earlier and had shockingly positioned the sun—and not the earth—at the center of the universe.[6] This notion had challenged traditional Biblical thought and was considered pure heresy at the time; since it was not warmly welcomed by the church, Galileo kept his beliefs private—at least for the moment. Yet it became a gateway to his breathtaking research in astronomy, with telescopes he invented to reveal "mountains on the moon, numerous stars invisible to the naked eye, the nature of the Milky Way and four of Jupiter's four satellites."[7] Galileo's findings were published in 1610 as *Sidereus Nuncius* (The Starry Messenger), which made him famous in Europe. Now forty-four years old, it was no coincidence when Galileo resigned his teaching chairs at the University of Padua and their modest salaries that same year to become a well-paid consultant and "personal Philosopher and

Mathematician" to the court of Cosimo de' Medici, Grand Duke of Tuscany, in Florence. [8]

As Galileo aged, he grew more intrepid in expressing his controversial views about a heliocentric universe. This put him on a direct and inevitable path of collision with the Roman Catholic Church, which crashed in 1633 when his next book was published. *Dialogue on the Two Chief World Systems, Ptolemaic and Copernican* gave Galileo's enemies the ammunition and opportunity for which they had been waiting to pounce. At sixty-seven and in failing health, Galileo was summoned to Rome, imprisoned, threatened with torture, tried, and convicted five months later for the suspicion of heresy. Adding insult to injury, his sentence was pronounced by Urban VIII, a friend who had formerly supported Galileo's scientific achievements when he was known as Cardinal Barberini, before he became pope. The verdict was thick with irony, too, since Galileo had always been "extremely religious not only by education but also because in the life of all creatures . . . he saw signs of a Supreme Will and Power." [9] William Shakespeare could not have crafted a more compelling tragedy, and the episode sparked a vicious backlash against the church that reverberates to this day. [10]

Now under house arrest, Galilei battled on in his research but slowly withered and grew blind. Yet the lion of his age held on long enough under the consoling care of his eldest daughter, Virginia, to publish in 1638 *Discourses on Two New Sciences*. [11] His final book reinforced the principles of force that had been first developed by da Vinci and Stevin, which Galilei then applied to moving objects. This launched an entirely new branch of science known as dynamics and introduced the ideas of gravity, velocity, and projectile motion that would shape the career of Isaac Newton in the coming generation.

There was more. His *Discourses on Two New Sciences* contained another imaginative stroke that Galileo called "the theory of the strength of materials."[12] For this, he used experimental statics to measure the amount of pressure that a timber plank could resist before it collapsed, and it made him a pioneer in his thinking about the intrinsic strength possessed by an object (oak, in this instance) and how it could be expressed. Since every object—timber, brick, stone—had differing characteristics in strength, they would therefore react differently when placed under stress, and Galileo was the first to recognize that mathematics might be a useful way to measure and calculate these varying kinds of resistive behavior, at least in theory.

No one knew it yet, but this was a profound idea. It would take another hundred years before some other, far-thinking scientific pioneers thought to test Galileo's theory in the everyday world, while trying to prevent a catastrophe under Michelangelo's dome.

Galileo's persistence and tenacity demonstrated how the Scientific Revolution had challenged and threatened conventional thought. His ideas had raised uncomfortable questions about traditional religious teachings that "perplexed and angered Catholic, Protestant, and Jewish theologians by seeming to reduce the standing of mankind."[13] This sentiment was aptly expressed by John Donne, too, an English poet who wrote in 1612 that "the new philosophy [of science] calls all in doubt."[14] Even Martin Luther—who was no stranger to controversy and had himself upset the established order of things when he launched the Reformation—"said of Copernicus" and his fledging theories that "this fool wants to turn the whole of astronomy upside down."[15]

Luther had been right, of course: these were upside-down times and European society was quickly changing. This was largely due to an emerging and expanding network of newsletters and periodicals written in a variety of languages that, by 1660, were binding the continent into a more collaborative community. Together, they forged a collective and international republic of like-minded individuals, groups, and associations that shared information and then engaged in vigorous discussion about it. This new circle of knowledge became the incubator for "meetings, lectures, visits by traveling scholars, correspondence, book purchases, personal libraries, and public experiments" within Great Britain and the rest of Europe.[16] Politicians soon learned that these discoveries could be leveraged to suit their own interests and the public was fascinated by them, too, particularly among the better-educated, and especially in England. Scientific academies formed in response, the first being the Royal Society of London for Improving Natural Knowledge, founded in 1660. Six years later, the Académie Royale des Sciences was established in Paris, though its early days seemed to place a higher emphasis on the gastronomic arts than scientific achievement, as noted by one of its members who "complained that too much time was wasted at the fancy dinners that preceded scholarly discussion."[17]

A similar center of scientific thought was founded in Italy around 1690 and had become known by 1711 as the Accademia delle Scienze dell'Istituto di Bologna. What differentiated the Istituto was its progressive attitude toward women for those times (as mirrored in the Pontificia Accademia degli Arcadi, to which Prospero Lorenzo Lambertini and Luigi Vanvitelli both belonged). The Istituto, for example, had recognized Laura Bassi, the physicist and Bolognese prodigy, with a membership in 1732 at a time when women were routinely excluded from such organizations. Bassi at

twenty-one years old was maybe the first woman to earn a doctorate degree in science, which was more remarkable since women were often discouraged from attending university lectures and restricted from using their laboratories.[18] She had been privately tutored as a teenager, instead, and after presenting "her disputation in natural philosophy so successfully . . . was given the degree of laureate at a solemn ceremony . . . crowned with a wreath of delicately wrought silver laurel leaves, and addressed in Latin oration, to which she made a suitable Latin reply."[19] Her brilliance was so apparent and impressive that a few weeks later Cardinal Lambertini "went to call on her at home [in Bologna] . . . and to urge her to continue her studies, as indeed she did."[20] Here, Lambertini—the future Pope Benedict XIV—showed his customary inclination to break the rules and cast aside societal convention by promoting Bassi, based on merit, along with other women, like Maria Gaetana Agnesi and Anna Morandi. They each went on to distinguished scientific careers in teaching and advanced research at the University of Bologna and sought in the coming years to "establish equal rights and duties with male colleagues" within their respective departments of physics, mathematics, and anatomy.[21]

Despite these long odds, other women made their mark within the scientific community, too. Margaret Cavendish was one of them, and as an early author of science fiction in England, she established many protocols for research and experimentation within the scientific community. She also became the first woman to attend meetings at the Royal Society of London and to participate in serious-minded discussions there. Others furthered the advancement of astronomy, mathematics, and physics, such as Maria Cunitz (in Silesia, Poland), Émilie du Châtelet (in France), and Maria Angela Ardinghelli (in Naples). But gender equality did not come quickly across the continent and was discouragingly

stagnant in England, where the Royal Society of London did not offer memberships to women until 1945.[22]

<center>⁂</center>

Today, many universities proudly promote their departments of science, along with the distinguished faculty and accomplishments in research that accompany them. Consequently, it is difficult for us to imagine the dilemma they faced during the Scientific Revolution. By the 1660s, there were about seventy-three of them in Europe, at places like Heidelberg University, the University of Montpelier, Oxford University, the University of Paris (the Sorbonne), the University of Pisa, Charles University in Prague, the University of Salamanca, and the University of Vienna, with the oldest being the University of Bologna, the hometown of Pope Benedict XIV. They were established because their sponsoring governments "believed that society would benefit from university learning, and because Europeans thirsted for knowledge."[23]

For centuries, these institutions had considered themselves as the guardians of tradition, the gateways to civilization, and the repositories of critical thought—be it in the law, literature, mathematics, medicine, philosophy, rhetoric, or theology. They demonstrated a degree of innovation in research and teaching practice, but that was often directed toward medical and anatomical studies, for which the Italian universities were the leaders and most well-known. At the University of Bologna, and particularly at the University of Padua, their operational structure tended to be less hierarchical and more flexible and featured less bureaucratic meddling. This, in turn, created a more autonomous environment for students, scholars, and faculty like Copernicus and Galileo to generate new research and then teach their "upside-down"

ideas—like a heliocentric universe.[24] But while these unproven, controversial, and possibly heretical theories might have passed muster at a place like the University of Padua, they gave rise to a growing tension at those many other universities that placed a more traditional emphasis on the arts and theology. These institutions grappled with whether to teach the new sciences and legitimize their novel points of view.

This began to slowly change in the 1680s, however, when one college in England took the bold step to sponsor a professor who had developed an entirely new way to explain "the system of the world."[25]

Of the most seminal discoveries made during the Scientific Revolution, none were more extraordinary and far-reaching than those published in July 1687 in *Philosophiae Naturalis Principia Mathematica* (*The Mathematical Principles of Natural Philosophy*).[26] Its prolific ideas were conceived in just two years but had taken another twenty to incubate and hatch, as authored by Isaac Newton, who was then forty-five years old and a professor of mathematics at Trinity College, Cambridge. Newton was born in 1642 and was not expected to survive his premature birth. He then overcame a "lonely and loveless" childhood and an undistinguished record as a student to improbably launch a path-breaking collection of theories that postulated how the Earth and stars moved through celestial space.[27] Curiously, Newton had been named as a professor many years before, in 1670, though his reclusive temperament was not well-suited to teaching, and which likely explained why "he continued talking to an empty room throughout almost every lecture he gave for the next seventeen years."[28]

Though he may have taken little interest in his students, Newton was nevertheless driven by many other pursuits. Astronomy and optics were among them, which led him to invent the reflecting telescope in the 1670s and brought instant notoriety from the Royal Society of London. His career took a fateful turn in the summer of 1684 when noted astronomer Edmond Halley paid a visit to Trinity College to convince Newton that he write a short paper—known as *De Motu Corporum in Gyrum* (On the Motion of Bodies in an Orbit)—to answer a then-puzzling question about planetary movement. Once he started to put thoughts to paper, "Newton could not restrain the creative force of his genius, and the end product was the *Principia*."[29] His manuscript took twenty-four months to produce and became a definitive treatise of phenomenon, propositions, rules, and theorems that had synthesized his preceding twenty years of scientific research and reflections. Newton organized his thoughts and presented them to the Royal Society of London in 1686, which Halley financed for publication in London the following year. Because Newton's book had introduced so many new and revolutionary ideas, and had presented them such a voluminous way, it was understandable that his peers needed time to read, absorb, and interpret their import. But once the utility of these far-reaching concepts became recognized and embraced, the opus brought Newton sensational celebrity, and his many acolytes began to call themselves Newtonians.

The *Principia* was written in Latin, the international language of scholars, and presented in three volumes: volumes 1 and 2 addressed *The Motion of Bodies* and volume 3 was alluringly titled as *The System of the World*. Taken together, the *Principia* addressed what Newton called the laws of nature on Earth and the laws of celestial mechanics in outer space, and then demonstrated through dozens of postulations that these laws followed an astonishing

pattern of reliable rules of mathematics.[30] His three best-known became the law of inertia (a body at rest stays at rest, and a body in motion stays in motion), the law of momentum (force equals mass times acceleration), and the law of conservation (for every action there is an equal and opposite reaction). Under this framework, Newton confidently defined our current notion of force and how it could be arithmetically calculated. He then showed how these forces could interact and combine with one other as they pushed and pulled their way across the universe. This had never been done before and it explained so much about earthly and planetary behavior that had been previously shrouded in mystery.

Newton's *Principia* was a masterwork in science that was comparable in every way to the literary achievements of *The Iliad* by Homer, *The Divine Comedy* by Dante Alighieri, and *Hamlet* by William Shakespeare. Moreover, its revolutionary way of thinking about the cosmos had required an even-handed application of theoretical analytics, empirical observation, and experimentation in the laboratory, which we now recognize as the bedrock of modern scientific technique. But six years after it was published, Newton suffered a severe bout of depression and upon recovery never regained his former footing; though he assumed other roles in business and government, his days in mathematics were largely over. Nonetheless, his reputation had been safely sealed by now, and he was knighted by Queen Anne in 1705, two years after his election as president of the Royal Society of London, a position Newton retained for the rest of his life. When he died in 1727 at age eighty-five, his titanic status became evident by a state funeral and then the honor as the first scientist to be buried inside Westminster Abbey. Tribute followed tribute, with none more eloquent than the one posed by Pierre-Simon Laplace, the French astronomer and mathematician of enormous

achievement, who noted a century later that "the *Principia* is pre-eminent above any other production of the human genius."[31] Laplace was uniquely qualified to make this assessment, since he leaned heavily on Newton's work to gain expansive insights of his own about the origins of our solar system, and was among the first to recognize the existence of black holes.

In sum, the *Principia* became the basis for an entirely new science known as "Newtonian physics," and it soon spread like a wildfire through dry brush.

⁂

While Newton was at Cambridge University at the onset of his brilliant career, a different kind of blaze swept through the heart of London. It had started along the River Thames' north bank at a bakery on Pudding Lane, and for ten days in September 1666 the fire proceeded to hollow out the city's ancient core, including its most prominent church, Old St. Paul's Cathedral. In all, the Great Fire of London burned through hundreds of acres and destroyed thousands of structures trapped in its path. As bad as things got, though, they could have been worse, since the flames had been headed toward Westminster Abbey and the king's court at Whitehall but only stopped short when the easterly winds finally faltered and allowed the fire to be contained and then extinguished.

Out of the ashes arose a new city, based on the designs of Christopher Wren, then thirty-four years old, and Robert Hooke, age thirty-one. They were members of the Royal Society of London, had been good friends while students at Oxford University, and worked tirelessly as partners to rebuild their capital. This launched Wren's meteoric career as one of Britain's most prolific architects. But less well-known was Hooke's contributions as "a figure of

extraordinary and diverse creativity" in architecture, astronomy, biology, cartography, chemistry, flying machines, geology, instrumentation, meteorology, microbiology, oceanography, physics, and more—which has since earned him the reputation as "Europe's last Renaissance man, and England's Leonardo."[32]

Hooke had been born in 1635 on the Isle of Wight and into a proud family of modest means. He was a sickly child and homeschooled as a boy, where "he was an extraordinarily quick learner, [and] possessed a manual dexterity which enabled him to build an impressive array of mechanical devices."[33] This gained him attention and the opportunity to attend Oxford University, where he met and befriended Wren. Around this time, he was also introduced to the renowned chemist Robert Boyle, who saw Hooke's potential and employed him as a laboratory assistant. This began Hooke's lifelong ascent in scientific research, which started with chemistry in 1655 and then quickly advanced to astronomy and futuristic designs for "flying chariots."[34]

Hooke was twenty-seven years old when the Royal Society of London received its charter in 1662 from King Charles II. For the next forty-one years and until the day he died, Hooke was entranced by the place and was its most vigorous and influential member. At the society he explored the wonderful world of science and tinkered to develop and improve new kinds of barometers, thermometers, telescopes, and theories on the earth's origins. Hooke's curiosity was quite broad, and he "devised so many experiments, invented so many instruments, discoursed on so many ideas and hypotheses that one marvels at how a single person could have accomplished so much in one lifetime."[35] Like Newton, he also ventured into celestial mechanics and the concepts of gravitation, force, and motion that had obsessed so many and that were so central during the Scientific Revolution.

In the aftermath of the Great Fire of London—and six years after the Royal Society of London's founding—Hooke had become such a prominent citizen that he was among the first to whom the city turned while it was still in shock. He had a knack for solving problems and was a skilled draftsman, and he used both to partner with Wren, whom the king had commissioned to rebuild the city and its infrastructure. The pair was consumed by the work and made a lot of money doing it, though often with little or no sleep and while "madly dashing around the city on foot . . . seeing to the building of this or that structure or laying out the boundaries of public and private property."[36] They had split the effort so that Wren would design the most prominent landmarks and churches, like St. Paul's Cathedral, while Hooke "was in charge of many public works" of less distinction, like wharfs and bridges, many of which were subsequently demolished or replaced over the years (or were bombed out during the Blitz). Understandably, Wren's imprint on present-day London therefore remains stronger than Hooke's. Nevertheless, and for the next fifteen years, Wren commonly asked Hooke for technical guidance and "it is now clear that more than a few structures constructed . . . were designed and executed by Hooke but were attributed to Wren."[37]

This was notably illustrated by Hooke's role during the reconstruction of St. Paul's Cathedral between 1672 and 1680. Wren had fashioned its new dome after Michelangelo's design at St. Peter's Basilica, and here Hooke ingeniously visualized an efficient way to overcome and resist the new dome's thrusting force by having its silhouette of stone and mortar follow the contours of a geometric pattern that resembled an upside-down parabola, or inverted catenary curve.[38] Wren immediately saw the elegance of Hooke's idea—which is also known as a force polygon—and relied on his friend's advice to vault the dome at St. Paul's. But what neither

Wren nor Hooke could have predicted was its import seventy years later, when Giovanni Poleni, then the most respected scientist and physicist in Italy, borrowed that same concept—without attribution—in his effort to save Michelangelo's dome.

Of Hooke's many other ideas, projects, and experiments, perhaps his most prolific was the one he had as a young man out of Oxford, which he formalized eighteen years later, in 1678. This was when he became the first to articulate the phenomenon of elasticity (or, as he also called it, "springiness"), by famously observing that any object, be it "metals, wood, stone, silk, bones, [or] glass" will stretch and compress when a force is applied to it, and that the amount of its deformation is proportionate to the size of that force.[39] In other words, he had just pioneered the way to calculate the amount (or magnitude) of a force by measuring the distance it had moved while under stress. What seems so simple and intuitive to us today had been elusive and puzzling to many early scientists, and this principle, known as Hooke's law, has been a staple of modern physics since he first proved its existence.

By the 1690s, Hooke's tireless work ethic, lack of sleep, and fragile constitution had caught up with him and had worn him down. He became "plagued with more headaches, stomachaches, dizziness, fainting spells, and colds. Yet he habitually stayed up late reading or working."[40] His legs became swollen and were in persistent pain, and over time he became blind, too. Though Hooke died in 1703, little recognized or rewarded (and with no portrait), he was among the towering, most expansive, and most versatile scientists in history; more than any other, Hooke had envisioned a way to apply scientific theory beyond the laboratory and use it to solve pragmatic problems that were encountered in the everyday world. It was a novel philosophy that would continue

to gain traction in the decades ahead and most visibly take root at Michelangelo's dome in the autumn of 1742.

⁂

Hooke had been fascinated by geology since he was a boy, and was among the world's first ecologists, writing in 1668 "that the Earth we inhabit and everything about it, its air, its water, its land, and all species of life, should concern us as humans. It behooves us therefore to know as much about the nature of things on Earth as possible."[41] This extended to his curiosity about the origin of fossils, rocks, and minerals, as well as tectonic movement, volcanic eruptions, and earthquakes. These interests consumed him for more than thirty years, between 1668 and 1699, when he delivered dozens of lectures and wrote many "discourses" on the theories of "Earthquakes and Subterraneous Eruptions."[42] Accordingly, there was a certain symmetry that linked Hooke's passing in 1703 to the apparent rise of seismicity in central Italy during the first half of the eighteenth century. The ground shaking caused by these earthquakes, in combination with any latent defects in construction, could have plausibly caused the cracks inside Michelangelo's dome to grow, worsen, and become more visible by the summer of 1742.

It is noteworthy that these same forty years brought a fresh batch of scientific discoveries, which reflected the true international character of the times. Gottfried Wilhelm Leibniz, for instance, was a German mathematician who—concurrent with, and independent of, Isaac Newton—invented calculus in the 1670s as an entirely new and versatile form of mathematics that could mirror the rhythms of motion.[43] It "engaged the imagination" and made mathematics "during the eighteenth century, the principal branch

of science which could not be ignored by any educated person."[44] Leibniz was a member of the Royal Society of London and also worked tirelessly to found the Royal Prussian Academy of Sciences where he served for sixteen years as its first president, until he died in 1716.

A year later the Swiss-born mathematician Johann Bernoulli, a former student of Leibniz, famously crystallized a concept known as the principle of virtual displacements. Bernoulli's idea was another in the long and elusive search to define and then arithmetically calculate the magnitude of a force—in this case, by measuring the amount of hypothetical effort that it took to move an object from point A to point B. In the meanwhile, the French mathematician and member of the Académie Royale des Sciences, Philippe de la Hire, had been inspired by his native country's magnificent traditions in medieval construction. De la Hire became "the first physicist to investigate the equilibrium of a [masonry] vault as a mathematical problem of statics," from which he explained why buildings and domes collapsed from time to time.[45] His research relied on the same composition of forces first thought up by Galileo and then advanced by Newton, and also corresponded with current work under way in the Netherlands, where in the 1720s Pieter van Musschenbroek was gathering various materials—such as timber, metal, and rope—and then testing them to predict their strength when subjected to different kinds of forces. Like Newton and Hooke, Van Musschenbroek was searching for a set of scientific rules that would explain the way the world worked, and his pioneering research with the "coherence of solid bodies" made him the founder of what we now call material science.[46]

Taken together, these many concepts represented the long arc of scientific thought and mathematic innovation within Europe at the moment when Luigi Vanvitelli, as architect of St. Peter's Basilica, noted the troubling cracks in Michelangelo's dome. It had been a relentless pace of discovery, starting with Alberti in the 1450s and then linking the greatest minds, the biggest ideas, and the most famous names—da Vinci, Galileo, Leibniz, and Newton—along with others who were less well-known, like Hooke and Stevin. By every measure, the three mathematicians that met with Vanvitelli under Michelangelo's dome in September 1742—Roger Joseph Boscovich, François Jacquier, and Thomas Le Seur—were as knowledgeable as any in Rome (and in Italy) about these new theories in calculus, statics, equilibrium, mechanics, virtual work, and material science. They had studied Bernoulli and de la Hire and were aware of Van Musschenbroek's experimental tests, too. More than that, they were leading Newtonians and had been steeped in the *Principia*, its *Laws of Nature*, and its notion of force. Yet they also knew that these ideas had been incubated in the controlled conditions of a laboratory, or a library, or the refined air of a scientific society. In other words, the concepts had been divined "without thinking of their practical application, least of all in the sphere of building construction," and none had been used to solve a problem as uniquely complicated as the gaping cracks inside the largest dome and at the most famous church in the world.[47] Fixing these cracks would be an uphill challenge against high stakes, and with no guarantees of success; yet in the brave and innovative spirit that personified the age, these three mathematicians had begun to envision what others could not.

They were determined to marry mathematics and scientific theory with the everyday world to save Michelangelo's dome.

6

THE OPINIONS

Michelangelo's dome was a simple design made from three, core ingredients: a pedestal, the double shell, and a crowning lantern. The pedestal was formed, in turn, from two components—a drum and an attic—which were largely installed before Michelangelo's death in 1564 but had sat dormant and open to the elements for another twenty-five lonely years above Rome's ancient hills, waiting for the money and know-how to finish the job. It was an impressive start, nonetheless, and these cylindrical walls of mortared brick and block now stood ten feet thick and some eight stories tall. Then, and with intuition as his guide, Michelangelo had had them buttressed by an impressive ring of stone columns and wing walls around the circumference as a muscular and pragmatic way (or so he thought) to resist the future dome's thrusting force, however large it turned out to be.

When Pope Sixtus V commissioned Giacomo della Porta to vault the dome and its double shell some thirty years later, in 1588, he stipulated that Michelangelo's hemispheric design be preserved in toto. But the harsh realities of construction and of gravity compelled Della Porta—again by intuition—to reduce the

dome's thrust, which meant a change to the outer shell's shape into a more elliptical and forgiving silhouette. After gaining the pope's explicit consent, Della Porta assembled an elaborate production of timber scaffolds and falsework at the top of the attic from where he launched his thirty-two tapered skeletal ribs toward the sky.[1] This colossal frame climbed another nine stories, was 150 feet across, and grew to seventeen feet thick in spots. To secure its stability and prevent its collapse during construction, the open webs between each rib were mortared together with layered severies of stone and brick that were up to ten feet deep.[2] The process would have been delicate and dangerous under any circumstance, let alone the aggressive and arguably reckless schedule imposed by Sixtus V, but it was further complicated by the cast iron chains that had to be wrapped around the outer shell's circumference to keep the dome's thrusting force at bay.[3] With the shells and the chains in place, Della Porta then lined the dome's outer face with sheets of lead and bronze to shield it from the weather.[4] Next, the inside shell was slathered with mosaics and frescos, which took some thirteen years to decorate, using a novel and ingenious kind of timber scaffold that hovered high above the church floor and burrowed into the dome's inner face in the same way that a mountaineer clings onto a sheer granite cliff.[5]

Michelangelo's dome was finished in 1593, when it was crowned by a cylindrical lantern made from stone.[6] Now fully assembled, it stood among the most daring structures in the world and was about as tall as the Great Pyramid of Giza, standing some 450 feet above the streets of Vatican Hill. The dome alone (without its pedestal) was made from sixty-one million pounds of masonry, while the lantern was made from another five.[7] For perspective, this was like stacking eighteen thousand cars neatly within a footprint of two square city blocks, and then gingerly hoisting them into position

some thirty stories above the streets. By any standard, Della Porta and his deputy, Domenico Fontana, deserved enormous credit for pulling off such a perilous achievement in just five years and without the benefit of modern machinery and equipment.

However, their ingenuity and tenacity could not contain the dome's thrusting force, nor keep the cracks away. So when Luigi Vanvitelli presented his troubling report to the pope in September 1742, he had likely anticipated that a counsel of architects and builders would convene soon after to figure out what might be done. But Pope Benedict XIV confounded them all when he instead sought guidance and advice from three mathematicians—of all people—who had little personal experience with construction and knew nothing about how domes were designed.

⊗

They may have been "largely Italian both by culture and career," but Italy was not their native home, after all. [8] Roger Joseph Boscovich was born in 1711 and raised in the Republic of Ragusa (now Dubrovnik), the eighth of nine children and the youngest of six boys. His family called him "Ruge" and his father, Nicolas, was a prosperous merchant who died when Ruge was ten years old. His mother, Pavica—or, more affectionately, "Pava"—came from a cultivated family with roots in Bergamo. She was "a robust and active woman with a happy temperament," which may explain how she bore nine children, ran a bustling household, and lived to be 103 years old. [9]

Ragusa was in the land of Illyria and had for centuries been a lucrative trading post in a strategic corner of the world. It was a cultured and sophisticated place, too, and the early education for the Boscovich children included a heavy dose of language and

literature. Young Ruge attended a local school run by the Jesuit order, where he excelled in Latin and Greek and "gained a reputation . . . for having an easy memory and a quick, deep mind."[10] The Jesuits were a popular and powerful flock within the Roman Catholic Church who were known for their rigid views of the faith that did not leave much room for differing points of view; yet, while their schools and classrooms may have been strict, the Jesuits were also well-known for their high caliber of instruction.[11]

Ragusa was not a college town, so it was common for families to send their sons abroad to prestigious places like the University of Bologna, the University of Padua, or La Sapienza in Rome for an advanced education. Boscovich did the same, having shown such bright academic promise that "he left his family and friends and native town . . . to travel across the Adriatic to the Papal States" when just fourteen.[12] He arrived at Ancona, the vital papal port on the Adriatic, in September 1725 and rode by carriage to Rome to enroll at the prestigious Collegium Romanum—again run by the Jesuits, and also known as the Gregorian University—which offered a broad curriculum in religious studies, the humanities, language, mathematics, and some science, like physics.[13] The campus overlooked the Piazza del Popolo, not far from the Vatican, and had been founded in 1551, when Michelangelo was *capomaestro* at St. Peter's Basilica.[14]

Boscovich studied hard at the Collegium Romanum while preparing for a career as a priest and following the footsteps of his oldest brother. Once his basic coursework was finished at age nineteen, Boscovich was introduced by Father Horatius Borgondi to the world of astronomy and mathematics. Borgondi was impressed by his young student's "absorption of arithmetic and algebra . . . and by his industry," and though Boscovich had a growing interest in other areas, too, like poetry and archaeology, he more often

"applied himself feverishly to studying the new world he had discovered in the works of Newton."[15] This "new world" became a nurturing influence for the young man, and Boscovich remained an avid Newtonian for the rest of his life.

During the 1730s, and as the cracks at Michelangelo's dome continued to grow, there were many opportunities for Boscovich to meet and befriend people of influence. Borgondi, for instance, was a member of the Pontificia Accademia degli Arcadi and likely encouraged and then helped his young protégé to join there, too. As an up-and-coming instructor at the Collegium Romanum, Boscovich could have readily become acquainted with Cardinal Prospero Lorenzo Lambertini and many of the future pope's other friends. One of them was Celestino Galiani, who had been "the first to promote Newtonian physics" in Rome while teaching at La Sapienza, and it is easy to imagine Galiani and Boscovich engaged at the Arcadi in deep conversation about the *Principia*.[16]

While at the Arcadi, Boscovich met Cardinal Silvio Valenti Gonzaga, who was a former student of Galiani and one of Lambertini's closest friends. Gonzaga would soon become a trusted and powerful secretary of state to the future Pope Benedict XIV; by coincidence his "ancestors came from Dubrovnik and it was not long before Boscovich was invited to Sunday gatherings [at Gonzaga's] elegant country seat," which were attended by many prominent Romans of the day.[17] Luigi Vanvitelli may have been on that guest list from time to time, too, where he and Boscovich could have met and discovered their mutual interest in the budding field of archaeology.[18] More than anyone, it was Gonzaga, twenty years his senior, who took young Boscovich under his wing and became his family away from home.

Beyond this social network, Boscovich demonstrated an impressive record of academic achievement at the Collegium Romanum.

Between 1735 and 1740 he performed original research on wide-ranging topics such as sunspots, the planetary movement of Mars, trigonometry, the aurora borealis, and geodesy (which is a science that measures the size and shape of our Earth).[19] His lectures were so well-received by the scholars and scientists in Rome that Boscovich became the clear choice to chair the Collegium Romanum's department of mathematics when his mentor, Borgondi, retired from teaching in 1740.[20] That was the same year Lambertini was elected as pope, and when the new pontiff visited the Collegium Romanum shortly after his coronation as Pope Benedict XIV, "the task of planning [the papal excursion] fell to Boscovich."[21]

These social circles and professional threads—through the Arcadi, the Collegium Romanum, and mutual friendships—show how Benedict XIV and Boscovich had had many opportunities to cross paths on earlier occasions. However, "despite this access, Boscovich was not a favorite or a protégé of the pope," and Benedict XIV seemed to maintain a lingering reticence about the star mathematician who, in his eyes "had too much Jesuit tradition and pushiness about him to earn full marks."[22] But to his credit, the new pope was able to set these personal feelings aside when Vanvitelli reported his troubling news about Michelangelo's dome in September 1742, and identified the young man as a rising talent and leading Newtonian who might be able to solve his problem.

Because Boscovich rose to high prominence after 1745, it subsequently fueled a burst of interest in his scientific research and life story. By contrast, we know far less about François Jacquier and Thomas Le Seur, though it was clear Benedict XIV thought highly of both. The dearth of biography is peculiar, since Jacquier and Le

Seur—both French by birth—appeared to play a leading role in what came next under Michelangelo's dome.

Jacquier was raised in Vitry-le-François, a village halfway between Paris and Nancy, where he showed an early and nimble interest in numbers and arithmetic. (By happenstance, he and Boscovich were born just three weeks apart.)[23] Jacquier joined the Order of the Minims as a young man, and around this time his uncle—and tutor—encouraged further schooling through the Franciscans. Subsequently, in 1727, at age sixteen, Jacquier went to Rome, where he lived and studied at the order's local French convent. There, his teachers recognized Jacquier's academic acumen and linguistic skills and encouraged his concentrated study in mathematics and language, namely Hebrew and ancient Greek.

Jacquier's talent became known to Cardinal Giulio Alberoni, who was nearly fifty years his senior and a Jesuit by training. Alberoni was a good friend to Benedict XIII and Cardinal Lambertini, and enjoyed a colorful yet mixed reputation as the "son of a gardener and a dress-maker, [who was] witty, dynamic, restless, and ill-mannered, [and] a good but aggressive administrator [who was] too fond of power."[24] When Pope Clement XII made him the papal ambassador to Ravenna in 1735, Alberoni brought Jacquier along on the mission and then teamed him with Eustachio Manfredi to evaluate a few waterworks and flood prevention projects.[25] Manfredi was accomplished, respected, and very well-connected within the Papal States, as a member of the Arcadi, a longtime friend to Lambertini, former teacher to Galiani, and founder of the Accademia delle Scienze dell'Istituto di Bologna. Consequently, his endorsement of Jacquier carried a lot of weight.

Jacquier met Thomas Le Seur in the 1730s while at the Franciscan convent. Le Seur was eight years older and had been raised in Rethel—a village fifty miles north of Jacquier's hometown. He,

too, had immigrated to Rome for training as a Minim, where the two discovered their common bond and became avid Newtonians. They parlayed this mutual interest to collaborate on an ambitious project in 1739 that provided guidance and commentary to the *Principia*. Their 450-page book took three years to finish and, tellingly, was published in Protestant Geneva, beyond the reach of the Roman Catholic Church. Because of their future connection to Boscovich at Michelangelo's dome, this book became subsequently known as the "Jesuit edition" of Newton's classic, but it was and remains a misnomer, since both authors were Minims.[26]

By 1740, Jacquier and Le Seur had become familiar names to the new pope, who recognized their leading qualifications in mathematics and physics. Benedict XIV was so impressed that within a few years he helped them to secure prestigious teaching posts at La Sapienza—Jacquier as chair of its newly established department of experimental physics, and Le Seur as the chair of higher mathematics.[27] The pope was particularly fond of Jacquier, whom he saw as "an excellent and conscientious teacher" and was "very diligent in everything concerning his assignments."[28] Jacquier seemed personable and well-rounded, too, as illustrated when years later a colleague in France wrote to thank him for making an introduction to Boscovich, whom his colleague found as "one of the most amiable men that I have ever known and I cannot compare him to anyone but yourself [Jacquier] for the combination of knowledge and social qualities."[29] So, there was neither serendipity nor chance involved when Benedict XIV summoned these three mathematicians to the Vatican in September 1742. Boscovich, Jacquier, and Le Seur were personally known to him and their reputations as scholars of the highest caliber were by now well-established around Rome.

There are few written accounts that describe their first inspection of the dome. But we can reasonably infer what happened when Boscovich, Jacquier, and Le Seur looked up from the basilica's floor that September morning and into an expanse that made them look small by comparison: 150 feet in diameter, 450 feet in circumference, and 350 feet into the air. Vanvitelli was there as well, along with Nicola Salvi and Ferdinando Fuga. Since invasive testing was not done that day, the group examined only those cracks that were visible at the dome's surface, for which Vanvitelli may have brought along a spyglass to help with magnification. He probably had a few renderings of the dome to use for reference, too, as drawn by Carlo Fontana in 1694. For their part, the mathematicians seemed to have made detailed field notes and measurements as the architects walked them through the building.

When the group peered into the inner dome's mass of overhead mosaics, the first batch of cracks would have been hard to miss. They were long and sinuous, and ran parallel to the vertical ribs, tearing at the surface of the curved inner shell, or *intrados*. There were at least sixteen such lesions, and they neatly creased the midspan between each rib, in a remarkably consistent pattern of damage. Some cracks were more serpentine than others, starting at its lantern some four hundred feet above the floor and snaking in a continuous trail down the dome's entire inner lining and into the attic.[30] By analogy, these cracks followed along the longitudinal meridians of a globe that began at the North Pole and then slithered south toward the Tropic of Cancer, with some extending to the equator.

Next, the architects and mathematicians would have climbed some 220 stairs within Donato Bramante's northwest pier (also known as Saint Helen's Pier) for a closer look at these same lesions.[31] It led onto a circular viewing gallery that was about fifteen stories above the basilica's floor, from where they climbed

another 320 steps inside the dome's "unstable spiral staircases," and while on their ascent became "very concerned about the horizontal cracks" they saw between the bricks.[32] This was a different kind of damage, known as a separation crack, and it had ominously severed the structural link between the inner and outer shells at the top of the dome, and had caused the shells to dangerously tear apart.

During their tour, Vanvitelli would have likely described to the group his earlier survey of Michelangelo's dome. This had included his inspection of its underlying system of structural support—namely Bramante's piers and foundations—which had been problematic sore spots and culprits of suspicion for the last two hundred years. They had first cracked in the 1540s, at which time Antonio da Sangallo the Younger had buttressed and repaired them. They cracked again in the 1680s, after alterations made by *capomaestro* Gian Lorenzo Bernini. Vanvitelli had found problems with them, too, when his inspection revealed "cracks in two of the main [roof] arches" that tied the piers together. But he relied on his intuition, personal experience, and professional judgment to conclude that they "were of minor significance" and there was "nothing much wrong" with the dome's substructure.[33]

Having noted the interior damage, the group would have next stepped outside and onto the basilica's rooftop terrace high above St. Peter's Square to survey the dome's exterior face. The outer shell had been sheathed in lead by Della Porta, which prevented an inspection of its elliptical *extrados*. But what they could see below the dome was frightening: a web of widespread and irregular cracks—horizontal, vertical, and diagonal—fracturing the drum and attic from top to bottom. These cracks had damaged the assemblage of arches, lintels, piers, voussoirs, and abutment walls that held the dome's pedestal together, and some cracks were seventy-five feet long and "wide enough to step through."[34] One account

described that "the entire wall of the drum and the attic, together with [its] columns and buttresses, have rotated outwards, dilating the dome and lowering the lantern."[35] Such visible and disturbing sign of distress within the dome could have been triggered by earthquakes, excessive thrust, settlement in the underlying soil, weakness within Bramante's piers, or some combination thereof. But whatever their origins, a titanic amount of force had been unleashed. It had reverberated across the dome and down into the drum, where it undermined the brick and block walls there that were, on average, ten feet thick. Something was seriously wrong, and this was a disaster lying in wait.

How such a perilous condition could have been overlooked before 1742 has not yet been explained. It is possible that the cracks were fresh, perhaps from a recent jolt by a sudden earthquake, but this is unlikely since no records suggest such a powerful seismic event in Rome around that time. Rather, it is more probable that a web-like network of cracks had opened but were ignored, given their perplexing presence and the immense headache they posed for the La Fabbrica di San Pietro in Vaticano and for previous popes to fix. Even so, it is puzzling that no one had thought to report such obvious patterns of structural damage before now. More troubling was the ominous likelihood that many more cracks still lingered within the dome than were visible at its surface, meaning that the damage might run far deeper than anyone's current suspicion.

❧

Had these alarming conditions been discovered today, the basilica would have been immediately cordoned for emergency evaluation and then indefinitely closed for repair. Instead, Vanvitelli, as *capo-maestro* and a leading authority for design and construction at the

Vatican, did not view the dome's stability as an urgent concern. While these cracks were a problem, the architect believed they could be fixed with a tried-and-true technique, though he had no basis beyond his own intuition to stake this point of view.[36] But Vanvitelli was wrong, and so were the others who thought like him. This is because there is nothing simple about a dome. The way that it absorbs and distributes its thrusting force is tricky to predict, even under the most straightforward conditions. Then there are the quirks of construction to consider, and the peculiarities in means, methods, and materials that can make a dome's behavior an even bigger challenge to understand.

When made from a monolithic material—like concrete at the Pantheon—a dome tends to perform in a more predictable way, since the concrete (in this instance) is uniform in its chemistry, composition, and strength characteristics. But when it is built as a composite structure—made of many materials like brick, stone, and iron as at St. Peter's Basilica—its behavior becomes far more difficult to anticipate. This is because each material has its own, distinctive set of physical and chemical properties that are then locked into the mortar as it glues them together into a single unit. To complicate things, the way that the brick, stone, and iron are patterned, along with the quality of workmanship in their assembly, affects how the dome absorbs and distributes its thrusting force. For example, an efficient geometric arrangement that is installed under careful conditions will perform, logically, in a more durable way. Even the most advanced techniques in design and construction, however, cannot prevent the inevitable and keep the mortar from drying out and weakening, which explains the minor cosmetic cracks that commonly appear even in the best-built masonry years after construction.[37]

A dome that is thoughtfully designed and carefully installed will tend to behave as a compressive structure, with most of its

forces pressing inward and down. Brick, stone, and mortar can absorb huge amounts of punishing compression, which is why they are so often used as archways, columns, and foundations. But these same materials have very low tensile capacities—which is why they are avoided as roof beams or bridge girders—and readily crack when forces make them bend, flex, and stretch. Thrust makes for a special challenge, since it manufactures a force vector that combines inward compression (along the dome's curvature) in tandem with an outward, tensile "kick" (at its base). So long as the dome's inherent strength can outlast its thrust, the system remains stable and can "bounce back" from the stress. Under these conditions, the dome's behavior is easier to predict because the system stays elastic and determinant. But there is trouble afoot when a dome's thrusting force exceeds its strength. Once this happens, the dome's balance is thrown off and its "springiness" (as Hooke would say) is permanently impaired. The system becomes inelastic and goes into a plastic state which, in turn, will cause the dome to rupture and crack. This kind of damage "brings about a profound change in the dome's statics," which, now compromised, makes its behavior far more indeterminate and difficult to predict.[38] It is a formidable enough challenge to repair a monolithic dome once it enters the plastic state, but, when a composite assembly like Michelangelo's dome "goes plastic"—which is precisely what Boscovich, Jacquier, and Le Seur observed on their site tour with Vanvitelli—the options become more elusive and maybe unsolvable.

This conundrum was why hooping rods made of iron were embedded into domed structures, like at the Hagia Sophia in Istanbul, Basilica di San Marco in Venice, the Basilica of Madonna dell'Umiltà in Pistoia, and Torre degli Asinelli in Bologna.[39] The practice evolved from the intuitive insight that iron, like many metals, has far more tensile strength than stone. These horizontal

rods were ingeniously installed to absorb the tension introduced by a dome's thrusting force, which kept the dome out of its dreaded plastic state and thereby prevented ruptures and cracks from forming. They were used inside Michelangelo's dome, too, by Della Porta in the 1580s, when he encased three hooping rods in the 1580s to maintain equilibrium and soak up the tensile force that the dome's brick, stone, and mortar could not.[40] But the ominous number of cracks, and their alarming size, were clear signs that the strategy had not worked.

Today, we have an increased understanding of domes and how to design and build them. Our advanced techniques in finite element analysis, for example, provide much improved, but still imperfect, precision when solving for inelastic conditions and indeterminate structures. We have also invented superior machinery, like long-span cranes and slip forms, to expedite the delicate process of assembly, along with heightened quality control to assure consistency in the workmanship of construction. But none of these tools were available to Michelangelo, Della Porta, or Vanvitelli when they designed, built, and assessed the dome at St. Peter's Basilica. Neither would they have known how to measure its thrust nor the strength of the brick, stone, mortar, and iron holding it in place. Though they may have held an intuitive grasp of how these materials behaved when placed into tension, torsion, shear, and compression, none could explain elastic and plastic behavior, or determinant and indeterminate structures, or why these things even mattered.

❧

This was the environment into which Boscovich, Jacquier, and Le Seur had stepped and now found themselves working. They knew that Michelangelo's dome had been tricky to design and build but

had not likely recognized its enormity until their "two on-site-visits with architects and building experts . . . in September and October 1742."[41] Further, they likely did not command much respect from the seasoned architects and builders around them, including Vanvitelli, since their qualifications with construction were meager and did not extend beyond Jacquier's brief experience with flood control from years earlier in Ravenna. Their youth was not an advantage, either, since all were in their thirties and faced a sea of potential critics who were many years older and were skeptical of any modern ideas these mathematicians might propose.

But Boscovich, Jacquier, and Le Seur did have a few factors working in their favor. They were nimble and accustomed to thinking about the most complicated problems in mechanics and astronomy, for example, and in a creative way that would have bewildered the average person of the day. They were well trained, too, and as leading proponents of the *Principia*, were visionaries who saw what others could not: scientific theory as a pragmatic tool for solving problems in the everyday world.

❧

The mathematicians presented their report to the pope just three months later, on January 8, 1743.[42] Interestingly, it was printed in Italian and not Latin, on thirty-six pages of densely arranged text and with an attached, oversized drawing that showed the crack-covered dome. Their pamphlet was titled *Parere di Tre Mattematici Sopra i Danni, Che si Sono Trovati nella Cupola di S. Pietro, Sul Fine dell'Anno MDCCXLII. Dato per Ordine di Nostro Signore Papa Beneddeto XIV* (The Opinions of Three Mathematicians Concerning the Damage That was Found in the Dome of St. Peter's, at the End of Year 1742. At the Instruction of Pope Benedict XIV).

In shorthand, it became known as *Parere* (The Opinions) and was broadly organized into five parts: an introduction, a detailed survey of the cracks, a root cause analysis to identify the reasons for crack formation, an assessment—using current scientific theory—of the dome's demise, and recommendations for repair. One of the report's many notable features was its signature page and byline, which named Le Seur and Jacquier as the lead authors:

> *Tommaso Le Seur dell'Ordine de' Minimi*
> *Professore di Mattematica.*
> *Francesco Jacquier dell'Ordine de' Minimi*
> *Professore di Mattematica.*
> *Ruggiero Giuseppe Boscovich della Comp[agnia] di Gesu*
> *Professore di Mattematica in Colleg[ium] Rom[anum].* [43]

This was a rare occasion for Boscovich, who published dozens of papers over the long arc of his storied, scientific career, and it telegraphed an acknowledgment of, and deference to, the progressive ideas initiated by his colleagues. [44]

From its start, their report was different from anything that had been previously published on the design and construction of buildings. Earlier books by Vitruvius, Leon Battista Alberti, and Giacomo Barozzi da Vignola, among others, had tended to have a softer edge that featured qualitative guidance, rather than a concentrated focus on complicated and technical problems, such as structural cracks and the damage they could cause. These mathematicians were aware that their investigation was breaking new ground and wrote as much in their preface, by defending their forthcoming approach "against anyone who would 'prefer practical knowledge, or might even say that [their] theory was harmful.'" [45] Le Seur, Jacquier, and Boscovich then went one step further to

assert with prescience that a working knowledge in construction was not enough to solve the cracks at Michelangelo's dome, since the problem was so vast and complex that only the most current concepts in mechanics could solve it.[46] Though the professors acknowledged that they were not experts in construction, they reasoned how this should not discount their findings, because everything that followed was premised on objective scientific principles and analysis.

The first part of *Parere* described the cracks that had formed, along with their characteristics. For this, the mathematicians referenced the drawings prepared in 1694 by Carlo Fontana to describe the dome and its measurements. They then systematically identified thirty-two separate types of cracks on display, along with their precise location, lengths, and orientation within the structure.[47] Their inventory often used words like *molto* (many), *tutto* (everywhere), and *quantita grandissima* (very large numbers) to describe these cracks and convey the extensive damage they had caused to the *intrados*, inner stairway, drum, attic, and buttress walls. Some were *dentro* (inside) and others *esteriore* (outside); some were *orizontali* (horizontal) and others *verticali* (vertical). In several instances, they were ominously noted as an *aperture* (opening) and documented with discomforting phrases like *in tutte poi son rotte* (all of them are broken) and *sono affatto dissestate* (they are quite bad).[48] Their survey ended with a summary of the previous studies made at Michelangelo's dome in 1603, 1631, and 1680, for which they expressed "some doubts."[49]

Once the mathematicians had concretely identified and mapped the cracks, they turned their attention to the larger problem of their root cause and why they had appeared in the first place. This was when the professors "took the crucial step of devising a simple model" of the dome that could help them evaluate its web-like

pattern of damage.[50] As their analysis evolved and took shape, they began to creatively link the concepts and research developed by earlier scientists to articulate a global theory of their own to explain the damage. Within a short time, they, like Vanvitelli, grew convinced "that there was no risk of further damage from continuing settlements of [Bramante's] piers and arches . . . [and rather] saw the outward thrusting of the dome, weighed down also by the lantern, as the real threat to future safety."[51] Thus began the quest by Le Seur, Jacquier, and Boscovich to unify the communities of science and mathematics with the everyday world. We take it for granted nowadays, but this had not been done before and was a bewildering approach for its time.

<center>≈</center>

Parere contained many ingenious ideas that were sparked by a combination of eclectic scientific discoveries. One was from Philippe de la Hire (in France) "regarding the collapse of vaults and domes"; another was based on a "theory of virtual work" by Johann Bernoulli (in Switzerland); with a third that came from Pieter van Musschenbroek's research (in the Netherlands) to address the strength of materials.[52] The mathematicians relied on each in a separate and imaginative way to better understand the cracks, explain why they had formed, and then fix Michelangelo's dome.

After studying the data and their model, Le Seur, Jacquier, and Boscovich arrived at a theory. They came to believe that the problem had started when the 2,500-ton lantern had sunken and pressed into the dome's crown beneath.[53] This had upset the delicate distribution of forces within the dome, causing its inner and outer shells to inflect, rotate, deform, and then dilate (*dilatando*). It introduced large and unwieldy amounts of tensile stress into

the skeletal frame and severies of Michelangelo's dome, which, in theory, should have been transferred to the circumferential hooping rods, installed by Della Porta in 1590. But this introduced the next problem, since the cast-iron hoops, according to the ideas expressed by Bernoulli and the experiments by Van Musschenbroek, did not have sufficient strength to overcome the overstress. So the rods gave out and the masonry dome, which had little tensile capacity to begin with, had cracked and ruptured along a hinge line (like the hinging on an accordion door), consistent with the predictions made by de la Hire. With cascading effect, this spiraled the dome beyond its elastic limit and into a perilous plastic state.[54] Now the dome was impaired, out of balance, and out of strength; its thrust had torn, and was continuing to tear, at the dome's structural fabric and had forcibly widened its base, already by nearly eighteen inches.[55] The punishing overstress had caused multiple separations, cracks, and hinge points to form in the brick and block, which explained the many lesions within the inner lining, and the problem was only getting worse.

Unfortunately, this was not the trail's end. Since the dome was defenseless and could no longer contain its own thrust, the overstress had now seeped and slithered into the supporting structure below. But the drum and attic did not have sufficient strength, either, so they failed, too—despite Michelangelo's best intentions—and shifted, tilted, and cracked in response to the relentless thrusting force. It had turned into a sequential failure, similar to a string of falling dominos, that began at the lantern and then progressively burrowed its way deep into the underlying structure to damage every part of Michelangelo's dome. These deformations, ruptures, and hinge points were famously diagramed on the singular drawing attached with *Parere*. The bad news only got worse when the mathematicians made their dire prediction that

if things continued as they were, the imbalance would progressively undermine the dome's stability until "the 'imminent' collapse of [its] entire resisting system."[56]

⁂

Against this frightening backdrop, there was a grain of good news. Though no one could see it yet, these three mathematicians had creatively developed a plausible and fact-based analysis that had for the first time explained the damage to Michelangelo's dome in a coherent and unified way. It may not have painted a pretty picture, but their report nevertheless provided an articulate and objective understanding of the cracks where none had existed before, and which to this point had been solely based on intuition and opinion. For this alone, *Parere* earns high marks for its imaginative use and pragmatic application of scientific principles.

Le Seur, Jacquier, and Boscovich then made another leap forward and offered their views on how to fix the dome and restore its balance in *perfetto equilibrio* (perfect equilibrium). Like other experts, they had reasoned how the dome's punishing thrust must be opposed, in *contraforti*, by more buttresses and iron hoops.[57] In response, they developed an "extensive reinforcement operation" to thicken the drum's sixteen buttress walls "and place new heavy statues on the top of them."[58] This idea, on its own, was neither new nor remarkable.

But it was the way that Le Seur, Jacquier, and Boscovich structured their next observation that made history. Like Vanvitelli, they had thought to embed additional iron rods into the dome, yet their approach was based on a fundamentally different premise. Like everything else in *Parere*, their philosophy was driven by scientific principles, and in that spirit they proposed to

arithmetically calculate the dome's thrust (with help from Ber-
noulli) and then compare it to the tensile capacity of the cast-iron
rods (from Van Musschenbroek). This became their method for
prescribing the number of rods—with precise dimensions—that
were needed to restore equilibrium within the dome and drum.
No one had thought before now to combine these concepts in
physics, mechanics, mathematics, and material science and use
them in such a rational, yet practical and imaginative way. It
was elegant in logic and led to their matter-of-fact observation,
written a short time later and in their typically understated and
clinical tone, that *della quale qui si trattava, dipende tutta da una
parte di Meccanica come e la Statica, sceienza* (what we are dealing
with here relies entirely on an aspect of mechanics as well as the
science of statics).[59]

The observation was as profound as it was revolutionary, and
it marked a radical departure from the vagaries of intuition,
personal judgment, and rules of thumb that had governed the
world of construction for thousands of years. Now, a structural
component—like a girder or a column or an iron chain—could
be "determined directly, by calculation," and under this approach
Parere had established a foundation for an entirely new way to
visualize and solve a variety of complicated, technical problems
"which is, for the first time, treated . . . in the modern sense."[60] Put
another way, these three mathematicians had smashed through a
monumental barrier to build a bridge between the old world to the
new, which "as a matter of principle, was a vital step forward" and
became a harbinger of current design practice.[61]

In these three short months, they created what we know today
as the practice and profession of engineering.

But no one knew this in January 1743, when Le Seur, Jacquier, and Boscovich tendered their report to the pope. While *Parere* was articulate, logical, and featured a clarity of vision that was steeped in science and mathematics, it was also full of ideas that were unconventional, theoretical, and untested. If *Parere* was a bridge, after all, would it stand up at a live construction site? Or was it a bridge to nowhere?

7

CRITICS AT EVERY CORNER

O nce Thomas Le Seur, François Jacquier, and Roger Joseph Boscovich delivered their *Parere*, they had for the moment completed their mission. The matter was in Pope Benedict XIV's hands now, and he was facing two reports on his desk that did not entirely square with each other. The first had been prepared by his dependable chief architect, Luigi Vanvitelli, and a seasoned team of construction experts whose findings about the Michelangelo's dome had matched the men: practical in tone, measured in response, and conventional in approach. The second was *Parere*, with its ominous assessments and untested ideas that had cast such a perilous and dark cloud over the cracks and the damage they had created. Yet each report carried a certain appeal for Benedict XIV, whose "good sense and moderation placed him at the modernizing edge as well as at the top of the Vatican."[1]

Benedict XIV saw Michelangelo's dome as a magnificent architectural jewel that had been designed by Italy's greatest artist. But it was also a lasting and sacred symbol of the Roman Catholic Church and a patriotic emblem of the sovereign Papal States and any repairs would need to be performed with meticulous care,

reliable techniques, and by professionals with proven expertise. The question confronting Benedict XIV was whether he could entrust the fate of his dome and its frightening nest of damage to Vanvitelli's simplistic analysis and traditional solution. Or should he rather place his faith in the radical theories and experimental notions proposed by three mathematicians with no experience in building design or construction? While the pope had been a long-time and steadfast sponsor of scientific advancement, his beliefs had limits.

Benedict had done his best to surround himself with competent counselors and trustworthy colleagues from whom "he sought advice vigorously and took it prudently."[2] This came naturally to him as part of his inborn, inquisitive temperament, and was reinforced as a young lawyer at the Rota while investigating a steady stream of contentious matters that required an appreciation for varying points of view. But Benedict XIV also had a pragmatic reason for seeking guidance from others, since he was busy being pope and was "beset not only by incessant work of every kind . . . but also by ceaseless demands upon his time."[3] His many roles and obligations—spiritual, administrative, ceremonial, diplomatic, and political—reduced his capacity for "careful weighing of data . . . [and] the close examination of arguments, before reaching any decision [about how to fix Michelangelo's dome]."[4]

This was a particularly challenging time for Benedict XIV. Foremost among his concerns in 1743 was the ongoing war between Austria and Spain, now in its third violent year (of eight), that was ravaging the neutral Papal Sates while "laying waste to [his beloved] Bolognese countryside."[5] At the same time, he was navigating the volatile and never-ending politics between Protestants and Catholics in Great Britain, outbursts from separatists in France, and financial woes from his accountants at the

Vatican bank. To compound matters, a plague had crossed the Strait of Messina with nothing to break its path north from Sicily. Accordingly, Michelangelo's dome was just one more problem on Benedict XIV's growing list of troubles, all which posed very real life-and-death consequences, and again underscored his need for sage counsel from people he could trust.

But these burdens and his punishing daily schedule did not seem to diminish Benedict XIV's congenial and collegial demeanor, or his effort to keep in close, personal touch with his flock. He arranged, for example, that each of his many bishops "come regularly to Rome to discuss their work" and to help him gauge the pulse of the church.[6] In a similar way, Benedict XIV created three ecclesiastic academies shortly after his election in 1740 to supplement the Accademia delle Scienze dell'Istituto di Bologna, which he considered "a first essential step in reversing the decay Rome had suffered under his immediate predecessors."[7] One convened in regular session at the Palazzo del Quirinale, near Trevi Fountain and at the crest of the city's ancient and tallest hill by the same name. The palace had been designed in part by Domenico Fontana in the 1580s—just before he teamed with Giacomo della Porta at Michelangelo's dome—and it was where Pope Sixtus V had escaped from the infamous Roman summer heat.[8] Benedict XIV attended many of the proceedings at the Quirinale to "keep an eye on them," since they were known to devolve, on occasion, into discussions that were "dangerous to established authority and belief."[9] More often than not, however, these sessions had been true to Benedict XIV's spirit and were commonly governed by a "precision of thought tempered by genial commonsense, gentleness to individuals, and firmness where fundamental principles were involved."[10]

We do not know Benedict's precise reaction to *Parere* at first reading, but every action thereafter seemed to demonstrate an urgent concern about the dome. This was made plain on January 12— just four days after Le Seur, Jacquier, and Boscovich had tendered their report—when the Vatican reprinted and dispatched *Parere* with all haste along the Italian peninsula, and to a broad spectrum of experts for second and third opinions.[11] These reprints explain the large number of copies of *Parere* that happily still exist, and one was published by a certain Simone Occhi in Venice later that year, using a different typeset from the original paper submitted by Le Seur, Jacquier, and Boscovich.[12] Another copy was sent to the University of Padua, which had emerged as Europe's leading institute of scientific advancement since Nicolaus Copernicus and Galileo Galilei were there. It was also dispatched to Bologna and its Accademia delle Scienze, as well as other eminent architects, mathematicians, and scientists practicing in Rome, Naples, and Sicily.[13]

Separately, Benedict XIV convened a congress at the Quirinale to discuss the dome and its cracks. It assembled on January 20, 1743, only two weeks after *Parere* had first crossed his desk. Many notable persons had been invited, including Francesco Olivieri, director of the La Fabbrica di San Pietro in Vaticano, and architects Luigi Vanvitelli, Nicola Salvi, Ferdinando Fuga, Gerolamo Theodoli, and Filippo Barigioni, who was also with the Fabbrica.[14] Le Seur, Jacquier, and Boscovich were there, too, along with Diego de Revillas, chair of mathematics at La Sapienza.[15] The panel was rounded out by another mathematician and literary scholar, Michelangelo Giacomelli, as well as Giovanni Gaetano Bottari, the influential and opinionated counselor to former Pope Clement XII.[16] Interestingly, it was Boscovich, as third author, who introduced and presented *Parere* to the group. For visual effect, the mathematicians

carted in a small-scale replica of the dome that Michelangelo had made from timber during the 1550s, on which Vanvitelli had painted an overlay to show off the ominous-looking cracks. It was telling that the panelists seemingly paid little attention to the scientific principles that had underpinned *Parere*, likely because they could not grasp these foreign and innovative ideas or their relevance.[17] After a spirited discussion, the forum agreed to the obvious: that the dome was now badly damaged and that new iron hoops be installed as a remedy. But true to his corrosive disposition, Bottari refrained from joining in until he could personally inspect the site, despite his limited experience with construction.[18] Moreover, it did not help that he had been publicly critical of Vanvitelli's earlier work, which had created a poisonous running rift between him, as current prefect of the Vatican Library, and Vanvitelli, as architect of St. Peter's Basilica.

This forum at the Quirinale had been a sensible and prudent gesture that was not unusual for its day. Such events were "known as an Expertise" and had been convened on previous occasions since the thirteenth century, when architects and master builders had been retained to "settle particularly difficult issues" that had surfaced at a construction site.[19] They were noteworthy and prestigious gatherings that provided handsome supplementary income for their participants, on top of a customary stipend for travel, meals, and lodging while at the job. William of Sens and Villard de Honnecourt were among the earliest and best-known of such experts, traveling from site to site across medieval Europe as itinerant consultants, offering opinions and technical guidance that were based on their expanding circle of projects, though they may or may not have been master builders themselves.

Maybe the most famous of these conferences was the "great convocation of specialists" from 350 years earlier, in May 1392.

They had mustered in Milan to address eleven thorny problems that had plagued the design and construction of that city's new, grand cathedral. Each issue was patiently presented to the group over several days of sometimes heated discussion, followed by a range of solutions for which each panelist then voted and their outcomes were adjudicated "based on the opinion of the majority."[20] It turned out that the most pressing item on their agenda had been to assess the structural integrity of the crossing piers, similar to those at St. Peter's Basilica in Rome, which was resolved when the specialists declared "upon their soul and conscience, that . . . the strength [of the cathedral piers] . . . is sufficient to support even more [weight]."[21] No discussion or analysis was furnished to explain why this was so, and it did not take a mathematician to see that their decisions in 1392 were quaint and almost archaic when compared to the more modern, precise, and scientific approach presented by *Parere* in 1743. The difference had by now become stark and obvious, and it showed how the world was changing, though only a few could see it at the time.

By coincidence, the cracks at Michelangelo's dome had paralleled another, unrelated, scientific dilemma to cross Benedict XIV's desk that year. It was raised by Jane Squire, an Englishwoman and a Catholic, who had petitioned the pope in a quest to solve the world's most pressing maritime problem of the day: longitudinal navigation. Though mariners had been sailing at sea for thousands of years, they only had the tools and technology to map their position along the latitudes, north and south of the equator. By contrast, things became murky and dangerous while navigating to the east and west, where there was no reliable way to record their

bearings along the meridians of longitude. Ships were commonly lost and wrecked as a consequence, along with the valuable life and cargo on board. This became known as the "longitude problem" and was a paramount and particular concern to the military, commercial, economic, and political tides of Britain; finding its solution was crucial toward maintaining the strategic security and nautical supremacy of that seafaring island. Accordingly, in 1714 Parliament made it a national priority and established the Board of Longitude, which was authorized to award large cash prizes to inventors who could piece this puzzle together.[22]

Squire believed that she had solved it by using a special blend of astronomy and geometry, but had been rebuffed in her ten-year campaign for an audience with the British Admiralty to take up her proposal. Out of frustration and as a last recourse, in 1743 she wrote to Benedict XIV, knowing of his interest in science. Squire had been right: the pope was intrigued by her letter and her book, *A Proposal for Discovering Our Longitude*, and extended the same courtesy to her as he had shown throughout his career to other women with academic promise, by sending her work to the Accademia delle Scienze in Bologna for the "opportunity to engage in an international scientific debate."[23] Though she was "reasonably well-versed in the . . . difficulties faced by navigators [while] charting a course," the Accademia delle Scienze was otherwise unimpressed by her proposal and ultimately found that "Signora Squire . . . has in no way developed or clarified the mentioned Problem [of longitude] . . . but left it in as much obscurity and uncertainty as before."[24] Others, too, in Britain "could make neither rhyme nor reason of Squire's book," while some found it "incomprehensible."[25]

Squire, in the meanwhile, had passed away at age fifty-seven. Though nothing came from her idea or Benedict XIV's initial interest in it, the episode reinforced his genuine embrace of

scientific novelty. It demonstrated, too, this pope's reliance on advisors to help him make informed decisions, and at the precise moment when *Parere* and its authors—Le Seur, Jacquier, and Boscovich—were under a similar kind of scrutiny for their own revolutionary proposal to solve the cracks at Michelangelo's dome.

It did not take long for the scrutiny to start. What had begun in polite silence at the Quirinale on January 20 grew within days to an orchestrated dissonance led by Bottari. He was then fifty-four years old, held the personal ear of the pope, and was an internationally known scholar who also managed and oversaw the prestigious Vatican Library. About ten years earlier, Bottari had accompanied Eustachio Manfredi, founder of the Accademia delle Scienze, on an expedition to explore a navigable route along the Tiber River toward Perugia.[26] The trip had seemed to fashion Bottari's self-image as an expert in construction though he had rarely, if ever, picked up a trowel. Since then, he had been on cordial terms with Giovanni Battista Piranesi and Ferdinando Fuga (who was also from Florence) through whom Bottari became conversant in architectural design. But in the eyes of a seasoned practitioner like Vanvitelli, Bottari was an amateur and a dilettante, whom he disdained as someone who "does not understand Architecture, yet wants to talk about it."[27] Nevertheless, by 1743 Bottari's "position and reputation [had] made him one of the most important voices on art in Rome."[28] His influential opinions had helped to preserve many of the remaining artifacts of antiquity within Italy, and he was a powerful advocate for the monuments of the Renaissance as well. Above all, he reserved a special reverence for the work of Michelangelo, who was a fellow Tuscan. Bottari's high standing was made

clear by the large number of institutes around Rome that invited him as a member, including the prestigious Accademia di San Luca, which had named him as an "academician of honor" five years before, in 1738.[29]

Over his long career, Bottari had remained attached to a set of rather parochial views that tended to "perpetuate historical traditions" and showed "little aptitude for or sympathy with original critical thinking."[30] He made stinging comments about those with whom he disagreed, and often disparaged their work and ideas. He published many of his poisonous remarks—knowing the damage they could cause—in a variety of books, tracts, pamphlets, and correspondence for distribution across Rome and beyond. Therefore, when Bottari became the voice of lone dissent at the Quirinale conference, Le Seur, Jacquier, and Boscovich rightfully "realized immediately that they [and their novel ideas] faced a dangerous enemy."[31]

Bottari began to vocalize his concerns about *Parere* just after the January session had adjourned. First, he criticized the mathematicians and their work as "imprecise and incomplete," as well as "vague and unspecific."[32] He then groused that *Parere* had not described the cracks in a comprehensive way or with sufficient detail. Finally, Bottari undermined the report's essential ingredient by suggesting its "calculations were false." By the time he was done, in three short days, Bottari had managed to cast a long shadow over the entire report, causing Boscovich to complain that "a voice is increasing in Rome that all of our calculations are wrong, [and] that everything [in *Parere*] relies on false suppositions."[33] It did not seem to matter to Bottari that *Parere* had described the dome's condition with more exactness than any other preceding survey, or that these mathematicians had made several visits to map the cracks with a precision that had not been previously achieved, or that the authors

had "made the calculations several times and verified the data by numerous measures because [they] found many inaccuracies in the previous drawings [by Carlos Fontana]."[34] Neither did Bottari seem to appreciate the complex ideas within *Parere* that, according to Boscovich, "had to summarize even the most elementary [concepts] in order to be understood in a country where very few people are acquainted with geometry and even fewer with calculation."[35] Adding insult to injury, Bottari had launched his blistering critique without bothering to visit the dome, or offering any alternative and constructive opinions that might contribute toward solving the problem posed by the cracks. All that seemed to matter to Bottari was an intent to undermine *Parere* and its authors, and to show they could not be trusted to fix Michelangelo's dome.

Part of this antipathy may have been personal and petty, since Bottari disapproved of the Jesuits, the religious order to which Boscovich belonged, which he may have mistakenly extended to Le Seur and Jacquier, by association. But his chief complaint seemed more metaphysical, by objecting to *Parere*'s treatment of the dome as a cold, clinical, abstract, Newtonian "system," rather than an organic, splendid, and humanistic "machine" as divined by Michelangelo's genius.[36] In short, Bottari did not like the novel, scientific thinking expressed in *Parere*, and his suspicions and malicious mischief had now quickly sown the seeds of doubt against Le Seur, Jacquier, and Boscovich. True to his chronic and polemic temperament, Bottari had found his next fight to pick and had opened the door for others to follow.

≫

The approach that Le Seur, Jacquier, and Boscovich had taken to evaluate Michelangelo's dome had followed the same footsteps as

prior pioneers in science, such as Galileo Galilei, Robert Hooke, and Isaac Newton. It was known as the Baconian method—named after Francis Bacon, a sixteenth-century contributor to the Scientific Revolution—and was predicated on a system of careful observation, from which the mathematicians could establish their framework and assumptions to propose and then prove their hypothesis. Once accomplished, they drafted their findings and patterns of thought openly in *Parere* so that the pope and his advisors could follow their logic. It is telling that Bottari "described their attitude as naïve," since every part of the analysis now became transparent and each opinion became fair game for comment.[37] By following the Baconian method, "the mathematicians [had] deliberately exposed themselves to criticism," which was nonetheless the underlying predicate and harbinger of modern, scientific research.[38]

As part of their process, Le Seur, Jacquier, and Boscovich had made clear that Michelangelo's dome was a complicated, three-dimensional structure. But what set *Parere* apart was the elegant way it transformed the dome's complex arrangement of brick, block, mortar, and iron into a two-dimensional paradigm. By simplifying the structure's geometry, statical behavior, and material properties, the mathematicians were thereby better able to calculate the dome's weight and thrusting force. They then used their model to visualize and develop a theory about overstress, hinging, dilation, and potential for collapse. Buildings had never been analyzed this way before, and *Parere*'s astonishing novelty in approach cannot be overstated.

Yet, in hindsight, not all the initial assumptions within their report were as neat, crisp, and simple as the mathematicians had first envisioned. That was its downside. Le Seur, Jacquier, and Boscovich were not aware, for example, of elastic and inelastic behavior, which led to their misleading assumption about the

transfer of thrust between the stonework and the iron chains, and the amount of tensile stress these rods had absorbed. Also, their schematic representation of the dome's hinging points and fracture lines were not quite accurate, which had overstated some of their calculations and skewed some of their findings.[39] But it was a brilliant start, nonetheless, and *Parere* had, seemingly overnight, changed the conversation about the cracks, how they had formed, and what to do about them. Going forward, *Parere* had shown how these kinds of complicated issues in construction could now be solved, and in an entirely new way: using mathematics and science in tandem with the valuable intuition and insights from experienced architects and builders in the field. It was a tectonic shift in approach that was difficult for most to grasp and would be tested by many quarrelsome and divergent voices in the months ahead.

The first voice filtered its way back to the Vatican in February 1743, about a month after the Quirinale conference. More arrived in March, claiming to have found flaws within *Parere* and including alternative theories about the damage at the dome. By spring, about a dozen experts had responded to Benedict XIV's request for help, including those of the kind one might expect—such as architects, builders, mathematicians, and physicists—along with some that one might not, such as antiquarians, economists, and philosophers. They discussed the cracks in reports that had colorful titles, like *proposizione* (propositions), *riflessioni* (thoughts), *sentimenti* (feelings), *risoluzione* (reconciliations), and *aggiunta* (additions). When taken together, they reveal valuable clues about the state of knowledge in architectural design, construction techniques, Newtonian physics, seismology, and structural mechanics

of the day. These manuscripts also hint at the professional rivalries, personal ambitions, and petty jealousies that existed among themselves and the authors of *Parere*, as they each vied for the pope's divided attention.[40]

The experts came from two camps: mathematicians, scientists, and general scholars who tended to assess the mechanics of the dome, and seasoned architects and builders, who addressed how to fix it. Some had personally inspected the basilica, but most had not. Many responses used diplomatic and carefully crafted language, while a few more were hard-edged and dismissive. Interestingly, most agreed with Bottari and were not reticent to express how *Parere* had overstated the dome's peril (but they were wrong). A few experts simply ignored *Parere* and focused instead on their own ideas to fix the cracks and make the repairs; their proposals showed a rudimentary grasp for the concepts of thrust and counterbalance, which were reflected by their suggestions to fill the dome's stairwell with concrete, or remove the dome's lantern, or to build some new buttresses around its drum. Other experts did just the opposite and ignored the cracks, seizing instead the opportunity to criticize Le Seur, Jacquier, and Boscovich for their fundamentally misguided use of mathematics and science in ways for which they were never intended. These critics argued, after all, that Michelangelo's dome had been built without such high-minded principles, so there was no need now for such exotic ideas to repair it. In the same way, one critic logically pointed out that, according to *Parere*, the dome should have collapsed by now, and since it had not, then the mathematicians and their entire theory held no merit. Ultimately, the experts agreed that these messy and complicated issues of construction should be left to those architects and builders with the so-called real expertise and training to fix the most important church in the world, rather than three junior *professore di mattematici*.

One author was identified only as "a mathematician," and he drafted his *sentimenti* from the University of Naples. It mirrored the same disapproving tone and tenor of other appraisals and may have been written by "any one of three persons: the mathematician and economist Bartolomeo Intieri . . . , the physicist Giuseppe Orlandi or the astronomer Pietro di Martino."[41] Whoever he was, he did not agree with *Parere* and its dire view that the iron hoops installed by Della Porta in 1588 were facing the peril predicted by Le Seur, Jacquier, and Boscovich, although the rods had indeed by now been overstressed and lengthened by eighteen inches (and were worsening).[42] Yet, he did not visit the dome or produce any laboratory tests, nor did he furnish an alternative theory to make his point. Like many of the other critics, this *matematico* had fallen into the same pattern of innuendo, vague intuition, and subjective analysis that Le Seur, Jacquier, and Boscovich had seen as a general shortcoming and were trying to remedy.

Another manuscript arrived from Sicily, prepared by Giovanni Amico, an architect, historian, and theologian practicing in Trapani. Amico was fifty-nine years old in 1743, largely self-taught, and had by now developed an outsized reputation based on his popular book published in 1726, *L'Architetto Prattico* (The Practical Architect).[43] He did not visit the dome either, and his report was premised on secondhand information gathered from a colleague in Rome who, in turn, had transcribed it from *Parere*. Because Sicily was and remains prone to powerful earthquakes, Amico was keenly aware of the loss of life that these events could cause and the damage they did to buildings. His proposal to fix Michelangelo's dome was predicated on a pragmatic solution that had been reliably used in Sicily under similar circumstances. He pitched the idea to install three, new, sizeable buttresses, known as *tholoi*, on top of the drum, which would burrow into the base

of the dome as a counterbalance to its thrusting force. Though he had not seen the cracks, Amico knew they were sizeable since his specifications pointedly emphasized that they be infilled with a continuous "bridge" of stone blocks that each measured more than two feet thick.[44] He then proposed to reinforce the dome's interior lining with a continuous ring of stone chains, similar to those employed by Filippo Brunelleschi at the cupola of Santa Maria del Fiore during the 1420s. Amico asserted that his solution would be less expensive than the new iron hoops then under consideration at St. Peter's Basilica in Rome, and would enhance the dome's stability while also serving as "an aesthetic enrichment."[45] Despite his good intentions and practical suggestions, Amico's ideas were rejected since they would have dramatically altered the designs by Michelangelo and Della Porta, a paramount concern to the pope, the Fabbrica, and Vanvitelli, as architect of the basilica.

The Vatican also received the *sentimenti* prepared by an anonymous and "scholastically trained" expert known as "Filosofo." It was an impressive, 125-page report that was wide-ranging and neatly divided into nine *proposizione* and with "the quality of a [professional] handbook."[46] The *parte prima* included "some thoughts on the most likely causes" of the cracks and how "with the use of physics one can draw some conclusions of the damage and discuss remedies."[47] In its *parte seconda*, the author offered "more thoughts on the opinions by three mathematicians in the present controversy."[48] His explicit reference to "the present controversy" is a telling acknowledgement that *Parere* and the ideas contained therein had by now become a matter for contentious debate. Along this same thread, Filosofo "entirely rebuts the conclusions of the mathematicians" and describes instead how the damage had been caused by extremes in temperature and humidity.[49] Though his manuscript often cited the experimental tests by Pieter van

Musschenbroek, Filosofo did not seem to inspect the dome nor perform research of his own to support his theory—like taking field measurements at different times of the year and under varying atmospheric conditions.[50] When his identity was subsequently revealed as "Jesuit Favre" it was surmised that Filosofo had "preferred to remain anonymous out of respect for . . . Boscovich, who was a Jesuit, too."[51]

Other respondents to *Parere* included a priest, a natural philosopher, an amateur architect, and a "*dilettante* in mathematics."[52] Taken together, they believed that "poor and hasty construction, differential settlements . . . [and] occurrences like earthquakes and lightning" had contributed to the dome's demise.[53] But Lelio Cosatti was by far the most quarrelsome among them, as expressed in his *Riflessioni . . . Circa il Patimento, e Risarcimento della Gran Cupola di S. Pietro* (Thoughts About the Suffering and Restoration of the Great Dome of St. Peter's). Cosatti was sixty-six years old in 1743, and was a mathematician who also knew a thing or two about architecture, having been personally acquainted years earlier with Filippo Juvarra, an early career influence on Vanvitelli.[54] Cosatti believed that *Parere* contained major flaws, and that these cast "serious doubts on [the mathematicians'] approach to the whole pattern of movements within the [dome]."[55] As examples, he noted how Le Seur, Jacquier, and Boscovich had ignored "some conspicuous cracks in the arches below the drum" (which they had not), and believed that they were also wrong about the dome's lantern as the source of the problem. He further claimed that "many professors of mathematics would agree with him" but "cites no names to support this."[56] While Cosatti's views of *Parere* were harsh and dismissive, his analysis was nonetheless thoughtful and articulate.[57] More important, though, was his crucial and separate sponsorship of Niccola Zabaglia—the magician of Vatican Hill—who would soon play a vital and prominent role once the repairs got under way in the months ahead.

Gabbriello Manfredi was perhaps the most diplomatic among these many critics. He was the younger brother by six years to Eustachio, who had founded the Accademia delle Scienze dell'Istituto di Bologna when it was first known, in 1690, as the Accademia degli Inquiti. The brothers had been longtime and steadfast friends with Benedict XIV, who in January 1743 had sent a copy of *Parere* to Gabbriello, then a professor of mathematics at the University of Bologna (and a member of the Bolognese senate). Skilled in logic and prudent like his brother, Gabbriello declined to comment "because he felt inadequately informed about the damage."[58] In his professional judgment, he could not form an educated, sensible, and helpful response without additional information, so he showed restraint and stayed out of the fray at Michelangelo's dome.

In the aggregate, these many reports were often vague, imprecise, and prepared without firsthand knowledge of Michelangelo's dome, the cracks, or extent of the damage. Additionally, their criticisms of Le Seur, Jacquier, and Boscovich seemed to be based on theories that were just as speculative and untested, if not more, than those described in *Parere*. But the manuscripts are valuable, nonetheless, because they reveal the tension between traditional belief and conventional wisdom on the one hand, and an emergent school of scientific thought on the other. That these critics tend to gloss over or ignore the underlying principles within *Parere* is not surprising, since Le Seur, Jacquier, and Boscovich were so far ahead in their thinking that few could understand or interpret their work. *Parere* had had its share of imperfections, but that was the essence of pioneering, scientific inquiry, after all—it was a restless process driven by theory and experimentation, which released its secrets slowly and in stages, over many months and often years. This was the monumental parallel between the *Parere* of 1743 and previous scientific discoveries, like Hooke's law of 1678 and the *Principia*

of 1687. Just as the revolutionary concepts by Robert Hooke and Isaac Newton had needed time, measured in decades, to take root, so would those by Le Seur, Jacquier and Boscovich. Others would gradually recognize and appreciate the brilliant leaps made by these three mathematicians, too, and *Parere* would have its day.

But not yet.

⊗

Faced by this barrage of hostile opinion, Le Seur, Jacquier, and Boscovich crafted a follow-on, rebuttal report in March 1743, titled *Riflessioni* (Reflections). It was a sixty-five-page narrative that addressed and clarified the issues raised by their critics, including the scathing remarks by Cosatti. Most telling, and after all the slings and arrows, was that the authors "contented themselves with restating their diagnosis and proposals . . . [and supported] them with further observations and arguments."[59] In the end, these mathematicians remained confident in their convictions and did not budge from their initial, remarkable views expressed in *Parere*.

But now the pope faced an even darker dilemma than before. Though the number of options and opinions on his desk had multiplied from two to fourteen, they still offered no definite answers. Hence, as the cracks continued to grow, and in this climate of uncertainty, controversy, and possible calamity, Benedict XIV did what he did best. He sought guidance from yet another voice to help resolve the impasse. But not from just any mathematician, architect, or builder—this expert was the most renowned scientist in Italy and among the most eminent in Europe—Giovanni Poleni.

8

PROFESSOR POLENI

The summer of 1683 had been a tense, turbulent, and uncertain time in Vienna, which was by now surrounded and besieged by some 150,000 Ottoman troops. They were directed by their chief officer, Grand Vizier Kara Mustafa, who had a simple mission and was determined to take the city with his formidable army and bring southeastern Europe into the orbit of Ottoman rule. Under this threat the Hapsburg emperor, Leopold I, evacuated the capital for safety and had appealed for help to Pope Innocent XI. The Vatican and the Hapsburgs had been longtime allies and their combined plea for volunteer recruits that summer had spread quickly across the continent, where some four hundred miles away in Venice it had stoked the ambitions of one Jacopo Poleni, who was newly wed but felt inspired to enlist.

We do not know Poleni's precise role in what came next, but it must have been impressive since Leopold I promoted him after the fierce fighting to lift the siege was finished, two months later along the Viennese hills. For his valor, Poleni was made a marquis in 1685 when he was thirty-one years old, and his elevated social stature was affirmed a year later by the Venetian Republic

(la Serenissima). It was a badge of privilege, prestige, distinction, and high civic standing that could be passed on to succeeding generations, and Poleni took little time to assign the title to his heir. Which is how Jacopo's first child, Giovanni—one of Europe's leading scientific lights of the eighteenth century—became part of the Italian nobility, as a marquis, while he was still a toddler.[1]

—※—

Giovanni Poleni was born in August 1683, while his father was fighting in Austria. Both parents were part of the established, stable, and educated Venetian middle class that had helped to shape the Venetian Republic into a place like none other.[2] Nestled for a thousand years inside its protective lagoon, the "Queen of the Adriatic" was legendary for its maritime trade, commercial prosperity, and sophisticated culture best captured by William Shakespeare's *The Merchant of Venice* alongside the sumptuous waterscapes painted by Francesco Guardi and Giovanni Canal (commonly known as Canaletto). The floating city was fiercely independent and had always bristled at any hint of meddling in its politics, policies, or practices, especially when attempted by neighbors like the pope, the Republic of Florence, or the Duchy of Milan.

As a boy, Poleni displayed clear intelligence and bright academic promise. He "was fortunate to have received some of the best alternative education available to Venetian citizens" at the Collegio alla Salute, which sat at the foot of the city's famous Grand Canal.[3] The school was run by the Somascan Fathers ("fathers of the orphans"), where his curriculum was filled with academic staples such as philosophy, Latin, and theology, along with painting, drawing, and architectural design.[4] Young Poleni developed a close bond with his tutor from school, Francesco Caro, who was among

the most learned scholars in Venice. It was Caro who introduced Poleni to the world of science during these formative years, and the boy became irreversibly drawn into its orbit, from which he never looked back.[5]

Poleni graduated from the Collegio alla Salute around 1700 but did not attend a traditional university. Rather, he "turned to the informal science instruction [that was then] available among the various religious orders in Venice."[6] It propelled Poleni and convinced him by 1707, at age twenty-four, to chart a career that would ultimately embrace the worlds of archaeology, astronomy, hydraulics, instrumentation, mathematics, mechanics, meteorology, nautical science, navigation, physics, and ship-building. Around this time, he began his lifelong friendship with Giovanni Battista Morgagni, who was also from Venice and had an equal fascination with the weather and meteorology. Morgagni would soon become renowned for his medical research and pioneering work in anatomical pathology.[7]

Poleni's elevated social standing had likely played a prominent role in his courtship of Orsola Roberti. She was from a noble family, too, having been raised in a small city, Bassano del Grappa, about sixty miles from Venice.[8] Their arranged match may have nevertheless required some salesmanship on the part of his parents, since Poleni at twenty-five years old had finished school but had no job, few professional accomplishments, and not much money to his name. The couple married in 1708, settled in Venice, and their first child, Jacopo, arrived ten months later. By now, Poleni had become absorbed by meteorology and the gadgets necessary to capture everyday atmospheric data—like barometers, clocks, and thermometers—which he dutifully recorded for most of his career. This attraction to gadgetry extended to mathematics, too, when he designed and then built a handheld machine that was simple

to operate and could perform arithmetic calculations. Today, we would describe it as an early calculator.

These combined interests became the topics for his first scientific paper, *Miscellanea—Hoc est Dissertatio I de Barometris et Thermometris. II Machinae Arithmeticae Eiusque Usus Descriptio. III de Sectionibus Conicis Parallelorum in Horologiis Solaribus* (A Miscellaneous Dissertation on Barometers and Thermometers, Arithmetic Machines and Their Description and Use, and of Parallel Conical Sections in Solar Clocks).[9] It was abbreviated to *Miscellanea* and identified Poleni as a serious scientist with serious potential. The book became his seminal achievement and led to an avalanche of professional success that he justly earned in the decades ahead.

By now, the nearby University of Padua had taken note of Poleni's talent. The school had been founded five hundred years earlier, in 1222, when "a group of students with their professors took refuge . . . to find the freedom of thought and teaching" from the more restrictive policies at the University of Bologna.[10] Over time, this small community of scholars at the University of Padua had grown to invent a place that was open to everyone and all brands of thought. Its strategy had paid off, and by the fifteenth century the University of Padua was a thriving and "leading center of scientific learning in Europe, at a time when virtually every other university showed little interest in scientific observation."[11] It is no coincidence that this transformation took place under the governance and watchful eye of the Venetian Republic which, because of the its long-standing antipathy toward Rome and the pope, had given the faculty at the University of Padua a wider berth to study, question, and debate the relationship between science and traditional Christian philosophy.[12] For example, while the Roman Catholic Church had commonly forbidden the practice of anatomical dissections because it marred the human body and thereby harmed

its divine soul within, the scholars and faculty at the University of Padua felt no such compunction and established in 1595 the first "anatomical theater" to perform systematic study and research on those same human bodies. [13]

This kind of academic freedom set the University of Padua apart from other schools and was its core attraction for students like Nicolaus Copernicus in the 1500s, and faculty like Galileo Galilei in the 1600s, to matriculate there in the first instance. Accordingly, when Poleni was offered a job in 1710 to chair the university's departments of astronomy and meteorology, soon after his *Miscellanea* was published, he jumped at the chance. Now twenty-seven years old, Poleni moved his young family the short distance to Padua, where he taught and lived along the well-appointed Via Beato Pellegrino for the next forty-five years. [14] This coincided with his election as fellow to the Royal Society of London, where he was sponsored by Isaac Newton, no less—author of the *Principia*, towering founder of modern physics, and president of the society—with whom Poleni became personally acquainted. [15]

In his early days at the University of Padua, the young professor grew to know Jakob Hermann, who taught mathematics and introduced calculus there. By now, Poleni's good friend Morgagni had joined the faculty to chair the department of theoretical medicine, where the pair resumed their joint pursuit of meteorology. This took more courage than it might seem since the prediction of weather was a gateway to foretelling the future, and a practice that had been a sore topic at Galileo's infamous trial. [16] But Poleni was protected by the Venetian Republic, after all, and this gave him the assurance to expand his research and correspond with other leading scientists on a broad range of topics—such as Johann Bernoulli in Switzerland, Newton in England, and Gottfried Wilhelm Leibniz in Germany. (By now, Newton and Leibniz were embroiled in

their legendary dispute over the invention of calculus and who had gotten there first.)

Poleni created a steady record of accomplishment during his first six years at the University of Padua, which set the stage for his being "remembered as a great teacher."[17] By 1715, his research in astronomy, celestial mechanics, and meteorology had so impressed his university colleagues that he was offered, at thirty-two years old, a second chair, this time at the department of physics. Poleni accepted the challenge, and later that year took another leap forward when he was hired by the Venetian Republic to assess its persistent problems with flooding and irrigation along the Veneto's western border.[18] This prompted Poleni to author a pair of books that addressed the "movement of water in estuaries, harbors, and rivers," along with "their impact of force."[19] They established his authority in hydraulics, which was further enhanced when Poleni was endorsed by Leibnitz for membership into the Royal Prussian Academy of Sciences.[20]

Around 1720 one of Poleni's colleagues, Nicolaus Bernoulli, opted to leave his post as chair of mathematics and return to his native Basel. He was nephew to Johann Bernoulli—the same mathematician who had recently refined the principal of virtual work—and to fill the vacant seat the trustees turned again to Poleni, who accepted the job.[21] After ten tireless years and at thirty-seven years old, Professor Poleni now chaired the departments of astronomy, physics, and mathematics at the University of Padua, the epicenter of scientific advancement in Europe. In the meantime, he had been invited to join two prestigious academies of science and was now "regarded by the Venetian government . . . as [its] precious consultant on all . . . questions dealing with the lagoon."[22] The professor's domestic life seemed happy and secure, too, as husband to Orsola and proud father to five boys and a girl.

But Poleni did not sit still or slow down. His research and teaching continued at a grinding pace for the next twenty years, for which he was rewarded with more prestigious memberships: at the Académie des Sciences in Paris, the Saint Petersburg Academy of Sciences, and the Accademia delle Scienze in Bologna, where he would have known Eustachio Manfredi and possibly Prospero Lorenzo Lambertini, the future Pope Benedict XIV.[23] Poleni discovered his new passion for archaeology around this time, too, which by then had become a raging obsession in Europe. Between 1735 and 1742 he published three papers, on topics that encompassed "the treasures of Greek and Roman antiquities," studies in Vitruvius, and his observations about the Temple of Artemis at Ephesus.[24]

But with success came sorrow and loss as well. In 1736 Poleni's youngest son, Eugenio, who had been heir to the marquis' family title, died at just eighteen years old. The following year, Poleni's wife, Orsola, and his father, Jacopo—the hero of Vienna—passed away. Within just fourteen months, Poleni had lost his spouse of nearly thirty years, his father, and his youngest child and heir, and his grief must have been profound. Yet from sorrow, and perhaps to keep himself occupied, came the professor's most lasting achievement and legacy, which famously took shape in 1738 as the "physics cabinet" at the University of Padua.

Until the eighteenth century, science was taught in the same way as most other academic topics. The typical classroom lecture featured a professor standing as a lector and reading from a textbook—commonly from Aristotle's observations about the natural world. The lector would then explain and interpret these

passages for his students in what was known as the "Aristote-
lian method" of teaching.[25] But that changed in the 1670s and
in England, with Robert Hooke and Isaac Newton. Because
their scientific achievements and ideas were "regarded as bril-
liant but difficult to understand" and were so hard to convey in
words, the Royal Society of London—based on Hooke's strong
influence—began to pioneer a new way to communicate such
novel concepts. They were demonstrations, rather than recitations,
and these forums quickly grew in popularity at the University of
Leiden, and were "somewhat fewer at Utrecht, Cambridge, the
Institute of Bologna, and the University of Turin."[26] They became
fascinating laboratories for learning, and these performances
required deliberate planning, carefully staged presentations, along
with specialized tools, equipment, and instruments to pull them
all together.[27]

This led to the systematic development of a new kind of class-
room and lecture hall that could showcase these latest trends in
scientific research. It became known as a "physics cabinet" and
in 1738, the Venetian Republic funded the University of Padua
with what was then the most sophisticated cabinet ever built. Poleni
was the logical candidate to kick-start the program and to "set up a
totally new course with a totally new methodology [where he] . . .
was not expected to simply read and comment [from] a text, but
had to present scientific theories and carry out demonstrations at
the same time."[28] It was a demanding role, and Poleni, now fifty-six
years old, was worn out and wary of the offer. He turned it down
at first, saying that "old as I am . . . I did not feel strong enough to
accept such a burden . . . [and] I shall say as the English say, 'let's
see.'"[29] But his hedging did not last long and Poleni, who had never
backed away from a challenge before, agreed a month later to chair
the new department of experimental physics.

Under the professor's direction, the cabinet at the University of Padua became the finest of its kind in Europe. It contained specially designed laboratories and an observation hall with one hundred seats—known as the Teatro di Filosofia Sperimentale—as well as "a large collection of machines of all sorts, made in France, in England, [and] in Holland."[30] At the cabinet inside the Palazzo del Bo, Poleni "carried out various spectacular experiments to catch the attention of his public" and "demonstrated some of the most important scientific discoveries of the seventeenth century."[31] His leadership, creativity, and hard work made Padua a premier destination across Europe for scientists, dignitaries, and everyday visitors alike, and was where Poleni "led his students on a tour of modern theories about matter and motion."[32] But the work was grueling and Poleni was "disturbed . . . by the crowd, by the heat, and by the difficult task of saying and performing while trying to make sure that [the experiments] should come out pleasing and current."[33]

By 1742, Poleni's many accomplishments, achievements, and contributions had made him one of Europe's leading lights in science. His commanding stature would have been readily recognized by Thomas Le Seur, François Jacquier, and Roger Joseph Boscovich, and especially as they were scholars of Newton's *Principia*. Benedict XIV would have known Poleni, too, because of the pope's personal interest in science as well as the professor's high standing at the Accademia delle Scienze. It was no surprise, then, in January 1743, when the pontiff sent *Parere* straightaway to Padua for Poleni's immediate review and reaction. But what came next was less expected, and for the next five years Poleni became an integral part of the solution to fix the cracks at Michelangelo's dome once and for all.

It took a week or so to deliver *Parere* through the driving winter weather to Padua, some three hundred miles north of Rome. At first reading, the professor recognized the mathematicians' creative novelty, and did not disagree with their ingenious blend of scientific principles that had stitched their theory together.[34] But Poleni had a pragmatic side, too, and "he had difficulty in envisaging" that the dome had behaved as Le Seur, Jacquier, and Boscovich had claimed.[35] Namely, he was skeptical that the structure would act as a singular and monolithic unit, and had expected—after reading in *Parere* about the large amounts of movement and dilation—that the cracks should have been more severe along the dome's inner lining.

To test these ideas, Poleni made "his own small model of the whole dome and drum and [then cut] it radially into four sections" so that he could replicate the response to its thrust.[36] This convinced him that there should have been many more horizontal cracks in the dome than there were, and "saw this as a further reason for rejecting" the underlying premise by Le Seur, Jacquier, and Boscovich.[37] But it had not been a fair fight, after all. Poleni's model was based on only four longitudinal wedges (in the shape of a lemon peel), rather than the actual, and far more elaborate, arrangement of thirty-two masonry ribs that were woven together in an interlocking network of stone severies. By "ignoring the fact that there was a vast difference" in their respective models, Poleni had consequently, and from the start, oversimplified and "seriously misrepresent[ed]" the analysis within *Parere*.[38]

These first findings were sent to the Vatican two months later, on March 21, 1743, as described in a ten-page manuscript titled *Riflessioni di Giovanni Poleni Sopra i Danni, e la Ristaurazione della Cupola del Tempio di S. Pietro di Roma* (The Reflections of Giovanni Poleni on the Damage and Restoration of the Dome of St. Peter's in Rome).[39] The paper expressed a few opinions about *Parere* that

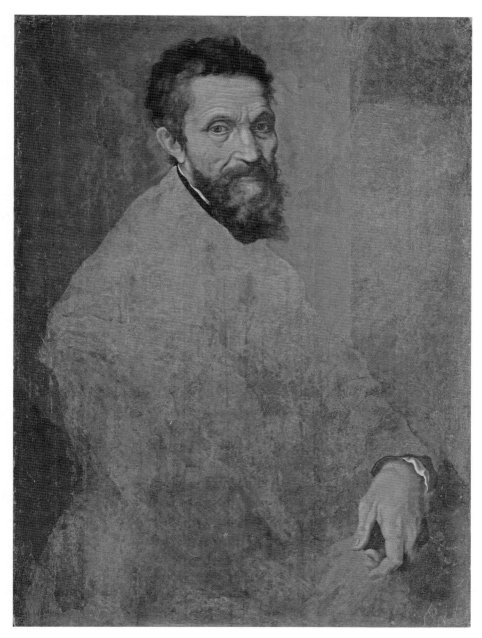

Unfinished portrait of Michelangelo di Lodovico Buonarroti (circa 1545) at age seventy and attributed to Daniele da Volterra. This was painted around the time when the great artist had been appointed by Pope Paul III as *capomaestro* of Saint Peter's Basilica. Note the way that Da Volterra modeled Michelangelo's left hand, and its striking similarity to Adam's iconic pose on the Sistine Chapel's ceiling. This subtlety may have been an intentional tribute paid by one artist to another. *Courtesy of The Metropolitan Museum of Art, Art Resource, New York.*

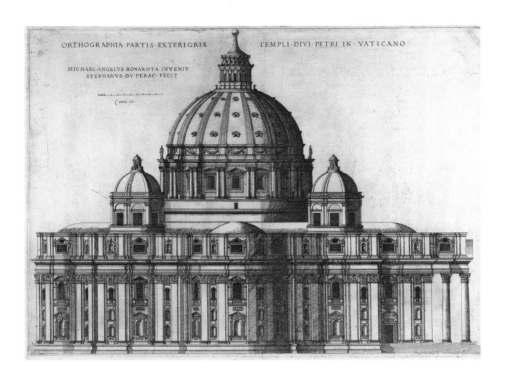

MICHAEL·ANGELVS·BONAROTA·INVENIT
STEPHANVS·DV·PERAC·FECIT

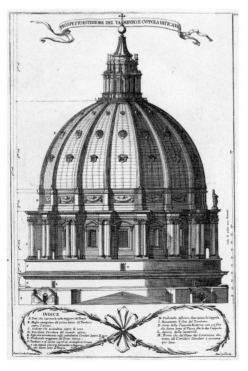

PROSPETTO ESTERIORE DEL TAMBVRO E CVPPOLA VATICANA

INDICE

ABOVE: The south elevation of Saint Peter's Basilica. It was rendered by Étienne du Pérac in 1569 and shows Michelangelo's design around the time of the great artist's death. Note the hemispheric shape of his dome, which was subsequently altered by Della Porta in 1588. The decision to extend the eastern nave around 1610 ruined much of the balance within Michelangelo's architectural intent. *Courtesy of The Metropolitan Museum of Art, Art Resource, New York.* LEFT: An architectural elevation of the dome soon after construction. It was rendered by Alessandro Specchi and shows the notable change in silhouette to an oval shape. This departure from Michelangelo's design required the express approval of Pope Sixtus V in 1588. © *Biblioteca Ambrosiana/ De Agostini Editore/ agefotostock.*

Portrait of Luigi Vanvitelli at age sixty-nine by Giacinto Diano. By this time, in 1769, Vanvitelli was late in life and deep into his design for the Royal Palace at Caserta (*Reggia di Caserta*), near Naples. He was an architect to the Vatican for some twenty-five years and oversaw the dome's repairs between 1742–48. Note the compass in his left hand, which was—and is—an instrument commonly used when drafting a set of architectural drawings. *Used with permission from the Italian Minister of Culture and the Reggia di Caserta.*

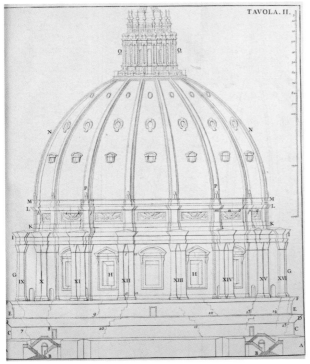

Michelangelo's dome was badly fractured by the spring of 1743, and most notably within its drum and attic. Some cracks were frightening in length and depth, and "wide enough to step through." They were documented and numbered on paper by Luigi Vanvitelli and then presented to Benedict XIV on nineteen drawings that were entitled the *Stato de' Difetti* ("the State of the Defects"). These same drawings were subsequently packaged within Giovanni Poleni's famous book, *Memorie Istoriche*, four years later in 1747. *Courtesy of Getty Research Institute, Los Angeles (85-B17849).*

Many ominous separation cracks had formed beneath the dome's lantern; they were observed along the "unstable" spiral stairway that held the inner and outer shells together. *Courtesy of Getty Research Institute, Los Angeles (85-B17849).*

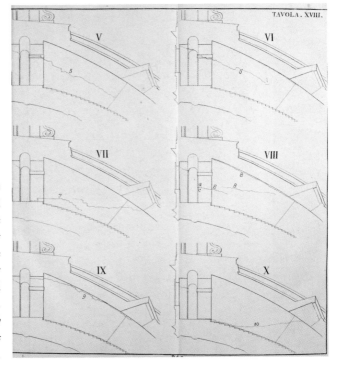

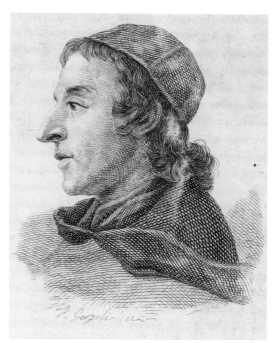

RIGHT: Portrait of Thomas Le Seur, who was an avid Newtonian physicist and the lead author of *Parere*. © *Biblioteca Ambrosiana/ De Agostini Editore/ agefotostock.* BELOW: Portrait of François Jacquier at fifty-three as rendered in the style of Laurent Pécheux. By this time, in 1764, the dome had been safely repaired. In 1739, Jacquier partnered with Thomas Le Seur to publish a commentary to Newton's *Principia* that became famously known as their "Jesuit Edition." The book placed them among the leading Newtonians of their day. © *Lyon Musee des Beaux Arts. Photo by Alain Basset.*

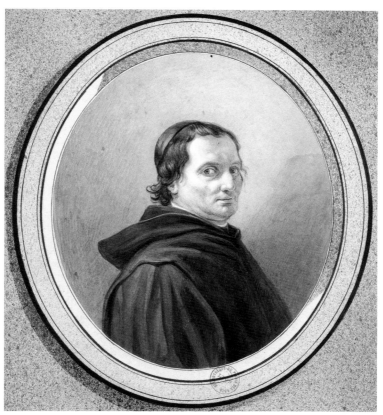

ABOVE: Portrait of Roger Joseph Boscovich, one of Europe's most notable polymaths and scientific minds of the eighteenth century. © *Biblioteca Ambrosiana/De Agostini Editore/ agefotostock.* BELOW: The unassuming title page to *Parere* as prepared by Le Seur, Jacquier, and Boscovich in the fall of 1742. The ideas contained within their thirty-six page pamphlet had thunderous implications and led to a revolution in architectural thought. *Parere* invented the practice of modern engineering, with its imaginative use of applied science and mathematics to solve complex problems in the everyday world. *Courtesy of the Getty Research Institute, Los Angeles (2928-606).*

Portrait of the Marquis Giovanni Poleni, physicist and Italy's leading scientist of the eighteenth century. He taught at the University of Padua for some fifty years, and created there his renowned "physics cabinet." *Courtesy of Science Source / Science Photo Library.*

MEMORIE ISTORICHE
DELLA
GRAN CVPOLA
DEL
TEMPIO VATICANO,
E DE' DANNI DI ESSA, E DE' RISTORAMENTI LORO,
DIVISE IN LIBRI CINQVE.

ALLA SANTITA' DI NOSTRO SIGNORE
PAPA
BENEDETTO XIV.

IN PADOVA. CIƆIƆCCXLVIII.
Nella Stamperia del Seminario.
CON LICENZA DE' SVPERIORI.

Title page to *Memorie Istoriche* which Poleni compiled and wrote between 1743–1747. His book became the model for modern forensic analytics. *Courtesy of the Getty Research Institute, Los Angeles (85-B17849).*

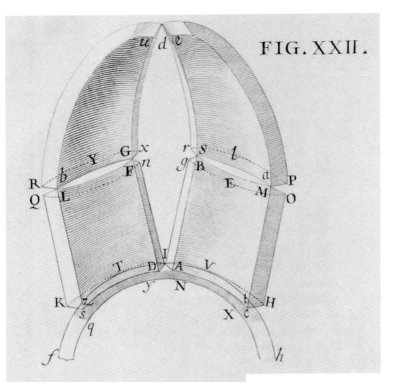

FIG. XXII.

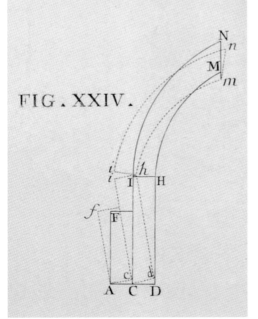

FIG. XXIV.

BOTH FIGURES: Poleni's earliest effort to model the dome's structural behavior was contained in his pamphlet entitled *Riflessioni*. It was published in March 1743, in direct response to the innovative scientific ideas outlined a few months earlier within *Parere*. Before these two pamphlets, thorny problems in construction were solved by subjective intuition. Here, Poleni shows the dome's 'hinge points' as shown in "*Tavola. H.*" inside *Memorie Istoriche*. *Courtesy of the Getty Research Institute, Los Angeles (85-B17849).*

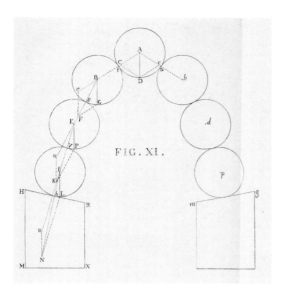

Between 1743 and 1747, Poleni continued to refine his ideas about the dome, its cracks, and its structural behavior. To do this, he borrowed heavily from the inverted catenary curve invented in the 1670s by Robert Hooke ("FIG. XI."). Poleni presented this idea in *Memorie Istoriche*, though he never gave credit to Hooke. *Courtesy of the Getty Research Institute, Los Angeles (85-B17849).*

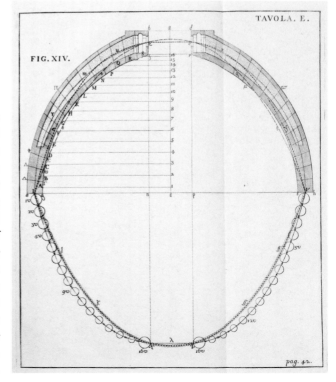

According to Poleni, the dome was never in peril because its thrusting force always remained within the confines of its catenary curve. He was wrong about this. Poleni prepared a visual representation of this concept in *Memorie Istoriche*, and it defined a new way to think about structural stability which we now know as "Limit Analysis." *Courtesy of the Getty Research Institute, Los Angeles (85-B17849).*

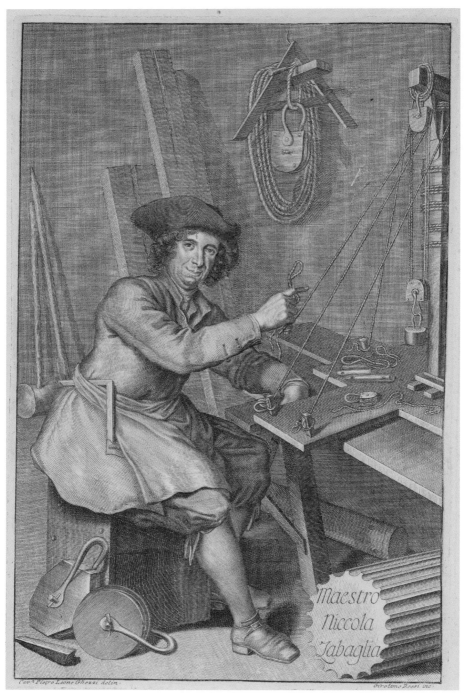

The only known portrait of Niccola Zabaglia. Here, he is shown industriously at work inside his personal workshop at the Vatican's *munizione*. (Opening plate from *Castelli e Ponti*, with etching by Pietro Leone Ghezzi, a noted caricaturist of the day). *Courtesy of Marquand Library of Art and Archaeology, Princeton University.*

Plate XXIV of *Castelli e Ponti*. Zabaglia designed and installed wondrous scaffolds in and around Rome and most famously at Saint Peter's Basilica. Without these scaffolds, none of the repairs at Michelangelo's dome could have been performed. (Etching by Francesco Restagni). *Courtesy of Marquand Library of Art and Archaeology, Princeton University.*

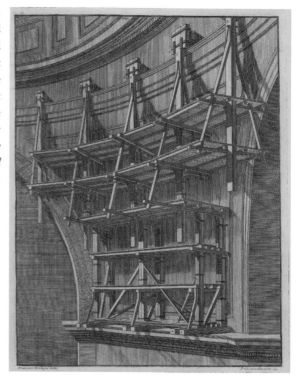

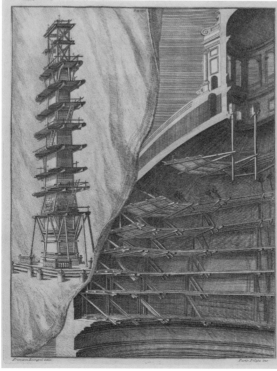

Plate XXVI of *Castelli e Ponti*. Here, Zabaglia's scaffolds are shown to contour the dome's *intrados* (or inner lining). These scaffolds were noted for their ingenuity, heft, girth, and safety. (Etching by Francesco Restagni). *Courtesy of Marquand Library of Art and Archaeology, Princeton University.*

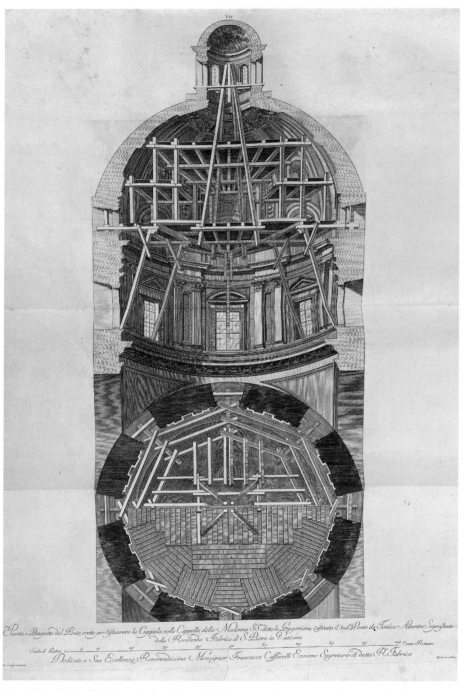

Plate LVI of *Castelli e Ponti*. Zabaglia's scaffolds were revolutionary in design and influenced the practice of construction for 200 years, until the advent of tubular steel framing in the 1940s. (Etching by Francesco Restagni). *Courtesy of the Getty Research Institute, Los Angeles (85-B16478).*

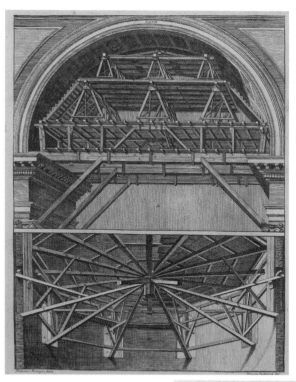

Plate XXVIII of *Castelli e Ponti*. There was an ever-present danger of injury—or worse—when working from such perilous heights at Michelangelo's dome. The *sanpietrini* and other workers on these scaffolds were devoted to Zabaglia because of his attentive focus toward their safety. (Etching by G. Sangermano). *Courtesy of Marquand Library of Art and Archaeology, Princeton University.*

The title page to Zabaglia's masterwork—*Castelli e Ponti*—which showcased his "precious talent as a 'mechanic.'" Zabaglia spent all of his professional life at the Vatican and the book elevated his stature across Europe. It made him an influential best-selling author, though he could neither read nor write. *Courtesy of Marquand Library of Art and Archaeology, Princeton University.*

CASTELLI, E PONTI
DI MAESTRO
NICCOLA ZABAGLIA
CON ALCUNE INGEGNOSE PRATICHE,
E CON
LA DESCRIZIONE DEL TRASPORTO
DELL'OBELISCO VATICANO,
E DI ALTRI
DEL CAVALIERE
DOMENICO FONTANA.

IN ROMA, MDCCXLIII.

NELLA STAMPERIA DI NICCOLÒ, E MARCO PAGLIARINI
MERCANTI LIBRARI, E STAMPATORI A PASQUINO.
CON LICENZA DE SUPERIORI.

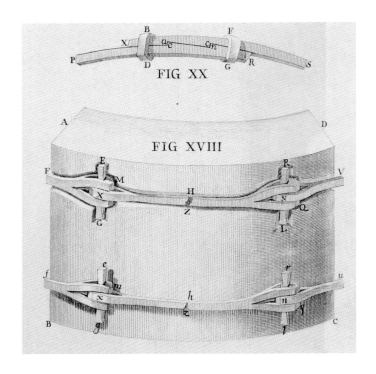

ABOVE AND BELOW: Poleni and Vanvitelli specified that Michelangelo's dome be reinforced and fixed by wrapping five new iron chains around its outside shell. This mirrored the recommendations within *Parere*. These chains were fabricated from the highest quality iron that could be cast and were installed in 1743–1744 ("*Tavola. F.*—FIG XVIII" and "FIG XX," and "*Tavola. H.*—FIG. XXIII"). *Courtesy of the Getty Research Institute, Los Angeles (85-B17849).*

The floor plate of Saint Veronica's Pier, which was built by Bramante between 1506–1515. It lies at the southwest corner of the basilica's crossing which encircles Saint Peter's tomb. Note the circular stairway "D" through which many of the new iron chains may have been hoisted up and into the dome. *Courtesy of the Getty Research Institute, Los Angeles (85-B17849).*

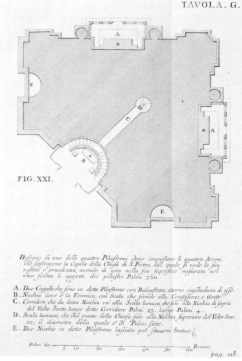

TAVOLA. G.

FIG. XXI.

Difegno di uno delli quattro Pilaftroni dove impoftano li quattro Arconi, che foftengono la Cupola della Chiefa di S.Pietro, dal quale fi vede la fua raftta e grandezza, avendo di giro nella fua fuperficie mifurata nel vivo fenza li aggetti dei pilaftri Palmi 320.

A. *Due Cappelle che fono in detto Pilaftrone con Balauftrata attorno ciafcheduna di effe.*
B. *Nicchia dove e la Veronica, con Scala che fcende alla Confeffione, e Grotte.*
C. *Corridore che da detta Nicchia va' alla Scala lumaca, che fale alla Nicchia di fopra del Volto Santo, lungo detto Corridore Palmi 23. largo Palmi 4.*
D. *Scala lumaca, che dal piano della Chiefa fale alla Nicchia fuperiore del Volto Santo; il diametro della quale e di Palmi fette.*
E. *Due Nicchie in detto Pilaftrone lafciate per fituarvi Statue.*

Palmi 60 8 10 20 30 40 50 60 Romani

pag. 118.

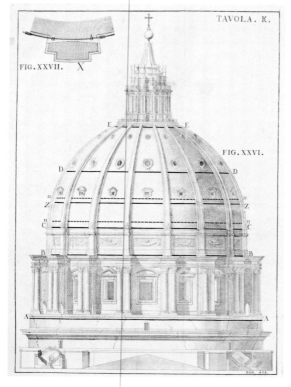

TAVOLA. K.

FIG. XXVII. X

FIG. XXVI.

PAG. 418.

The location of Poleni's five new iron chains were shown in *Memorie Istoriche.* They were installed in 1743–1744 and shown as A, B, C, Z, and D. The sixth iron chain was embedded just beneath the lantern in 1748. The iron chains installed by della Porta from 1588–1590 were shown as dashed lines at locations n, u, and E. *Courtesy of the Getty Research Institute, Los Angeles (85-B17849).*

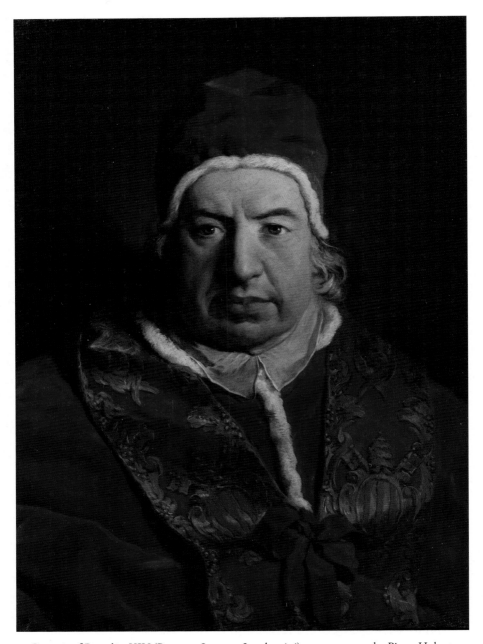

Portrait of Benedict XIV (Prospero Lorenzo Lambertini) at seventy-one by Pierre Hubert Subleyras. It was painted in 1746 and around the time when the dome was under repair. This pope's forward-thinking ideas, intelligence, moral fiber, humor, wit, and warmth made him "without question, the most remarkable occupant of the throne of Saint Peter during the eighteenth century." *Courtesy of The Metropolitan Museum of Art. Image source: Art Resource, NY.*

were mildly supportive, but most of them were not. He thought, for example, how mathematics might be a useful tool when designing a structure from the ground up, but would be less helpful at a damaged building, such as Michelangelo's dome. Poleni rightfully based his premise on the many complicating circumstances that may have caused the damage, such as "earthquakes [and] thunderbolts," along with "natural variations in the resistance of the stones, the faults in their workmanship, [and] the different strength and solidity of the cement."[40] All of these circumstances, he argued, made the utility of mathematics more speculative and less reliable.

Some of the views revealed in *Riflessioni* were a surprise, coming from a seasoned scientist, and an experimental physicist at that. Poleni expressed, for example, that "if it was possible to design and build S[aint] Peter's dome without mathematics, and especially without the new-fangled mechanics of our time, it will also be possible to restore it without the aid of mathematicians and mathematics."[41] Another opinion was particularly startling, when he voiced that "Michelangelo knew no mathematics and was yet able to build the dome. Mathematics is a most respectable science, but in this case it has been abused."[42] Later, Poleni stated what other critics had similarly leveled against *Parere*, which was that the dome should have given out "long ago" had the analysis by Le Seur, Jacquier, and Boscovich been on the mark: "Heaven forbid that [their] calculation is correct. For, in that case, not a minute would have passed before the entire structure had collapsed."[43]

But Poleni had made a fundamental misstep about the dome's behavior. He believed that the small number of cracks inside the dome itself was a sign that it had not moved much, which had thereby convinced him that it was stable and safe for the moment. He then turned his attention to the alarming number of cracks beneath the dome, at the attic and drum, and determined they

had been mostly caused by defective workmanship and building materials.[44] In short, Poleni appeared to believe that there was little relationship between the dome above and the drum below, and that they had behaved as two separate units, rather than an integrated system under duress.

He was wrong about this. The lantern, dome, attic, and drum were indeed part of a single unit acting in tandem, which was an important distinction since the overall system contained a critical defect that had been "baked" into the dome's original design—known as a structural incongruity. It was big trouble and had been lying in wait at Michelangelo's dome since construction began in 1588. The source of the problem lay inside the drum and its dangerously slender dimensions when compared to the sturdy network of ribs above. This was the dramatic, weak link—or incongruity—that was susceptible to, and exploited by, the dome's punishing thrust; a sort of ticking time bomb that had caused the drum and attic to buckle and tear itself apart, in a way that we might now classify as a "soft-story collapse." Le Seur, Jacquier, and Boscovich had recognized the peril of this circumstance, but others were less convinced. Poleni had missed it, too, and this skewed his findings and led him to underestimate the crippling and "real level of damage" to the dome.[45]

Nonetheless, Poleni believed that he had a well-founded basis for his confidence in the dome's integrity. It was steeped in the idea developed in the 1670s by Robert Hooke, who was then advising his colleague, the architect Christopher Wren, on the design of St. Paul's Cathedral in London. Hooke had built a small-scale model of the cathedral's crossing and had then ingeniously draped a length of chain across its diameter. The chain had drooped and sagged to assume a natural, parabolic shape known as a catenary curve, which defined the upside-down silhouette of the cathedral's

future dome. In theory, the chain could then be "dipped in plaster and allowed to set, [so that] . . . when turned right side up . . . 'all the tension forces reverse to become pure compressions with a distribution ideal for masonry.'"[46] According to Hooke, the dome's thrust at St. Paul Cathedral's would follow the contour of his catenary curve and his structure would remain stable so long as this "line of thrust does not fall outside the masonry at any point."[47]

Essentially, the catenary curve was a type of force polygon that was first developed in the sixteenth century. It had helped early physicists to visualize the idea of equilibrium—today we also know it as limit analysis—and as a versatile tool that calibrates how much force a structural system, like a building or bridge, can absorb before it will yield and collapse. Poleni was an early adopter of Hooke's inverted catenary curve and it convinced him that (1) the thrust within Michelangelo's dome had been contained by its double shell, (2) the dire straits predicted in *Parere* had been exaggerated, and (3) the structure was therefore stable and safe.[48]

Despite his confidence, however, Poleni nevertheless saw fit to "place new tension rings" that would prevent further propagation of the cracks and mitigate future damage.[49] Poleni had lyrically likened the tension in these rings to "the cells forming the fibers of muscles" and both he and Vanvitelli believed that the rods could be installed "without any [permanent] modifications to its architecture."[50] Curiously, he did not seem to sense the irony that his recommendation for more rings had represented an implicit agreement with the findings by Le Seur, Jacquier, and Boscovich in *Parere*, nor did he recognize that he had made "initial recommendations for sizes and locations [for these chains], though without giving any basis for them."[51] Given these circumstances, it seemed that even Poleni—the most eminent scientist in Italy—had fallen into the same age-old trap when it came to construction, and had

based his beliefs on tradition, intuition, and subjective judgment, rather than scientific analysis and calculation.

This was the same, stubborn paradigm that Le Seur, Jacquier, and Boscovich were trying to change; but so far, their ideas had fallen on deaf ears.

❧

Benedict XIV received Poleni's early thoughts in April 1743. They clearly struck a resonant chord because the pope invited the professor to Rome straightaway to study the dome for himself. Poleni arrived at the Vatican on May 1, and for the next seven weeks he inspected Michelangelo's dome on eighteen separate occasions while accompanied by Luigi Vanvitelli.[52] By now, Vanvitelli had been reengaged by the Fabricca to perform a more thorough survey of the cracks, and he and Poleni quickly became like-minded comrades.[53] Their inspections showed, for example, that Donato Bramante's four titanic piers and connecting arches were in good shape and fairly free of damage, which made them confident that the puzzle of the cracks at Michelangelo's dome lay within the domed structure itself, rather than its supporting foundation or the soils beneath. They also affirmed their initial views that the problem could be solved in total by wrapping and then tightening five enormous iron chains around the dome's circumference.[54]

Poleni finished his work and returned to Padua on June 19, 1743.[55] At that time, he turned over a report to Benedict XIV titled *Stato de' Difetti* (State of the Defects), which contained Vanvitelli's recent survey of Michelangelo's dome.[56] It also included Poleni's *Aggiunte Alle Riflessioni di Giovanni Poleni Sopra i Danni e Sopra la Ristaurazione del Tempio di S. Pietro in Roma* (The Additional

Thoughts of Giovanni Poleni about the Damage and Restoration of the Basilica of St. Peter's in Rome).[57] The *Aggiunte* reiterated Poleni's position that the dome was not facing imminent peril, though this time with a caveat—namely, that if the cracks at the upper stair, between the inner and outer shells, were not addressed, then the "dome would worsen with time and lead eventually to grave danger if nothing was done."[58] It also specified the precise dimensions for his new iron rods, and that each cross section be about eight square inches though, again, "there was no supporting analysis [and he] merely stated that [the rods] would be larger than the existing chains."[59] Poleni then gave further instructions on how to fabricate and install the rods, along with "the quality of the metal [to be] used and the workmanship in shaping [the chains, which] should be of the highest possible standard."[60] His parting recommendation prescribed that the cracks and fissures be filled with a combination of wedges made from bronze (to minimize rust), "specially cut stones," and fine plaster, once the new rods were in place.[61] In short, the *Stato de' Difetti*, became the framework for future repairs under Michelangelo's dome.

Poleni's report was thorough and well-reasoned, but his *Aggiunte* did not address a critical issue and it is puzzling how he could have missed it. Inside the *Stato de' Difetti* were the nineteen drawings prepared by Vanvitelli during his many inspections in the spring of 1743, and these finely crafted plates showed with graphic precision the hundreds of fissures and cracks that had now damaged the dome, the drum, and the attic. By today's standards, they would have prompted any competent building inspector to immediately close the basilica for safety concerns, yet in the presence of such clear and obvious distress, neither Poleni nor Vanvitelli seemed to be overly alarmed by what they saw.[62]

Benedict XIV had demonstrated a sense of urgency about these cracks from the first moment he learned about them in September 1742. Then, in just nine months, he gathered in a systematic way the best minds and ideas to figure out what had happened and was prepared to use Poleni's *Aggiunte* and *Stato de' Difetti* as the road map for repairs. Benedict XIV had come to trust Poleni and was clearly impressed by the professor's credentials, reputation, experience, and sensible point of view, and decided by the summer of 1743 to pair him with Vanvitelli to oversee the coming campaign to fix the dome.

Upon Poleni's departure for Padua, the pope paid him "a reward amounting to 1000 scudi for the prints [inside the *Stato de' Difetti*] and as a personal thank you." Then, possibly at the suggestion of Giovanni Gaetano Bottari, Benedict XIV commissioned Poleni to maintain a running record of all that had gone on so far under the dome and to continue that process until the dome's repairs were complete.[63] From then on, Poleni and Vanvitelli worked closely together to fix the dome and became good friends while doing it.

In the meanwhile, Bottari had seemed to have gotten his way, too. His campaign to undermine *Parere*—in tandem with the criticism leveled by others—had by now stirred up enough suspicion to ensure that its authors were excluded from any further input or involvement under Michelangelo's dome.[64] But this does not minimize their role, nor the importance played by Le Seur, Jacquier, and Boscovich. Their pamphlet had profoundly challenged the landscape of discussion about the cracks within Michelangelo's dome and had elevated the conversation about why they had formed and how to fix them. The mathematicians had approached the issue in a novel way and with an open mind to try and solve an age-old problem; though misunderstood and maligned, their *Parere* had

provoked an avalanche of intense reaction that was steeped none-theless in technical discussion, rather than intuition and subjective points of view, where before there was none.

Might all these reflections, resolutions, feelings, discourses, supplements, observations, and opinions from some fifteen consultants have been offered without *Parere* as a foil?[65] Did *Parere* specifically motivate these experts to launch their dozens of alternative theories, counter-theories, ideas, and proposals? It is hard to know. But it was clear, nonetheless, that Le Seur, Jacquier, and Boscovich had forced them to confront, head-on and in a new way, the uncomfortable and perilous reality facing Michelangelo's dome. These three mathematicians and their novel ideas had changed the paradigm, causing their critics to think differently about the cracks, and in a way that was more enlightened, even if the critics had not fully grasped these scientific concepts.

In short, *Parere* had ushered in a new world, and within twenty-five years the old ways would vanish. This was its true legacy, and is how *Parere*'s influence should be measured.

But it was one thing to postulate about the repairs and to design the iron rods in theory, and quite another to do the hard work of field construction. These new and finely crafted chains would be difficult to fabricate and perilous to install—some three hundred feet off the floor—and the basilica could not be shut down while the work was under way. Poleni and Vanvitelli needed a talented and inventive expert to lead the job, and fortunately they did not have to look far to find him. He had been a builder at the Vatican for some sixty years, and his recent, best-selling book had drawn admiring reviews and had made him a celebrity of sorts.

9

A MAGICIAN'S TOUCH

Niccola Zabaglia was born into a Roman family of modest means and lineage.[1] Little is recorded about his early life, though we know he did not have much schooling and was hired at fourteen as a common laborer around the Vatican's construction yard, where he worked for the next seventy-two years and for the rest of his life. Zabaglia had landed the job in 1678 when Gian Lorenzo Bernini, foremost sculptor of the Italian baroque, was then eighty years old, having already spent some fifty of them as *capomaestro* at St. Peter's Basilica. His majestic design for its oval-shaped piazza and embracing colonnade had come to shape St. Peter's Square in much the same way as Michelangelo's dome had defined the church next door.

Though Bernini's piazza had marked the end of major construction on Vatican Hill, dozens of other buildings around the papal complex remained in perpetual need of maintenance and improvement. To support this campaign, the area around the basilica, notably along its southern side, had grown into a vast storage yard "equipped with avant-garde organization and technology."[2] The yard contained forges and carpentry stalls, pens to store the

stockpiles of brick and block (today we call them laydown areas), and an assortment of warehouses known as the *munizione*, where spare parts, tools, and equipment for construction were kept in large supply. It extended beyond Vatican Hill, too, where the pope "had exclusive ownership of a river . . . [and] its riverbanks," as well as a port where supplies were shipped, like the travertine blocks from a papal quarry at Tivoli, about twenty miles to the east.[3]

Though it took a few years, Zabaglia's career made a dramatic uptick in the 1690s. That was when the basilica's *capomaestro*, Mattia de Rossi, along with Carlo Fontana—who had just published his sumptuous survey of the church, *Il Tempio Vaticano*—created an elite task force and singled out Zabaglia to perform "several technical undertakings" around the Vatican.[4] For his inaugural assignment in 1695, when Zabaglia was thirty-one years old, he divined a way to ingeniously lift and move an enormous block of red porphyry (a type of granitic rock) dating from Constantine's day, into the basilica as its baptismal font. He had to cobble together a clever assembly of "metal levers, hoists, and tackles" to do it, and in a way that displayed his keen interest in logistics and an intuitive knack for solving the toughest problems in construction.[5] After that, Zabaglia was in high demand at other, complicated jobs around Rome, and they all seemed to entail the delicate lifting and careful moving of a ponderous and exotic object, like an obelisk, from point A to point B. At one of them, in 1703, Zabaglia customized a crane to hoist fifty statues made from travertine to the top of Bernini's colonnade in St. Peter's Square, and perch them on the parapets high above the piazza.[6]

During these years, Zabaglia demonstrated his superb mastery of a process known as staging. It was, and remains, a vital component at every construction project and ensures that the right amounts of labor, material, equipment, and machinery are deployed

when needed around a site. There is a lot of intricate—and often overlooked—advanced planning that is necessary to properly stage a job, and it determines what construction will take place, and in what sequence, and with what methods. The process is fraught with risk because of the long list of logistical challenges that can commonly undermine a project, especially when performed in hazardous places, such as in the middle of a busy street, or underground, or high in the air. Zabaglia understood these realities better than most and was increasingly sought for his diligence, expertise, and choreographic skill in construction staging.

Along the way, Zabaglia began to tinker with the tools, equipment, and machinery of his trade to improve their utility. By now, he was in his fifties and had seen the benefits of gathering a task force of talented workers to collectively take on the most stubborn technical problems around a site. To that end, he formed at St. Peter's Basilica what he called the "school of practical mechanics," and this elite fraternity became known as the *sanpietrini*: a collection of "young people already expert" as carpenters, masons, stonecutters, smiths, and decorators who were "ready and suitable for any job at any time, with no need to get mixed up with [the] architects . . . and outsiders, who . . . tend to delay the work."[7] Membership was exclusive and limited to Zabaglia's son, Pietro; his brother Alessandro; and his nephew Antonio, along with a handful of others he had personally trained and who were "the fittest to go in the air . . . for the tasks necessary for the maintenance of the great church of [Saint] Peter."[8]

Zabaglia discovered his true calling about ten years later, when he invented a network of ingenious scaffolds that brought him international notoriety and defined his legacy.[9] By now, he was keenly focused on safety, too, since he had grown up at the Vatican's construction yard watching, firsthand, "the high risk taken

by workers" and the "several accidents [that] occurred . . . [as] reported by relatives of workers involved."[10] The dividends from all his hard work converged and paid off in 1731, when Zabaglia was sixty-seven years old and tasked to stage the renovations then taking place inside St. Peter's Basilica. These were not easy repairs to make, since the sea of mosaics and paintings that lined the church interior—and needed to be cleaned, repaired, and restored after a century of service—were some fifteen stories off its floor. But Zabaglia was up to the challenge, and he assembled a framework of towering timber scaffolds for artists to easily climb and safely do their work. These structures were unique in their scale, heft, and versatility, which, unlike earlier scaffolding systems, did not need to be dismantled and then reassembled once a section of mural or painting was restored. Instead, his designs could be nimbly moved and repositioned en masse to an adjacent area of wall, so that the work could proceed in a smooth and seamless (and less expensive) sequence of operation, and without any pause.[11]

Necessity inspired Zabaglia to invent a second kind of scaffold. Unlike his tower design, which sat squarely on the ground and was limited in height to about ten stories, his suspension scaffold was far different. It took on the appearance and dimension of a marvelous, floating city of timber that had magically burrowed into the walls and ceilings of the church hundreds of feet above its floor. These illusionary effects of suspension were achieved by the special way he connected his matrix of horizontal planks, called *falconi*, to a supporting framework of diagonal bracing and vertical posts, known as *candele*. Once in place, his system resembled the honeycombs inside a beehive. It was arranged in an efficient, modular configuration with generous dimensions and headroom that allowed workers to readily clamber up and down the scaffold's many platforms, which ran as many as seven stories.[12] His suspended system

offered another clever advantage, too, since it did not obstruct the foot traffic of clergy and pilgrims or impede day-to-day operations inside the basilica. Both of Zabaglia's inventions—his timber towers and suspended scaffolds—were known for their girth and sturdy character that could safely support large teams of decorators, painters, masons, and carpenters at the same time, along with their tools, material stock, and equipment as they worked from dizzying heights above the basilica's floor. [13]

The murals inside St. Peter's Basilica were fully restored in 1734, and after three years most of Rome had by now gotten a firsthand glimpse of Zabaglia's magnificent scaffolds. Their extraordinary and inventive craftsmanship placed him in higher demand than before, and he was recruited to help solve the most specialized and unorthodox staging requirements at projects around Rome. [14] His ideas continued to gather attention and gain traction, and notable architects like Luigi Vanvitelli, Nicola Salvi, and Ferdinando Fuga would have known Zabaglia's distinctive handiwork, which was unlike anything achieved before at a construction site in simplicity, scale, or economy. His ingenious designs were changing the way that builders built and staged their jobs, and in a way that kept workers safe.

La Fabbrica di San Pietro in Vaticano was so impressed by Zabaglia's "precious talent as a 'mechanic'" that it rewarded him with a dedicated workshop inside the *munizione*; he made small-scale models for his magnificent scaffolds there, along with prototypes for his hoisting machines, and then tested them for their fitness in the field. [15] The Curia took note, too, particularly from Lodovico Sergardi as well as Lelio Cosatti, a mathematician and acquaintance of Pope Benedict XIV. (This was the same Cosatti whose harsh criticism had helped to swamp *Parere* and its authors Thomas Le Seur, François Jacquier, and Roger Joseph Boscovich.)

These two had recognized Zabaglia's achievement as an opportunity to showcase the Vatican as a progressive institution and nudged him to publish his masterworks, for which they became ardent sponsors and champions. [16]

Zabaglia's book was printed in Rome in an oversized format that was bursting with brilliant etchings and illustrations. It was titled *Castelli e Ponti di Maestro Niccola Zabaglia con Alcune Ingegnose Pratiche e con la Descrizione del Trasporto dell'Obelisco Vaticano e di Altri del Cavaliere Domenico Fontana* (Castles and Bridges of Master Niccola Zabaglia with Some Ingenious Practices and a Description of the Transport of the Vatican Obelisk and Other Items of the Knight Domenico Fontana).

This first edition included a *prefazione* (preface), which included the only known portrait of Zabaglia, shown industriously at work inside his workshop, and as executed by the painter and caricaturist Pietro Ghezzi. Then came the fifty-four plates that were etched in near-photographic detail to showcase the many inventive ideas introduced by Zabaglia over the long arc of his career. These images demonstrated how the Scientific Revolution was changing the world of construction, while celebrating at the same time the traditional skills, grit, and acrobatics of its workers, as they were climbing ladders, hauling stones, and cleaning monuments. [17] The book featured a rich variety of tools, ropework, hoists, hardware, techniques in carpentry, and "a fascinating assortment of the scaffolds invented by Zabaglia." [18] Explanatory captions in both Latin and Italian accompanied each plate (*Spiegazione delle Tavole*), as written by Sergardi and Cosatti, since Zabaglia could neither read nor write.

The imagery in *Castelli* were works of art on their own merit, and the book drew glowing reviews from its readers. It elevated Zabaglia, who was now seventy-nine years old and "well-known

and beloved by [the] common people," to a status of celebrity.[19] *Castelli*'s influence cannot be overstated, since it provided guidance in construction that was commonly referenced in Europe and the Americas for the next two hundred years. It remained popular for decades, and when demand called for another printing eighty years later, in 1824, it was expanded by six plates to show some of the newer scaffolds built by Zabaglia's best students.[20] This second edition "was as successful as the previous one" and now included "the biography of the life and work of Zabaglia compiled from the clear memory of lawyer Filippo Maria Renazzi, deputy secretary of the reverend Fabbrica of Saint Peter's."[21]

Call it chance or call it fate, but either way *Castelli* was published just as Pope Benedict XIV was deliberating over his next move at Michelangelo's dome. Given Zabaglia's long experience and recent notoriety, it was no surprise when in the summer of 1743 the pope recruited him to install the iron rods prescribed by his chief scientist, Giovanni Poleni, and chief architect, Luigi Vanvitelli, to stop the cracks. But what Benedict XIV may not have fully grasped was that Zabaglia was not simply the most qualified to do the work—he was the *only* one with the necessary skill and experience for the job. It would not be easy and there were no guarantees of success, but the grizzled veteran with sixty-five years' experience at the Vatican's construction yard agreed to try.

Benedict XIV had by now earned high marks for the clarity and direction he had brought to the project. He had solicited and sifted through a dozen different ideas that had theorized the cause of the cracks inside Michelangelo's dome and then cobbled together a team of experts who he thought could fix them. Some of these ideas

had been more helpful than others, but there was little doubt that Benedict XIV was the guiding hand behind the operation. That he had shepherded the process in nine short months, from September 1742 to June 1743, was equally impressive, given the slower pace of life then and the winter weather that would have hampered communication among his consultants during this period.

The pope had tasked Poleni and Vanvitelli to oversee the project, and these two had jointly developed a traditional strategy to stop the cracks and stabilize Michelangelo's dome. They intended to wrap five more horizontal bands of iron around the dome's circumference and entomb them within the fabric of the massive masonry shell. Each iron chain would be made from as many as thirty-two bars, and each bar would be fabricated with an oval-shaped eyebolt at either end, which would fasten to its neighbor with a vertical pin, also made from cast iron.[22] Once the bars were in place and assembled, the pins would be wedged and tightened "by hammering, so that each part of the hoop [was] equally pressed" to stabilize the circumferential stonework and prevent the dome's thrust from pushing and pulling the structure any further apart.[23]

At this stage, in July 1743, Poleni had not yet returned to his laboratory in Padua. Therefore, it is not clear how he determined that five additional rings—with a cross-section of about eight square inches each—had the requisite heft to stabilize the dome.[24] That the professor's design was not so different from the one proposed by Le Seur, Jacquier, and Boscovich, which had been steeped in mathematics and scientific theory, suggests that *Parere* may not have been as far off the mark as its critics, including Poleni, had emphatically asserted (though none would have acknowledged it). Moreover, he and Vanvitelli had by now recognized that the base of the dome, its drum and attic, was a weak link that needed to be stabilized and strengthened straightaway. Accordingly, they

specified their first and second iron rings be installed at the bottom of the drum and of the attic, respectively. The remaining three rings would wrap around the dome's outer shell, at its base and then at third points in height.[25] Again, this was consistent and in tacit agreement with *Parere* and its premise that the dome's thrust had torn through the entire structure, which was why the drum was so badly battered and the attic so severely bruised.

This problem was not new. Many corners of medieval France, Great Britain, and Germany had invented an effective way to buttress and counterbalance the large thrusts encountered at their buildings. Today, we use the term *Gothic* to describe these structures in stone and their aesthetic elegance, dramatic effect, and economy of design. But the Italians, and most of all in central Italy, held a strong preference for their more classical Latin traditions and expressed "skepticism about—indeed a polemic against—Gothic architecture."[26] This antipathy and suspicion had been vocalized two hundred years earlier by Giorgio Vasari, architect and friend to Michelangelo, who had particularly harsh words for this northern European manner of construction. He called it a *maledizione di fabbriche* (an accursed building style) and equated its features and ornament with the Germans and their predecessors, the Goths.[27]

Though the Gothic movement is now highly regarded and rightfully admired, the term was initially intended as a pejorative to disparage the northern tribes whom the Italians had perceived as barbaric, and most "especially those who crossed the Alps into Italy after the collapse of the Roman empire."[28] In order to avoid these unpleasant historical associations, many parts of Italy adopted and pioneered the use of iron hoops, rather than the pointed, stone arch work to absorb the powerful thrust at their buildings. These iron rings acted like the staves of a barrel to resist its outward pressure and had been successfully used as structural reinforcement at

towers and domes for centuries, such as Basilica di San Marco in Venice, the Duomo in Florence, Basilica of Madonna dell'Umiltà in Pistoia, the Basilica di Santa Margherita in Montefiascone, and the Torre degli Asinelli in Bologna.[29] The rods that Poleni had prescribed at Michelangelo's dome were the same in character but would face a thrusting force that was far more amplified, punishing, and potentially damaging.

But before they could be installed, an organizational structure of authority had to be established at the project. Benedict XIV had the ultimate sway, but as the head of state he had other pressing items to occupy his time and would have little involvement beyond occasional briefings and visits to check in on progress. Instead, the pope delegated the oversight to Vanvitelli and the Fabbrica's director, Francesco Olivieri, along with another Vatican architect, Filippo Barigioni. They, in turn, would coordinate the day-to-day operations with Zabaglia and Filippo Valeri, who was the *fattore* (project manager) and "person in charge for managing staff and materials" at Michelangelo's dome.[30] These five formed the team who, along with Poleni, made all the major and minor decisions about the job, not knowing with certainty whether their plan would work and if the cracks could be stopped.

The daily records and details of construction that followed is "in part still obscure," yet we know enough to piece together how the team intended to stage the project, set the scaffolds, sequence the work, and install the large quantities of material stock needed to execute the job.[31] The hoops alone, and their fittings, required a lot of advanced planning and oversight as they were forged, cured, and carted to Vatican Hill. Then there were dozens of other logistical details to resolve, like the techniques to hoist each bar some three hundred feet (or more) onto Zabaglia's suspended scaffolds, from where each piece would be individually

set into its custom-fit cavity inside the dome. This small core of experts was collectively responsible for every technical, administrative, and financial aspect of the project, and would direct dozens of workers in their valiant race to save Michelangelo's dome. Despite these best efforts, there remained the sobering reality that the most important ingredient to their plan—the iron chains—was also the most temperamental. If not properly batched, these hoops could fracture and fail, and because of the way they were fabricated at the forge, this remained a distinct and worrisome possibility.

<center>❧</center>

Metallurgy has a long, rich, and complicated history that began with the native minerals in the earth. Metals come in many varieties—such as aluminum, copper, iron, nickel, tin, titanium, and zinc—and each have different physical and chemical characteristics. Some have been long coveted as monetary currency, such as gold and silver; others, like magnesium and zinc, offer medicinal benefits; while many can be shaped into tools and used for weaponry, such as copper, iron, and titanium. Some five thousand years ago it was learned that tin and molten copper, when mixed in just the right amounts, formed a resultant metal (or alloy) called bronze, which was far more durable and useful than either base metal. The next few thousand years defined the Bronze Age, which shaped civilization and the swords and plows that made day-to-day life in those times far easier for men, women, and children everywhere.

More tinkering led to a similar discovery, but this time with iron, which was more plentiful than copper. When iron ore was blended with another abundant earth element—carbon, which came from a charcoal fire—the residual metal became "harder, more durable, and [held] a sharper edge than bronze."[32] This was

how the Iron Age began, and it became the gateway for centuries of explosive economic growth and industrial achievement. But since iron melted at a far higher temperature than copper, it could only be extracted in a cumbersome, two-stage process called smelting. The outcome produced a "lumpy, glowing hot coral" known as a bloom that a blacksmith could then heat in a forge and then hammer, from which wrought iron was created.[33] Though superior to bronze, wrought iron was slow, painstaking, and expensive to make and could only be batched in small quantities.

But this changed in Europe during the fifteenth century, when the first blast furnace was invented.[34] It altered history because of the large quantities of molten iron ore that could now be heated at once inside a foundry. The liquid iron trickled into troughs that "resembled a sow suckling a litter of piglets," from which the term *pig iron* was born.[35] It was also known, less lyrically, as cast iron, since the molten metal was stored in vats, or casts, where the iron solidified into billets (or ingots), which could be subsequently reheated for shaping. It revolutionized the production process for making iron but also introduced a new and unintended consequence along the way, since the high heat trapped far more carbon and other harmful impurities (like sulfur and phosphorus) in the molten liquid. This dramatically changed its chemistry and made the material more brittle—and there was never a good time for a sword to shatter in battle or for an axe to splinter in the forest. The extra carbon also reduced the iron's tensile strength, which was especially worrisome at Michelangelo's dome since its new hoops would be pressurized in tension by thousands of tons of thrust.

A lot of scientific experimentation went toward finding a cure for this fatal flaw during the eighteenth century. It led to the invention of steel, which added "enough carbon to make it harder than wrought iron, but not so much as to make it as brittle as cast

iron."[36] Steel was first fabricated in England during the 1750s, just after the new rings had been encased within Michelangelo's dome; it, too, was a slow and expensive process that could only be batched in small amounts, called crucibles (and was known as *crucible steel*). It took another century before Henry Bessemer discovered a new way to reliably produce low-cost and high-quality steel at an industrial scale, using his famous invention known as the Bessemer process.

Hence, steel was not a viable option when Poleni and Vanvitelli specified some thirty-seven tons of iron for the new stabilizing hoops at Michelangelo's dome (whose combined weight was roughly equivalent to eleven midsize automobiles).[37] Theirs would be made from cast iron, instead, and forged "from the papal foundry in Conca, nowadays known as Borgo Montello, near Nettuno," some forty miles south and east of the Vatican.[38] In the 1740s, there were a few pontifical foundries within the Papal States, and they each made different kinds of products. For example, the Pontificia Fonderia di Marinelli in Agnone—about 125 miles east of Rome—was among the oldest, and was known for its fine crafting of bells and decorative ornaments. Since the new rings from Conca would be fabricated over many months, their batching would need to be carefully balanced to ensure the same chemistry for each bar and each fitting. These components were critical to the mission and had to meet the highest quality standards then available for iron, so that each link of the chain was as homogenous and consistent as its neighboring bar, to reliably resist the punishing thrust from Michelangelo's dome.

Production of the first and bottommost ring began in June 1743, soon after Poleni left Rome for Padua. This was another clear sign of Benedict XIV's sense of urgency about the dome and his concern

for its stability. It also underscored the odd dichotomy that had marked this episode for the last six months; namely, that on the one hand, Benedict XIV had seemed to agree with the dire predictions described in *Parere*, while on the other he had entrusted the project to Poleni and Vanvitelli, who were less grim about the potential for peril.

The cast-iron bars and fittings for the bottom ring were loaded onto carts at the Conca foundry and then hauled to the Vatican's construction yard, where they arrived on August 3, 1743.[39] This was the largest of the five hoops, with a circumference of roughly 570 feet—or nearly two football fields stretched end to end—and weighed about nine tons when the eye bolts and connection ties were included.[40] Next, the ring was preassembled, with each piece lain on the pavement of St. Peter's Square.[41] This was a critical part of the operation, since any defect in forging needed to be proactively spotted and remedied while on the ground to ensure a proper fit before lifting the bars high into the dome, when it would far more difficult to fix. The work to stabilize the drum and attic moved forward once the bars for the second and slightly smaller ring arrived at St. Peter's Basilica a few months later.[42]

Zabaglia needed about seventeen stout workers and four months to assemble his scaffolds around the inner face of the drum, and by now he had had years of experience under Michelangelo's dome and was familiar with its many nooks and features. He had, for example, likely been part of Vanvitelli's initial inspection team in 1742 and had also built scaffolds "without disfiguring the walls with holes" a year later, so that the "Marquis Poleni could inspect the cracks."[43] With the new scaffolds in place, the masons began to stage their work inside the drum and "draw the outline" for their circumferential wall cavities, where the iron chains would soon be lodged, tightened, and entombed.[44]

Their installation began in the winter of 1744, when each of the thirty-six bars were lifted by hand from the construction yard at St. Peter's Square and into the basilica. They were then winched and hoisted to the basilica's rooftop terrace, likely from within its spiral stairway at the north transept.[45] By now, the masons had fully mobilized and were busy, high up on the platforms of Zabaglia's magnificent scaffolds, sculpting the cavities where the iron bars would be laid. It was a carefully choreographed process of targeted demolition, taking place some 250 precarious feet above the basilica's floor. Once the housing was carved around the drum's inner face, the iron bars were carried from the outside terrace and up a short flight of stairs that fed into the dome's vast interior; from there, the chains were winched up and onto the suspended scaffolds.[46] Bar by bar, each chain was meticulously laid out in a long horizontal arc around the drum's circumference, wedged together to its neighbor by an eye ring and iron pin, which were then hammered tight.[47] Once the bars were snugly in place, its cavity was filled and sealed with bricks, blocks, and mortar, then covered over with panels of travertine to protect the iron from weather and keep it from rusting. It took four short months to install the first two hoops with these techniques, and the drum and attic were finished by March 1744.[48]

Now the team turned its attention to the dome itself. Work began on these third and fourth chains without any pause and followed the same methodical process as before. An added complication was that these next rings were staged some fifty feet higher—and three hundred feet off the floor—which made the scaffolds more daring and daunting to install. But Zabaglia and his crew pulled it off without an apparent hitch, and these next two hoops were fully assembled, again in four months, by July 1744.

Because of the high stakes, those who labored on Zabaglia's sturdy platforms were among the best in the business. This was the

most renowned church in the world, after all, and the unique aspects of the job and the opportunity to work alongside the *sanpietrini* to fix Michelangelo's dome was a badge of the highest prestige. Too, these workers possessed specialty skills that were harder to find, so they were therefore likely to have been better paid than their peers at other projects.[49] But then again, their higher pay may also have been due to the peculiar hazards and uncommon risks of working inside the dome and from great height. This was a business, after all, that was (and remains) among the most dangerous way to earn a living and where, statistically, its workers died at a comparatively young age.

Life on these scaffolds was a kind of fraternity. The workers developed a close bond among themselves that came from the daily camaraderie, conversations, horseplay, needling, off-color jokes, and taking of meals that were all shared in confined quarters and at dizzying heights. While we can admire their élan, we cannot, however, fully appreciate the risks and the dangers that they faced. Like their peers at other projects, they wore no protective gear and donned felt caps, rather than today's hard hats, and ordinary shoes compared to modern, steel-toed work boots. Their loose-fitting shirts and trousers allowed for flexibility in movement, but could dangerously snag, too.[50] Their physical strain and exertion was enormous, and they often toiled in uncomfortable and contorted positions that required climbing, crouching, kneeling, leaning, and stretching for hours each day. There were no safety goggles to protect their eyes and no electricity to power their tools and lanterns.[51]

Ultimately, what separated this project from any other, anywhere, was its sheer and terrifying height. While the workers on Zabaglia's platforms may have grown accustomed to the high altitude, and may or may not have worn a leather safety harness, there were no railings, screens, or protective nets beneath to break a slip or a fall.[52] As a consequence, it was imperative that they always

keep their heads clear, and so their wine—a basic staple that was often safer to drink than water—was likely diluted by at least a third. [53] With or without these precautions, injury (or worse) was a real and ever-present risk, and when it happened these workers had no medical or disability insurance to protect them or their dependents. Subsequently, it is easy to understand their deep devotion to Zabaglia and his keen and paternal interest for their safety.

In the meanwhile, the repairs continued and advanced in the fall of 1744 toward its fifth and final ring, now 330 feet off the ground. At this height, the Statue of Liberty—as measured from the base of her pedestal to the tip of her torch—would have comfortably fit beneath Zabaglia's scaffolds, and with headroom to spare. Benedict XIV had seemed well pleased with the progress, and though he had undoubtedly visited and admired the site before now, the first written report of an informal papal inspection did not occur until mid-September 1744, as the fifth ring was under way. At this stage, Zabaglia had erected some adjacent, suspended scaffolds, too, so that the cracks and lesions around the dome's inner lining could be repaired and sealed. His last chain was firmly in place by December 1744, eighteen months after the project had started, coinciding with the patching and crack repairs that were taking place elsewhere within the dome and drum. [54] Though in hindsight it had seemed so clinical and straightforward, the operation was uncertain, hazardous, and not for the faint of heart. There were many opportunities for mishap at any moment while casting the rings, assembling the scaffolds, hoisting the bars, carving the masonry, tightening the rings, and patching the drum. Everything about the project was tailored and unique, and each piece of iron and crevice of brick and block had to be custom fit. There was also the sobering reality that these rings and the effort to install them may not, after all, have been sufficient to keep the dome from

cracking. Nothing like this had been tried before and at such a Herculean scale, and there was no guarantee of success.

The uncertainty aside, none of this could have been achieved without Zabaglia. His steady influence and spritely demeanor at age eighty had by far outpaced the impact of any other architect, mathematician, or scientist at the job and, rightfully, his effort did not go unnoticed. Benedict XIV rewarded Zabaglia with a sizeable cash bonus of one hundred *scudi d'oro pontificio* when the job was complete.[55] He and his crew then dismantled the magnificent scaffolds and in a way that was characteristic of the man: workmanlike, methodical, and without fanfare. Each scaffold was removed, plank by plank, along with the hoists, ropes, winches, blocks, pulleys, and assortment of hand tools that went with them, and then carefully lowered onto the basilica's floor. From there, the equipment was carted back inside the *munizione* and stored, waiting for the next special project on Vatican Hill, wherever that might be.

Benedict XIV had done it. He had shepherded a problem of titanic dimension and in twenty-seven months had hopefully (and prayerfully) saved Michelangelo's dome from disaster. This far-sighted pope had recognized a terrible risk that others had seemingly ignored and then took up the challenge to solve it. He sought out and assembled an experienced and talented team with the best qualifications he could find in Poleni, Vanvitelli, and Zabaglia, and they had masterfully executed their plan. But the circle of credit went beyond this, too, and extended to the foundry in Conca, the *munizione* at St. Peter's Square, to the peak of the dome itself, and to every carpenter, blacksmith, mason, ironworker, plumber, and common laborer that had helped to realize this remarkable mission

without serious misstep or mishap. It had been a testament to leadership, innovation, teamwork, collaboration, and most notably to Zabaglia, who at an advanced age had accomplished his pinnacle achievement within a long and legendary career.

But the success was superficial and illusionary, after all, until many nagging and lingering questions could be answered. Had the five iron rings been properly batched? Would the chains really work as intended? What if the cracks returned? These kinds of hoops may have been successfully deployed at other sites in Italy, but not at such a monumental scale or with higher stakes than this.

In short, no one knew or could predict whether the iron rings at Michelangelo's dome would perform as intended. Instead, they could only watch, wait, pray, and hold their collective breath.

10

THE MEMOIRS

There was a rich tradition on Vatican Hill that had seemed to start in the eighteenth or nineteenth century and is regrettably no longer practiced. It held that, on certain special and solemn occasions, St. Peter's Square would be draped "in festal red hangings" and then lit up in a spectacle of "flickering flames" and the "living glow of candlelight."[1] Photographs of the pageantry from the 1930s show one of these spectral events, where every interior alcove, archway, pier, and pendentive of the church was shown off like the elaborate stage set of an Italian opera. They featured thousands of lanterns outside the basilica, too, which accentuated the stately columns, entablatures, and pediments surrounding St. Peter's Square. But the most magnificent display was reserved for those torches that lit up Michelangelo's dome, from the base of its drum to the tip of its lantern, some 450 feet above the pavement. The torches were arranged in ten horizontal tiers that neatly encircled the dome's silhouette, and each torch sat on a bracketed plate made of bronze. Hundreds of these plates were affixed to the dome's sixteen vertical ribs, and they are still plainly visible today to observant visitors.

All told, these magical light shows at St. Peter's Square were created with some nine hundred torches, five thousand lanterns, and candelabras that were too many to count.[2] They were positioned and staged from dizzying heights, and each fixture was carefully installed and then lit, one by one, by that same elite task force—the *sanpietrini*—first established by Niccola Zabaglia. They had been an intrepid fraternity from the first day Zabaglia had thought up his "school of practical mechanics" in the 1720s, and this group's legacy and bravado had only grown through the decades. The aerial acrobatics of their membership were legendary, and the *sanpietrini* were commonly seen swinging, careening, and staging their work from hundreds of feet above terra firma, often from a trapeze made from a simple chair of timber plank, to perform any and every kind of repair or unique improvement at the basilica.[3] For this reason, lighting the lamps for these special shows at every balcony, colonnade, parapet, and rooftop in St. Peter's Square was, for them, another ordinary day on the job. But they reserved their most dramatic maneuvers, by far, for Michelangelo's dome, where they were seen to rappel its sixteen stories and steep elliptical outer shell, like mountaineers, to ignite the torches, from the peak of the lantern to the base of its drum, without the assurance of protective nets or safety gear beyond their singular rope line.

Rust marks from the torch plates show that the dazzling light shows at St. Peter's Square were in full force after 1870. Though the tradition may have started before then, the larger point is that these *sanpietrini* were the ones most likely to perform this same maneuver at Michelangelo's dome after Zabaglia had finished his repairs years before, in 1744, and to inspect at close range and as a first line of defense any visual evidence of fresh cracking in the dome, drum, or attic.

These inspections by the *sanpietrini* assume a heightened relevance since there is a gap in the written record after Zabaglia had dismantled his scaffolds and stored them in the *munizione*. There are invoices, for example, at La Fabbrica di San Pietro in Vaticano's historical archive—known as L'Archivo della Fabbrica di San Pietro—that show some work taking place under Michelangelo's dome around this time, but they are relatively few and nondescript.[4] The Archivo had been established in 1579, fifty years after the Fabbrica was established and a decade before Giacomo della Porta vaulted the dome. It is a rich repository that contains a vast assortment of construction documents, ranging from contracts to drawings to pay stubs, and was initially (and optimistically) set up to adjudicate disagreements and disputes lodged by builders at St. Peter's Basilica.[5] Accordingly in this instance, the absence of information between 1745 and 1747, and where few observations, reports, conversations, or findings seem to have been recorded suggests little, if any, concern and nothing out of the ordinary taking place under Michelangelo's dome. This is noteworthy at a place like the Vatican, where every facet of construction for the last two centuries had been so fastidiously papered for posterity. It provides a sound basis from which we today can reasonably deduce that the *sanpietrini* found no further cracks in the dome, and that the new iron rings had held firm.

Poleni's solution had seemed to work as intended after all.

But then came the snag.

❧

There was nothing new about using an iron chain to strengthen a dome made of bricks, blocks, and mortar. It had been common practice in central Italy for hundreds of years and Della Porta

and Domenico Fontana used the same technique when vaulting Michelangelo's dome in the 1580s. They had embedded five such chains (called *cerchi*, or circles), and three were sealed into the bottom half of the dome in 1589 as the pace of construction had accelerated.[6] These early hoops were made from sixteen bars that spanned the dome's sixteen ribs, and each had a cross section of iron that was about four square inches. A year later, Della Porta installed two more rods at the peak of the dome as construction was nearing its end. These upper rings were staged from scaffolds some thirty-six stories above the pavement of St. Peter's Square, and each were made from thirty-two bars that were about 170 feet in circumference (or half a football field, from end to end).[7]

Though the details are not clear, we can nonetheless piece together what happened in 1747, about 150 years later. That was when a routine inspection of the dome, likely by the *sanpietrini*, revealed that one of Della Porta's uppermost chains was "broken" and had severed, either in part or in whole, making it unfit for use.[8] On the one hand, this was good news, since the fracture was not fresh—possibly caused by a lightning strike—and, in the absence of surrounding damage, was another clue to demonstrate how Zabaglia's recent repairs had taken root to successfully stabilize the dome.[9] But on the other hand, Della Porta's ruptured ring was sited at the peak and least accessible part of the dome, and any effort to repair or replace the damaged chain would be a delicate and dangerous operation performed at a perilous height.

News of the ruptured ring was quickly communicated to Luigi Vanvitelli, whose job as chief architect was to figure out the next move. Sensibly, he assumed that both of Della Porta's older chains around the lantern had been compromised, and specified they be replaced, as "compensation" by a new, singular, sixth iron hoop.[10]

This prompted the Fabbrica to place a rush order to the papal foundry in Conca for three tons and thirty-two more bars of the highest quality cast iron that it could fabricate. They were carted to Vatican Hill a month or two later, and then preassembled on the pavement of its square to ensure their proper geometry and that the metalwork was free of defects.[11]

In the meanwhile, Zabaglia was recommissioned to dust off his tools and equipment inside the *munizione* and put back to work under Michelangelo's dome. Zabaglia was in his mid-eighties now, and as he stared up at his next assignment some thirty-six stories off the basilica's floor, saw no need to stray from his formula for success. He intended to install this sixth ring with the same staging techniques from four years earlier, and his experienced team of *sanpietrini* promptly burrowed their distinctive scaffolds deep into the facing of Michelangelo's inner, hemispheric dome. They then hauled the new iron bars from the nearby stockyard into the church, and hoisted the rods to the roof and onto Zabaglia's suspended platforms at the uppermost reaches of Michelangelo's dome.[12] For context, this sixth hoop was entombed, tightened, and sealed into the brick and block before the invention of elevators or the evolution of skyscrapers, which were more than a century into the future. In this way, Zabaglia and his team in the 1740s were among the true pioneers of high-rise construction: performing delicate work at dizzying height, where only a few tradesmen had been known to climb in five thousand years of recorded history.

※

Six years and six hoops later, the job was done. Zabaglia and his team had patched the last wall for the last chain, then unceremoniously lowered their tools and equipment to the basilica's floor.

Next, they dismantled their magnificent scaffolds, plank by plank, and neatly stacked and stored them (again) for future use inside the *munizione*.[13] Zabaglia had pulled off another seamless operation with precise execution and without misstep or injury. Though there may have been less fanfare surrounding this sixth (and hopefully final) ring, it did not diminish Zabaglia's effort, impact, or achievement. The cracks had not returned, and Michelangelo's dome had been seemingly stabilized and spared from further damage and potential catastrophe. Everyone with a role to play—from the Fabrica to the architects to the foundry labor to the carpenters—had contributed in their own helpful and distinctive way. After years of uncertainty and apprehension, they had collectively solved at the end, in 1748, what had seemed so elusive and unsolvable at its beginning, in 1742.[14]

Since the cracks were no longer a going concern, Pope Benedict XIV could shift to face more pressing items of the day. The world had moved on, after all, and the repairs to Michelangelo's dome, though urgent at the time, had also been a concentrated and costly drain to the Vatican treasury, which was then facing a vast deficit. This financial burden, when combined with the shortfalls inherited from his predecessors, motivated Benedict XIV to institute a heavy dose of financial reforms within the Curia. Under the circumstances, it is fortunate that Benedict XIV "was totally free from ambition and the desire for personal splendor, as otherwise the monetary affairs of the Papal States would have fallen into irrevocable decay."[15] Yet, even then, there were incessant pressures on this pope to economize, primarily because of the "troop movements of one European army or another" on Italian soil, which had been precipitated by the War of Austrian Succession.[16] It was a misnomer that was a part of the latest, century-long tussle between England and France, and this current episode had erupted

in 1740, four months after Benedict XIV's coronation. The fighting went on for eight years and over a broad geographic expanse, but was particularly vicious inside the defenseless Papal States, which had hollowed out its economy and caused, by extension, Vatican revenues to plummet.

In 1748 the Treaty of Aix-la-Chapelle ended the war. It relieved the financial strain placed on the Papal States and gave Benedict XIV some latitude "to spend a little on affairs of art, architecture, and learning, matters [for] which . . . a certain public magnificence was demanded."[17] In this role, he made important contributions, by expanding the collections of the Capitoline Museums in Rome, which was the first modern and pathbreaking public museum of art in the world. He also founded the adjacent Gallerie de Quadri (now the Pinacoteca Capitolina, or Picture Galleries) and filled it with a rich assortment of Renaissance and baroque paintings along with a long legacy of Italian antiquities.[18]

The full burden of the papacy's heavy mantle descended and draped around Benedict XIV's shoulders after Michelangelo's dome was repaired. By then, in 1748, he "was beset . . . by incessant work of every kind, work that called for careful planning and concentrated thought . . . [and] by ceaseless demands upon his time."[19] This required his active diplomatic engagement with the monarchies of Europe, where he, as pope, was in steady discussions as both spiritual leader of the Roman Catholic Church and sovereign ruler of the Papal States. In this dual role, Benedict XIV negotiated many agreements, known as concordats, that spelled out a diverse range of policies important to those times, such as the conditions for claiming religious sanctuary, taxation of the clergy, and how to share church revenue with its secular neighbors.[20] It was a grueling and all-consuming process, but Benedict XIV tried to keep his sense of humor through it all. For instance, he "liked to

say that his pen was his best friend" and would try to "snatch time for writing whenever he could," whereupon, with customary wit, he would remark that "people will not marvel at what I've written, but that I found time to write it."[21]

These many financial pressures and reforms had thereby reduced the available budget for construction, maintenance, and improvements across Vatican Hill. The constraints were felt at St. Peter's Basilica, too, which in turn affected Vanvitelli's livelihood and future prospects within the Fabbrica. He was approaching fifty now, and the 1740s had been a busy time for the able architect. His eight children were born then (1739–1750) and, sadly, two had died young.[22] To provide for his family, he had sensibly explored other professional opportunities once the repairs to Michelangelo's dome were under way in 1744. During these years, he pursued, for example, the façade's design at Milan Cathedral, teamed with old friend Nicola Salvi at the Royal Chapel in Lisbon, and won the commissions in Rome to build the convent at Sant'Agostino as well as the interior of Santa Maria degli Angeli (located inside the Diocletian Baths).[23]

In the meanwhile, Thomas Le Seur, François Jacquier, and Roger Joseph Boscovich had quietly shrugged off their dismissal from Michelangelo's dome five years before. The reputations of Le Seur and Jacquier had grown from their recent association with Benedict XIV and the Vatican, along with their noted expertise with the *Principia*. The king of Sardinia was so impressed by their credentials that in 1745 he offered Le Seur and Jacquier each a professorship in physics at the University of Turin. But Benedict XIV had not forgotten them and interceded through his chief of staff, Cardinal Valenti Gonzaga, to keep these two talented mathematicians in Rome by obtaining prestigious and equivalent teaching positions for them at La Sapienza.[24]

By 1748, Boscovich was busier than before. He was still the chair of mathematics at the Collegium Romanum where, according to some, his teaching and research projects had left him with "little leisure, and it is a matter of wonder how he found time for the work he completed."[25] He published some twenty new research papers between 1743 and 1748 on broad-ranging topics in archaeology and astronomy, and that included a pamphlet in 1745 titled *De viribus vivis* (The Living Forces), which offered his personal views on "the inequalities of the force of gravity."[26] At this stage Boscovich "was increasingly considered as an original intellectual who could eloquently defend his ideas," which prompted his election to the Pontificia Accademia degli Arcadi in Rome in 1744, the Accademia delle Scienze in Bologna in 1746, and the Académie des Sciences in Paris as a "corresponding member" in 1748.[27]

But it turned out that Boscovich did have time for leisure after all, and based on his active social calendar, he seemed to have made the most of it. In the 1740s, for example, he was often seen around Rome in the company of senior Vatican figures and visiting dignitaries, ambassadors, and diplomats.[28] As an academic, he also enjoyed longer holidays than most, and in the summer of 1745 collaborated as "an enthusiastic archaeologist" with Vanvitelli to unearth an ancient villa in the ancient town of Tusculum along the Alban Hills on the outskirts of Rome. Here he discovered "certain other treasures found among the ruins," while "excavating and copying mosaic floors and uncovering a sundial which he believed was the one which Vitruvius . . . mentions in his writings."[29] Two summers later, Boscovich returned to his boyhood home in Dubrovnik for the first time since his teens, more than twenty years earlier. (It was the last time he would see the place.)[30]

When Boscovich returned to Rome in the fall of 1747, his career at age thirty-six appeared every bit as bright as Giovanni Poleni's

had been, when Poleni—now the leading scientist in Italy—was the same age.

⁂

The professor, in turn, was sixty years old when he left Rome and returned to Padua in June 1743. By now, Poleni had become increasingly ensconced in the study and behavior of domed structures, as evidenced by his stop in Florence on his way home to admire and examine the cupola that Brunelleschi had vaulted there.[31] It was the first step on the next leg of his journey where, for the next four years, he tried to make better sense of what he had seen under Michelangelo's dome in the spring of 1743. Poleni tested, for example, the tensile strength of the dome's iron chains in his laboratory, by methodically measuring several samples in his *macchina divulsoria* (divulging machine): "An apparatus very similar to Musschenbroek's original [groundbreaking] model" from the 1720s.[32] He then developed a more rigorous way to analyze the dome, by dividing it into fifty slices, rather than the four wedges first postulated in his *Riflessioni*. This motivated him to revisit his catenary curve (though he never gave proper credit to Robert Hooke), which he had used to visually demonstrate how the dome's "compressive stresses alone should [have been] able to sustain [its thrusting] loads."[33] Remarkably, his research did not seem to hinder his full complement of other teaching, research, and administrative obligations at the university, where Poleni continued as the acting chair in its departments of physics, astronomy, and mathematics.

These many extra efforts did not change Poleni's mind about Michelangelo's dome. He continued to believe years later that it had always been in equilibrium, was never in danger of faltering,

and that his design for its five new iron rings in 1743 had permanently stopped the cracks.[34] But Poleni had a blind spot, too, and he continued to ignore the ongoing similarity between his solution—which was grounded by intuition and tradition, from the one proposed by *Parere*—which was premised in mathematics and scientific principles. More crucially (and more troubling) was his erroneous conclusion that the dome had never been at risk of collapse, which was disproved in a rigorous analysis published in 2019 that found "the static conditions of the dome were actually quite critical [and the dome was] even close to failure."[35]

We do not currently know the details surrounding the replacement of Le Seur, Jacquier, and Boscovich in favor of Poleni. But there is a strong suggestion that Giovanni Gaetano Bottari was behind it. If so, and however one might interpret Bottari's undermining tactics and mischief, he had nevertheless made a valuable contribution at the project soon after. As an archivist and student of history, Bottari was mindful that the events under Michelangelo's dome—with all their complexity, uncertainty, novelty, and possible adverse consequences—were an important episode in the making. As a result, he appeared to successfully nudge the Fabbrica and convince the pope, with whom he was personally well-acquainted, to collect and preserve as much of the contemporaneous written record about the dome and its repairs as could be gathered.[36] Benedict XIV acknowledged the prudence behind this idea and parceled the assignment to Poleni, possibly as a parting instruction when the professor left for Padua in June 1743.

As it turned out, Poleni was perfectly suited for the task. Over the years, he had acquired at the university the "habit of saving every scrap of paper that had anything to do with official duties," and that by simply holding on to them had demonstrated that he was "a far more careful archivist . . . than many [of his]

contemporaries."[37] Moreover, he enjoyed a long-standing repu-
tation at the University of Padua for preparing class notes that
were thorough, detailed, and "well illustrated by diagrams."[38] Put
another way, Benedict XIV could not have found a better candidate
to make sense of the expanding galaxy of documents about the
dome that had rapidly accumulated on his desk. The professor took
his mission to heart over the next fifty-three months, and compiled
what became the definitive written account of the cracks, repairs,
and sequence of events that took place under Michelangelo's dome:
from Vanvitelli's first survey in 1742, to Zabaglia's magnificent
scaffolds of 1744, to the discovery of Della Porta's ruptured chain
in 1747. It was published in Italian (and, interestingly, not in Latin)
and Poleni wrote it while in Padua with the following title: *Memorie
Istoriche della Gran Cupola del Tempio Vaticano, e de' Danni di Essa, e
de' Ristoramenti Loro, Divise in Libri Cinque. Alla Santita' di Nostro
Signore Papa Benedetto XIV* (Memoirs of the Great Dome at the
Vatican, and of its Damage and Repairs, Divided in Five Books.
Dedicated to Our Holy Pope Benedict XIV).

In shorthand, it became known as *Memorie Istoriche* (The
Memoirs) and was structured into five parts, or *libros*, that ran
some 475 pages and were crammed with densely arranged text,
diagrams, tables, and plates.[39] It was a massive, well-organized,
and pioneering effort, and its occasional meanderings or disjointed
non sequiturs can be excused once one considers the mountain of
technical information it contained, along with the complexity
of its content.

The first part, "Libro Primo," covered about a hundred pages
that included the history of construction on Vatican Hill. It
described the demolition of Old St. Peter's Basilica and how the
new church had been built, along with the architects who designed
it. Then came a lengthy discussion of Michelangelo's dome and its

construction, its structural behavior and characteristics, the materials and craftsmanship from which it was built, along with its other *particolarita* (peculiarities).[40] Then, in section 8, Poleni launched into an overview on the general behavior of domes, from which he introduced the underlying concept of his new iron chains, their benefits, and how they were installed. "Libro Primo" contained many notable etchings, too, of arches and how they work, along with Poleni's force polygon that had famously and for the first time applied the concept of limit analysis in a concise and elegant way (plates C, D, and E).[41] Near its end, Poleni attached a superbly crafted, three-dimensional rendering of his iron bars and how they had contoured the dome's outer shell and were connected to one another (plate F).[42]

"Libro Secondo" was more succinct. It encompassed the *Stato de' Difetti* (The State of the Defects) that Vanvitelli prepared in the spring of 1743, and where he had mapped on nineteen separate etchings and plates the dozens, if not hundreds, of cracks then coating the dome. Poleni prefaced these drawings with a bit of historical context about the domes and their collective problems with cracks at Santa Maria del Fiore in Florence, Santa Margherita in Montefiascone, Sant'Antonio in Padua, and San Marco in Venice. Helpfully, he also included an architectural plan of Saint Veronica's Pier, which was built by Bramante in the 1510s, and which showed the central spiral stairway through which Poleni's new iron bars may have been hauled to the roof and then ultimately up and onto Zabaglia's scaffolds (plate G).[43]

Books 3, 4, and 5 contained most of the written correspondence and technical papers sent to Benedict XIV after his call for help in the winter and spring of 1743. This was the first time these documents had been gathered into a central repository, and it enabled their many divergent opinions to be readily compared and assessed.

Parere was among them, of course, along with the dissenting points of view expressed in Lelio Cosatti's *Riflessioni*, Filosofo's *Sentimenti*, and Poleni's *Aggiunte*.[44] In all, *Memorie Istoriche* compiled the judgments made by fourteen separate consultants, and together they tellingly reveal the current state of knowledge about construction and architectural design in eighteenth-century Italy.[45]

Later in book 3, Poleni attached his diagram from 1743 that had simplistically modelled Michelangelo's dome as four wedges, along with their corresponding hinge points (plate H). In book 4, he furnished an architectural elevation to show where Zabaglia had installed the five, and eventually six, iron rings inside the dome (plate K). "Libro Quinto" was the shortest section and it discussed the newly discovered rupture in Della Porta's uppermost chain, which would take another year to investigate and replace.

In all, *Memorie Istoriche* was a remarkable—and expensive—book to assemble and publish. But it was worth every scudi and is the principal reason we know so much about the drama that took place under Michelangelo's dome between 1742 and 1747.[46] The book became an early model for the way that structural forensics could and should be performed: it was lucid, the first of its kind, and established the professional protocols now followed when we investigate bridges, buildings, dams, and tunnels that have failed or collapsed. Though not an easy read or elegant in arrangement, *Memorie Istoriche* is a classic and influential title that stands among "the most important in the history of architecture" and is as relevant to our modern world as Vitruvius's *Ten Books on Architecture* had been to Michelangelo's.[47]

But maybe the most poignant part of Poleni's masterwork appeared at its end, which might explain why it goes unnoticed and is often taken for granted. These last twelve pages contain two indexes, sorted alphabetically and in neatly prepared professional

typeset. One is the *Indice degli Autori, e d'Altri Nominate* (Index of Authors and Other Names), and it contains the roster of some 250 persons who had shaped Vatican Hill, St. Peter's Basilica, and Michelangelo's dome between 1500 and 1750; the other is an eight-page glossary called the *Indice di Cose* (Index of Things), which defined the 230 architectural terms and features that had been previously cited in books 1–5. In an age before our more modern publishing practices, these indices represented an enormous undertaking in both labor and expense that were reserved for only the most important books. Their inclusion within *Memorie Istoriche* thereby offered another subtle yet critical clue that underscored the magnitude of the book's papal imprint, the import of Poleni's task, and Benedict XIV's personal and steadfast commitment to save Michelangelo's dome.

The *Indice degli Autori* was a fitting curtain call to a drama marked by controversy, risk, and an uncertain outcome. Its roster represented the most influential and illustrious persons of the sixteenth, seventeenth, and eighteenth centuries, and is as impressive in its own way as the one inside Giorgio Vasari's pathbreaking *Lives of the Artists* from 1550. Some of the same artists are there, too, like Leon Battista Alberti, Donato Bramante (listed as "Lazzaro, da Urbino"), Filippo Brunelleschi, Baldassare Peruzzi, Raphael, Antonio da Sangallo the Younger, and "M. Pollione Vitruvio," along with "Cavaliere" Gian Lorenzo Bernini (spelled "Bernino"). Other architects with familiar names are referenced too, such as Carlo Fontana, Ferdinando Fuga, Carlo Maderno, and Nicola Salvi. But the most prominent by far was Michelangelo Buonarroti (spelled "Michelagnolo"), who is cited twenty-two times and with a deep and powerful reverence.

The popes who sponsored the construction on Vatican Hill are included, and there are many of them. They include Constantine

(Constantino il Grande), Julius II (*il papa terribile*), Paul III (who hired Michelangelo as *capomaestro* in the 1540s), and Sixtus V (who vaulted the dome forty years later). The Curia, which paid all the bills to fix the dome, is represented by Giovanni Francesco Olivieri (as director of the Fabbrica), Giovanni Gaetano Bottari (as prefect of the Vatican Library), and Cardinal Silvio Valenti Gonzaga (Benedict XIV's chief of staff). The current pope is there, of course, and his name is designated in full capitals as BENEDETTO XIV to mark his reigning status. His forty-three citations within *Memorie Istoriche* aptly demonstrate the active role that Benedict XIV played at the project and his determination to fix Michelangelo's dome.

The chief scientists are referenced as Johann Bernoulli, Galileo Galilei, "Giovanni Keplero," Pieter van Musschenbroek, and Isaac Newton. So is Giovanni Poleni, the self-described *Autore di Queste Memorie Istoriche*, who was cited the most often, some forty-eight times. But the *Indice degli Autori* snubbed Robert Hooke and his inventive catenary curve, though Hooke had deserved to be recognized.

Then came the leading mathematicians of the day, like Philippe de la Hire, Gottfried Leibnitz, and the *Tre Matematici* in their Italianized form, as Tomasso le Seur, Francesco Iacquier, and Ruggiero Guiseppe Boscovich. Their critics are named, too, as Saverio Brunetti, Gaetano Chiavery, Lelio Cosatti, P.A. Diofanio, Gabbriello Manfredi, Lodovico Antonio Muratori, D. Diego Revillas, Niccolo Ricciolini, Giovanni Rizzetti, Domenico Sante Santini, and "Marchese" Girolomo Theodoli, along with the more cryptic "Filosofo," "Signor N. N.," "Cavaliere," and the "Matematici di Napoli."

Finally, there are the intrepid builders, without whom the dome could not have been built in the first instance or fixed in the next. They are familiar and legendary characters that include Domenico

Fontana, Giacomo della Porta, Luigi Vanvitelli, Niccola Zabaglia, and his able assistant, Tommaso Albertini. Their collective prominence is reflected by their sixty separate citations within the *Indice degli Autori*, which is more than any other in *Memorie Istoriche*. The roles they played and the influence they carried cannot be overstated.

<center>❧</center>

In hindsight, it is hard to know why the Fabbrica seemed to be caught unaware and flat-footed by the extent and magnitude of the cracks at Michelangelo's dome. There were so many of them, were so plainly visible, and were configured in such a disturbing pattern, that any sensible architect, *capomaestro*, or *sanpietrini* of that time should have readily spotted them as a serious concern much sooner than September 1742. But they had not, and in the absence of a singular, triggering event, such as an earthquake, it is more likely that the cracks were sourced from a potent combination of latent defects that had been "baked" into the dome and promoted by its hasty construction, its structural incongruities, and the soft soil conditions around Vatican Hill. Any and each of these underlying flaws could have readily caused the cracks to start small and then gradually propagate to degrade the dome, especially during the decades of higher seismicity that were observed in the region between 1700 and 1740. This theory seems to explain why the cracks were not observed (at least in large numbers) in the 1680s, or during Carlo Fontana's inspection of 1694, yet had geometrically multiplied to such large quantities by 1742.

Regardless of how the cracks had gotten there, it was fortunate that Benedict XIV was the reigning pontiff during the 1740s, when Michelangelo's dome was teetering on possible

collapse. Though he had not campaigned to be pope and may not have wanted the job, Benedict XIV was assuredly the right man at the right place, and at the right time. His predecessors of the 1720s and 1730s, for example, Benedict XIII and Clement XII, had neither the intellectual capacity nor mental stamina to oversee such a complex project. Moreover, his successors into the 1770s, Clement XIII and Clement XIV, were "slow to take decisions" and "lacked the imagination and verve" to lead such a challenging effort, too.[48] By accepting the challenge and fixing the dome for which few other popes seemed capable, Benedict XIV should be, and is, rightfully celebrated as a bright light in church history. Fittingly, his commemorative monument inside St. Peter's Basilica is just a short stone's throw away from the dome he helped to save.

There was a larger lesson at Michelangelo's dome, too, because in the end, it turned out that no one person had the singular best way to fix it. It was a massive undertaking that was solved through the power of collaboration and the deference that the contributors showed toward the expertise of the others. They had relied on each other, and together they developed a solution that had worked. These mathematicians, scientists, builders, and architects had come from many walks of life and social orbits, and had had different educations and professional experience, and may not have been the best of friends either. Despite their differences, the group recognized the importance of their common goal and were commonly able to maintain a cordial and respectful demeanor toward each other throughout the campaign to save Michelangelo's dome. (Though Bottari's polemical temperament stood out, admittedly, as an obvious exception.) This trait was as valuable in the 1740s as today, and is a timeless reminder of the power in teamwork.

But that does not change the obvious, which was that Michelangelo's dome had been repaired, after all, by using the same techniques that had been passed down from previous centuries. These iron rings had been designed and then installed with a traditional approach that was steeped in trial and error, intuition, and rules of thumb. On the surface, then, perhaps nothing had changed, after all. But this is deceptive, because *Parere* had subtly yet most assuredly changed the conversation. It had planted the seed of novelty by challenging the brightest minds of the day, like Poleni and Cosatti, to consider how mathematics and science could be leveraged as a new tool to solve the toughest and most complicated problems in the everyday world. Le Seur, Jacquier, and Boscovich had not meant for their *Parere* to diminish the role of tradition but had offered it as a more creative, objective, and predictive way to think about, and then solve, an age-old problem. They did not intend for *Parere* to replace human judgment, but to complement and elevate it, and their enlightened ideas became a part of the pathway forward from which our world never looked back. In hindsight, the repairs to Michelangelo's dome turned out to be a bright line that separated the old world from the new and it opened the door for the next generation of scientists, who would parallel *Parere*'s genuine novelty and then transform its utility.

This new breed of scientist had begun to call themselves *ingenieurs*, and they were gaining fast and steady traction in France. Their invention, called engineering—in tandem with *Parere*—would profoundly change the world and make it a better place.

THE ADVENT OF
MODERN ENGINEERING

B y the year that Giovanni Poleni was born, in 1683, a new kind of heavy munition—artillery—had become a standard part of contemporary warfare. Fueled by gunpowder, it could lob a formidable orb of iron, called a projectile, from a cannon with unparalleled destructive impact. These cannon (and their orbs) were cast from the heat of a blast furnace foundry and by the seventeenth century had become "effective weapons against some of the mightiest castle walls in Europe."[1] Because these punishing guns were so lethal and cruel, they were known to quickly change the tides of battle, which made them a valuable military asset as well as a blunt instrument of political statecraft.[2] The Europeans and the Ottomans both possessed this technology, and artillery of differing shapes and sizes were likely scattered along the hills and fields of Vienna during its famous siege in 1683, where Poleni's father, Jacopo, had earned his title as a marquis.[3]

In the decades ahead, these systems of artillery became increasingly sophisticated in design and manufacture. They also required

a new kind of precision and instruction to operate once it became apparent that their projectiles followed the same principles of motion—known as ballistics—that Isaac Newton had predicted in his *Principia*. Accordingly, it did not take long to recognize that some training in Newtonian physics would help to work these heavy guns. Their brutish scale and tonnage drove the need for new military tactics, too, since a heavier grade of infrastructure—like bridges that were stronger, roads that were more rugged, and ports that were deeper—was required to roll them from the forge and onto a battlefield. In all these ways, then, this explosive technology represented a fundamental change in warfare, and it promoted a different kind of military strategy that combined traditional soldiering maneuvers with sophisticated ground logistics and the science of ballistics.[4] Soon it was apparent that the officers placed in responsible charge of these artillery units were in the vanguard of this movement, and the best positioned to shape these modern tactics.

But it turned out not to be so new after all. Before the invention of gunpowder, other sorts of heavy weapons had been contrived, such as a catapult and assault tower, which for their time were similarly intricate to design and operate. One of the more ominous was a siege engine, which was a word rooted from the Latin, *ingenium*, and that carried a dual connotation: either as an inanimate machine that was built for warfare or as a person with a clever knack for solving problems. (The word had a deeper origin, too, that went "back to the ubiquitous [Latin] root, 'gen' [meaning] to bear . . . [and] to give birth to."[5]) Over time, the officers who designed and operated these ponderous mechanical engines came to have names of the same shade, like *ingeniarius* or *ingeniator*, and by the fifteenth century these titles had evolved into *engignier* or *engigneour* in the Old French, *engyneour* according to Middle English, or *ingegnere*

in Italy.[6] These same officers were then often tasked to develop
defensive tactics as well, that could repel the very weapons and
engines of war they had created in the first instance. This fostered
a rich variety of creative and elaborate ideas in fortification—such
as moats, deep trenching, and polygonal walls—that required a
working knowledge of construction and the strength of materials.
Hence, from its earliest days, an *ingeniarius* was a person known
to be battle-tested, inventive, pragmatic, and capable of solving
complicated problems in the everyday world.[7]

Military tactics and technology continued to evolve and grow
more ponderous during the seventeenth century. To keep up, a
new kind of academy emerged in Europe, whose purpose was to
train officers for a full-time professional career in the armed ser-
vice. It was distinctly different from the kind of instruction and
curriculum offered at traditional universities, and the first such
school seemed to have been established in France, under King
Louis XIV's Ministry of War in 1675 (the year Pope Benedict
XIV was born).[8] It was founded as *Les Corps des Ingenieurs du Génie
Militaire* (Corps of Military Engineers, or Corps du Génie for
short) on the recommendation by Sébastien Le Prestre de Vauban,
a soldier with firsthand experience in siege warfare and renowned
for his avant-garde designs of star-shaped fortresses.[9] The Corps
du Génie was quick to embrace these changing paradigms, and
its cadets "enjoyed a scientific education, with specific emphasis
on mathematics" as part of their core training, where they studied
ballistics and the techniques for building the roads, harbors, and
bridges necessary for modern warfare.[10] Sensibly, then, "the term
'Ingenieur' was first used, in France, as a professional title for a
scientifically trained technician in the public service" who, by the
close of the seventeenth century, was an officer with elite military
status in this advanced age of warfare.[11]

From these roots, a legacy of military academies began to pro-
liferate across the continent throughout the eighteenth century.
They were established in Austria, Bavaria, Britain, the Netherlands,
Italy, Prussia, Russia, and Sweden, and took special hold in the
northeast of France, among "the seven towns where there were
garrisons of artillery," in the native region of François Jacquier and
Thomas Le Seur. [12] These academies emphasized the growing
and vital role of science and mathematics as a primary part of
officer training, and this kind of focused curriculum was first
administered in 1720 at the newly-established Artillery College in
La Fere, near the Belgian border. [13] (This was the same time when
Giovanni Poleni was ensconced at the University of Padua, Luigi
Vanvitelli was starting his architectural practice in Rome, Niccola
Zabaglia was recruiting his corps of *sanpietrini* on Vatican Hill,
and Prospero Lorenzo Lambertini was still a lawyer at the Rota and
had not yet been elevated to cardinal.)

Bernard Forest de Belidor was an early professor of math-
ematics at La Fere. He was an officer in the French army who had
recognized the utility for his students "to be armed with scientific
data in a concise and handy form," and in the 1720s while a young
man himself, taught an influential class called *Nouveau Cours de
Matematique* (New Lessons in Mathematics). [14] What he had ini-
tially intended as a way "to make math[ematics] interesting" for his
students and "particularly when applied to the fields of engineering
and artillery," ultimately brought Belidor international attention and
acclaim. [15] The Nouveau Cours de Matematique launched his
career and his promotion as commissioner of the artillery, where
he wrote a series of textbooks that linked mathematics, machinery,
Newtonian physics, and construction all together. [16] His innovative
work "enjoyed great popularity with the experts" and illustrated
how "the scientific treatment . . . of statics and strength permitted

a more rational design of . . . structures."[17] Belidor's most notable
title was *Science des Ingenieurs*, which was published in 1729 and at
the same time as Pieter van Musschenbroek's far-reaching and
"systematic study" on material science.[18] Belidor's book bore "a
certain likeness to our modern [engineering] manuals" and was so
popular that it was reprinted many times over the next hundred
years and until 1830.[19]

Another engineering academy was established in 1749 in
Charleville-Mezieres, France, also along the Belgian frontier, just
after Zabaglia had installed the sixth (and last) hoop at Michel-
angelo's dome: the *École du Corps Royale du Génie* (Royal School
of Engineering). Its mission was to train officers for a career in the
French army by using the most modern techniques and advanced
curriculum. The school was directed by Charles Camus, who
"insisted that all engineers should speak the same mathematical
language, and constructed courses that combined arithmetic,
geometry, mechanics, and hydraulics." The École du Corps was
merit-based, and Camus was "quite explicit that bourgeois youths
were to be admitted to the school as well as nobles." He maintained
an exacting examination for all prospective candidates, which
made the school "unusual in having certain entrance requirements
beyond the ability to read and write."[20]

By mid-century, large pockets of Europe were transforming
into a more urban and complex society. This introduced certain
challenges that engineering, with its special emphasis on applied
mathematics and science, could help to solve. More than any
others, these *ingenieurs* were the best trained and best equipped to
build, for example, more reliable systems of fresh water, along with
better sanitation and improved transportation networks to meet
these looming public needs. They created a new profession known
as the civil engineer (*génie civil*), to differentiate these kinds of

large-scale municipal projects, dedicated to the public's well-being, from those of a more traditional military officer (*génie militaire*). This prompted the founding in Paris of the *École Nationale des Ponts et Chaussées* (National School of Bridges and Roads), which was directed first by Daniel Trudaine in 1747 and then by Jean Perronet in 1760. Both were trained *ingenieurs* and assumed their jobs with a vigor that placed the École des Ponts at the vanguard of civil engineering, and "secured the Continent-wide supremacy of French road and bridge building for a long time to come."[21] By illustration, Trudaine designed a network of modern roadways across France that linked Paris to its frontiers and ports, which he mapped in his *L'atlas de Trudaine*.[22] Perronet, in turn, was "famous as the builder of many classic masonry bridges," for "which he designed and constructed throughout France."[23]

Charles Coulomb graduated from the Corps du Génie around this time, and later became famous for his pioneering work in physics and electricity.[24] But less well-known were the equivalent innovations he introduced in the 1760s and 1770s as an *ingenieur du roi* in the Corps Royale. "More than any of his predecessors," Coulomb pragmatically applied the principles of statics, mathematics, and material science to solve the customary challenges at everyday construction projects, such as "the bending of beams, the fracture of columns, and the calculation of . . . thrusts."[25] He also examined soil as an engineered material, which ultimately launched the professional practice now known as geotechnical engineering. His ideas had coincidentally relied on the same scientific research and mathematical principles developed by Johann Bernoulli, Philippe de la Hire, and Pieter van Musschenbroek that were also referenced in *Parere* by Le Seur, Jacquier, and Boscovich.[26] Coulomb's work became a springboard that would launch an extended set of theories proposed a generation later, by Claude-Louis Navier.

It was Navier, most of all, who elevated the practice of engi-
neering by turning it into a recognized profession with defined
methods and established protocols. He was an *ingenieur* who taught
at the École des Ponts in the 1820s, and in that role he published
dozens of papers, manuals, and "brilliant lectures" that were largely
responsible for inventing the idea of structural analysis and the
concept of material science "in the modern sense."[27] This was best
illustrated in his *Resume des Lecons* (Lesson Summaries), published
in 1826, which was crammed with instructions, tables, equations,
and diagrams to show—in a clear and concise way—how these
new techniques in engineering could be applied at many kinds of
construction projects.[28] More than that, Navier trained hundreds
of students while a professor at the École des Ponts and ingrained
these principles of applied science and mathematics into a codified
set of conventions and guidelines for them to follow. This quietly
made him one of the most influential, yet relatively anonymous,
figures of the nineteenth century and beyond.

By the 1830s, a new breed of pragmatic scientist had gained
full traction in France. What Belidor started in the 1720s had
evolved a century later into a fully formed profession that relied on
mathematics and science as a matter of routine to pragmatically
solve the most stubborn problems of everyday life. But it is worth
noting that Belidor's work, while novel, was largely steeped in
theory, and it postulated how these new ideas could or might be
applied in the real world. It took many decades before a connec-
tion was firmly established between Belidor's theory and Cou-
lomb's practical applications at a live construction site, and in this
context, it was clear that *Parere* had gotten there first. In 1742
Le Seur, Jacquier, and Boscovich had visualized a brilliant cou-
pling of ideas that had linked scientific theory and mathematics to
the everyday world some thirty years before Coulomb and eighty

years ahead of Navier. The French had made invaluable subsequent contributions, but these imaginative analytics by Le Seur, Jacquier, and Boscovich—at the largest and most complicated dome in the world, and while it was under distressed conditions, no less—was the earliest demonstration on record of a powerful methodology that would come to define the core tenets of this new profession known as engineering. *Parere* was at the vanguard of the movement and had indisputably invented a new, useful, and far-reaching way to see the world.

Yet the British were not sitting idle either, and were advancing a view of this bold new profession in a way that was far different from their counterparts across the English Channel.

The age of artillery and its explosive military implications were emblematic of the titanic aspirations then overtaking all of Europe. The continent's political dominance was growing in tandem with its population, and each nation had an unabated thirst for fuel to power its own sovereign economy. Timber had been the traditional source of supply, but during the eighteenth century this collective appetite for fuel had stripped the trees within once-abundant forests. It triggered an alarming ecological nightmare across the continent and drove the need to innovate and find a broader solution, which turned out to be coal.[29] This jet-black combustible rock was a wonder for its day and offered many attractive advantages over timber because of its abundance, long rates of burn, high thermal output, ease of transport, and low cost to consumers. But it had a few drawbacks, too, and the largest was digging it safely out of the ground, from mines that burrowed deep below the earth and were dark, full of dust, poorly ventilated, prone to collapse, and that

often flooded. In short, mining the coal from out of these shafts was a miserable experience and a perilous job.

This changed dramatically—and for the better—in 1712. That was when Thomas Newcomen invented the atmospheric steam engine in the West Midlands of England. It used coal to heat large amounts of water that, in turn, generated lots of steam, which then powered a pump to keep the mine dry and circulate fresh air back into it.[30] Newcomen was largely self-educated and self-made, and someone who "knew a fair bit of geometry, . . . could draw clearly, and . . . read all that was available on subjects that interested him."[31] His invention promoted large-scale extraction from underground seams, and in such vast quantities that coal quickly replaced timber as the primary fuel source for Britain, and then large swaths of Europe not long after.[32] Newcomen's innovation "cannot fail to be an object of interest to every intelligent inquirer," and it provided the raw power to launch a variety of other nascent industries, "manufactures," "commerce," and "useful arts."[33] More than that, it "produced a great advancement in the state of society" by heightening safety and improving "the condition of the labouring class" in the mines, and "if any single invention can be said to have inaugurated the steam revolution, then [the Newcomen Engine] was it."[34]

<hr />

A century earlier and around 1620, Dud Dudley had been tinkering with iron ore. "There can be few characters more colourful or more controversial" than Dudley, who was noble by birth, yet illegitimate, and had fought as an officer loyal to King Charles I on the losing side of the English Civil War. While serving, he was apparently captured, but then impressively escaped his jailors "from

the Tower of London."[35] Like Newcomen, he was from the West Midlands, and took over his father's blast furnace as a young man. There, Dudley seemed to discover a better way to smelt iron ore and batch it in large quantities. To do so, he had stoked his furnace with an experimental residue of coal, called coke—rather than the more traditional charcoal (which was a residue from timber).[36] Though Dudley patented his process, he did not reveal the precise formula for coking—perhaps to preserve his commercial interests—which to this day has cast lingering doubts over his claim for inventing the coking process.[37]

Smelting remained a cryptic art until Abraham Darby revived the coking process three generations later, around 1710. It appears that Darby was Dudley's great-grand-nephew, and he found a way to coke and batch a superior brand of iron at an industrial scale out of a once "derelict blast furnace at Coalbrookdale."[38] Darby's son, Abraham II, inherited the family business and his grandson, Abraham III, sealed the factory's famous legacy when he teamed in 1775 with architect Thomas Farnolls Pritchard. Together, they demonstrated the dramatic potential of cast iron construction when Pritchard designed and Darby then fabricated and built their renowned Iron Bridge in Coalbrookdale, over the River Severn.[39] It was the first heavy-grade structure made of metal anywhere in the world and became the template for how bridges, buildings, and towers of the future could and should be assembled.[40]

Darby had pursued his process for coking on the hunch it would lead to commercial success and financial profit. But what he did not know, and could not have anticipated, was its monumental impact on the world stage. His furnace at Coalbrookdale triggered the Industrial Revolution, ushering in a century of rapid technological change, abundant economic expansion, a higher quality of life, and dramatic opportunities for upward societal mobility, first within

Britain, then Europe, and then the Americas. It turned out that Darby's process for batching was emblematic of "a widespread urge toward invention" that had then "gripped people in all strata of society. Everyone was inventing, from unemployed weavers [and] small hand workers . . . to manufacturers like Wedgewood and members of nobility."[41] But the most spectacular of these inventions were driven by the mathematics and experimental science then practiced by a new generation of British engineers. Their scientific achievements, in tandem with a pronounced entrepreneurial streak, came to personify by the 1760s the "peculiarly English character of [this] technological explosion."[42]

Among the most influential engineers of the day were James Watt, John Smeaton, and Thomas Telford. Like Dudley and the Darbys, they were largely self-taught and self-made, and their pragmatic inventions and personal ambitions were fueled as much by financial profit as for the benefit of crown and country. Watt, for example, was just as comfortable while tinkering in a laboratory as he was staking a survey in an open field. His steam engine was a vast improvement over Newcomen's initial design and became the singular defining feature of the Industrial Revolution because it reliably furnished the "moving power to give motion to other machines."[43] The Watt engine literally spun the wheels of progress—be it for the steam locomotives or the textile mills—and was "an invention highly creditable to human genius . . . [having] produced greater and more general changes . . . than has ever been effected by any one invention recorded in history."[44]

Smeaton continued this tradition and went on to typify the eighteenth-century British engineer. He knew the science behind a mechanical engine and the mathematics required to design a bridge and was equally adept at building either one. His work extended to canals, harbors, and even a lighthouse, and his curiosity also led to

experiments that improved the performance of cement as a binding agent—the "glue"—within modern concrete.[45] Smeaton was a distinguished scientist who was recognized with a membership to the prestigious Royal Society of London, and he became the first in Britain to "style himself" as a "civil engineer."[46] He founded the Society of Civil Engineers in 1771, which became the Institution of Civil Engineers and was renamed again in 1830 as the Smeatonian Society of Civil Engineers.[47] In the meantime, Telford was charged with the design of Britain's vast, new, underlying system of infrastructure—like aqueducts and roads—that enabled the Industrial Revolution to prosper.[48] He "was [also] responsible for well over a thousand bridges" and co-inventor of a design that was so radical and untested that he "often [said] a lengthy prayer before" pressing it into service.[49] Today, we call it a suspension bridge, and it is among the most graceful, ingenious, and universally admired of all engineering designs.

Taken together, these fresh innovations by Watt, Smeaton, Telford, among others, led to cleaner water, better sanitation, safer travel, higher literacy, a more plentiful power grid, and consumer goods that were more affordable. It was all achieved with machines, materials, and engines that were more reliable and rugged, and that allowed bridges to span longer and buildings to climb higher than previously thought possible. These British engineers were every bit as clever and innovative as their counterparts in France, but they used a different stick to measure their success. While the French engineers were formally schooled and trained at academies of mathematics and science, their counterparts in Britain tended to be self-made and self-taught and learned their science loosely, through hands-on experimentation. While the French engineers practiced under a structured, centralized, bureaucratic agency, the British engineers were more geographically dispersed and commonly

operated as individuals, sole proprietors, entrepreneurs, and capitalists. While the French engineers focused on scientific theory, mathematic principles, and the *process* of design, their British counterparts were absorbed by scientific invention, machinery, and the *outcome* of design. Simply put, the French were theorists, the British were pragmatists, and *both* played a vital role in this new and evolutionary movement of modern engineering practice.

After the 1830s, the convergence of mathematics, physics, material science, and engineering only continued to accelerate. Technological change had become an incessant aspect of modern life by now, and this new breed of scientist was pivotal, though commonly anonymous, in finding the tools and solutions necessary to harness it. These engineers drove many innovations by the mid-nineteenth century (such as elevators, plate glass, fireproofing, Bessemer steel, and reinforced concrete) that propelled the proud emblems of our culture and symbolized our upward aspirations and outward ambitions. Just a century after *Parere* had been tendered to Benedict XIV, with its radical notion of using applied science and mathematics at a construction site, the idea had not only gained traction, but, astonishingly, had become recommended practice at every kind of bridge, building, and tower in Europe. Now these kinds of structures could be built at an unparalleled size, height, and speed, and London's Crystal Palace of 1851 was among the most heroic: erected "in the incredibly short space of nine months" from an avant-garde combination of cast iron and glass, and with a footprint that was four times that of St. Peter's Basilica.[50]

It did not take long for societal ambitions to grow again and overtake these mid-century achievements. Engineers were at the vanguard of these aspirations, too, and helped to realize them at the most daring, iconic, and enduring projects yet conceived, such as the Brooklyn Bridge in 1883, the Eiffel Tower in 1889, the

Panama Canal in 1914, the Empire State Building in 1931, and Hoover Dam in 1935. Though it is difficult today to appreciate the pride and awe that these projects imparted in those times, they solidified the practice of engineering and cemented the public's confidence and trust in the profession, which continues to this day.[51]

But the use of applied science and mathematics to solve complicated problems in the everyday world did not stop with bridges, buildings, and towers. This same pragmatic process of thought seeped into dozens of other avenues of discovery: from the circuits that power every electrical device, to the chemistry that converts crude oil into gasoline, to the biology that promotes detection of disease, and to the rockets that fuel our aviation industry. Today, engineering touches, and dramatically improves, every aspect of our lives and in dozens of ways: agriculture, artificial intelligence, biometrics, communications, computing technology, consumer goods, data management, environmental preservation, food processing, healthcare, machine learning, manufacturing, pharmaceutical and medical research, energy and power production, supply chain logistics, transportation networks, water resource management, and the list continues. The profession has an enormous global reach that constructively touches, affects, and benefits billions of people every day and in every corner on the planet and into outer space.

When Telford died in 1834, the world was by now a far more complicated place. Its challenges were so technical, complex, interrelated, and sophisticated in nature that no one person could navigate them on their own. More than that, it had now become an acknowledged and routine practice to solve these same challenges with the help of applied science and mathematics—just as Thomas Le Seur, François Jacquier, and Roger Joseph Boscovich had foreseen some ninety years earlier, in 1742. Though this idea was dismissed and largely ignored at the time, the concepts expressed

inside their succinct, thirty-six-page *Parere* had thunderous implications. It demonstrated that the simpler days of the master builder and *capomaestro* were long gone and that the more intuitive times of Vitruvius, Brunelleschi, and Michelangelo were over.

These three unassuming mathematicians had invented the future.

EPILOGUE

The story of how Michelangelo's dome was saved is as much a drama about the people who saved it as the science and mathematics they used to have it fixed. These characters showed strong leadership, took decisive action under adversity, and then worked together to creatively fix the cracks, save the dome, and solve the common problem. We are the beneficiaries of that teamwork.

Niccola Zabaglia's record of inventive achievement had started inside St. Peter's Baptistery as a young man in the 1690s, and he saved his best work for last when he repaired Michelangelo's dome between 1743 and 1748. Though these two projects were fifty years apart, they were only separated by five hundred feet. Most of his other jobs were sandwiched nearby, too, inside the basilica or around Vatican Hill.

Zabaglia died at age eighty-six, two years after installing the sixth and final iron ring around Michelangelo's dome. When he passed, his scaffolds had been on magnificent display, off and on,

at St. Peter's Basilica for some thirty years and were the safest and most reliable, durable, and versatile of their kind around the world of construction. By now, his reputation had been safely sealed for posterity through his book, *Castelli*, and for the next two hundred years his innovations remained the legendary symbols of excellence at any building site and were only supplanted in the 1940s when stronger, tubular steel became readily available. He was an effective leader, too, and groomed a talented supporting cast of *sanpietrini* that could step up in his absence. They included Angelo Paraccini, who "continued to train young apprentices," and Tommaso Albertini, who succeeded Zabaglia and served for many years thereafter as master mason at the basilica and deputy to its chief architect.[1]

~

There is a picturesque park near the foot of the domed Basilica of Sant'Antonio in Padua, known as the Prato della Valle (Meadow in the Valley). Its lawn is a gathering spot for conversation and gossip, and the place traces back a few thousand years to Roman roots, when it was a mud-filled swamp. The Prato della Valle assumed its current elliptical shape in the 1700s when it was landscaped with trees, a central moat, and eighty-eight, life-size statues that were made of marble to celebrate the city's leading thinkers from the eighteenth century. In the park's northwest quadrant stands statue number 52, which was sculpted in 1781 in the likeness of Giovanni Poleni.[2]

By then, Poleni had been dead for twenty years, after achieving a career in science that few in Italy, beyond Galileo Galilei, had matched. The professor wrote some eighty-three research papers while in Padua and they displayed his probing curiosity on wide-ranging topics: archaeology, architecture, astronomy, the aurora

borealis, celestial motion, experimental physics, fluid mechanics, geometry, the Gregorian calendar, hydraulics, mechanical calculators, meteorology, military architecture, naval design and navigation, shipbuilding, and trigonometry.[3] He never took the easy path, rarely slowed down, and, like Zabaglia, saved his finest work for later in life, when he invented the physics cabinet while in his fifties and crafted his *Memorie Istoriche* ten years after.

Once his job was done at St. Peter's Basilica in the 1740s, Poleni discovered a knack for solving other kinds of thorny problems in construction at castles and cathedrals in northern Italy, at places such as Bergamo, Brescia, Milan, Pavia, Venice, and Vicenza.[4] Then he tried his hand at nautical science and shipbuilding for the Venetian Republic while he was at the same time expanding his centerpiece program in experimental physics at the University of Padua.[5] Poleni attributed much of his professional success to a lifelong love of reading and "devoted great attention to his library," which grew to six thousand volumes and was among the finest in the city.[6] His accomplishments are that much more impressive given the chronic migraine headaches from which he suffered, starting in the 1720s and which lasted for the rest of his life. Poleni died peacefully in 1761 at age seventy-eight, after "a few days of rapid deterioration"; it was fitting that his autopsy was performed by his old friend, Giovanni Battista Morgagni, who was by now an anatomist and medical pathologist of international repute.[7]

The Venetian Republic celebrated Poleni soon after, in 1762, by minting a commemorative medal in his likeness.[8] Today, the University of Padua has named its museum of physics as the Museo Giovanni Poleni and has filled it with the experimental equipment from his famous cabinet. It is fittingly nestled around the corner and a short stone's throw from the Galileo Galilei Department of Physics and Astronomy.

≋

Luigi Vanvitelli and Poleni remained friends until the professor's death. By then, Vanvitelli's architectural career had blossomed, having "designed and directed approximately seventy interventions on existing buildings, including villas, palaces, churches, shrines, monasteries and convents in the Papal States, in the Grand Duchy of Tuscany, in the Kingdom of Naples and the Duchy of Milan."[9]

Many of these commissions arrived after 1744, once the repairs to Michelangelo's dome were largely complete, and the timing was fortunate, since Pope Benedict XIV had tightened his papal purse, and construction around Rome was starting to dry up. Out of necessity, Vanvitelli looked south and toward Naples for professional opportunity, which he found when he won the architectural plum of the century, based on his design at the Reggia di Caserta (Royal Palace of Caserta) for King Charles III of Spain, Carlo di Borbone.[10] This commission brought Vanvitelli close to the king and queen, who pored over his architectural design "at every stage with the utmost minuteness."[11] It became the high-water mark of Vanvitelli's career and the basis for a royal publication, the *Dichiarazione* (Declaration), which he coauthored in 1756 and elevated his professional stature across Europe.[12] The Reggia di Caserta's cornerstone was laid on Charles III's birthday in January 1752 and Vanvitelli used the occasion to move his wife and seven children to Naples—the place he was born—and from where he never left.[13]

His Royal Palace of Caserta was intended from the start to rival the splendor of the Palace of Versailles, and it took decades to build the Reggia di Caserta's colossal assemblage of 1,200 rooms, along with its stately courtyards, grassy malls, fountains, statuary, and radiating avenues necessary to "maintain thousands

of servant-bureaucrats who governed the Kingdom of Naples."[14] Vanvitelli and the king had designed the palace together, but Charles III "never spent a night" there since he was next in line to the Spanish throne and was called away to assume its crown in 1759.[15] He was good to his word, however, and continued to fund the project, although Vanvitelli had by now fallen "into a despondency" after Charles III's departure, from which the architect never recovered.[16]

The former architect of St. Peter's Basilica was still hard at work in 1773, practicing the "lessons in proper modern architecture" in Caserta and elsewhere around Naples.[17] But there was little ceremony when Vanvitelli died later that year, "ever more prey to melancholy" and some thirty years after his repairs to Michelangelo's dome.[18] His Reggia di Caserta was designated as a UNESCO World Heritage site in 1997 and is now recognized as a splendid architectural display of the late Italian baroque.[19]

We know less about Thomas Le Seur and François Jacquier, but all accounts showed them as amiable, accomplished, and with careers that far exceeded their unassuming demeanors.[20] They were a part of the next generation of scientific scholars who came into their own during the 1740s, with their pathbreaking *Commentario Perpetuo* (Thorough Commentary), which explained Newton's *Principia* to thousands of otherwise mystified scientists and sealed their reputations as top-flight physicists and mathematicians.[21] Their work became quickly known within the circles of the Royal Society of London and the Académie des Sciences in Paris, and both were asked to join shortly thereafter.[22] They then went on to chair the departments of experimental physics and higher

mathematics at La Sapienza, where they taught for many years.[23] The pair became leading experts in hydrology, too, and were commonly commissioned by various communes to solve some of Italy's most perplexing problems with waterworks.

In 1768 Le Seur and Jacquier collaborated to write another book, *Elemens du Calcul Integral* (Elements of Integral Calculus), which furthered the utility of calculus in the everyday world. Like their earlier work, *Elemens du Calcul* was thorough, well-structured, and readable, which explained the book's appeal among aspiring mathematicians. By now, Le Seur and Jacquier had also joined the Royal Prussian Academy of Sciences, and were mentors to pioneering women in science, too, like the marquise Émilie du Châtelet in France and Maria Gaetana Agnesi in Italy.[24]

Le Seur died two years later, at age sixty-seven; Jacquier lived for almost twenty years more, until 1788, passing at age seventy-seven. By then, Charles Coulomb had published his novel ideas about engineering and its implications in construction. The two may not have been aware of Coulomb's work, performed first in Martinique and then Paris, since they were living in Rome, but Le Seur and Jacquier would have likely been heartened to know that their creativity and foresight from forty years before had taken root, and that their *Parere* had been on the right path all along.

❧

Roger Joseph Boscovich remained warm friends with Le Seur and Jacquier long after their collaboration under Michelangelo's dome.[25] Though they each enjoyed lasting careers, it was Boscovich that became "increasingly recognized as a natural philosopher of world stature."[26] He was a dedicated teacher, too, and was known to focus (like Giovanni Poleni) as much on his method of

instruction—to capture the attention of his students—as on the content of his lectures. [27]

Boscovich was a talented polymath who researched and wrote some 108 papers between 1735 (when starting his career at age twenty-four) and 1787 (when he died). They addressed an impressive diversity of topics, such as the nature of infinity, ocean tides, "the inequality of gravity," repairs to the imperial library in Vienna, atmospheric conditions on the moon, along with the ruins of ancient Troy. [28] Among them was his far-sighted search for a singular, unifying idea to explain the natural world. It was titled *Philosophiae Naturalis Theoria Redacta ad Unicam Legem Virium in Natura Existentium,* and it postulated "a system of 'material points' [now called atoms] which attract or repel each other." [29] No one knew it yet, but his theory would become a building block for modern molecular theory. [30]

The twenty years between 1740 and 1760 became "his most prolific period of mature scholarship, but there was much else, [too]." [31] Boscovich by now was engaged with Roman archaeology, Egyptian hieroglyphics, cartography, and "long vigils in astronomical observation." [32] This was in tandem with an international initiative to measure the earth—a fervent topic of the day known as geodesy—for which "Boscovich was a leading participant" and that led to his many field surveys across Europe. [33] Like Le Seur and Jacquier, he was often sought by the Papal States, the Duchy of Milan, and the respective Republics of Florence and Venice for "advice on questions of practical hydraulics." [34] In the meantime, his body of work gained international recognition, and Boscovich was invited to join the Accademia delle Scienze in Bologna, the Académie des Sciences in Paris, the Saint Petersburg Academy of Sciences, and the Royal Society of London. [35]

It turned out that Boscovich also had the social skills that were well matched for certain kinds of diplomatic missions. This led him into a sort of double life that for fifteen years combined political intrigue inside of Austria, Britain, and France, with the unassuming hum of university academics.[36] But thunder struck soon after, when his religious order, the Jesuits, was chased out of Western Europe in the 1760s, and it forced Boscovich—who was a Jesuit yet did not agree with the order's more inflexible positions—to make some hard choices about his faith and where to live.[37] Ultimately, he found refuge in Paris "with the approval of Louis XV [in] a well-paid post . . . as director of optics for the French navy . . . [making him] a subject of the French crown."[38] Boscovich enjoyed his nine years in France, and it gave him the opportunity to meet many leading scientists of his day, such as Benjamin Franklin.[39]

His friendly and well-mannered demeanor seemed to change, however, with advancing age.[40] This may have stemmed from a chronic injury to his leg, which made Boscovich "increasingly irritable" and known to take "offence over real or imaginary slights."[41] These moods led to "petty irritations, jealousies, intrigues, [and] excessive touchiness" with colleagues and friends "that he was unable to rise above."[42] To his credit, though, Boscovich was determined to "make peace with his enemies" once able to return to Italy, in 1782.[43] He settled near Rome and then Milan, "where former opponents were inclined to let bygones be bygones," but by now his health and his mind were in clear and steady decline.[44] Boscovich died in near obscurity at age seventy-six, and "all trace of where his body was buried was lost" inside the church of Santa Maria Podone in Milan.[45]

He stayed forgotten there, from 1787 until his contributions were rediscovered about a century later, and since the 1960s

Boscovich has emerged as a seminal figure of modern physics. His pioneering ideas on molecular theory are now considered "absolutely original, ingenious, and profound," and "a masterpiece of anticipation" that were arguably a century ahead of their time.[46] Croatia's national center for scientific research in Zagreb is named as the Roger Boscovich Institute.

Prospero Lorenzo Lambertini served as Pope Benedict XIV for almost eighteen years. While in office, he dealt with a sea of domestic headaches and international "quagmires of European dynastic politics" that were strikingly similar to our own, such as a long and devastating war, fiscal deficits, censorship, trade and taxation policy, delicate negotiations with unfriendly sovereign states, anti-Semitism, and the definition of marriage.[47] Benedict XIV worked tirelessly on these matters, and they kept him up deep into the night, for almost every night, and to the state of insomnia.[48] As pope, he was "a lifelong advocate of pragmatism . . . and peaceful compromise," which was invaluable while navigating the other thorny issues of his day, like the expulsion of the Jesuits from Portugal, wholesale excommunication of Protestants, slavery in Brazil and Portugal, and, of course, the unsettling cracks at Michelangelo's dome.[49]

But Benedict XIV's legacy, influence, and imprint on Western culture spans far beyond these ephemeral concerns of church and state. He was a leader of the Enlightenment in Italy, and his progressive ideas pushed society forward in many extraordinary ways. Benedict XIV introduced reforms that resonate in our own time and heightened the quality of nursing for the sick, relief for the poor, and promoted education for boys *and* girls.[50] His support

for higher education was legendary, too, particularly within the sciences, where he advocated that Newtonian physics be taught at Italian universities and actively encouraged women to reach their academic potential.[51] This was most apparent in his home city, Bologna, and its venerable university, which he wished to "bring up to the highest European standard."[52] Though he never saw the place again after becoming pope, Benedict XIV's concern for people and "human beings in pain" prompted his sponsorship of a new department of surgery there, along with the instruction of anatomy and obstetrics.[53] He backed up his words with donations in the 1740s and 1750s that included "his own magnificent personal collection of books . . . [and] thousands of drawings and engravings," along with the money to build a "great hall . . . in which to house them."[54] Benedict XIV advanced the standing of La Sapienza in Rome, too, by establishing a new department for experimental physics—similar to the model established by Giovanni Poleni at the University of Padua—and a new chair in higher mathematics.[55] In short, he did not view science as a threat to God's creation, but rather as a marvelous illustration of it.

Benedict XIV made important and progressive cultural contributions, too. He saved Michelangelo's dome, finished Trevi Fountain, and "preserved the Colosseum from ruin," pillage, and demolition.[56] He also expanded the Capitoline Museum as "a new kind of public cultural space" to promote civic pride and encourage artistic education. He became personally invested in this effort between 1748 and 1750 when he founded the Pinacoteca Capitolina, and where, seemingly with his own money, he "was able to quickly amass a large and impressive group of [313 Italian] paintings . . . that might otherwise have been sold abroad."[57]

Pope Benedict XIV had many admirable, personal qualities. He took a "determined stand against nepotism," for example,

and used his office to elevate and reform the church, rather than enrich his family or his friends (for which they never, apparently, forgave him).[58] Benedict XIV was frugal and expected the same from others within the Curia, and then applied the same fiscal approach to reduce the Vatican's deficit and improve its cash flow.[59] He was fair-minded, too, and had "no hesitation about defending people he thought had been wrongly accused," and could be "roused to fury by malicious gossip and injustice."[60] As an advocate for free speech, "the idea of using the censorship system to silence opponents was anathema" to him, and under his careful navigation this pope slowly changed the Roman Catholic Church's "blanket prohibition" against the ideas of Nicolaus Copernicus and Galileo Galilei.[61]

Benedict XIV contracted the first signs of pneumonia in April 1758, and he died peacefully within a week. His passing sent Rome into deep mourning and was a sad event "outside [of] Italy, and outside the Church."[62] By then, Benedict XIV's forward-thinking ideas, in tandem with his wide-ranging display of intelligence, moral fiber, humor, wit, and warmth had become legendary across Europe. More than that, he had demonstrated that faith and science were not incompatible, that art could be an instrument for the public good, and that the church must be an agent of social reform.[63] "He was, without question, the most remarkable occupant of the throne of Saint Peter during the eighteenth century," and the dome that he helped to save at St. Peter's Basilica is a tangible testament toward that legacy.[64]

It is tempting to hope that Michelangelo—despite his many peeves with prior popes—would have thought so, too.

ACKNOWLEDGMENTS

I t is a fitting coincidence that this book took shape when the University of Padua celebrated its 800th anniversary. The campus was among the first and finest centers of concentrated scientific thought, and it played a pivotal role in saving Michelangelo's dome. Today we embrace the many branches of science and its benefits to modern society, but there was a time when science was commonly viewed with skepticism, trepidation, and fear. The University of Padua was founded on the principle of academic freedom and changed that perception and those attitudes. The place quickly assumed a leading position of scientific research and inquiry across Europe, and at a time when it was not always safe to call oneself a scientist.

My thanks to Professors Carole Paul and Robin Thomas for their generous insights into Italian culture and institutions of the eighteenth century. Also, to Rachael Nutt at Princeton University's Marquand Library of Art and Archaeology, and Tracey Schuster at the Getty Research Institute for their intrepid assistance while tracking down many rare images for use in the book. My agent, Laurie Abkemeier, encouraged the project from its outset and

faithfully read my many drafts with her customary enthusiasm and support at every step of the way. Ross King was a continuous source of guidance and I am grateful for his many, constructive suggestions in research and writing. Claiborne Hancock at Pegasus Books believed in the story, and the talented team of editors there—Jessica Case, Maria Fernandez, Jessica LeTourneur Bax, and Daniel O'Connor—helped to make it even better. My thanks as well to the supportive staff at Malaga Cove Library in Palos Verdes, which might be the finest historic library in California, and is where I spent long hours while crafting the chapters.

Any factual errors are my own.

Finally, a word about my dad, Charlie. He was an engineer in the early days of electrical engineering, and he pioneered a new generation of radar technology after World War II. His inventive research in meteorology elevated the art of weather prediction and the quality of life for millions of people. Like the mathematicians who saved Michelangelo's dome, Charlie was on the cutting edge of science too, and he did it in part at the Massachusetts Institute of Technology which, like the University of Padua, was—and remains—the most advanced center of scientific research anywhere in the world.

Dad died young but left a legacy that was long and lasting. This book is dedicated to his achievements in engineering excellence and his lifelong love of learning.

BIBLIOGRAPHY

Ackerman, James. *The Architecture of Michelangelo*. Chicago: University of Chicago Press, 1986.

———. "Gothic Theory of Architecture at the Cathedral of Milan." *Art Bulletin* 31, no. 2 (1949): 84–111.

Alberti, Leon Battista. *The Ten Books of Architecture (The 1755 Leoni Edition)*. Mineola, NY: Dover Publications, 1986.

Armstrong, Martin. "Most and Least Trusted Professions in Britain." Statista, November 27, 2020. https://www.statista.com/chart/19397/trusted-professions-in-britain-ipsos/.

Arroyo, Salvador Perez. *Introduction to Poleni*. Vol. 1. Madrid: Technical Institute of Materials and Construction, 1982.

———. *Introduction to Poleni*. Vol. 2. Madrid: Technical Institute of Materials and Construction, 1983.

Ashton, Thomas S. *Iron and Steel in the Industrial Revolution*. New York: Augustus M. Kelley Publishers, 1968.

Ashworth, William B., Jr. "Scientist of the Day: Jean-Rodolphe Perronet." Linda Hall Library. https://www.lindahall.org/about/news/scientist-of-the-day/jean-rodolphe-perronet.

———. "Scientist of the Day: Luigi Vanvitelli." Linda Hall Library. https://www.lindahall.org/about/news/scientist-of-the-day/luigi-vanvitelli.

Barnard, Henry. *Military Schools and Courses of Instruction in the Science and Art of War*. New York: E. Steiger, 1872.

Besley, John, and Derek Hill. "Science and Technology: Public Attitudes, Knowledge, and Interest." National Science Foundation, May 2020. https://ncses.nsf.gov/pubs/nsb20207/.

Blond, Stephane J. L. "The Trudaine Atlas: Government Road Mapping in Eighteenth-Century France." *Imago Mundi* 65, no. 1 (2013): 64–79.

Boorsch, Suzanne. "The Building of the Vatican: The Papacy and Architecture." *Metropolitan Museum of Art Bulletin* 40, no. 3 (Winter 1982–1983).

Borngasser, Barbara. "Gothic Architecture in Italy." In *Art of Gothic: Architecture, Sculpture, Painting*, edited by Rolf Toman, 242–251. Cologne: Konemann, 2007.

Britannica, The Editors of Encyclopaedia. "Philip V." Encyclopedia Britannica, December 15, 2022. https://www.britannica.com/biography /Philip-V-king-of-Spain.

Bull, George. *Michelangelo: A Biography*. New York: St. Martin's Press, 1996.

Buonarroti, Michelangelo. *Complete Poems and Selected Letters*. Translated by Creighton Gilbert. New York: Modern Library, 1965.

———. *The Complete Poetry of Michelangelo*. Translated by Sidney Alexander. Athens: Ohio University Press, 1991.

———. *A Record of His Life as Told in His Own Letters and Papers*. Translated by Robert W. Carden. London: Constable & Company Ltd., 1913.

Camasi, Romano. "Catalogues of Historical Earthquakes in Italy." *Annals of Geophysics* 47, no. 2/3 (April/June 2004).

Cameron, Averil. *The Later Roman Empire: AD 284–430*. Cambridge, MA: Harvard University Press, 1993.

Camuffo, Dario. "Galileo's Revolution and the Infancy of Meteorology in Padua, Florence and Bologna." *Méditerranée* (2021).

Capecchi, Danilo. "Historical Roots of the Rule of Composition of Forces." *Meccanica* 47 (November 2012).

Cavazza, Marta. "Benedict's Patronage of Learned Women." In *Benedict XIV and the Enlightenment: Art, Science, and Spirituality*, edited by Barbara Messbarger, Christopher Johns, and Philip Gavitt, 17–39. Toronto: University of Toronto Press, 2016.

———. "The Biographies of Laura Bassi." V&R eLibrary, November 20, 2014.

Chapman, Alan. "England's Leonardo: Robert Hooke (1635–1703) and the Art of Experiment in Restoration England." *Proceedings of the Royal Institution of Great Britain* 67 (1996).

———. *England's Leonardo: Robert Hooke and the Seventeenth-Century Scientific Revolution*. Boca Raton, FL: CRC Press, 2004.

Cohen, I. Bernard. *A Guide to Newton's* Principia. Berkeley: University of California Press, 1999.

Coldstream, Nicola. *Medieval Architecture*. Oxford: Oxford University Press, 2002.

Colvin, Howard. *A Biographical Dictionary of British Architects, 1600–1840*. London: Butler & Tanner Ltd., 1978.

Como, Mario. "Brunelleschi's Dome: A New Estimate of the Thrust and Stresses in the Underlying Piers." *Applied Sciences* 11, no. 9 (2021). https://www.mdpi.com/2076-3417/11/9/4268.

———. "Thrust Evaluations of Masonry Domes: An Application to the St. Peter's Dome." *International Journal of Masonry Research and Innovation* 4, no. 1/2 (2019).

Cossali, Pietro. *Elogio di Giovanni Poleni*. Padua, Italy: Tipografia Bettoni, 1813.

D'Amelio, M. G. "The Construction Techniques and Methods for Organizing Labor Used for Bernini's Colonnade in St. Peter's." *Proceedings of the First International Congress on Construction History*. Vol. 1. Madrid: Instituto Juan de Herrera, Escuela Técnica Superior de Arquitectura, 2003.

D'Amelio, M. G., and N. Marconi. "Technology and Repairs in Castelli e Ponti di Maestro Nicola Zabaglia (Rome, 1743)." *Transactions on the Built Environment* 66 (2003).

Da Vignola, Giacomo Barozzi. *Canon of the Five Orders of Architecture*. Translated by John Leeke with an introduction by David Watkin. Mineola, NY: Dover Publications, 2011.

De Belidor, Bernard Forest. *Dictionnaire Portatif de l'Ingenieur*. Paris: Libraire du Roi pour l'Arrillerie & Poulie Génie, 1755.

———. *Nouveau Cours de Mathématique à l'Usage de l'Artillerie et du Génie*. Paris: Libraire du Roi pour l'Arrillerie & Poulie Génie, 1757.

De Marchi, Stefano, and Maciej Uppsala. "In the Footsteps of Copernicus: Padua and Uppsala." *Irish Mathematical Society Bulletin*, no. 83 (Summer 2019).

De Sanctis, Aldo, Antonio Lio, Nicola Totaro, and Antonio Zappani. "The Basilica of Saint Peter: Surveys as Models of Knowledge (XVII and XVIII Centuries)." *Disegno*, (March, 2018).

De Tipaldo, Emilio. *Biografia degli Italiani Illustri Nelle Scienze, Lettere ed Arti del Secolo XVIII, e de'Contemporanei, Volume Decemo*. 10 vols. Venice: G. Cecchini, 1834–1845.

Del Negro, Piero. "Venetian Policy toward the University of Padua and Scientific Progress during the 18th Century." In *Universities and Science in the Early Modern Period*, Archimedes, vol. 12, edited by M. Feingold and V. Navarro-Brotons. Dordrecht, Netherlands: Springer, 2006.

Der Nersessian, Sirarpie. *Armenian Art*. Translated by Sheila Bourne and Angela O'Shea. Paris: Arts et Metiers Graphique, 1978.

Di Sante, Assunta. *The Archive of the Fabbrica di San Pietro in the Vatican: The History and Documentary Heritage as a Source for the History of Rome*. Rome: Palombi, 2015.

Dijksterhuis, E. J. *Simon Stevin: Science in the Netherlands around 1600*. The Hague: Martinus Nijhoff, 1970.

Dooley, Brendan Maurice. *Science and the Marketplace in Early Modern Italy*. Lanham, MD: Lexington Books, 2001.

Drake, Ellen Tan. *Restless Genius: Robert Hooke and His Earthly Thoughts*. New York: Oxford University Press, 1996.

"Engineer." *Online Etymology Dictionary*, September 8, 2014. https://www.etymonline.com/word/engineer#etymonline_v_25786.

Farey, John. *A Treatise on the Steam Engine, Historical, Practical, and Descriptive*. London: Longman, Rees, Orme, Brown, and Green, 1827.

Feingold, Mordechai, and Victor Navarro-Brotons, eds. *Universities and Science in the Early Modern Period*. Dordrecht, Netherlands: Springer, 2006.

Fermi, Laura, and Gilberto Bernardini. *Galileo and the Scientific Revolution*. Mineola, NY: Dover Publications, 2003.

Findlen, Paula. "Calculations of Faith: Mathematics, Philosophy, and Sanctity in 18th-Century Italy (New Work on Maria Gaetana Agnesi)." *Historia Mathematica* 38, no. 2 (2011): 248–91.

———. "The Pope and the Englishwoman: Benedict XIV, Jane Squire, the Bologna Academy, and the Problem of Longitude." In *Benedict XIV and the Enlightenment: Art, Science, and Spirituality*, edited by Barbara Messbarger, Christopher Johns, and Philip Gavitt, 40–73. Toronto: University of Toronto Press, 2016.

Fitzpatrick, Mary, and Antonietta Fitzpatrick. "Roger Joseph Boscovich: Forerunner of Modern Atomic Theory." *Mathematics Teacher* 61, no. 2 (1968).

Fletcher, Banister. *A History of Architecture*. 18th ed. Revised by J. C. Palmes. New York: Charles Scribner's Sons, 1975.

Fontana, Carlo. *Il Tempio Vaticano e sua Origine*. Rome: Francesco Buagni, 1694.

Frankl, Paul. "The Secret of Mediaeval Masons." *Art Review* 56, no. 3 (1945).

Freedman, Jeri. *Women of the Scientific Revolution*. New York: Rosen Publishing, 2018.

Funari, Marco, Luis Silva, Elham Mousavian, and Paulo Lourenco. "Real-Time Structural Stability of Domes through Limit Analysis: Application to St. Peter's Dome." *International Journal of Architectural Heritage* (2021).

Fusco, Annarosa, and Marcello Villanni. "Pietro da Cortona's Domes between New Experimentations and Construction Knowledge." *Proceedings of the First International Congress on Construction History*. Vol. 1. Madrid: Instituto Juan de Herrera, Escuela Técnica Superior de Arquitectura, 2003.

Gerbino, Anthony, ed. *Geometrical Objects: Architecture and the Mathematical Sciences, 1400–1800*. Cham, Switzerland: Springer International Publishing, 2014.

Ghosh, Sanjib Kumar. "Giovanni Battista Morgagni (1682–1771): Father of Pathologic Anatomy and Pioneer of Modern Medicine." *Anatomical Science International* 92, no. 3 (2017).

Gibbon, Edward. *The Decline and Fall of the Roman Empire*. Vol. 2. New York: Alfred A. Knopf, 1993.

Giedion, Sigfried. *Space, Time and Architecture*. Cambridge, MA: Harvard University Press, 1973.

Giuli, Paola. "Prospero Lambertini and the Accademia degli Arcadi (1694–1708)." In *Benedict XIV and the Enlightenment: Art, Science, and*

Spirituality, edited by Barbara Messbarger, Christopher Johns, and Philip Gavitt, 315–340. Toronto: University of Toronto Press, 2016.

Glatigny, Pascal Dubourg. "Epistemological Obstacles to the Analysis of Structures: Giovanni Bottari's Aversion to a Mathematical Assessment of Saint-Peter's Dome." In *Geometrical Objects: Architecture and the Mathematical Sciences, 1400–1800*, edited by Anthony Gerbino. Cham, Switzerland: Springer International Publishing, 2014.

Godoy, Luis, and Isaac Elishakoff. "The Experimental Contribution of Petrus Van Musschenbroek to the Discovery of a Buckling Formula in the Early 18th Century." *International Journal of Structural Stability and Dynamics* 20, no. 5 (2020).

Govoni, Paola, and Zelda Franceshi, eds. *Writing about Lives in Science*. V&R Unipress, 2015.

Grafton, Anthony. *Leon Battista Alberti: Master Builder of the Italian Renaissance*. New York: Hill & Wang, 2000.

Grendler, Paul. "The Universities of the Renaissance and Reformation." *Renaissance Quarterly* 57 (2004).

Harris, John. *Sir William Chambers, Knight of the Polar Star*. London: A. Zwemmer Ltd., 1970.

Haynes, Renee. *Philosopher King: The Humanist Pope Benedict XIV*. London: Weidenfeld & Nicolson, 1970.

Heilbron, John. "Benedict XIV and the Natural Sciences." In *Benedict XIV and the Enlightenment: Art, Science, and Spirituality*, edited by Barbara Messbarger, Christopher Johns, and Philip Gavitt, 177–205. Toronto: University of Toronto Press, 2016.

Hersey, George. *Architecture, Poetry, and Number in the Royal Palace at Caserta*. Cambridge, MA: MIT Press, 1983.

Heyman, Jacques. *Coulomb's Memoir on Statics: An Essay in the History of Civil Engineering*. Cambridge: Cambridge University Press, 1972.

———. "Poleni's Problem." *Proceedings of the Institution of Civil Engineers* 84, no. 1 (1988).

Hibbard, Howard. *Michelangelo: Painter, Sculptor, Architect*. New York: Chartwell Books, 1975.

Higgs, Carl. "Dud Dudley and Abraham Darby: Forging New Links." Black Country Society, February 18, 2009. http://www.blackcountrysociety. co.uk/articles/duddudley.htm.

Hill, Elizabeth. "Roger Boscovich: A Biographical Essay." In *Roger Joseph Boscovich S.J., F.R.S., 1711–1787: Studies of His Life and Work on the 250th Anniversary of His Birth*, edited by Lancelot Law Whyte, 17–101. New York: Fordham University Press, 1961.

Hitchcock, Henry-Russell. *Architecture: Nineteenth and Twentieth Centuries*. New York: Penguin Books, 1977.

Holmes, Richard. *The World Atlas of Warfare: Military Innovations that Changed the Course of History*. New York: Viking Studio Books, 1988.

Horton, Scott. "Donne: An Anatomy of the World." harpers.org, January 13, 2012.

Hunt, John M. "Betting on the Papal Election in Sixteenth-Century Rome." Center for Gaming Research, Occasional Paper Series, no. 32 (May 2015).

"Ipsos Veracity Index 2022." https://www.ipsos.com/en-uk/ipsos-veracity-index-2022.

James, Ioan. *Remarkable Physicists: From Galileo to Yukawa*. Cambridge: Cambridge University Press, 2004.

Johns, Christopher. "The Scholar's Pope: Benedict VIX and the Catholic Enlightenment." In *Benedict XIV and the Enlightenment: Art, Science, and Spirituality*, edited by Barbara Messbarger, Christopher Johns, and Philip Gavitt, 3–16. Toronto: University of Toronto Press, 2016.

King, Ross. *Brunelleschi's Dome*. London: Walker Books, 2000.

———. *Michelangelo and the Pope's Ceiling*. London: Penguin Books, 2003.

Krautheimer, Richard, and Slobodan Curcic. *Early Christian and Byzantine Architecture*. New Haven, CT: Yale University Press, 1986.

Kulishenko, Yevgeniya. *The Dome of St. Peter's Restoration of the Eighteenth Century*. Rome: Pontifical Gregorian University, 2016.

Lawrence, A. W., and R. A. Tomlinson. *Greek Architecture*. New Haven, CT: Yale University Press, 1996.

Lee, Tae-Woo. *Military Technologies of the World*. Westport, CT: Praeger Security International, 2009.

Lees-Milne, James. *Saint Peter's: The Story of Saint Peter's Basilica in Rome*. London: Hamish Hamilton Ltd., 1967.

Leibniz, Gottfried Wilhelm. *Selections*. Edited by Philip P. Wiener. New York: Charles Scribner's Sons, 1951.

Le Seur, Tommaso, Francesco Jacquier, and Ruggiero Giuseppe Boscovich. *Parere di Tre Matematici Sopra i Danni, Che si Sono Trovati Nella Cupola di S. Pietro, Sul Fine dell'Anno 1742. Dato per Ordine di Nostro Signore Benedetto XIV*. Rome: Fratelli Palearini, 1742. Cicognara Collection 3849 and 3820.

———. *Riflessioni di Padri Tommaso Le Seur, Francesco Jacquier e Ruggiero Giuseppe Boscovich Sopra Alcune Difficolta Spettanti i Danni, e Risarcimenti della Cupola di S. Pietro*. Rome: 1743. Cicognara Collection, 3849.

Le Seur, Thomas et al. *Scritture Concernenti i Danni della Cupola di San Pietro di Roma e i Loro Rimedi*. Venice: Simone Occhi, circa 1742. https://mininglibrarytreasures.wordpress.com/1-2/.

Lopez, Gema. "Poleni's Manuscripts about the Dome of Saint Peter's." *Proceedings of the Second International Conference on Construction History*. Vol. 2. Exeter, UK: Short Run Press, 2006.

Lynch, J. "Charles III." Encyclopedia Britannica, March 29, 2023, http ://wwwbritannica.com/biography/Charles-III-king-of-Spain.

Mainstone, Rowland J. "The Dome of St. Peter's: Structural Aspects of Its Design and Construction, and Inquiries into Its Stability." *Architectural Association School of Architecture*, no. 39 (1999): 21–39.

———. "Saving the Dome of St Peter's." *The Construction History Society*, Vol. 19, (2003), 3–18.

———. "Structural Analysis, Structural Insights, and Historical Interpretation." *Journal of the Society of Architectural Historians* 56, no. 3, (1997).

Manchester, William. *A World Lit Only by Fire*. Boston: Little, Brown and Company, 1992.

Manfredi, Tommaso. "Luigi Vanvitelli." *Biographical Dictionary of Italians* 98 (2020).

———. "Academic Practice and Roman Architecture during the Reign of Benedict XIV." Translated by Christopher Johns. In *Benedict XIV and the Enlightenment: Art, Science, and Spirituality*, edited by Barbara Messbarger, Christopher Johns, and Philip Gavitt, 439–466. Toronto: University of Toronto Press, 2016.

Marcon, Fanny, Giulio Peruzzi, and Sofia Talas. "The Physics Cabinet of the University of Padua: At the Crossroads between Veneto and Europe." *OPUSCULA MUSEALIA* 26 (2019).

Marconi, Nicoletta. "Nicola Zabaglia and the School of Practical Mechanics of the Fabbrica of St. Peter's in Rome." *Nexus Network Journal* 11 (2009): 183–200.

———. "Technicians and Master Builders for Restoration of the Dome of St. Peter's in Vatican in the Eighteenth Century: The Contribution of Nicola Zabaglia (1664–1750)." *Proceedings of the Third International Congress on Construction History*. Vol. 3. Berlin: NEUNPLUS1, 2009.

Markovic, Zeljko. "Boscovich's 'Theoria.'" In *Roger Joseph Boscovich S.J., F.R.S., 1711–1787: Studies of His Life and Work on the 250th Anniversary of His Birth*, edited by Lancelot Law Whyte, 127–152. New York: Fordham University Press, 1961.

McDonald, Hunter. "The Origin of the Word 'Engineer': Its Etymology and Applications Considered." *Scientific American Supplement*, November 7, 1914.

Mclean, Alick. "Renaissance Architecture in Florence and Central Italy." In *The Art of the Italian Renaissance: Architecture, Sculpture, Painting*, edited by Rolf Toman, 98–129. Cologne: Konemann, 2007.

Merriman, John. *A History of Modern Europe: From the Renaissance to the Present*. New York: W. W. Norton, 2019.

Messbarger, Barbara, Christopher Johns, and Philip Gavitt, eds. *Benedict XIV and the Enlightenment: Art, Science, and Spirituality*. Toronto: University of Toronto Press, 2016.

Milton, Henry. "Filippo Juvarra and Architectural Education in Rome in the Early Eighteenth Century." *Bulletin of the American Academy of Arts and Sciences* 35, no. 7 (1982).

Mindeguia, Francisco. "Martino Ferrabosco, el Libro de l'Architettura di San Pietro nel Vaticano entre el limite y la maravilla." *Annali di Architettura* 23 (2011).

Navier, Louis. *Resume Des Lecons Donnes a l'Ecole des Ponts et Chaussees, sur Application de la Mecanique.* Brussels: Societé Belge de Librairie, 1839.

Newton, Isaac. *The Principia: Mathematical Principals of Natural Philosophy.* Translated by I. Bernard Cohen, Anne Whitman, and Julia Budenz. Berkeley: University of California Press, 2016.

"Old Images of Candle-Lit Vatican, St. Peter's Basilica Dome Flickers." *ABC World News*, March 21, 2013. https://www.youtube.com/watch ?v=0llH85URoOw&ab_channel=ABCnewsQQ.

Ottoni, Federica, and Carlo Blasi. "Hooping as an Ancient Remedy for Conservation of Large Masonry Domes." *International Journal of Architectural Heritage* 10, no. 2/3 (2015): 164–81.

Paul, Carole. "Benedict XIV's Enlightened Patronage of the Capitoline Museum." In *Benedict XIV and the Enlightenment: Art, Science, and Spirituality,* edited by Barbara Messbarger, Christopher Johns, and Philip Gavitt, 341–366. Toronto: University of Toronto Press, 2016.

———. *The Borghese Collections and the Display of Art in the Age of the Grand Tour.* London: Routledge, 2016.

Pevsner, Nikolaus. *Pioneers of Modern Design: From William Morris to Walter Gropius.* New York: Penguin Books, 1975.

Phillips, Charles. *The Illustrated History of the Popes.* Dayton, OH: Lorenz Books, 2018.

Pinto, John. *The Trevi Fountain.* New Haven, CT: Yale University Press, 1986.

Poleni, Giovanni. *Memorie Istoriche della Gran Cupola del Tempio Vaticano.* Vol. 1, edited by Jose Calavera and Pérez Arroyo. Madrid: Technical Institute of Materials and Construction, 1982.

———. *Memorie Istoriche della Gran Cupola del Tempio Vaticano.* Vol. 2, edited by Jose Calavera and Pérez Arroyo. Madrid: Technical Institute of Materials and Construction, 1983.

———. *Memorie Istoriche della Gran Cupola del Tempio Vaticano e de' Danni di Essa, e de' Ristoramenti Loro, Divise in Libre Cinque.* Padua: Nella Stamperia del Seminario, 1748.

Present, Pieter. *Learning in the World: Petrus van Musschenbroek (1692–1761) and "(Newtonian) Experimental Philosophy."* Brussels: Brussels University Press, 2019.

Richardson, Lawrence. *A New Topographical Dictionary of Ancient Rome.* Baltimore: Johns Hopkins University Press, 1992.

Riva, M. A. et al. "The Death of Raphael: A Reflection on Bloodletting in the Renaissance." *Internal and Emergency Medicine* 16 (2021): 243–44.

Rosen, William. *The Most Powerful Idea in the World: A Story of Steam, Industry, and Invention.* London: Jonathan Cape, 2010.

Schlimme, Hermann. "Construction Knowledge in Comparison: Architects, Mathematicians and Natural Philosophers Discuss the Damage to St. Pater's Dome in 1743." *Proceedings of the Second International Conference on Construction History.* Vol. 2. Exeter, UK: Short Run Press, 2006.

Scott, J. F. "Boscovich's Mathematics." In *Roger Joseph Boscovich S.J., F.R.S., 1711–1787: Studies of His Life and Work on the 250th Anniversary of His Birth,* edited by Lancelot Law Whyte, 183–192. New York: Fordham University Press, 1961.

Scotti, R.A. *Basilica: The Splendor and the Scandal: Building St. Peter's.* New York: Viking, 2006.

"Siege of Vienna." *Encyclopedia Britannica,* January 12, 2023. https://www .britannica.com/event/Siege-of-Vienna-1683.

"Significant Earthquake Database." National Oceanic and Atmospheric Administration. https://www.ngdc.noaa.gov/hazel/view/hazards /earthquake/event.

Signorelli, Bruno. "Giovanni Poleni." *Biographical Dictionary of Italians.* Vol. 84. Rome: Istituo della Enciclopedia Italiana, 2015.

Smith, Craig. *How the Great Pyramid Was Built.* Washington, DC: Smithsonian Books, 2004.

Sobel, Dava. *Longitude: The True Story of a Lone Genius Who Solved the Greatest Scientific Problem of His Time.* New York: Walker Publishing Company, 1995.

Spoerl, Joseph S. "A Brief History of Iron and Steel Production." Lecture notes, Saint Anselm College, 2004.

Stalley, Roger. *Early Medieval Architecture.* Oxford: Oxford University Press, 1999.

Straub, Hans. *A History of Civil Engineering.* Translated by Erwin Rockwell. Cambridge, MA: MIT Press, 1964.

Struik, Dirk J. *A Concise History of Mathematics, Volume II: The Seventeenth Century–The Nineteenth Century.* Mineola, NY: Dover Publications, 1948.

Swaan, Wim. *The Gothic Cathedral.* London: Ferndale Editions, 1981.

Tetti, Barbara. *The Restoration of Architecture and Works of Art in the Eighteenth Century: The Vocabulary, Theory, and Achievement of Luigi Vanvitelli.* Lewiston, NY: Edwin Mellen Press, 2016.

Thomas, Robin. "From the Library to the Printing Press: Luigi Vanvitelli's Life with Books." *Journal of the Society of Architectural Historians* 69, no. 4 (2010).

"Thomas Telford: Biography." Sky History, n.d. https://www.history.co.uk /biographies/thomas-telford.

Tipler, Paul. *Physics*. New York: Worth Publishers, 1976.

Tivnan, Edward. "François Jacquier." *The Catholic Encyclopedia*. Vol. 8. New York: Robert Appleton Company, 1910.

Toman, Rolf, ed. *The Art of Gothic: Architecture, Sculpture, Painting*. Cologne: Konemann, 2007.

Toman, Rolf, ed. *The Art of the Italian Renaissance: Architecture, Sculpture, Painting, Drawing*. Cologne: Konemann, 2007.

Traetta, Luigi. "Bernard Forest de Belidor: Engineer, Manualist and Machine Historian." *Advances in Historical Studies* 9 (2020).

Tribe, Shawn. "The Sanpietrini and the Illumination of St. Peter's Basilica." *Liturgical Arts Journal*, July 3, 2020.

"The Triumvirate: Coal, Iron, and Steam." Creatures of Thought, July 13, 2021. https://technicshistory.com/2021/07/13/the-triumvirate-coal-iron -and-steam/.

Tuchman, Barbara. *The March of Folly*. New York: Ballantine Books, 1984.

Vasari, Giorgio. *The Lives of the Artists*. Translated by Julia and Peter Bondanella. Oxford: Oxford University Press, 1988.

———. *Lives of the Artists*. Vol. 1. Translated by George Bull. London: Penguin Books, 1965.

Verdon, Timothy. "600 Years of Brunelleschi's Dome, the Largest Brick Vault in the World." La Stampa, June 11, 2020. https://www.lastampa .it/vatican-insider/it/2020/06/12/news/i-600-anni-della-cupola-del -brunelleschi-la-piu-grande-volta-in-laterizio-del-mondo-1.38956407/.

Vitruvius. *Ten Books on Architecture*. Translated by Morris Hicky Morgan. Mineola, NY: Dover Publications, 1960.

von Simson, Otto. *The Gothic Cathedral*. Princeton, NJ: Princeton University Press, 1974.

Walker, Juliann. "Carlo Fontana and the Origins of the Architectural Monograph." Master's thesis, University of California Riverside, 2016.

Wallace, William E. *Michelangelo, God's Architect: The Story of His Final Years and Greatest Masterpiece*. Princeton: Princeton University Press, 2019.

Ward-Perkins, J. B. *Roman Imperial Architecture*. New Haven, CT: Yale University Press, 1981.

White, John. *Art and Architecture in Italy 1250–1400*. New Haven: Yale University Press, 1966.

Whyte, Lancelot Law. "Boscovich's Atomism." In *Roger Joseph Boscovich S.J., F.R.S., 1711–1787: Studies of His Life and Work on the 250th Anniversary of His Birth*, edited by Lancelot Law Whyte, 102–126. New York: Fordham University Press, 1961.

Whyte, Lancelot Law, ed. *Roger Joseph Boscovich S.J., F.R.S., 1711–1787: Studies of His Life and Work on the 250th Anniversary of His Birth*. New York: Fordham University Press, 1961.

Williams, Kim, and Marco Bevilacqua. "Leon Battista Alberti's Bombard Problem in Ludi Matematici: Geometry and Warfare." *Mathematical Intelligencer* 35, no. 4 (2013).

Zabaglia, Niccola. *Castelli e Ponti di Maestro Niccola Zabaglia con Alcune Ingegnose Pratiche e con la Descrizione del Trasporto dell'Obelisco Vaticano e di Altri del Cavaliere Domenico Fontana*. Rome: nella stamperia di Niccolo, e Marco Pagliarini, 1743.

———. *Castelli e Ponti di Maestro Niccola Zabaglia con Alcune Ingegnose Pratiche e con la Descrizione del Trasporto dell'Obelisco Vaticano e di Altri del Cavaliere Domenico Fontana, Edizione Seconda, coll'Aggiunta di Machine Posteriori e Premesse le Notizie Storiche della Vita e delle Opera dello Stesso Zabaglia Compilate dalla Chiarissima Memoria dell'Avvocato Filippo Maria Renazzi, Segretario Sostituto della Reverenda Fabbrica di San Pietro*. Rome: Nella Stamperia di Crispino Puccinelli Stampatore della Reverenda Fabbricca di San Pietro in Via Valle N. 53, 1824.

———. *Castelli e Ponti di Maestro Niccola Zabaglia e con la Descrizione del Trasporto dell'Obelisco Vaticano del Cavaliere Domenico Fontana*. Madrid: Universidad Politecnica de Madrid, 2005.

NOTES

1. THE POPE'S PROBLEM

1 Timothy Verdon attributes this to a remark recorded by Giornio Vasari, a friend and biographer of Michelangelo.

2 For context, his dome could comfortably contain the Statue of Liberty and its pedestal.

3 In 1586 and just before construction of Michelangelo's dome, Pope Sixtus V established that the college be limited to seventy members. Fourteen cardinals were absent from the conclave of 1740, while fifty-one cast votes in the final tally.

4 Rules to govern the conclaves were established by Pope Gregory X as early as 1274. Policies to deter gambling were decreed by Pope Gregory XIV in 1591, just after Michelangelo's dome was raised. John Hunt's study shows that the practice was never entirely extinguished.

5 Haynes, *Philosopher King*, 157. By popular opinion of the time, candidates Porzia and Ottobani had both succumbed to "papal rabies": a sickness of the blood brought on by alternating bouts of "hope and discouragement."

6 Haynes, *Philosopher King*, 157.

7 The conclave met for 180 days—from February 18 to August 17. On average, fresh ballots would have been tallied at least once and often twice each day.

8 Haynes, *Philosopher King*, 90.

9 Haynes, *Philosopher King*, 16–17.

10 Haynes, *Philosopher King*, 18.

11 The Collegio Clementino was founded in 1595, just after Michelangelo's dome was raised. Its main building may have been designed and built by Giacomo della Porta as one of his last commissions (he died in 1602).

12 Pope Innocent XII reigned until 1700; Pope Clement XI to 1721; and Pope Innocent XIII until 1724.

13 He was baptized as Pietro Francesco Orsini and renamed when he joined the Dominicans.

14 Haynes, *Philosopher King*, 4, 40.

15 It was around this time that Benedict XIII opened the beloved Spanish
 Steps—Scalinata della Trinita dei Monti—to the public.

16 Haynes, *Philosopher King*, 41. Cardinals wore a distinctive, bright red that
 was reserved for the Sacred College of Cardinals.

17 Others were apparently in on this scheme, too, including the chief
 steward of Benedict XIII's own, inner household. But it was controlled
 from Benevento, southeast of Rome, where Coscia was archbishop. Ital-
 ians were outraged by Benedict XIII's incompetence and having allowed
 it to happen. Coscia was tried within weeks of Clement XII's installation,
 excommunicated, and then sentenced to ten years in prison, but his sen-
 tence was commuted in lieu of his paying a heavy fine.

18 Haynes, *Philosopher King*, 44.

19 Haynes, *Philosopher King*, 44.

20 Haynes, *Philosopher King*, 44.

21 Haynes, *Philosopher King*, 152.

22 Haynes, *Philosopher King*, 46–56.

23 Haynes, *Philosopher King*, 71–75. The institute was founded in 1690 and inau-
 gurated in 1711 as the Accademia delle Scienze dell'Istituto di Bologna.

24 Haynes, *Philosopher King*, 47–48, describes Francesco Peggi as "hunched
 up and fattish," and Giampetro Zanotti as "greedy Giampetro who once
 ate fifty-five fritters at a sitting."

25 Haynes, *Philosopher King*, 42, 151, 162–63, cites amusing episodes when
 Lambertini used such salty expressions.

26 Heilbron, "Benedict XIV and the Natural Sciences," 194.

27 The Capitoline Museums (Musei Capitolini) were first established by
 Clement XII in 1733, and then expanded by Lambertini in the 1740s
 after he became pope. It was envisioned as a new type of public space,
 where ordinary people could enjoy and appreciate their cultural heritage.
 It set the precedent for the British Museum (1759), Uffizi Gallery (1769),
 Vatican Museum (1770), Belvedere Museum in Vienna (1776), Royal
 Museum in Stockholm (1792), and the Louvre (1793). See Paul, "Bene-
 dict XIV's Enlightened Patronage."

28 Haynes, *Philosopher King*, 48.

29 Haynes, *Philosopher King*, 48.

30 Haynes, *Philosopher King*, 158.

31 Haynes, *Philosopher King*, 158.

32 Haynes, *Philosopher King*, 159.

33 The sale of indulgences was not new: John XIX was the first pope, circa
 1025, to grant them. But it was the vast and enterprising scale and the
 colossal magnitude of money encouraged by Pope Leo X that enraged
 Martin Luther. Per Haynes, *Philosopher King*, 194, Benedict XIV was
 personally opposed to the practice.

34 It encompassed present-day Rome and environs, along with the provinces of Marche, Romagna, Umbria, and parts of Emilia. Its core urban centers included Ancona, Bologna, Orvieto, Perugia, Ravenna, and Urbino.

35 Dooley, *Science and the Marketplace in Early Modern Italy*, 99.

36 Mainstone, "The Dome of St. Peter's," 23: "The known evidence for the dome itself is limited to several preparatory drawings, engravings…, [and] part of the inner shell of a wooden model."

2. BUILDING THE BASILICA

1 Richardson, *New Topographical Dictionary of Ancient Rome*, 405; Lees-Milne, *Saint Peter's*, 64–65.

2 Lees-Milne, *Saint Peter's*, 65. Marcus Valerius Martialis was a contemporary of Pliny the Elder.

3 Caligula's circus was crowned by an Egyptian obelisk that was eighty feet tall, known as the Vatican Obelisk or as St. Peter's Needle. It was barged to Rome in the year 37 c.e.—from Alexandria or Heliopolis—and keeps watch today from the middle of St. Peter's Square.

4 Gibbon, *Decline and Fall of the Roman Empire*, vol. 2, 17–19. "Of the fourteen regions into which Rome was divided," four were spared, "three were levelled with the ground, and the remaining seven . . . displayed a melancholy prospect of ruin and desolation." Despite Nero's indifference, "the vigilance of government appears not to have been neglected," and victims of the fire were provided immediate, emergency food and housing.

5 Peter was crucified in an inverted position because he felt unworthy of comparison with Jesus.

6 Gibbon, *Decline and Fall of the Roman Empire*, vol. 2, 158–63.

7 Basilican churches were built in Antioch, Bethlehem, Jerusalem, Tyre, and beyond, with another seven in Rome. Constantine ruled jointly with Licinius from 312-324 c.e., and as sole emperor between 324 and 337 c.e.

8 Roman basilicas from the Imperial Age were used as law courts, civic centers, and places to conduct business. They served as imperial audience halls, too, and often featured a semicircular recess, known as an apse, along their short sides that contained statuary of the current, reigning emperor.

9 The earthquake occurred around the year 450 c.e. The Avignon Papacy (1309–1376) was followed by a confused period of competing popes known as the Great Schism (1378–1417). By 1500 Rome had been sacked and looted on various occasions by the Normans, Ostrogoths, Saracens, Vandals, and Visigoths.

10 Lees-Milne, *Saint Peter's*, 124.

11 Alberti, *Ten Books of Architecture*, 240.

12 Vasari, *Lives of the Artists* (Bull, trans.), 210: "From then on Rossellino always went to Leon Battista for advice."

13 Vasari, *Lives of the Artists* (Bull, trans.), 209. Many repairs were subse-
 quently commissioned by Sixtus IV between 1471 and 1484. The basilica's
 walls were stabilized under his watch, and he installed more windows,
 repaired the roof, and repaved the site. He also commissioned the con-
 struction of the Sistine Chapel.

14 Lees-Milne, *Saint Peter's*, 136.

15 Tuchman, *March of Folly*, 93, 96.

16 Scotti, *Basilica*," 41–3. Julius II may have also consulted with Fra
 Giovanni Giocondo da Verona. Donato Bramante is known by other
 names, too, like Donato di Pascuccio d'Antonio, as well as Donato
 d'Angelo Lazzari.

17 Scotti, *Basilica*, 98–9.

18 Scotti, *Basilica*, 78; King, *Michelangelo and the Pope's Ceiling*, 6.

19 Raphael was the most gifted among them and was commissioned to paint
 many frescoes inside the nearby papal apartments. Bramante probably
 knew his father, Giovanni Santi, since both were painters around the
 same time and while in the service of Duke Federigo di Montefeltro of
 Urbino (Scotti, *Basilica*, 45).

20 Ackerman, *Architecture of Michelangelo*, 317.

21 Tuchman, *March of Folly*, 113. Theses 51 and 82 (of 95) cited Luther's spe-
 cific complaints with the new basilica.

22 Tuchman, *March of Folly*, 106: Leo "showered endless favors on Raphael"
 and would have likely made him a cardinal had the artist "not forestalled
 him by dying at 37." Vasari's *Lives of the Artists* (Bondanella, trans.), 327
 and 336, famously reported the painter's fondness for women: "Raphael
 was a very amorous person . . . delighting much in women, and ever ready
 to serve them" (King, *Michelangelo and the Pope's Ceiling*, 197). However, a
 recent study suggests that the artist died from a pulmonary disease, rather
 than syphilis. See Riva et al., "Death of Raphael."

23 Giuliano da Sangallo had worked in and around the Vatican since the
 1470s and was architect to the Medici family, uncle to Antonio da San-
 gallo the Younger, and a friend to Michelangelo.

24 Tuchman, *March of Folly*, 120.

25 Giovanni Antonio Dosio (1533–1611), who was mostly known as a
 sculptor, also sketched many Roman streetscapes in his career. His views
 of Vatican Hill in the 1560s and '70s provide a precise visual record of
 Old St. Peter's Basilica as well as the state of current construction at the
 new St. Peter's Basilica, before the dome's vaulting.

26 Renamed by Sixtus V to La Congregazione della Reverenda Fabbrica di
 San Pietro.

27 Lees-Milne, *Saint Peter's*, 160.

28 Ackerman, *Architecture of Michelangelo*, 317; Less-Milne, *Saint Peter's*, 61.
 Raising the money meant reinstating the sale of indulgences.

29 The Florentines began to mint a coin around the year 1250 that was about three and a half ounces of twenty-four-karat gold, known as the florin and became a standard form of currency in Tuscany and around Europe. Venice produced a competing coin soon after, in 1284, of equivalent value called a ducat (from the Italian, *ducato*, for dukedom), which was famously featured in Shakespeare's *The Merchant of Venice*. A third coin appeared in the Piedmont region, known as the scudo (pl. scudi) in both silver and gold with far less metallic content. The architects, builders, mathematicians, and scientist who raised St. Peter's Basilica and fixed its dome were commonly paid in ducats and scudi and most frequently by silver scudo (*scudo di moneta*) and papal scudo made from gold (*scudo d'oro pontificio*). Some meaningful benchmarks suggest that one ducat from those times was equivalent to about two thousand dollars in the year 2022. See Paul, *Borghese Collections*, 262; Scotti, *Basilica*, 80; and King, *Michelangelo and the Pope's Ceiling*, 3–4.

30 Lees-Milne, *Saint Peter's*, 163, 187; Scotti, *Basilica*, 194.

31 Lees-Milne, *Saint Peter's*, 164–65; Scotti, *Basilica*, 188.

32 King, *Michelangelo and the Pope's Ceiling*, 23; Bull, *Michelangelo*, 13. Michelangelo was apprenticed in his teens for a three-year term to the Florentine painter Domenico Ghirlandaio. But there was little rapport between them and even "signs of jealousy" on the part of Ghirlandaio, who, just a year into the contract, referred his young apprentice to Lorenzo de' Medici's school at the Garden of San Marco where Michelangelo became a trained sculptor.

33 Lees-Milne, *Saint Peter's*, 177, 188.

34 Vasari, *Lives of the Artists* (Bondanella, trans.), 474–82.

35 Hibbard, *Michelangelo*, 154.

36 Vasari, *Lives of the Artists* (Bondanella, trans.), 467.

37 Michelangelo's letter to Bartolomeo Ferrantini in the summer of 1547; see Buonarroti, *Complete Poems and Selected Letters*.

38 Ackerman, *Architecture of Michelangelo*, 319.

39 Michelangelo's letter to his nephew, Lionardo di Buonarroto Simini, in July 1547; see Buonarroti, *Complete Poems and Selected Letters*.

40 Vasari, *Lives of the Artists* (Bondanella, trans.), 467.

41 Buonarroti, *Complete Poetry of Michelangelo*, 169–71. Buonarroti, *Record of His Life as Told in His Own Letters and Papers*, 316–17, points to more mischief.

42 Michelangelo's letter to Lionardo, February 13, 1557, in Buonarroti, *Record of His Life as Told in His Own Letters and Papers*, 299–301.

43 Ackerman, *Architecture of Michelangelo*, 323.

44 Como, "Thrust Evaluations of Masonry Domes," 35–36, 40–41. Thirty-three thousand tons is the rough equivalent of eighteen-thousand, mid-sized automobiles which, for context, approximates the parking capacity

at many stadiums in the United States. Dodger Stadium in Los Angeles, for example, can accommodate sixteen-thousand cars (https://stadiumparkingguides.com/dodger-stadium-parking/).

45 Ackerman, *Architecture of Michelangelo*, 319; Vasari, *Lives of the Artists* (Bondanella, trans.), 467. Most of the new work was in the south and north transepts, exterior walls, and north chapels.

46 Michelangelo's letter to the Cardinal of Carpi, September 13, 1560, in Buonarroti, *Record of His Life as Told in His Own Letters and Papers*, 316–317.

47 Vasari, *Lives of the Artists* (Bondanella, trans.), 470. Giorgio Vasari was a successful painter and architect who, around 1550, invented the field of art history when his legendary anthology of artists was published as "the Lives of the Most Excellent Italian Architects, Painters, and Sculptors, from Cimabue up to our own times: described in the Tuscan Language, by Giorgio Vasari, Aretine Painter, with his useful & necessary introduction to their arts"; see Bull, *Michelangelo*, 345.

48 Today, there are 214 members of the Sacred College of Cardinals.

49 Zabaglia, *Castelli*, plates xxxvii–lv; Straub, *History of Civil Engineering*, 96–99; Scotti, *Basilica*, 203–7; Lees-Milne, *Saint Peter's*, 218–21.

50 Poleni, *Memorie Istoriche*, book 4, plate K; Marconi, "Technicians and Master Builders," 998; Mainstone, "The Dome of St. Peter's, 24–26, 37; Mainstone, "Saving the Dome of St Peter's," 4–5, 7–8.

51 Scotti, *Basilica*, 218–24; Giedion, *Space, Time and Architecture*, 90.

52 The dome was 108 feet tall. Construction began in mid-July 1588 and was completed twenty-two months later, in mid-May 1590. This equates to an average rate of 4.9 vertical feet each month.

53 Boorsch, "Building of the Vatican," 3.

54 Giedion, *Space, Time and Architecture*, 87.

3. MASTER BUILDERS AND THEIR METHODS

1 These kinds of corbels and blockwork were also used during the Egyptian Old Kingdom at the Grand Gallery inside Khufu's Great Pyramid at Giza, and the underground chamber at the pyramid of Meidum. Both convey a similar spatial effect, though at a more modest (and claustrophobic) scale. They were vaulted around 1,300 years before the Treasury of Atreus and about 4,000 years before Michelangelo's dome.

2 Vitruvius, *Ten Books on Architecture*, book I, prefaces 2 and 3. Though Alberti affirmed that Vitruvius wrote with "universal Knowledge," he also complained it was written with such confusing grammar that "to the *Latins*, [Vitruvius] seems to write *Greek*, and to the *Greeks*, *Latin* . . . and he might almost as well have never wrote at all . . . since we cannot understand him" (Alberti, *Ten Books of Architecture*, book 6, 111).

3 Vitruvius, *Ten Books on Architecture*, books IV.8.3 and V.10.5.

4 The cathedral complex at Pisa (the Baptistry of San Giovanni, the Basilica
 of Santa Maria Assunta, and the campanile) "together form one of the most
 famous building groups of the world" (Fletcher, *A History of Architecture*,
 468). They are the among the finest of their kind and we would admire their
 architectural effect with or without the tower's famous "lean." The Campo
 Santo was designated as a UNESCO World Heritage site in 1987.

5 The New York City Common Council prepared a Commissioner's Plan
 of 1811 to standardize the widths of Manhattan's avenues at one hundred
 feet, and typical cross streets—or blocks—at sixty feet.

6 Vasari, *Lives of the Artists* (Bondanella, trans.), 365. The Italian word for a
 dome is "cupola;" the Italian word for an entire cathedral is "duomo."

7 Verdon, "600 Years of Brunelleschi's Dome."

8 King, *Brunelleschi's Dome*, 242.

9 Mainstone, "Structural Analysis," 327, identifies at least fifty-eight cracks
 in the dome and walls of Hagia Sophia. King, *Brunelleschi's Dome*, 66, 175,
 notes cracks in the basilica walls beneath the great cupola, first in 1420
 at the north tribune, and then in 1429 along the side walls of the nave.
 According to Como, "Brunelleschi's Dome," 2, further cracks were noted
 in 1639, about two hundred years after construction; more were observed
 about fifty years later and the largest were identified in 1984.

10 Commonly, these steering committees were formed *before* the start of
 construction. But at St. Peter's Basilica, the Fabricca was established
 nearly twenty years *after* Bramante's earliest designs, in 1523.

11 From the Latin, *plumbum*. Plumbers could often be identified by their
 "deep pallor." Vitruvius, *Ten Books on Architecture*, books VIII.6.10,
 VIII.6.11, cites lead as a known hazard that was "hurtful to the human
 system," either by excessive handling or by ingestion through water pipes
 that were lined with the substance.

12 Swaan, *Gothic Cathedral*, 83–84.

13 Swaan, *Gothic Cathedral*, 90–99. Honnecourt's sketchbook also contained
 a serendipitous variety of mechanical contraptions, weaponry, household
 gadgets, biblical personalities, Roman ruins, along with minstrels and a
 roaring lion. White, *Art and Architecture in Italy*, 452–453, describes, for
 example, the prestigious rank and privileges given to Lorenzo Maitani,
 who was recognized in 1310 by the city fathers of Orvieto with a Lati-
 nized title: "universalis caputmagister."

14 The altar was necessarily positioned at the western end because of the
 pragmatic, physical challenges imposed by Constantine years before,
 when he deliberately built his basilica atop the marshy cemetery and
 irregular terrain on Vaticanus Mons.

15 Vitruvius, *Ten Books on Architecture*, book I.1.4. White, *Art and Architecture
 in Italy*, 455–457, describes "two large drawings" preserved at Orvieto
 Cathedral that represent, by 1310, "the earliest case in the whole history

of Italian architecture in which preliminary designs for an entire project have survived."

16 Frankl, "Secret of Mediaeval Masons," 46.

17 There is uncertainty surrounding the the the term "freemasons." According to Von Simson, *Gothic Cathedral*, 220: "The quarryman and stone cutter became a 'freemason' if he was able to work 'freestone', i.e., finegrained sandstone or limestone." This is affirmed by Swaan, *Gothic Cathedral*, 74–75, and 320, n6. On the other hand, Frankl's "Secret of Mediaeval Masons," 46, cites that "Mediaeval masons were called 'free masons' since they were not bound to a guild in any specific city."

18 In Egypt, the pyramids had been measured by the "cubit," which was about twenty inches long, and was comprised of seven "palms" with four "digits." So, there were twenty-eight digits in a cubit.

19 King, *Brunelleschi's Dome*, 79; Swaan, *Gothic Cathedral*, 75–76.

20 Swaan, *Gothic Cathedral*, 76.

21 Vitruvius, *Ten Books on Architecture*, book III.4.1.

22 Coldstream, *Medieval Architecture*, 55; King, *Brunelleschi's Dome*, 80.

23 Mainstone, "Structural Analysis," 337.

24 Alberti, *Ten Books of Architecture*, 238.

25 Beauvais is among the most daring structures in the history of construction. It was tall and narrow, and pushed the boundaries of structural stability to its precipice, as evidenced by the collapse of its roof in 1284, and its crossing in 1573.

26 Alberti, *Ten Books of Architecture*, 238.

27 The Leaning Tower of Pisa was stabilized in the 1990s. Though it could have been restored to an upright position, the "lean" was kept intact—using an intricate arrangement of steel cables and counter-weights—to preserve its status as a cultural landmark and tourist attraction.

28 "Ominous cracks appeared in the vault" of the adjacent Sistine Chapel, too, early in the reign of Julius II and only twenty years after it was opened, in 1483. (King, *Michelangelo and the Pope's Ceiling*, 20).

4. THE ABLE ASSISTANT

1 Hersey, *Architecture, Poetry, and Number*, 88.

2 Thomas, "From the Library to the Printing Press," 509–14. Lorenzani's brother, Paolo (Luigi's great-uncle), was formerly a musical composer at Versailles in the court of Louis XIV, the Sun King.

3 Tetti, *Restoration of Architecture and Works of Art*, 40.

4 Thomas, "From the Library to the Printing Press," 511.

5 Manfredi, "Luigi Vanvitelli," 1.

6 Milton, "Filippo Juvarra and Architectural Education," 27.

7 Milton, "Filippo Juvarra and Architectural Education," 27.

8 Manfredi, "Luigi Vanvitelli," 2; Tetti, *Restoration of Architecture and Works of Art*, 95.

9 Haynes, *Philosopher King*, 155.

10 Tetti, *Restoration of Architecture and Works of Art*, 95.

11 Giuli, "Prospero Lambertini and the Accademia degli Arcadi," 317–21.

12 Giuli, "Prospero Lambertini and the Accademia degli Arcadi," 318.

13 Giuli, "Prospero Lambertini and the Accademia degli Arcadi," 319.

14 Giuli, "Prospero Lambertini and the Accademia degli Arcadi," 322.

15 Tetti, *Restoration of Architecture and Works of Art*, 95.

16 Manfredi, "Academic Practice and Roman Architecture," 441.

17 Gibbon, *Decline and Fall of the Roman Empire*, vol. 2, 158–63; Lees-Milne, *Saint Peter's*, 61, 117.

18 Pinto, *Trevi Fountain*, 99.

19 Pinto, *Trevi Fountain*, 98–99.

20 Pinto, *Trevi Fountain*, 98.

21 Tetti, *Restoration of Architecture and Works of Art*, 95–100; Hersey, *Architecture, Poetry, and Number*, 90.

22 Thomas, "From the Library to the Printing Press," 516.

23 Da Vignola, *Canon of the Five Orders of Architecture*, vi.

24 Thomas, "From the Library to the Printing Press," 517.

25 Thomas, "From the Library to the Printing Press," 510.

26 Thomas, "From the Library to the Printing Press," 515.

27 Tetti, *Restoration of Architecture and Works of Art*, 95–96.

28 Manfredi, "Academic Practice and Roman Architecture," 451.

29 Manfredi, "Academic Practice and Roman Architecture," 451.

30 Glatigny, "Epistemological Obstacles to the Analysis of Structures," 209.

31 Tetti, *Restoration of Architecture and Works of Art*, 96; Hersey, *Architecture, Poetry, and Number*, 93. Vanvitelli's subsequent design at Santa Maria degli Angeli e dei Martiri in Rome was heavily criticized by Bottari, who "hated every aspect" of the work and believed it more closely resembled a butchery than an improvement; see Thomas, "From the Library to the Printing Press," 518. This infuriated the architect and he bitterly rebuked Bottari who, according to Vanvitelli, "does not understand architecture and should not speak about it." See Manfredi, "Academic Practice and Roman Architecture," 455.

32 Manfredi, "Academic Practice and Roman Architecture," 446, 456.

33 Manfredi, "Academic Practice and Roman Architecture," 448.

34 Manfredi, "Academic Practice and Roman Architecture," 450; Harris, *Sir William Chambers*, 22. Chambers was best known for his design in 1775 of Somerset House, a neoclassical landmark located in the heart of London and overlooking the River Thames near Waterloo Bridge. Charles Bulfinch from Boston admired it while on his European grand tour in the 1780s and it inspired his design in 1794 of the Massachusetts State House.

35 Mainstone, "The Dome of St. Peter's," 30. According to Schlimme, "Construction Knowledge in Comparison," 2854, architect Giuseppe Paglia was also part of the investigation.

36 De Sanctis et al., "Basilica of Saint Peter," 205. According to Schlimme, "Construction Knowledge in Comparison," 2854, architect and mathematician Paolo Falconieri also studied the issue and wrote about it one year later, in 1695.

37 "Significant Earthquake Database," Italy, 1590–1742.

38 "Significant Earthquake Database," Italy, 1590–1742.

39 Mainstone, "The Dome of St. Peter's," 31; Como, "Thrust Evaluations of Masonry Domes," 37; Poleni, *Memorie Istoriche*, book 2, plates i, ii, xv, xvi, xviii, xix.

40 De Sanctis et al., "Basilica of Saint Peter," 203, 204, 211n3. "The intelligent professor" (*l'intelligente professore)*, was Ferabosco's invention.

41 Fontana, *Il Tempio Vaticano e sua Origine*.

42 Walker, "Carlo Fontana and the Origins of the Architectural Monograph," 72.

43 Walker, "Carlo Fontana and the Origins of the Architectural Monograph," 71; Fontana, *Il Tempio Vaticano e sua Origine*, 311–37. Fontana also included a few detailed, comparative drawings of the Pantheon in Rome and the Duomo in Florence; see Fontana, *Il Tempio Vaticano e sua Origine*, book 7, 465, 467, 485, 487.

44 De Sanctis et al., "Basilica of Saint Peter," 205–7; Fontana, *Il Tempio Vaticano e sua Origine*, 331.

45 Hill, "Roger Boscovich," 35; Marconi, "Technicians and Master Builders," 993.

46 Schlimme, "Construction Knowledge in Comparison," 2853; Glatigny, "Epistemological Obstacles to the Analysis of Structures," 204.

47 Marconi, "Technicians and Master Builders," 993; Hill, "Roger Boscovich," 35; Kulishenko, *Dome of St. Peter's Restoration of the Eighteenth Century*, 16. See also chapter 9, note 1.

48 Mainstone, "Saving the Dome of St Peter's," 4. Marconi cites September 22 in "Technicians and Master Builders," 993, while Mainstone cites September 20 in "The Dome of St. Peter's," 31.

49 Mainstone, "Saving the Dome of St Peter's," 4–5; Mainstone, "The Dome of St. Peter's," 31.

50 Poleni, *Memorie Istoriche*, book 2, sections xxi–xxiii.

51 Mainstone, "Saving the Dome of St Peter's," 4–5; Mainstone, "The Dome of St. Peter's," 31.

52 Schlimme, "Construction Knowledge in Comparison," 2856.

5. *MATTEMATICA* AND *SCIENZA*

1 Williams and Bevilacqua, "Leon Battista Alberti's Bombard Problem," 2.

2 Straub, *History of Civil Engineering*, 56.
3 Capecchi, "Historical Roots of the Rule of Composition of Forces," 1894.
4 Fermi and Bernardini, *Galileo and the Scientific Revolution*, 10.
5 James, *Remarkable Physicists*, 1.
6 Straub, *History of Civil Engineering*, 63.
7 James, *Remarkable Physicists*, 3.
8 Fermi and Bernardini, *Galileo and the Scientific Revolution*, 23.
9 Fermi and Bernardini, *Galileo and the Scientific Revolution*, 23.
10 In 1992 Pope John Paul II acknowledged that the Catholic Church had erred, 359 years after Galileo's conviction.
11 Fermi and Bernardini, *Galileo and the Scientific Revolution*, 29.
12 Straub, *History of Civil Engineering*, 66.
13 Merriman, *History of Modern Europe*, 291.
14 Horton, "*Donne: An Anatomy of the World*.
15 Merriman, *History of Modern Europe*, 291.
16 Merriman, *History of Modern Europe*, 302.
17 Merriman, *History of Modern Europe*, 305.
18 Freedman, *Women of the Scientific Revolution*, 12. Per Grendler, "Universities of the Renaissance and Reformation," 9: "The bachelor's degree had disappeared in Italian universities by about 1400. Hence, students at Italian universities sought doctoral degrees …. In stark contrast, the largest number of graduates in northern European universities were young men for whom the bachelor of arts was the terminal degree."
19 Haynes, Philosopher King, 67.
20 Haynes, Philosopher King, 67.
21 Cavazza, "Biographies of Laura Bassi," 71; Freedman, *Women of the Scientific Revolution*, 24; Merriman, *History of Modern Europe*, 304–5; Johns, "Scholar's Pope," 9–10.
22 Freedman, *Women of the Scientific Revolution*, 16–25; Merriman, *History of Modern Europe*, 303–4.
23 Grendler, "Universities of the Renaissance and Reformation," 2–6.
24 Grendler, "Universities of the Renaissance and Reformation," 11–14.
25 From Newton's title for book 3 of his *Principia*. By 1700, the universities at Padua and Cambridge were considered the finest schools of scientific thought in Europe. Their reputations were comparable to those of the Massachusetts Institute of Technology (MIT) and the California Institute of Technology (Caltech) today.
26 Commonly known as "The Mathematical Principles of Celestial Mechanics," as coined by Pierre-Simon Laplace a century later. Newton revised his *Principia* twice more, in 1713 and 1726.
27 James, *Remarkable Physicists*, 22.
28 James, *Remarkable Physicists*, 23.
29 Cohen, *Guide to Newton's* Principia, 12.

30 Cohen, *Guide to Newton's* Principia, 109.

31 James, *Remarkable Physicists*, 25.

32 Drake, *Restless Genius*, 9; Chapman, "England's Leonardo."

33 Chapman, "England's Leonardo," 241.

34 Drake, *Restless Genius*, 15.

35 Drake, *Restless Genius*, 18.

36 Drake, *Restless Genius*, 35.

37 Drake, *Restless Genius*, 36.

38 Drake, *Restless Genius*, 35; Poleni, *Memorie Istoriche*, book 1, plates D and E.

39 Straub, *History of Civil Engineering*, 69.

40 Drake, *Restless Genius*, 54.

41 Drake, *Restless Genius*, 81.

42 Drake, *Restless Genius*, 77–125, 153–365.

43 This launched the famous controversy between Gottfried Wilhelm Leibniz and Isaac Newton over whose claim had priority. It started in 1699, erupted in 1711, and gradually abated after Leibniz died a few years later. The current view is that Newton pioneered the concept of the new calculus, but that Leibniz invented the mathematical symbols that we use today in its deployment.

44 Straub, *History of Civil Engineering*, 76.

45 Straub, *History of Civil Engineering*, 139.

46 Present, *Learning in the World*, 117.

47 Straub, *History of Civil Engineering*, 108.

6. THE OPINIONS

1 Sixteen ribs at each shell. Poleni, *Memorie Istoriche*, book 1, plate C; Fontana, *Il Tempio Vaticano e sua Origine*, 321, 323; Mainstone, "The Dome of St. Peter's," 26–30.

2 Como, "Thrust Evaluations of Masonry Domes," 35–36.

3 Poleni, *Memorie Istoriche*, book 4, plate K; Mainstone, "The Dome of St. Peter's," 24–26. These "circumferential ties" were "about 6 cm [centimeters] by 4 cm in cross-section" and able to resist "500 or 600 tons" of thrust "acting around the [dome's] whole circumference."

4 Como, "Thrust Evaluations of Masonry Domes," 37.

5 Mainstone, "The Dome of St. Peter's," 29–30. Zabaglia, *Castelli*, plates xxiv–xxvi, display how the scaffolds would likely have been configured to install the inner decorations.

6 Zabaglia, *Castelli*, plates lxi and lxii. The lantern was then capped by an enormous sphere—known affectionately as "Palla"—cast from copper and eight feet across. A Latin cross made of bronze was affixed to Palla and it added another sixteen feet in height.

7 Como, "Thrust Evaluations of Masonry Domes," 40–48, performed a thorough calculation of the dome's weight and thrust. He relied on "the

same unit of weight of Poleni, the pound, that corresponds to 0.372 kg."
I adjusted Como's analysis by a factor of 1.220 since today's pound is
equivalent to 0.454 kilograms. Scotti, *Basilica*, 226, cites that "more than
616,000 tons rest on Michelangelo's drum"—which is far greater than
that established by Como's analysis—yet does not discuss its derivation.

8 Hill, "Roger Boscovich," 17.

9 Hill, "Roger Boscovich," 24.

10 Hill, "Roger Boscovich," 27.

11 Some of the key prosecutors in the Catholic Church's case against Galileo
 were Jesuits.

12 Hill, "Roger Boscovich," 27. Men and women "came of age at 17 years
 and 3 months." So, Boscovich was three years younger than most of his
 classmates for much of his academic career.

13 Hill, "Roger Boscovich," 27, 29.

14 Piazza del Popolo marks the trailhead for the ancient Via Flaminia. Its
 current configuration was planned by Sixtus V and Domenico Fontana in
 the 1580s.

15 Hill, "Roger Boscovich," 29.

16 Heilbron, "Benedict XIV and the Natural Sciences," 179; Cavazza,
 "Benedict's Patronage of Learned Women," 28.

17 Hill, "Roger Boscovich," 34.

18 Hill, "Roger Boscovich," 41–42; Whyte, "Roger Joseph Boscovich," 215.

19 Hill, "Roger Boscovich," 34–35; Whyte, "Roger Joseph Boscovich," 214.

20 Hill, "Roger Boscovich," 32–33.

21 Heilbron, "Benedict XIV and the Natural Sciences," 192.

22 Heilbron, "Benedict XIV and the Natural Sciences," 192–93.

23 The year 1711 was propitious across the long arc of the Scientific Revolu-
 tion. Roger Joseph Boscovich was born in May, François Jacquier in June,
 and Laura Bassi—a fellow Newtonian who was enthusiastically champi-
 oned by Pope Benedict XIV—in October. The Accademia delle Scienze
 dell'Istituto di Bologna was inaugurated in December.

24 Haynes, *Philosopher King*, 155.

25 Tivnan, "François Jacquier."

26 Glatigny, "Epistemological Obstacles to the Analysis of Structures,"
 204. There were five editions of the *Principia*. The first was published by
 Newton in 1687, which he updated in 1711 and again in 1726, just before
 he died. The "Jesuit" edition, by François Jacquier and Thomas Le Seur,
 appeared in 1742. Émilie du Châtelet prepared a detailed translation that
 was published posthumously in 1756 which remains the definitive stan-
 dard in French.

27 Heilbron, "Benedict XIV and the Natural Sciences," 193. According to
 Haynes, *Philosopher King*, 171, the positions were reversed.

28 Heilbron, "Benedict XIV and the Natural Sciences," 193.

29 Hill, "Roger Boscovich," 60.

30 Le Seur, Jacquier, and Boscovich, *Parere*; Poleni, *Memorie Istoriche*, book 2, plates xv, xvi.

31 By the 1740s, there seems to have been at least two stairwells (and maybe three) within the basilica that could access the rooftop. One was inside Bramante's northwest pier (or Saint Helen's Pier), as represented in Poleni, *Memorie Istoriche*, book 2, plate G. The second was inside the northern tribune. Aptly, both are near the current monument that commemorates Benedict XIV.

32 Poleni, *Memorie Istoriche*, book 2, plates xii, xiii, xvii, xviii, xix; Como, "Thrust Evaluations of Masonry Domes," 37; De Sanctis et al., "Basilica of Saint Peter," 208; Ottoni and Blasi, "Hooping as an Ancient Remedy," 171.

33 Mainstone, "Saving the Dome of St Peter's," 4.

34 Le Seur, Jacquier, and Boscovich, *Parere*; Glatigny, "Epistemological Obstacles to the Analysis of Structures," 212; Poleni, *Memorie Istoriche*, book 2, plates i–xix; Mainstone, "The Dome of St. Peter's," 31; Como, "Thrust Evaluations of Masonry Domes," 47.

35 Como, "Thrust Evaluations of Masonry Domes," 36: recorded by Saverio Brunetti, a member of Vanvitelli's earliest inspection team.

36 Mainstone, "Saving the Dome of St Peter's," 5.

37 Como, "Brunelleschi's Dome," 3.

38 Como, "Brunelleschi's Dome," 3; Mainstone, "Structural Analysis," 317–18.

39 Ottoni and Blasi, "Hooping as an Ancient Remedy," 166 173–75; Mainstone, "The Dome of St. Peter's," 32.

40 Le Seur, Jacquier, and Boscovich, *Parere*; Poleni, *Memorie Istoriche*, book 4, plate K; Mainstone, "Saving the Dome of St Peter's," 4, 13.

41 Schlimme, "Construction Knowledge in Comparison," 2856.

42 Mainstone, "The Dome of St. Peter's," 32.

43 Le Seur, Jacquier, and Boscovich, *Parere*, xxxvi.

44 Whyte, "Roger Joseph Boscovich," 213–21. His first paper was published in 1735 and his last seemed to have been written in the early 1780s, produced at an average rate of every five to six months.

45 Le Seur, Jacquier, and Boscovich, *Parere*, iv; Schlimme, "Construction Knowledge in Comparison," 2856.

46 Le Seur, Jacquier, and Boscovich, *Parere*, iv; Schlimme, "Construction Knowledge in Comparison," 2857.

47 Le Seur, Jacquier, and Boscovich, *Parere*, iv–ix; Poleni, *Memorie Istoriche*, book 2; Mainstone, "Saving the Dome of St Peter's," 17n15; Schlimme, "Construction Knowledge in Comparison," 2857.

48 Le Seur, Jacquier, and Boscovich, *Parere*, iv–ix; Schlimme, "Construction Knowledge in Comparison," 2857.

49 Le Seur, Jacquier, and Boscovich, *Parere*, ix–x; Schlimme, "Construction Knowledge in Comparison," 2857.

50 Schlimme, "Construction Knowledge in Comparison," 2857; Mainstone,
 "The Dome of St. Peter's," 32, 39n42; Mainstone, "Saving the Dome of St
 Peter's," 8–9, 17n19.
51 Mainstone, "Saving the Dome of St Peter's," 8, 17n17.
52 Le Seur, Jacquier, and Boscovich, *Parere*, xxiii–xxv; Straub, *History of
 Civil Engineering*, 112–14; Schlimme, "Construction Knowledge in
 Comparison," 2857–58; Mainstone, "Saving the Dome of St Peter's," 6, 9,
 17n21–23.
53 For context, 2,500 tons roughly equates to 1,500 mid-sized automobiles
 which, when parked side-by-side, will fill a six-acre lot.
54 Straub, *History of Civil Engineering*, 111–16; Mainstone, "Saving the
 Dome of St Peter's," 7–11, 17–18n17–30.
55 Schlimme, "Construction Knowledge in Comparison," 2859; Como,
 "Thrust Evaluations of Masonry Domes," 38.
56 De Sanctis et al., "Basilica of Saint Peter," 209.
57 Le Seur, Jacquier, and Boscovich, *Parere*, xxx–xxxvi.
58 Como, "Thrust Evaluations of Masonry Domes," 38–39; De Sanctis et al.,
 "Basilica of Saint Peter," 208.
59 Le Seur, *Riflessioni Sopra Alcune Difficolta*, xxxvi.
60 Straub, *History of Civil Engineering*, 116; Mainstone, "Saving the Dome of
 St Peter's," 9–11, 18n28–30.
61 Straub, *History of Civil Engineering*, 116.

7. CRITICS AT EVERY CORNER

1 Heilbron, "Benedict XIV and the Natural Sciences," 194.
2 Heilbron, "Benedict XIV and the Natural Sciences," 188.
3 Haynes, *Philosopher King*, 200–201.
4 Haynes, *Philosopher King*, 200–201.
5 Findlen, "Pope and the Englishwoman," 43–44.
6 Haynes, *Philosopher King*, 193.
7 Heilbron, "Benedict XIV and the Natural Sciences," 180–81.
8 Today the Quirinale Palace is the residence for the sitting president of Italy.
9 Heilbron, "Benedict XIV and the Natural Sciences," 180–81.
10 Haynes, *Philosopher King*, 193; Johns, "Scholar's Pope," 4; Heilbron,
 "Benedict XIV and the Natural Sciences," 181.
11 Mainstone, "The Dome of St. Peter's," 32–34.
12 Le Seur, Thomas et al. *Scritture Concernenti i Danni della Cupola di San
 Pietro di Roma e i Loro Rimedi* was a bound collection of three pamphlets.
 Parere came first and was followed by a short, non sequitur *articolo* about
 the apparently false rumors of instability at the dome of Santa Maria del
 Fiore in Florence. The third paper was written by "Filosofo," in rebuttal to
 the *Parere* by Le Seur, Jacquier, and Boscovich (see also Poleni, *Memorie
 Istoriche*, book 3, section xlvi, and book 4, section lxi).

13 Poleni, *Memorie Istoriche*, books 3 and 4; Schlimme, "Construction Knowledge in Comparison," 2854–55.

14 Theodoli's best-known work had been the Teatro Argentina, built in 1731 and near the site where Julius Caesar was assassinated. Barigioni was best-known for the fountain base that encircled the Egyptian obelisk at the Piazza della Rotonda in Rome—twenty years earlier, in 1711—facing the Pantheon.

15 De Revillas lived in a monastery on the Aventine Hill, near the Vatican and across the Tiber River. He was noted for his work in meteorology and cartography and was a member of the Royal Society of London and the Istituto di Scienza in Bologna.

16 Glatigny, "Epistemological Obstacles to the Analysis of Structures," 205–12. Giacomelli was well-known to Benedict XIV, to whom the pope entrusted the translation of various literary works into Latin.

17 Mainstone, "Saving the Dome of St Peter's," 11.

18 Glatigny, "Epistemological Obstacles to the Analysis of Structures," 205–12.

19 Coldstream, *Medieval Architecture*, 55; Swaan, *Gothic Cathedral*, 84.

20 Ackerman, "Gothic Theory of Architecture at the Cathedral of Milan," 90–92. Von Simson, *Gothic Cathedral*, 221, editorializes how the team-work and collective achievements of these Medieval builders seem "truly astonishing" by comparison to "the self-centered and quarrelsome indi-vidualism of [the] Renaissance."

21 Ackerman, "Gothic Theory of Architecture at the Cathedral of Milan," 91.

22 Sobel, *Longitude*.

23 Findlen, "Pope and the Englishwoman," 47.

24 Findlen, "Pope and the Englishwoman," 59.

25 Findlen, "Pope and the Englishwoman," 61.

26 Glatigny, "Epistemological Obstacles to the Analysis of Structures," 209.

27 Thomas, "From the Library to the Printing Press," 518.

28 Thomas, "From the Library to the Printing Press," 518; Manfredi, "Aca-demic Practice and Roman Architecture," 451.

29 Glatigny, "Epistemological Obstacles to the Analysis of Structures," 209.

30 Manfredi, "Academic Practice and Roman Architecture," 452.

31 Glatigny, "Epistemological Obstacles to the Analysis of Structures," 211.

32 Glatigny, "Epistemological Obstacles to the Analysis of Structures," 210.

33 Glatigny, "Epistemological Obstacles to the Analysis of Structures," 211.

34 Glatigny, "Epistemological Obstacles to the Analysis of Structures," 211.

35 Glatigny, "Epistemological Obstacles to the Analysis of Structures," 211.

36 Glatigny, "Epistemological Obstacles to the Analysis of Structures," 211–12.

37 Schlimme, "Construction Knowledge in Comparison," 2864.

38 Schlimme, "Construction Knowledge in Comparison," 2864.

39 Straub, *History of Civil Engineering*, 112–16; Mainstone, "Saving the Dome of St Peter's," 8–11; Mainstone, "The Dome of St. Peter's," 32–34.

40 Poleni compiled them in *Memorie Istoriche*, books 3–5.

41 Schlimme, "Construction Knowledge in Comparison," 2854, 2859.

42 Schlimme, "Construction Knowledge in Comparison," 2859.

43 The second volume was published in 1750, two years after Michelangelo's dome was fully repaired.

44 Kulishenko, *Dome of St. Peter's Restoration of the Eighteenth Century*, 11; Schlimme, "Construction Knowledge in Comparison," 2859, 2862.

45 Kulishenko, *Dome of St. Peter's Restoration of the Eighteenth Century*, 11.

46 Schlimme, "Construction Knowledge in Comparison," 2860.

47 Le Seur, Thomas et al., *Scritture*, 61.

48 Le Seur, Thomas et al., *Scritture*, 100.

49 Schlimme, "Construction Knowledge in Comparison," 2860.

50 Le Seur, Thomas et al., *Scritture*, 121, 123, 142.

51 Schlimme, "Construction Knowledge in Comparison," 2861.

52 Schlimme, "Construction Knowledge in Comparison," 2855.

53 Mainstone, "Saving the Dome of St Peter's," 11.

54 Marconi, "Technicians and Master Builders," 993.

55 Schlimme, "Construction Knowledge in Comparison," 2861.

56 Schlimme, "Construction Knowledge in Comparison," 2861.

57 Marconi, "Technicians and Master Builders," 994.

58 Schlimme, "Construction Knowledge in Comparison," 2859. *Parere* was delivered solely to Gabbriello, since his older brother, Eustachio, had died four years earlier.

59 Mainstone, "The Dome of St. Peter's," 34.

8. PROFESSOR POLENI

1 De Tipaldo, *Biografia degli Italiani*, 336. His full title was Marquis, Count of Saint Michael the Archangel, and Knight, Along with His Descendants.

2 Di Tipaldo's *Biografia degli Italiani*, 336–42, describes Poleni's early life. Cossali's *Eligio* describes the longer arc of Poleni's overall professional career.

3 Dooley, *Science and the Marketplace in Early Modern Italy*, 95; Signorelli, "Giovanni Poleni," 1.

4 De Tipaldo, *Biografia degli Italiani*, 336.

5 Dooley, *Science and the Marketplace in Early Modern Italy*, 95.

6 Dooley, *Science and the Marketplace in Early Modern Italy*, 95–96. This again undercuts the persistent, monolithic, and erroneous narrative that the Catholic Church was opposed to science.

7 Cossali, *Elogio di Giovanni Poleni*, 12; Ghosh, "Giovanni Battista Morgagni," 311. Morgagni's research revealed that disease was not some vague and amorphous ailment that circulated within the human body but was rather a degenerative condition that originated in targeted spots, like organs, tissues, and the bloodstream.

8 De Tipaldo, *Biografia degli Italiani*, 337.

9 Cossali, *Elogio di Giovanni Poleni*, 91; De Tipaldo, *Biografia degli Italiani*, 337.

10 Camuffo, "Galileo's Revolution and the Infancy of Meteorology," 14. The University of Bologna was established in 1088 and was the first institution in Europe to resemble what we recognize today as a center of advanced learning and modern instruction.

11 Merriman, *History of Modern Europe*, 296.

12 Del Negro, "Venetian Policy toward the University of Padua," 169.

13 Camuffo, "Galileo's Revolution and the Infancy of Meteorology," 14.

14 Arroyo, *Introduction to Poleni*, vol. 2, section 1; Dooley, *Science and the Marketplace in Early Modern Italy*, 94; Signorelli, "Giovanni Poleni," 1, 4.

15 De Tipaldo, *Biografia degli Italiani*, 338; Marcon, Peruzzi, and Talas, "Physics Cabinet of the University of Padua," 160.

16 Camuffo, "Galileo's Revolution and the Infancy of Meteorology," 16–17; Ghosh, "Giovanni Battista Morgagni," 306.

17 Dooley, *Science and the Marketplace in Early Modern Italy*, 95.

18 De Tipaldo, *Biografia degli Italiani*, 339; Cossali, *Elogio di Giovanni Poleni*, 54–55.

19 Cossali, *Elogio di Giovanni Poleni*, 91.

20 Di Tipaldo *Biografia degli Italiani*, 338.

21 Cossali, *Elogio di Giovanni Poleni*, 41–46.

22 Dooley, *Science and the Marketplace in Early Modern Italy*, 95.

23 Di Tipaldo, *Biografia degli Italiani*, 338.

24 Cossali, *Elogio di Giovanni Poleni*, 94–95.

25 Camuffo, "Galileo's Revolution and the Infancy of Meteorology," 6; Marcon, Peruzzi, and Talas, "Physics Cabinet of the University of Padua," 158.

26 Dooley, *Science and the Marketplace in Early Modern Italy*, 100.

27 Marcon, Peruzzi, and Talas, "Physics Cabinet of the University of Padua," 158–59.

28 Marcon, Peruzzi, and Talas, "Physics Cabinet of the University of Padua," 159–60.

29 Marcon, Peruzzi, and Talas, "Physics Cabinet of the University of Padua," 160–61.

30 Marcon, Peruzzi, and Talas, "Physics Cabinet of the University of Padua," 158. These were the words of French astronomer Jérôme Lalande, who visited the physics cabinet at the Palazzo del Bo in Padua in 1765, four years after Poleni's death, and wrote admiringly about what he saw.

31 Marcon, Peruzzi, and Talas, "Physics Cabinet of the University of Padua," 162; Dooley, *Science and the Marketplace in Early Modern Italy*, 98.

32 Dooley, *Science and the Marketplace in Early Modern Italy*, 98.

33 Dooley, *Science and the Marketplace in Early Modern Italy*, 101.

34 Lopez, "Poleni's Manuscripts," 1960.

35 Mainstone, "Saving the Dome of St Peter's," 11n34.

36 Lopez, "Poleni's Manuscripts," 1959; Mainstone, "Saving the Dome of St Peter's," 12.

37 Mainstone, "Saving the Dome of St Peter's," 12n36.

38 Mainstone, "Saving the Dome of St Peter's," 12; Mainstone, "The Dome of St. Peter's," 35.

39 Poleni, *Memorie Istoriche*, book 3, 282–92.

40 Straub, *History of Civil Engineering*, 114–15; Mainstone, "Saving the Dome of St Peter's," 12n37; Lopez, "Poleni's Manuscripts," 1964.

41 Straub, *History of Civil Engineering*, 114.

42 Straub, *History of Civil Engineering*, 114–15.

43 Straub, *History of Civil Engineering*, 115n2.

44 Lopez, "Poleni's Manuscripts," 1964.

45 Ottoni and Blasi, "Hooping as an Ancient Remedy," 171. Soft-story failures are often observed after an earthquake and can commonly cause many fatalities and heavy damage to buildings.

46 Drake, *Restless Genius*, 35.

47 Straub, *History of Civil Engineering*, 141n2–3.

48 Poleni, *Memorie Istoriche*, book 1, plate E.

49 Lopez, "Poleni's Manuscripts," 1968, 1970.

50 Como, "Thrust Evaluations of Masonry Domes," 38.

51 Lopez, "Poleni's Manuscripts," 1961; Mainstone, "Saving the Dome of Saint Peter's," 12n39.

52 Lopez, "Poleni's Manuscripts," 1970.

53 Mainstone, "Saving the Dome of St Peter's," 12.

54 Poleni, *Memorie Istoriche*, book 1, plate F, book 3, plate H, book 4, plate K; Lopez, "Poleni's Manuscripts," 1972.

55 Lopez, "Poleni's Manuscripts," 1970.

56 Poleni, *Memorie Istoriche*, book 2, 141ff.

57 Poleni, *Memorie Istoriche*, book 3, 323–30; Lopez, "Poleni's Manuscripts," 1970.

58 Mainstone, "Saving the Dome of St Peter's," 12; Lopez, "Poleni's Manuscripts," 1972.

59 Mainstone, "Saving the Dome of St Peter's," 12.

60 Lopez, "Poleni's Manuscripts," 1969.

61 Lopez, "Poleni's Manuscripts," 1968, 1970, 1973.

62 Poleni, *Memorie Istoriche*, book 2.

63 Marconi, "Technicians and Master Builders," 998; Glatigny, "Epistemological Obstacles to the Analysis of Structures," 212; Mainstone, "The Dome of St. Peter's," 34. See chapter 2, note 29, for discussion of scudi.

64 Glatigny, "Epistemological Obstacles to the Analysis of Structures," 212.

65 Poleni, *Memorie Istoriche*. Books 3 and 4 list these responses more lyrically as *discorsi, parere, riflessioni, osservazioni, sentimenti, aggiunti,* and *risoluzione.*

9. A MAGICIAN'S TOUCH

1 Zabaglia is referenced as both "Niccola" and "Nicola" in the literature and research about his life. In his own book, *Castelli*, he is named as "Niccola," which to this author suggests Zabaglia's personal preference and is the spelling I have therefore elected to use.

2 D'Amelio, "Construction Techniques and Methods for Organizing Labor," 693–94.

3 D'Amelio, "Construction Techniques and Methods for Organizing Labor," 694. It was the Aniene River, and the port was known as Traspontina, along the Tiber River near the Vatican.

4 Marconi, "Technicians and Master Builders," 991.

5 Marconi, "Technicians and Master Builders," 992.

6 D'Amelio and Marconi, "Technology and Repairs," 48; Marconi, "Nicola Zabaglia and the School of Practical Mechanics," 186.

7 Marconi, "Nicola Zabaglia and the School of Practical Mechanics," 191–92.

8 Marconi, "Nicola Zabaglia and the School of Practical Mechanics," 192. The other *sanpietrini* were Tommaso Albertini, Pietro Antonio, Giovanni Corsini, and Angelo Paraccini. Albertini succeeded Zabaglia as master mason at the basilica in 1750 and developed many inventive scaffold designs of this own in the 1770s.

9 Marconi, "Technicians and Master Builders," 991.

10 D'Amelio, "Technology and Repairs," 52.

11 Zabaglia, *Memorie Istoriche*, plate x.

12 Zabaglia, *Memorie Istoriche*, plates xxiii–xxix; Marconi, "Nicola Zabaglia and the School of Practical Mechanics," 187.

13 D'Amelio, "Technology and Repairs," 48–52; Marconi, "Nicola Zabaglia and the School of Practical Mechanics," 185–87.

14 Marconi, "Technicians and Master Builders," 992. Zabaglia moved, for instance, an entire fresco panel that measured some twenty-five feet tall into a studio for restoration, as well as an obelisk at Lateran Square that was nearly fifty feet high. He built another magnificent scaffold at the Basilica of St. Paul Outside the Walls when its stone vaulting needed repairs.

15 Marconi, "Nicola Zabaglia and the School of Practical Mechanics," 187.

16 Marconi, "Technicians and Master Builders," 993; Marconi, "Nicola Zabaglia and the School of Practical Mechanics," 191.

17 Zabaglia, *Castelli*, plates ix, xi, xiii, xv, xvii.

18 Zabaglia, *Castelli*, plates i–viii; Marconi, "Nicola Zabaglia and the School of Practical Mechanics," 191. The plates were largely prepared by Francesco Rostagni. *Castelli* also contained fifteen illustrations of the Vatican Obelisk and how it had been moved a century before, as prepared by Carlo Fontana in the 1690s.

19 Marconi, "Technicians and Master Builders," 996.

20 Marconi, "Nicola Zabaglia and the School of Practical Mechanics," 191.

21 Marconi, "Nicola Zabaglia and the School of Practical Mechanics," 195.

22 Poleni, *Memorie Istoriche*, book 1, plate F; Marconi, "Technicians and
 Master Builders," 996; Lopez, "Poleni's Manuscripts," 1973. Thirty-two
 bars at the lower rings to reinforce the drum and attic, and twenty-four
 bars at the upper rings to reinforce the dome.

23 Marconi, "Technicians and Master Builders," 996.

24 Mainstone, "Saving the Dome of St Peter's," 11–12. Poleni specified five
 rings of about 8.5 square inches each, while *Parere* had specified three
 rings, each that were roughly 9.5 square inches.

25 Poleni, *Memorie Istoriche*, book 4, plate K. Their locations were designated
 as *A, B, C, Z*, and *D*. The iron chains installed by Giacomo della Porta in
 1588 were labeled as *n* and *u*. According to Marconi, "Technicians and
 Master Builders," 994, Della Porta installed three chains inside the dome
 and then another two just below the lantern, which was designated as *E*,
 on Plate K.

26 Borngasser, *Gothic Architecture in Italy*, 241. Stone vaults with pointed
 arches, resembling Gothic design, were often used in northern Italy
 because of its geographic proximity to Germany. Gothic features
 appeared in southern Italy, too, because of the Kingdom of Sicily's strong
 roots with the Normans and their French culture and building traditions.

27 Borngasser, *Gothic Architecture in Italy*, 241–42; Coldstream, *Medieval
 Architecture*, 26.

28 Borngasser, *Gothic Architecture in Italy*, 242. Coldstream, *Medieval Archi-
 tecture*, 23–26, states "that by the seventeenth century the term Gothic
 was widely used, but that in England at least it had become a neutral
 epithet." A similar pejorative was leveled at impressionist painters in
 nineteenth-century France, who were then experimenting with a revo-
 lutionary form of expression and technique in painting that has subse-
 quently become a beloved movement known as impressionism. See King,
 Ross. *The Judgment of Paris: The Revolutionary Decade That Gave the World
 Impressionism*, Walker Books, 2006.

29 Poleni, *Memorie Istoriche*, book 2, sections xvii–xx; Ottoni and Blasi,
 "Hooping as an Ancient Remedy," 166–77; Mainstone, "Saving the Dome
 of St Peter's," 5. The Torre degli Asinelli in Bologna was rectangular and
 reinforced with iron straps at its bottom third.

30 Marconi, "Technicians and Master Builders," 996.

31 Marconi, "Technicians and Master Builders," 996.

32 Spoerl, "Brief History of Iron and Steel Production," 1; "Triumvirate," 5.

33 Spoerl, "Brief History of Iron and Steel Production," 1; "Triumvirate," 7.
 Trace amounts of carbon—less than 0.60 percent content—is all that is
 needed to transform native iron ore into wrought iron.

34 Though the technology may have been known in China well before. See
 "Triumvirate," 8.

35 Spoerl, "Brief History of Iron and Steel Production," 1–2.

36 Spoerl, "Brief History of Iron and Steel Production," 1–2. The carbon
 content for cast iron commonly ranges between 3.0 and 4.5 percent, and
 for steel is far lower: between 0.2 and 1.5 percent.

37 I used scaled drawings from Fontana and Fletcher to calculate the diam-
 eters for the five new rings. They ranged between 130 and 182 feet, for an
 aggregate circumferential length of about 2,370 lineal feet. Their cross-
 sectional area was roughly 8.33 square inches, and the density of cast iron
 is about 491.5 pounds per cubic foot. Then, I estimated that the vertical
 pins and connection assemblies added 10 percent to the tonnage.

38 Marconi, "Technicians and Master Builders," 996.

39 Zabaglia, *Castelli*, plates xiv–xvi; Marconi, "Technicians and Master
 Builders," 996.

40 Poleni, *Memorie Istoriche*, book 4, plate K, chain A. Each bar was roughly
 eighteen feet long.

41 Marconi, "Technicians and Master Builders," 997.

42 Poleni, *Memorie Istoriche*, book 4, plate K, chain B. Each bar was roughly
 fifteen feet long.

43 Zabaglia, *Castelli*, plates xxiv, xxv, xxvii; Marconi, "Technicians and
 Master Builders," 996.

44 Marconi, "Technicians and Master Builders," 997.

45 Poleni, *Memorie Istoriche*, book 2, plate G, stairway D.

46 Zabaglia, *Castelli*, plate xxvi.

47 Poleni, *Memorie Istoriche*, book 1, plate F.

48 Marconi, "Technicians and Master Builders," 997.

49 Swaan, *Gothic Cathedral*, 75–76; King, *Brunelleschi's Dome*, 74–75.

50 Zabaglia, *Castelli*, plates ix–xix.

51 Zabaglia, *Castelli*, plates i–viii, xix, xxi.

52 Zabaglia, *Castelli*, plates ix, xi, xiii, xx–xxx.

53 King, *Brunelleschi's Dome*, 140.

54 Marconi, "Technicians and Master Builders," 997.

55 Marconi, "Technicians and Master Builders," 998. Since the bonus was
 given—personally—by the pope, it was likely to have been minted from
 gold, as the *scudo d'oro pontificio*, rather than the more commonplace *scudo
 di moneta* that was made from silver.

10. THE MEMOIRS

1 Tribe, "Sanpietrini and the Illumination of St. Peter's Basilica."

2 "Old Images of Candle-Lit Vatican."

3 "Old Images of Candle-Lit Vatican."

4 Marconi, "Technicians and Master Builders," 998.

5 Di Sante, *Archive of the Fabbrica di San Pietro*, 1–2.

6 Marconi, "Technicians and Master Builders," 994, fig. 2.

7 Poleni, *Memorie Istoriche*, book 4, plate K; Marconi, "Technicians and Master Builders," 994; Mainstone, "Saving the Dome of St Peter's," 24–26.

8 De Sanctis et al., "Basilica of Saint Peter," 209.

9 Mainstone, "Saving the Dome of St Peter's," 12; Arroyo, *Introduction to Poleni*, vol. 2, section 3.

10 De Sanctis, "Basilica of Saint Peter," 209.

11 Marconi, "Technicians and Master Builders," 998.

12 Marconi, "Technicians and Master Builders," 998.

13 Marconi, "Technicians and Master Builders," 998; Mainstone, "Saving the Dome of St Peter's," 12.

14 According to Hersey, *Architecture, Poetry, and Number*, 93, Vanvitelli alluded "to continued problems with the dome well into the 1760s." But there are few specifics, and it runs contrary to other sources about the project.

15 Haynes, *Philosopher King*, 169.

16 Haynes, *Philosopher King*, 169.

17 Haynes, *Philosopher King*, 170.

18 Paul, "Benedict XIV's Enlightened Patronage," 341–50.

19 Haynes, *Philosopher King*, 200–201.

20 Haynes, *Philosopher King*, 202–3.

21 Heilbron, "Benedict XIV and the Natural Sciences," 189.

22 Tetti, *Restoration of Architecture and Works of Art*, 96. His five sons: Carlo (1739), Piero (1741), Gaspare (1743), Tommaso (1744), and Francesco (1745) were followed by three girls: Anna Maria (1747), Maria Cecilia (1748), and Maria Palmira (1750). Tommaso died a month after birth, and Anna Maria passed at five years.

23 Tetti, *Restoration of Architecture and Works of Art*, 48. Vanvitelli stepped in to assist Salvi, who apparently had health problems at the time. Vanvitelli's work at Santa Maria degli Angeli was heavily criticized by his arch-nemesis, Giovanni Gaetano Bottari. See chapter 4, note 31.

24 Tivnan, "François Jacquier"; Heilbron, "Benedict XIV and the Natural Sciences," 192–93.

25 Hill, "Roger Boscovich," 40.

26 Whyte, "Roger Joseph Boscovich," 215–16; Hill, "Roger Boscovich," 43. This was additive to the fifteen or so papers Boscovich published before *Parere*, in 1742.

27 Hill, "Roger Boscovich," 36 and 40.

28 Hill, "Roger Boscovich," 36–37, 49.

29 Hill, "Roger Boscovich," 41–42, 215–16.

30 Hill, "Roger Boscovich," 46.

31 Arroyo, *Introduction to Poleni*, vol. 2, section 3.

32 Mainstone, "Saving the Dome of St Peter's," 13; Heyman, *Coulomb's Memoir on Statics*, 80; Marcon, Peruzzi, and Talas, "Physics Cabinet of the University of Padua," 162, fig. 3. The device, in its Rococo styling and ornament, is on display at the Museum of the History of Physics at the University of Padua.

33 Como, "Thrust Evaluations of Masonry Domes," 40; Lopez, "Poleni's Manuscripts," 1961.

34 Poleni's *Riflessioni* is compiled in his *Memorie Istoriche*, book 3, section xlvii. His *Aggiunta* is in section lvi.

35 Como, "Thrust Evaluations of Masonry Domes," 40–48.

36 Glatigny, "Epistemological Obstacles to the Analysis of Structures," 212.

37 Dooley, *Science and the Marketplace in Early Modern Italy*, 95, 97.

38 Dooley, *Science and the Marketplace in Early Modern Italy*, 95.

39 The plates were prepared from copper etchings engraved by Pietro Monaco and printed by Antonio Peroni. See Marconi, "Technicians and Master Builders," 998.

40 Poleni, *Memorie Istoriche*, book 1, 18–30.

41 Lopez, "Poleni's Manuscripts," 1974.

42 These plates were labeled as *tavola* (tables).

43 Saint Helen's Pier was at the northwest quadrant of the crossing. The other piers were known as Saint Longinus to the northeast, Saint Veronica at the southwest, and Saint Andrew to the southeast.

44 Poleni, *Memorie Istoriche*, book 3, sections xl, xli, xlv, xlvi, xlviii, xlix, lvi.

45 Poleni, *Memorie Istoriche*, book 3, sections xxxvii–lvi, and book 4, sections lvii–lx. The report by Giovanni Amico, the architect from Trapani, was not part of the collection.

46 From Marconi, "Technicians and Master Builders," 998, the etchings and plates inside the book cost 997 scudi (probably *di moneta*), which was paid from the 1,000 *scudi d'oro pontificio* given by Benedict XIV to Poleni in June 1743 to cover the costs of compiling and publishing *Memorie Istoriche*.

47 Arroyo, *Introduction to Poleni*, vol. 2, section 5.

48 Phillips, *Illustrated History of the Popes*, 210, 214. Clement XIII ordered "the covering up or even painting out" of nude statuary and paintings around the Vatican, including some of the frescoes within the Sistine Chapel. Clement XIV "lacked the necessary strength of character" to prevent the controversial dissolution in 1773 of the Jesuit order (to which Boscovich had belonged), from which he sank into a dark depression and died a year later.

11. THE ADVENT OF MODERN ENGINEERING

1 Lee, *Military Technologies of the World*, 242.

2 Holmes, *World Atlas of Warfare*, 77.

3 The Ottoman Turks had cannons in their arsenal by 1422. See Lee, *Military Technologies of the World*, 242–43.

4 Holmes, *World Atlas of Warfare*, 79, 86–87.

5 McDonald, "Origin of the Word 'Engineer,'" 294.

6 McDonald, "Origin of the Word 'Engineer,'" 294; McDonald, "engine (n.)" and "engineer (n.)"; Straub, *History of Civil Engineering*, 118.

7 McDonald, "Origin of the Word 'Engineer,'" 294–95. Interestingly, "no trace of … the word 'engineer'" has been found from antiquity and these skilled positions "were designated otherwise, as, for example … 'moduli' (levelers), 'scientia' (builders), 'agrimensores' and 'geometricii (land surveyors, [and] 'architectos' (architects)." Per McDonald, the use of the term *engineer* to define a driver of railroad engines was first used in 1832, and in American English.

8 Straub, *History of Civil Engineering*, 120. Jacques Heyman cites the founding in 1676. See Heyman, *Coulomb's Memoir on Statics*, 191.

9 Straub, *History of Civil Engineering*, 118–20. The Corps du Genie was also known as the Ingenieurs du Roi, or the King's Engineers.

10 Straub, *History of Civil Engineering*, 120.

11 Straub, *History of Civil Engineering*, 120.

12 Barnard, *Military Schools and Courses of Instruction*, 5–6, 133.

13 Traetta, "Bernard Forest de Belidor," 70–71; Barnard, *Military Schools and Courses of Instruction*, 133.

14 The *Nouveau Cours* was published in 1720 and reprinted in 1757. See Straub, *History of Civil Engineering*, 121, and Traetta, "Bernard Forest de Belidor," 71.

15 Traetta, "Bernard Forest de Belidor," 71. Leon Battista Alberti had also tried to make math fun in his book, *Ludi Matematici* (Games in Mathematics), published around 1450.

16 Traetta, "Bernard Forest de Belidor," 70–71; Heyman, *Coulomb's Memoir on Statics*, 84–88.

17 Straub, *History of Civil Engineering*, 121, 181.

18 Heyman, *Coulomb's Memoir on Statics*, 80, 84; Godoy and Elishakoff, "Experimental Contribution of Petrus Van Musschenbroek, 2. Van Musschenbroek's book was published in Leiden and in Latin as *Physicae experimentales, et geometricae, de magnete, tuborum capillarium vitreorumque speculorum attraction, magnitudine terrea, cohaerentia corporum firmorum. Disertationes ut et Ephemerides Meteorologicae Ultrajectinae* (Dissertations and Meteorological Journals about Experimental Physics, Geometry, Magnets, Capillary Tubes, Glass Mirrors, the Size of the Earth, and the Attraction between Solid Objects).

19 Straub, *History of Civil Engineering*, 121–22. De Belidor also provides advice in selecting a suitable construction contractor. See Straub, *History of Civil Engineering*, 136–37.

20 All from Heyman, *Coulomb's Memoir on Statics*, 191–92.

21 Straub, *History of Civil Engineering*, 121.

22 Blond, "Trudaine Atlas."

23 Straub, *History of Civil Engineering*, 125; Ashworth, "Scientist of the Day: Jean-Rodolphe Perronet."

24 Heyman, *Coulomb's Memoir on Statics*, 1; Tipler, *Physics*, 702–5, 727–33. Coulomb's experiments with electricity led to his famous observation that "like" electrical charges repel one another and "unlike" charges attract, and that these charges were, in effect, a force that could be arithmetically calculated using a formula that he divined, which is now known as Coulomb's law. In addition, a unit of electrical charge, defined as a *coulomb* in the International System of Units, is named in recognition of his research.

25 Straub, *History of Civil Engineering*, 146–51; Heyman, *Coulomb's Memoir on Statics*, vii.

26 Coulomb's milestone achievement in civil engineering was written in 1773 and was known as the *Memoires des Savants Etrangers* (Memoirs of Foreign Scholars). The most renowned portion of his *Memoirs* was a paper titled "Essai Sur une Application des Regles de Maximis et Minimis a Quelques Problemes de Statique, Relatifs a l'Architecture." See Straub, *History of Civil Engineering*, 79, and Heyman, *Coulomb's Memoir on Statics*, 1ff.

27 Straub, *History of Civil Engineering*, 152–53.

28 The book was reprinted in 1839.

29 Giedion, *Space, Time and Architecture*, 168–69; Rosen, *Most Powerful Idea in the World*, 144–47; Higgs, "Dud Dudley and Abraham Darby." Before the advent of coking, the amount of charcoal needed for "the production of 10,000 tons of iron demanded nearly 100,000 acres of forest, which meant that a single seventeenth-century blast furnace could denude more than four thousand acres [of trees] each year." See Rosen, *Most Powerful Idea in the World*, 144.

30 "Triumvirate," 1–2.

31 Rosen, *Most Powerful Idea in the World*, 30.

32 "Triumvirate," 3.

33 Farey, *Treatise on the Steam Engine*, v.

34 Farey, *Treatise on the Steam Engine*, v; Rosen, *Most Powerful Idea in the World*, 29.

35 Higgs, "Dud Dudley and Abraham Darby."

36 Per Rosen, *Most Powerful Idea in the World*, 148: "Coke is what you get when soft, bituminous coal is baked in a very hot oven to draw off most of the contaminants, primarily sulfur . . . [W]hile it was . . . not perfect for smelting iron, it was a lot cheaper than the rapidly vanishing store of wood."

37 Higgs, "Dud Dudley and Abraham Darby." Dudley composed about his invention in his memoir that he composed later in life, titled *Metallum Martis*.

38 Higgs, "Dud Dudley and Abraham Darby"; "Triumvirate," 10.

39 Colvin, *Biographical Dictionary of British Architects*, 662; Pevsner, *Pioneers of Modern Design*, 126.

40 The Iron Bridge was designated as a UNESCO World Heritage site in 1986.

41 Giedion, *Space, Time and Architecture*, 165.

42 Rosen, *Most Powerful Idea in the World*, 149.

43 Farey, *Treatise on the Steam Engine*, 1.

44 Farey, *Treatise on the Steam Engine*, 2–3.

45 Straub, *History of Civil Engineering*, 170, 206. Cement acts as a binding agent and is one of the four essential ingredients necessary to make concrete. The other ingredients are small aggregates of stone, larger aggregates, and fresh water.

46 McDonald, "Origin of the Word 'Engineer,'" 294. Like the French, the British had established a military academy of their own at Woolwich, near Greenwich, which furnished formal training to military engineers. See Barnard, *Military Schools and Courses of Instruction*, 6, 585.

47 According to McDonald, "Origin of the Word 'Engineer,'" 294, the Society of Civil Engineers included "many of the most eminent members of the profession, but it [was] rather of the nature of a social club than of a scientific association."

48 Colvin, *Biographical Dictionary of British Architects*, 819–20; Straub, *History of Civil Engineering*, 176.

49 Colvin, *Biographical Dictionary of British Architects*, 820; "Thomas Telford." The suspension bridge was also pioneered by James Finley and Isambard Kingdom Brunel in Britain. See Pevsner, *Pioneers of Modern Design*, 126–29. Charles Navier tried his hand at a suspension bridge, too, over the River Seine in Paris, but it was plagued by problems for which Navier was unfairly held responsible, and the design was subsequently scrapped. See Straub, *History of Civil Engineering*, 156–57.

50 Straub, *History of Civil Engineering*, 184; Pevsner, *Pioneers of Modern Design*, 132–33; Hitchcock, *Architecture*, 184.

51 The closest analogy is our space race during the 1960s, and the pride and wonder it inspired around the world when Apollo 11 landed on the moon in July 1969. Engineers consistently earn high scores in public opinion polls, along with nurses (who are the most trusted), medical doctors, and teachers. The least trusted are politicians, advertising executives, and journalists. See Besley and Hill, "Science and Technology," fig. 7.6; "Ipsos Veracity Index 2022"; and Armstrong, "Most and Least Trusted Professions in Britain."

EPILOGUE

1 Marconi, "Nicola Zabaglia and the School of Practical Mechanics," 192.

2 Statue number 36 is dedicated to Galileo Galilei, and numbers 66 and 67 are dedicated to alumni from the University of Padua who went on

to become Popes Alexander VIII (1689–1691) and Clement XIII (1758–1769, and as successor to Benedict XIV).

3 Cossali, *Elogio di Giovanni Poleni*, 91–105.

4 Cossali, *Elogio di Giovanni Poleni*, 67–69; Signorelli, "Giovanni Poleni," 3.

5 Cossali, *Elogio di Giovanni Poleni*, 7; Signorelli, "Giovanni Poleni," 4.

6 Signorelli, "Giovanni Poleni," 4. Apparently, Poleni's son, Francesco, tried a few years later, in 1763, to sell the library "abroad" but the Venetian Republic intervened to keep the books within its jurisdiction. But they did not stay for long, since Napoleon Bonaparte confiscated the library thirty years later, in 1793.

7 Ghosh, "Giovanni Battista Morgagni," 306–11; Signorelli, "Giovanni Poleni," 4.

8 Signorelli, "Giovanni Poleni," 4.

9 Tetti, *Restoration of Architecture and Works of Art*, 39.

10 Tetti, *Restoration of Architecture and Works of Art*, 8. Charles III was born in 1716 as the fifth son to King Philip V of Spain. He governed the Kingdom of Naples from 1734-59, when he was known as Charles VII of Naples. He resigned his Neapolitan crown to assume the Spanish throne in 1759 after the death of his brother, Ferdinand VI (Lynch, J. "Charles III.")

11 Hersey, *Architecture, Poetry, and Number*, 87–88.

12 Thomas, "From the Library to the Printing Press," 520–25; Hersey, *Architecture, Poetry, and Number*, 3.

13 Manfredi, p. 4; Tetti, *Restoration of Architecture and Works of Art*, 96; Thomas, "From the Library to the Printing Press," 522.

14 Hersey, *Architecture, Poetry, and Number*, 9. It was no coincidence that Charles III intended his Royal Palace of Caserta to rival the Palace of Versailles. His father, Philip V, had ruled Spain from 1700–1746, during which time Spanish influence was re-asserted in Europe (and included control over the Kingdom of Naples). The Reggia di Caserta was intended to symbolize this heightening political prominence, especially as Charles III was a great grandson to King Louis XIV of France—who had sponsored the construction of the Palace of Versailles in the seventeenth century (Britannica, The Editors of Encyclopaedia. "Philip V").

15 Ashworth, "Scientist of the Day: Luigi Vanvitelli"; Hersey, *Architecture, Poetry, and Number*, 4, 87–88.

16 Hersey, *Architecture, Poetry, and Number*, 93.

17 Tetti, *Restoration of Architecture and Works of Art*, 97; Hersey, *Architecture, Poetry, and Number*, 93–97.

18 Hersey, *Architecture, Poetry, and Number*, 96.

19 Ashworth, "Scientist of the Day: Luigi Vanvitelli."

20 Hill, "Roger Boscovich," 60.

21 Misnamed as the "Jesuit Edition."

22 Tivnan, "François Jacquier"; Hill, "Roger Boscovich," 42. See Institut
 de France and its roster of members at the Academy of Sciences, where
 Le Seur and Jacquier were each designated as a *correspondant de Clairaut*.
 Alexis Clairaut (1713–1765) was a giant within French mathematics at
 that time.
23 Heilbron, "Benedict XIV and the Natural Sciences," 193.
24 These memberships appear on the title page of *Elemens du Calcul Inte-
 gral*. Per Findlen, "Pope and the Englishwoman," 264: Jacquier "praised
 [Agnesi] as a woman whose mathematical skills were easily comparable to
 those of many learned men." Per Freedman, *Women of the Scientific Revo-
 lution*, 24: Agnesi was a "brilliant student who learned seven languages"
 and her book on mathematics, published in 1748, was the first "to discuss
 both differential and integral calculus." Findlen, "Pope and the English-
 woman," 264, further noted how Jacquier "enjoyed a warm friendship
 with Chatelet, having greatly admired her [book titled] *Institutes of Physics*
 and arranged its Italian translation." He also "played an important role in
 encouraging Chatelet to become the French translator of Newton's *Prin-
 cipia*." Per Freedman, *Women of the Scientific Revolution*, 23, Châtelet was
 among the finest physicists and mathematicians in France. She died at
 forty-two during childbirth, and her definitive translation and commen-
 tary to *Principia* was published posthumously, ten years later, in 1759.
25 Hill, "Roger Boscovich," 60; Markovic, "Boscovich's 'Theoria,'" 147.
26 James, *Remarkable Physicists*, 47.
27 James, *Remarkable Physicists*, 48.
28 Whyte, "Roger Joseph Boscovich," 213–21.
29 Fitzpatrick, "Roger Joseph Boscovich," 168.
30 Fitzpatrick, "Roger Joseph Boscovich," 168; Whyte, "Boscovich's
 Atomism," 102.
31 James, *Remarkable Physicists*, 49.
32 Hill, "Roger Boscovich," 42–43, 79–80.
33 James, *Remarkable Physicists*, 49; Fitzpatrick, "Roger Joseph Boscovich,"
 174; Hill, "Roger Boscovich," 42–45; Scott, "Boscovich's Mathematics,"
 185–86.
34 James, *Remarkable Physicists*, 49; Heilbron, "Benedict XIV and the Nat-
 ural Sciences," 192.
35 The Institut de France and its roster of members at the Academy of Sci-
 ences. See Hill, "Roger Boscovich," 40, 62, 65–66.
36 Hill, "Roger Boscovich," 46–50, 58–59, 81–82, 89–91.
37 James, *Remarkable Physicists*, 51; Hill, "Roger Boscovich," 56, 83: The
 Jesuits were suspected and accused "of political plotting, of being a danger
 to every State, [and] of breeding sedition everywhere."
38 Hill, "Roger Boscovich," 91–92; James, *Remarkable Physicists*, 54–55.
39 James, *Remarkable Physicists*, 55; Hill, "Roger Boscovich," 59–60

40 Hill, "Roger Boscovich," 37, 60.

41 James, *Remarkable Physicists*, 54; Hill, "Roger Boscovich," 83–84.

42 Hill, "Roger Boscovich," 85; James, *Remarkable Physicists*, 54.

43 James, *Remarkable Physicists*, 55.

44 James, *Remarkable Physicists*, 55; Hill, "Roger Boscovich," 97–98.

45 Hill, "Roger Boscovich," 98.

46 Fitzpatrick, "Roger Joseph Boscovich," 169; Whyte, "Boscovich's Atomism," 102, 124; Haynes, *Philosopher King*, 171–72; Markovic, "Boscovich's 'Theoria,'" 127.

47 Johns, "Scholar's Pope," 12; Phillips, *Illustrated History of the Popes*, 209.

48 Haynes, *Philosopher King*, 46.

49 Johns, "Scholar's Pope," 4.

50 Johns, "Scholar's Pope," 5; Cavazza, "Benedict's Patronage of Learned Women," 27.

51 Cavazza, "Benedict's Patronage of Learned Women," 18, 28; Johns, "Scholar's Pope," 9.

52 Cavazza, "Benedict's Patronage of Learned Women," 19, 29; Haynes, 55–56, 71–76, 172.

53 Haynes, *Philosopher King*, 46, 74–76.

54 Haynes, *Philosopher King*, 172.

55 Haynes, *Philosopher King*, 171; Heilbron, "Benedict XIV and the Natural Sciences," 193.

56 Haynes, *Philosopher King*, 171.

57 Paul, "Benedict XIV's Enlightened Patronage." 341–51; Johns, "Scholar's Pope," 8–9.

58 Johns, "Scholar's Pope," 7; Haynes, 228.

59 Haynes, *Philosopher King*, 168–70.

60 Haynes, *Philosopher King*, 42, 59–60.

61 Haynes, *Philosopher King*, 60, 184; Heilbron, "Benedict XIV and the Natural Sciences," 178, 189, 194.

62 Haynes, *Philosopher King*, 228.

63 Messbarger et al., *Benedict XIV and the Enlightenment*, xxix, xxx.

64 Johns, "Scholar's Pope," 3.

INDEX